WILLIAM AND HENRY WALTERS,
THE RETICENT COLLECTORS

born in 1819 in Central Pennsylvania, modest circumstances ambition took him moved to Baltimore in 1841, where made a fortune in rye whiskey + RRs + shipping.

20 yrs later had amassed a fortune + ~~had~~ one of the best private art collections in the country. Only enhanced as escaped to Paris a his family during civil war years, 1861–1865. Where Henry first (a his sister) got his taste for arts, visiting galleries + artists' studios.

Toured Italy + went to London where his wife died of pneumonia. Allayed grief by "immersed himself in the Paris art market." Toured much of the continent. Auctioned off his original collection in U.S. to have more funds to purchase in Euro. Once war settled, returned to Baltimore

Helped purchasing for the Corcoran Gallery in D.C.

WILLIAM AND HENRY WALTERS, THE RETICENT COLLECTORS

William R. Johnston

PUBLISHED BY
THE JOHNS HOPKINS UNIVERSITY PRESS
BALTIMORE AND LONDON
IN ASSOCIATION WITH
THE WALTERS ART GALLERY

In memory of Sara Delano Redmond

© 1999 The Walters Art Gallery
All rights reserved. Published 1999
Printed in the United States of America on acid-free paper
4 6 8 9 7 5 3

The Johns Hopkins University Press
2715 North Charles Street
Baltimore, Maryland 21218-4363
www.press.jhu.edu

Library of Congress Cataloging-in-Publication Data will be found
at the end of this book.
A catalog record for this book is available from the British Library.

ISBN-13: 978-0-8018-6040-9
ISBN-10: 0-8018-6040-7

Contents

ILLUSTRATIONS

Plates

Color illustrations appear after page 140.

Figures

PREFACE

IN 1966, WHEN I JOINED THE STAFF, the Walters Art Gallery was widely acknowledged to rank among the most important small museums in North America. Its collections were renowned for their breadth and quality in fields as diverse as Egyptian bronzes, Roman sarcophagi, illuminated manuscripts, Italian panel paintings, and Sèvres porcelain. Rumors were still rife that untold riches remained in its basement waiting to be discovered, but these rumors proved to be exaggerations. Since the gallery's opening as a public museum in 1934, more than twenty-two thousand items had been documented, but because of limited exhibition space, many had been returned to storage. Several attempts to raise funds for an additional building had failed, but in 1964 a campaign that would succeed was launched under the leadership of the recently appointed director, Richard H. Randall Jr.

Many of the gallery's staff devoted their entire careers to the institution. Legendary in their respective disciplines, the "two Dorothys"—Dorothy E. Miner, librarian and keeper of manuscripts, and Dorothy K. Hill, curator of ancient art—explored various aspects of the collection's history. The registrar, Winifred Kennedy, meticulously recorded any documents pertaining to the gallery's holdings. Apart from the former director, Edward S. King, who could vaguely recall being greeted by Henry Walters with a limp handshake when his father had taken him to a gallery reception in the early 1900s, the early curators had not been acquainted with the collection or with Baltimore before 1934. Fortunately, their research was assisted by several relatives of the Walterses, most notably Laura Delano, a niece to whom Henry had been particularly close. The curators could also draw upon the reminiscences of James C. Anderson, Henry Walters's building superintendent, who remained on the staff after 1934, and of C. Morgan Marshall, the gallery's first administrator, who had also been acquainted with Henry Walters.

It had always been assumed that, once she was freed of other respon-sibilities, the indefatigable Dorothy Miner would tackle the history of the Walters Art Gallery. That opportunity never arose, and with her death in 1973 much of the knowledge that she had accumulated over thirty-nine years was lost. The following year, the opening of the new wing was commemorated with an exhibition devoted to the gallery's history. On that occasion, I began to delve into the lives and accomplish-ments of the bafflingly enigmatic William T. Walters and his son Henry.

By the 1970s, the public had consigned the senior Walters to oblivion. In acquiring the art of his own era, in both European and Asian fields, he was said to have failed to anticipate modern tastes. If William was re-called at all, it was as a mean-spirited old man who disowned his daugh-ter, only later relenting and, according to lore, leaving his porch light burning as a beacon to guide the errant waif home. In contrast, his son Henry was remembered as a beneficent philanthropist whose unerring judgment in art matters more than compensated for his father's lapses. Henry's accomplishments in other fields, however, were overlooked. Few Baltimoreans could remember encountering him; apparently, one of the city's most illustrious sons had spent little time at home.

That William and Henry Walters were both recalled as essentially two-dimensional characters was very much their own doing. Neither wel-comed publicity. William belonged to a generation of businessmen who valued self-reliance and believed in keeping their own counsel. Dealings with the public and press were invariably on William Walters's own terms and occurred only when they were to his advantage. Even in a society that valued privacy, Henry Walters's reserve was regarded as ex-cessive. He shunned interviews, was almost never photographed, and was said to have been so secretive that he would not sign a hotel register.

Various circumstances contributed to the anonymity of the Walterses. When much of downtown Baltimore was destroyed in a 1904 fire, only a few family documents were retrieved from W. T. Walters and Company, the office that managed the family's local affairs. Little of Henry's corre-spondence was preserved, and what has survived, apart from his letters to his young nieces, is succinct in the extreme. Letters that may have been kept in his New York residence have never been found. If they did exist, they apparently were discarded after his death, perhaps in ad-herence to his wishes.

The paucity of correspondence notwithstanding, the careers of both generations of the family, as financiers and as art collectors, can be traced through various other sources. William Walters, for example, expressed

his views on art matters in publications, including the collection hand-
books that he issued periodically beginning in 1878. George A. Lucas, a
Baltimorean who resided in Paris from 1857 until his death in 1909,
served as an art consultant to both William and Henry. Lilian M. C.
Randall, Dorothy Miner's successor in the manuscript department, tran-
scribed and published Lucas's diaries. They provide invaluable informa-
tion regarding William's and Henry's travels abroad and their European
purchases before 1909. Some dealers' invoices survive, but these were
usually censored by Henry, who clipped out the prices and other sensi-
tive information. Fortunately, a log maintained by James C. Anderson
(Walters's building superintendent) presents an overview of the growth
of the holdings. He recorded the arrival in Baltimore of art shipments
from New York and abroad and cursorily enumerated their contents.
The log reflects the ebb and flow of Henry Walters's collecting, and
occasional entries can be matched with specific objects in the collection.

From a present perspective, William Walters emerges as a self-made
individual of modest beginnings and with little formal education who,
through grit, determination, and a flair for business, amassed a fortune
in the highly competitive field of railroad financing. As an art collector,
similar qualities were combined with a remarkable zeal and seriousness
of purpose. No mere acquisitor, he patronized artists, stinting no effort
to promote those he favored — William H. Rinehart, Antoine-Louis
Barye, and Léon Bonvin being the most notable. It is perhaps as a prose-
lytizer for such diverse fields as European and American painting, Far
Eastern art, fine book printing, and the breeding of the sturdy Percheron
horse that he should chiefly be remembered.

Although many of his activities can be traced, Henry Walters the man
remains elusive. Born into more privileged circumstances than his father
was, he far exceeded William's ambitions in business and collecting. As a
true philanthropist, without revealing his identity he extended his gen-
erosity to various causes, most often those pertaining to art apprecia-
tion, education, and health. In collecting, Henry was motivated by a
goal never actually stated: he wanted to create a public museum as a
memorial to his father. Inevitably, he made mistakes, perhaps more than
he would have admitted. He was, however, well aware of the potential
for difficulties, and what is more remarkable is the number of significant
works of art that he did acquire. Although his expenditures for art may
seem modest compared to those of the most prodigious collector of the
period, J. Pierpont Morgan, Henry Walters more than matched the great
banker in the astonishing breadth of his interests.

In exploring the careers of these two most reticent individuals, I have been well aware that neither would have welcomed the endeavor. Rather, they would have preferred to let their achievements speak for themselves. Nevertheless, in their quest for anonymity, they inadvertently posed a challenge that I found irresistible.

ACKNOWLEDGMENTS

THIS BOOK IS DEDICATED TO THE MEMORY of Sara Delano Redmond, whose recollections of "Uncle Harry" brought to life the otherwise nearly unfathomable Henry Walters. Sadly, neither she nor far too many of the individuals mentioned below are alive today. Members of the Walters-Delano family who have been unflagging in their encouragement include Frederick B. Adams, Warren Delano, Laura D. Eastman, Sylvie R. Griffiths, Cynthia R. Mead, Sheila R. Perkins, Joan R. Read, and Jane D. Ridder.

Partial funding provided by Sotheby's ensured the completion of this publication. I am especially indebted to Katherine Ross, assistant vice-president for museum services, and to Aurelia Bolton of Sotheby's Associates in Baltimore for their continued interest in the undertaking.

Were it not for the contributions of numerous colleagues at the Walters Art Gallery, both past and present, this project could not have been realized. Research was begun during Richard H. Randall Jr.'s directorship and was further promoted by his successor, Robert P. Bergman. With the unwavering support of the present director, Gary Vikan, the project has finally been brought to fruition. At the Walters, I am particularly grateful to the following for their generosity and forbearance: Bernard Barryte, Carol Benson, Elizabeth Burin, Terry Drayman-Weisser, Kathleen Emerson-Dell, Stephen Harvey, Kelly Holbert, Winifred Kennedy, Edward S. King, Dorothy E. Miner, William Noel, Lilian M. C. Randall, Ellen D. Reeder, Marianna Shreve Simpson, Joaneath Spicer, Susan Tobin, Hiram W. Woodward Jr., and Eric Zafran.

Charles Mann, the former chief of rare books and special collections at the Pennsylvania State University, followed the project from the outset, sharing with me his remarkably encyclopedic knowledge of the Victorian era. Likewise, I am deeply indebted to Walter E. Campbell, whose insights regarding Henry Walters's friend, William Rand Kenan Jr., and

early twentieth-century Wilmington, North Carolina, proved exceptionally helpful. Mary Garofalo accompanied me to William Walters's early haunts in central Pennsylvania and transcribed archival materials.

In citing others who have provided assistance over the years, I have undoubtedly overlooked some, and to them I extend my apologies. I thank the following: Justin Anderson, Madeleine Fidell Beaufort, Patricia L. Bentz, Lesley N. Boney, James H. Bready, James A. Bryan, Randolph W. Chalfant, Carl F. Christ, Thomas Cotter, Emmett Curran, S.J., Sister Bridget Marie Engelmeyer, Thomas J. Farnham, Harry A. Focht, Thomas J. Garnham, Mada-anne Gell, V.H.M., William H. Gerdts, Caroline Durand-Ruel Godfroy, Mary K. Hendrickson, Lance Humphries, William J. Junkin, Franklin W. Kelly, Mary Harvey LeGore, Mary C. Walsh Loux, Trudi Y. Ludwig, John D. Mayhew Sr., Bet McLeod, H. J. McMillan, Elinor F. Morgan, Jennifer K. Pitman, Oliver H. Reeder, Ann B. Robertson, Joan Runkel, Laura Schneider, Elizabeth Schaaf, Hans Schuler, Barry Shifman, Constance G. Simmons, John A. Slade, Elizabeth Bradford Smith, Anne B. Markham Schulz, The Honorable and Mrs. William Cattell Trimble Sr., Ruth Irwin Weidner, Suzanne Wolff, Nicholas Varga, Janet Zapata, and E. Nicholas Ziegler.

Louise MacDonald edited the initial chapters, setting me on the proper course, and Victoria Gross tirelessly typed and retyped the manuscript.

At the Johns Hopkins University Press, I extend my gratitude to Henry Tom for his suggestions regarding style and to Linda Forlifer for her final editing of the text.

Had it not been for the whole-hearted support and sound judgment of my wife and colleague, Sona, *William and Henry Walters, the Reticent Collectors* would not have been completed.

WILLIAM AND HENRY WALTERS, THE RETICENT COLLECTORS

THE EARLY YEARS,
1819–1861

IN LIVERPOOL, PENNSYLVANIA, where barges laden with coal, lumber, and grain once plied a canal separating houses from the river (fig. 1), diesel trucks now rumble along U.S. Route 15. The foundry, mills, tannery, and distillery, formerly mainstays of the town's economy, have long since disappeared. Otherwise, Liverpool has not changed dramatically in size or appearance since the early nineteenth century.[1] It was here, among some two hundred households stretching along the west bank of the Susquehanna, upriver from Harrisburg, that William Thompson Walters was born on May 23, 1819, in a two-story, brick house facing the river. He was the first of eight children born to Henry and Jane Mitchell Thompson Walters.[2]

Records of the Perry County courthouse reveal that the senior Walters was a restless individual. A general merchant and vendor of liquors, he also speculated in real estate and was briefly one of the town's wealthiest residents. In 1826, he was appointed postmaster, a position he retained for seven years.

In the late 1830s, Henry Walters left Liverpool to serve as the "cashier," or manager, of the Harrisburg National Bank. The sole surviving document from this period that bears his signature is a note dated April 4, 1837. Acknowledging receipt of a check for five thousand dollars, it is addressed to James Buchanan, the senator and later U.S. president. Late in life, Henry Walters suffered financial reverses and returned to Liverpool, where he died intestate with various properties heavily mortgaged.[3]

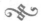

William Walters apparently was not content with the rather prosaic Walters lineage, which was traceable only to an elusive grandfather, an English immigrant of no recorded accomplishments named Jacob. Rather, he welcomed references to his Scotch-Irish maternal forebears, who had

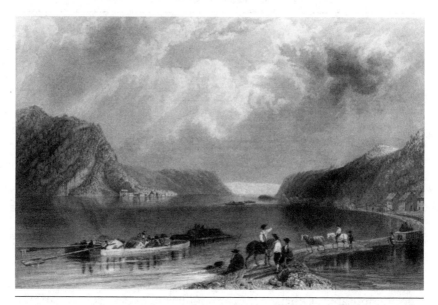

FIG. 1. William H. Bartlett (1809–54), *View of the Susquehanna, at Liverpool*
(engraving), from Nathaniel Parker Willis, *American Scenery* (London, 1840)
(WAG Archives). In this village on the west bank of the Susquehanna,
eighteen miles north of Harrisburg, Pennsylvania, William T. Walters was born
in 1819. During William's youth, the canal in the foreground was excavated
through a common originally used for horse races. The village of Millersville is
seen on the opposite bank.

left their stamp on the settlement of central Pennsylvania. His mother,
Jane, was two generations removed from "Pioneer" John Thomson, a
Scottish Covenanter who had made his way to Pennsylvania via County
Antrim, Ireland, about 1735. Eventually, Thomson settled near the Juni-
ata River, three miles east of what became the village of Thompsontown.
This doughty Scot is said to have worn the kilt and bonnet until the day
he died. He married three times and produced fourteen progeny, who,
in turn, intermarried with the Greenlees, Wylies, Mitchells, and Patter-
sons, all prominent in the annals of the region. Jane's father, William, the
third son of the "pioneer," served in the New Jersey campaign during
the Revolutionary War, receiving the commission of second lieutenant.
Subsequently, he married Jane Mitchell of Letterkenny, Pennsylvania,
whose father had been killed in a massacre during the French and Indian
War. An energetic individual, William Thompson (as the name was now
spelled) founded Thompsontown and erected a handsome brick house
overlooking the Juniata. He established numerous enterprises, includ-
ing a store, several gristmills and sawmills, and a distillery.[4]

Little is known of William Walters's upbringing. When his family left Liverpool for Harrisburg, he moved to Philadelphia, purportedly to study civil engineering at the University of Pennsylvania. His name does not appear in the university's records, suggesting that he may actually have enrolled in a private academy or pursued studies independently, availing himself of the city's rich libraries and lecture programs.[5]

After mastering the prevailing technology in metallurgy, William returned to the state's hinterland. He took a position with the Lycoming Coal Company in Farrandsville, Clinton County, a settlement so isolated that it could be reached only by "horse path at low water." Despite his youth, the nineteen-year-old Walters was placed in charge of an experimental furnace set up to manufacture iron using local bituminous coal. The venture failed because of its inaccessibility, and Walters moved on to the Pioneer Furnace, in Pottsville, Schuylkill County, where anthracite coal was first used successfully for the production of iron.[6] Within a year or two, however, William Walters abandoned smelting and returned to his family's traditional interest, commerce. Apparently searching for broader horizons, he left Pennsylvania for Baltimore, Maryland, early in 1841.[7]

At midcentury, Baltimore had attained a distinctive character. Known as the City of Monuments, it boasted of its Washington and Battle Monuments and of its many fine buildings, among them the Roman Catholic Cathedral, the Unitarian Church, Saint Mary's Chapel, the McKim Free School, and the Greenmount Cemetery portals, all still extant. The Merchant's Exchange, old City Hall, and the white marble drinking fountains have long since been razed. Baltimore was an attractive place noted for the uniformity and neatness of its red brick houses embellished with white marble stoops. After exhausting the city's architectural attractions, visitors invariably noted the beauty of the local women. Even the usually caustic Frances Trollope, mother of the novelist Anthony, marveled at the appearance of the women she saw attending church in 1839.[8]

Financially, the city was booming. From 1830 to 1850, the population soared from 63,000 to 102,000. The economy, based on industry, trade, and agriculture, thrived despite a nationwide recession in the late 1830s. The introduction of such industries as textiles, iron, shipbuilding, and railroads swelled the ranks of the wealthy citizenry, previously dominated by landed gentry and by banking and mercantile interests. Ships from Baltimore now transported tobacco and grain to Great Britain, and trade with South America and the West Indies flourished in meats, tex-

tiles, barrel staves, and grain. Within the region, the city served as the hub of a market economy that extended to Washington and to the South, to the wheatlands of western Maryland, and northward along the Susquehanna Valley.[9]

It was the potential for commerce with central Pennsylvania that captured William Walters's imagination. Baltimore's position in the competition for this trade had recently been strengthened by new transportation facilities. The Philadelphia-Wilmington-Baltimore Railroad was completed in 1839, and both the Baltimore and Susquehanna Railroad (between Baltimore and Harrisburg) and the Susquehanna and Tidewater Canal were finished in 1840. The last represented an alignment of the business interests of south-central Pennsylvania with those of Baltimore. The canal linked into a vast network of waterways and railroads, facilitating the movement of farm produce (especially grain), flour, coal, and lumber from the interior of Pennsylvania to Havre de Grace, the terminus for rail transport to Baltimore.

Walters decided to come to the city to join the ever-growing ranks of businessmen, particularly commission and liquor merchants. He entered into partnership with Samuel Hazlehurst to form the firm Hazlehurst and Walters, with offices located on the Baltimore harbor at 16 Spear's Wharf. The new enterprise drew on Walters's familiarity with central Pennsylvania to specialize in produce from that region.[10]

In 1846, when he was twenty-six, William Walters married Ellen Harper, the daughter of a prosperous Philadelphia grocer turned merchant.[11] The Harpers traced their American roots to an Arthur Harper who had sailed from Ireland in 1770 and arrived in Philadelphia on King George III's birthday (June 4). At the time, Philadelphians had been celebrating by singing "God Save the King" and "Rule Britannia," but as a result of "the ill judged conduct of the British Cabinet," these songs were soon replaced by "Yankee Doodle" and "Hail Columbia." Judging from an early photograph, Ellen, with her broad forehead and small features, was not a conventional beauty (fig. 2), although her genial personality and warm disposition were said to have provided a foil for her more assertive husband. The marriage produced three offspring, William Thompson Jr., who died in early childhood, and Henry (known as Harry) and Jennie, born in 1848 and 1853, respectively (fig. 3).[12]

The young family lived in a succession of downtown quarters. Then, in 1857, Walters followed the lead of prosperous Baltimoreans fleeing urban noise and grime and moved north to Mount Vernon Place, an

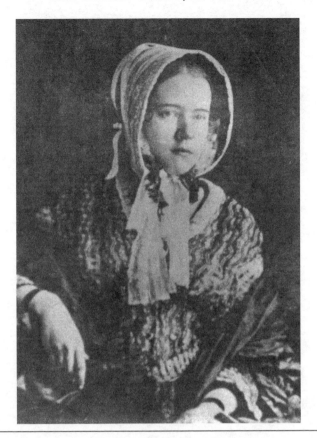

FIG. 2. Daguerreotype of Ellen Walters in 1846
(WAG Archives).

elevation dominated by Robert Mills's Washington Monument. Com-
posed of two small intercrossing parks, Washington Place and Mount
Vernon Place, this area had begun to be developed in the 1840s. During
the second half of the century, it emerged as the heart of the city's social
life. Walters initially leased 65 Mount Vernon Place (now 5 West Mount
Vernon Place) and then acquired the property outright from the original
developers, the William Tiffany family.[13] A handsome, three-story brick
structure with a white marble porch, the Walters house paled beside the
residence two lots to the east, also designed by John Rudolph Niern-
see.[14] The latter structure, erected between 1848 and 1850 for Dr. John
Hanson Thomas, the wealthy scion of an old southern Maryland family,
was hailed at its completion as "one of the most elegant and princely
specimens of architectural taste and mechanical skill!" With its classical

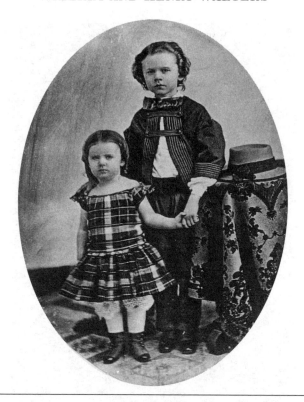

FIG. 3. Henry and Jennie Walters, about 1856. Photograph courtesy of a Walters family descendant.

portico, French windows, and string of cast-iron palmettes on the roof-line, it dominated the square (fig. 4).[15] The Thomas and Walters dwellings displayed a similar imaginative interpretation of the late Greek Revival style with pronounced Italianate overtones.

It was at Mount Vernon Place that William Walters raised his family. The frail Ellen was assisted by a devoted family retainer, Betsey Anthony, who had been William's childhood nurse.[16] To escape Baltimore's oppressive summers, the family, except for William, fled to the seaside, choosing at least on one occasion the fashionable Virginia resort Old Point Comfort. During another summer, they retreated to the popular Virginia spa Capon Springs (now in West Virginia).

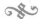

Meanwhile, in 1850, a schism developed within the firm of Hazlehurst and Walters. Hazlehurst left to become a flour merchant. Walters remained on Spear's Wharf, where he opened the commission merchant

firm of Walters and Harvey. His new partner, Charles Harvey, was a Philadelphian related through marriage — Charles's brother Henry Darch Harvey was Ellen Walters's brother-in-law. Other members of the firm included Joshua Penn McCay (1830–1905) and Edwin Walters, who joined his elder brother in 1857.[17]

Soon known as W. T. Walters and Company, the firm specialized in liquors. On January 14, 1852, a notice appeared in the *Baltimore Sun* announcing the opening of a new warehouse at 68 Exchange Place in the center of the commercial district. The imposing five-story brick structure with a decorative iron colonnade was reputed to be "the most complete establishment of its kind in the county" and to have a storage capacity of fifty-five thousand gallons (fig. 5). Mules kept within the building powered the pumps that transferred the liquors from one story to another.[18]

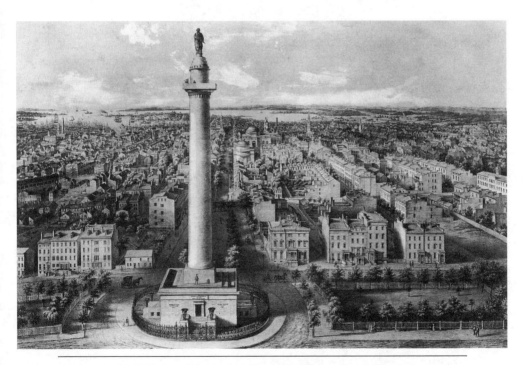

FIG. 4. E. Sachse and Company, *View of Baltimore City,* lithograph, 1850 (private collection). In this view looking south toward the harbor and the Patapsco River, the foreground is dominated by Mount Vernon Place and the George Washington Monument. Immediately to the right of the monument is the Thomas house (now Hackerman House), which is separated by an empty lot from the residence purchased by William Walters in 1857.

FIG. 5. W. T. Walters and Company, 68 Exchange Place, page from the *Baltimore City Directory*, 1855–56 (WAG Archives). In this advertisement, the firm boasted of having the "finest and largest stock of Old Rye Whiskey in the United States."

The firm dealt in Pennsylvania rye whiskey, which it rectified, or blended and refined, and then bottled in the Baltimore warehouse. The principal house brand was Baker's Pure Rye, although J. Martin Old Rye and Old Monongahela were also sold. A rumor circulated that the resourceful Walters aged his ryes by shipping them as ballast on clippers

plying the Baltimore–Rio de Janeiro coffee trade. That these whiskeys were "imported" also gave them a certain cachet in Maryland, a state noted for its ryes, and they were much in demand not only in the mid-Atlantic region but also in the deep South. Fine wines and brandies also constituted a highly profitable commodity for the firm before the imposition of heavy duties during the Civil War.[19]

During the 1850s, Walters diversified his financial interests, investing heavily in the Baltimore and Susquehanna Railroad Company. The line conveyed both passengers and freight, including the most profitable commodity, whiskey, between the Pennsylvania interior and Baltimore. That his holdings were extensive may be surmised from his appointment in 1852 as a director of the railroad, representing the company's interests in Maryland. In 1854 the Baltimore and Susquehanna; its offshoot, the York and Maryland; and two Pennsylvania railroads, the York and Cumberland and the Susquehanna, were consolidated as the Northern Central Railway Company. During 1860 and 1861, crucial years when the railroad was obliged to seek refinancing, Walters served as director representing both the stockholders and Baltimore City. Among his colleagues on the board was Simon Cameron, the influential Republican senator and future secretary of war under Lincoln, who was to remain a lifelong friend.[20]

In addition to these economic ties with Pennsylvania, Walters was associated with maritime interests in the South. As early as 1853 he participated in a committee formed to solicit subscriptions for the establishment of a steamship line running to Savannah. Subsequently, according to early biographical notices, he was a member of the boards of several shipping lines serving the South. Walters boasted to Cameron that his firm had come to have "the largest business and most extensive correspondence with the South in our City."[21]

Before the Civil War, Baltimore's cultural life, apart from its popular theaters, lagged behind that of the other major East Coast cities. The condition of the libraries, for example, may be surmised from George H. Calvert's observation that the incorporators of the Mercantile Library Association "were more adept at discerning the difference between Spanish mackerel and sheeps head, between Château Margaux and Château Lafitte, than between a volume of Swift and one of Sterne."[22] A counterpart to Philadelphia's Franklin Institute, the Maryland Institute for the Promotion of the Useful Arts was incorporated in 1825, but its activities remained at a standstill between a disastrous fire in 1835 and

the completion of a new building in 1848. The progress of the various academies, athenaeums, and historical societies fostering the fine arts in Baltimore was faltering at best. Rembrandt Peale's Baltimore Museum and Gallery of Pictures, founded in 1814 as "an elegant rendezvous of taste, curiosity, and leisure," was operated in the twenties by his brother Rubens, who withdrew in 1833 to pursue his fortune with a similar venture in New York. Other short-lived institutions included a Baltimore Athenaeum, opened in 1824, and the Maryland Academy of Fine Arts, which the *Baltimore Sun* predicted would add "honor and dignity" to the city with a program of lectures on painting, sculpture, anatomy, and chemistry (September 8, 1838). Fortunately, one institution endured, the Maryland Historical Society, which was organized in 1844 and opened three years later. The historical society presented annual exhibitions of Old Master paintings and contemporary works drawn from local collectors, beginning in 1848.[23]

William Walters belonged to another cultural organization, the Allston Association, which held informal meetings in the residence of the painter Frank B. Mayer. In the winter of 1858–59, the association acquired property at 40 Saint Paul Street, where exhibitions and musical soirees were held. In June 1863 the Allston Association, which was suspected of being a stronghold for secessionists, was closed by the federal leader General Schenck.

The paucity of cultural establishments notwithstanding, there was a tradition of collecting in the city. Preeminent at the beginning of the century, even by national standards, was Robert Gilmor Jr. (1774–1848), the son of a Scottish immigrant who had amassed a fortune in commerce with Russia and the Far East. Educated in Amsterdam and Marseilles, young Gilmor developed a predilection for Old Master paintings and drawings and also patronized contemporary American talents, including the genre painter William Sidney Mount, the landscape specialists Thomas Cole and Thomas Doughty, and the neoclassical sculptor Horatio Greenough. At one point, Gilmor was estimated to have as many as four hundred paintings. In addition, he accumulated engravings, antiquities, medieval artifacts, illuminated manuscripts, autographs, and mineral specimens. Late in life, in a moment of reflection, he admitted to an old friend, George Graff of Philadelphia, that his collection equaled if not surpassed any other in the country in both "numbers" and "originality" but readily conceded that "one good picture of a London cabinet would be worth the whole" of his. Gilmor had hoped to bequeath his vast holdings to the Smithsonian Institution, but financial reverses

shortly before his death in 1848 resulted in the sale of his library and the dispersal of the art, some of which eventually reached public museums in Baltimore and elsewhere in the country.[24]

A more conventional collection was accumulated by Granville Sharpe Oldfield (1794–1860), an English merchant who had married and settled in Baltimore. Most of the 685 pictures in his collection were either supposed Old Master paintings or framed engravings, although there were also some works by contemporary English and American artists. Among the later collections Walters may have known was that of Dr. Thomas Edmondson (1808–56), an ardent supporter of local artists, who, like Gilmor, also acquired Dutch masters. He lent generously to the exhibitions of the Maryland Historical Society, where, after his death, a portion of his collection remained on deposit for almost two decades.

William Walters belonged to a generation of Baltimore collectors that continued to be drawn to local talents but also ventured into the New York art market, buying landscapes by the painters of the fashionable Hudson River school and even, occasionally, works by contemporary European artists. It is to his mother that credit must be given for cultivating in William a taste for art. To her is ascribed the admonition "The busy portions of a young man's life . . . are taken up full enough to keep him out of mischief or contamination. It is his leisure time and surplus money that must be provided for and a young man can employ his time and money in no better way than by devoting them to accumulating and appreciating the noble works of literature and of art."[25] More simply expressed, Jane Walters believed that reading and collecting art would keep her son out of trouble. William apparently shared his mother's faith in the salubrious effects of these pursuits. As he wrote in 1864 to his friend Benjamin Newcomer,

> after the consolations of religion and the enjoyment of the affections, I believe there is no fountain from which flows a source of more pure and elevated enjoyment than is furnished by a cultivation of a taste for the beautiful, and indeed, show me a man, or woman either, having a true interest in or love for the beautiful and I will show you half a christian. To surround your family with forms of material beauty and loveliness — with illustrations of virtue and noble deeds — with admonitions of duty and affection, it is to impress them that there is a literature of art by no means second to that of letters in the importance of its teachings.[26]

Such credence in the moral and intellectual benefits offered by the arts was not exceptional and could be traced to the beginning of the century

as a prevailing theme in American thought running counter to the puritanical association of the arts with sensuality and Old World despotism.

William Walters always said that the first five dollars he earned were used in about 1847 to buy a painting, E. A. Odier's *Retreat from Moscow*. Both the circumstances of the purchase and the picture's present whereabouts are unknown. Presumably a replica of the Swiss artist's *Épisode de la retraite de Russie* in the Amiens Museum, the painting reflected Walters's lifelong fascination with the Emperor Napoleon.[27]

The Granville Sharpe Oldfield sale, held in Carroll Hall at Baltimore and Calvert Streets in May 1855, realized $16,422.25, a sum unprecedented in the city. At the sale Walters found himself bidding against such leading citizens and art enthusiasts as Johns Hopkins, the wholesale provisions merchant; Thomas Swann, the banker and politician; and S. Owings Hoffmann, a Robert Gilmor relative. Walters's purchases on this occasion, fortunately, were not indicative of his future aspirations. They included copies of paintings by Murillo and Salvator Rosa commissioned by Oldfield, what were purported to be original oils by Gerard de Lairesse and Rosa da Tivoli (whose given name was Philipp Peter Roos [1657–1705]), a painting of cattle by Thomas Sidney Cooper, two scenes by J. W. Yarnold (an obscure British marine artist much patronized by Oldfield), and a painting of guinea pigs by the local animal and genre specialist Hugh Newell.[28]

The same year, Walters may have assumed the role of patron and helped to sponsor William H. Rinehart's first trip abroad. The son of a Carroll County farmer, Rinehart had arrived in Baltimore in 1836 to work in Baughman's Marble Yard, cutting fireplace mantles and monuments, while pursuing studies in the evenings at the Maryland Institute. He eventually became an expatriate and settled in Rome, where he prospered as a sculptor specializing in neoclassical figurative pieces and portraits of his countrymen traveling in Italy. Walters and Rinehart were lifelong friends, with the former managing the sculptor's finances in this country and eventually serving as his executor. In addition, Walters commissioned some important works, among them the *Woman of Samaria* of 1859, the sculptor's earliest major endeavor.[29]

In 1856, Walters joined the Maryland Historical Society and lent to the annual exhibition four oils by Hugh Newell. A year later, he submitted the Odier Napoleonic picture, a coastal scene by J. W. Yarnold, a landscape by a painter named Schlesinger, and the replicas of works by Salvator Rosa and Murillo from the Oldfield collection.[30]

Once the family was settled in Mount Vernon Place, the pace of William's collecting accelerated. Among the most prominent of the local artists at this time was Alfred Jacob Miller, who had returned to the city in 1842 after completing commissions for his Scottish patron, the eccentric adventurer Sir William Drummond Stewart. Miller had accompanied Stewart on an expedition to the annual fur-trader's rendezvous in the Green River Valley (in what is now western Wyoming) in 1837. Unlike other artists who visited the Far West, notably George Catlin, Karl Bodmer, and John Mix Stanley, Miller did not confine himself to recording Indians but also depicted the other participants in the fur trade. Miller's subjects often included French Canadians, métis, and the mountain men who wintered alone in the Rockies, tending their traps in anticipation of the next summer rendezvous. The artist's clientele in Baltimore was twofold, embracing those who were content with competent likenesses and others, mostly collectors, who were drawn to his romantic oils and watercolors of the Far West. Early in 1858, Walters requested three oil paintings: a portrait of his friend, the sculptor Rinehart, and two western subjects. In July he gave Miller what must be considered the commission of a lifetime, an order for two hundred watercolors at twelve dollars apiece. These paintings, each accompanied by a descriptive text, were delivered in installments over the next twenty-one months and ultimately were bound in three albums. Transcriptions of the field sketches drawn during the 1837 expedition, these watercolors serve as a unique record of the closing years of the western fur trade.[31]

At this time the Hudson River school of landscape painters in New York remained dominant on the American scene, buoyed, in part, by a wave of cultural nationalism and also by an awakening nostalgia for a pristine wilderness already doomed. Walters, perhaps recalling his rural beginning, shared these sentiments, writing of the Hudson River with a barbed dig at well-traveled Americans who failed to appreciate their own natural assets: "I have said a thousand times, it is one of the most prominent of the many beautiful things on Earth which is not appreciated as much as it deserves—leaving out the Castellated ruins of the Rhine it would no doubt excell in beauty that so celebrated resort of all tourists of the world from whence, I regret it, for their want of intelligence and taste, I have known many of our countrymen to return not having seen the Hudson except from a New York ferry boat."[32]

In June 1858, William Walters plunged into the New York market with characteristic zeal, ordering works from Asher B. Durand, then president of the National Academy of Design and acknowledged successor to Thomas Cole as leader of the Hudson River painters. He also

commissioned landscapes from John Frederick Kensett, one of the most noted adherents of the school. The terms for both artists were identical: they could set their own fees within a $500–$700 range, and the choice of subjects was left to their discretion. The following May, Walters received from Durand a large, vertical composition dominated by a black birch and a sycamore growing at the edge of a precipice with a distant view beyond, all rendered in the meticulous detail characteristic of the artist, who had trained as an engraver. *In the Catskills* was based on studies undertaken at Plaaterkill Clove the previous summer. It was larger than originally intended and cost Walters $1,500. He was apparently satisfied with the transaction and commissioned another picture the following year. *Sunday Morning,* a highly idealized landscape showing a woodland vista in which parishioners proceed through a meadow to a church on a hill, was described as "a poem suggesting to the mind that stillness and feeling of sacred rest which is often experienced on a calm Sunday morning in a beautiful country."[33]

Surviving correspondence shows that relations between John Kensett and the Walters family were particularly cordial.[34] Occasionally visiting relatives in Baltimore, Kensett shared with his patron insights into the New York art market, and Walters offered suggestions about dealings with clients and also maintained for the artist a constant supply of Havana "segars." For Walters, Kensett's harmonious compositions evoking the more tranquil aspects of nature, rendered with strict fidelity, struck an especially sympathetic note. Walters praised a Newport view that he had previously seen at the National Academy.

> There was a "realism" — real well defined actual water — and equally real Rocks — no vagueness — no uncertainty — and does anyone believe it hadn't true sentiment, and fine feeling — but I don't think you ever had, or can paint a picture without fine feeling — and therefore, I have been drawn more closely to those of your works which contained more of the realistic and less of the uncertainly defined — there is poetry of art, as well as letters — and there is no art without it — and that poetry of yours has gone most deeply in my heart where you have spoken in the plainest and most clearly defined words — for certainly — trees-mountains — Rocks air Ec Ec are the artists' poetic words.[35]

As was true of the Durand commission, Walters was not content with one painting but commissioned three more from Kensett.[36]

In December 1858, the Artists' Fund Society held an auction at the National Academy of Design in New York for the benefit of the widow and children of William Ranney. The genre painter had died the pre-

vious year, leaving a large mortgage on his house. Three hundred eleven pictures, including those left in the artist's studio at his death and others donated by fellow artists, were sold for an estimated $9,000. Since art auctions were not yet commonplace in New York, Walters regarded the Ranney sale as a rare occasion when the efforts of leading artists were "exposed to popular competition." He took the opportunity to acquire Frederic E. Church's *Morning in the Tropics* for $555, the highest price paid at the sale and an unprecedented amount for so small a picture. Inspired by Church's travels in Ecuador in 1857, the painting, measuring only 8½ by 14 inches, drew considerable attention to the sale and was later made popular through a widely distributed engraving. Although Walters's previous transactions with artists had been private, at the Ranney sale he publicly revealed for the first time his commitment to collecting and his willingness to pay for quality.[37]

Although his preference in landscape painting was decidedly for the pastoral, contemplative works of Kensett rather than the more grandiloquent productions of Church, Walters did become the first owner of *Twilight in the Wilderness,* generally regarded as the culminating work in a series of Maine landscapes. In every respect a foil to *Morning in the Tropics,* this painting is an expression of the fused transcendental and real experience of nature, recording that ephemeral moment between sunset and darkness. For Walters, *Twilight in the Wilderness* seemed "a little fire worksey," with its crimson-madder sky, but was "a good specimen of him [Church] in unity of design" and "far more satisfactory than the Andes [*Heart of the Andes*]."[38] With reason, Walters may have felt some discomfort with his purchase. The painting was weighted with complex meanings. Not only did it present an image of America's pristine, primeval wilderness already threatened by civilization's unrelenting progress, but it bore political overtones as well; the artist, deeply disturbed by the nation's impending schism, presented this painting as a call for contemplation and renewed faith. Any doubts as to his intent were expelled by the appearance a year later of *Our Banner in the Sky,* an oil sketch of a landscape at dawn with the national flag emblazoned in the glowing sky.[39]

Walters considered the cause of the Ranney sale to be worthy, but he deprecatingly likened himself to Dogberry, Shakespeare's ass in *Much Ado about Nothing,* for paying high prices. He gave four hundred dollars for *Anthony Van Corlear,* "a delicious little painting" by Charles Loring Elliott. The image of the trumpeter in Washington Irving's *Diedrich Knickerbocker's a History of New York* reflected this popular portraitist's long-standing interest in the literary genre, which may have begun dur-

ing his early training with John Quidor, the quixotic illustrator of works by James Fenimore Cooper and Washington Irving.[40] In 1860, Walters commissioned Elliott to paint a portrait of Asher B. Durand, and when Elliot was strapped for funds, the Baltimore collector intervened on his behalf, using Durand as his liaison. For his efforts he received as a gift a self-portrait accompanied by a note from Elliott: "You will gratify me by accepting the accompanying portrait of myself as a slight testimonial of my esteem for you and I also wish it to express my admiration for you and your manly, consistent and liberal support of American Art."[41]

The White Captive, shown in the recently opened gallery of William Schaus, created a sensation during the winter art season of 1859–60. The sculptor, Erastus Dow Palmer of Albany, New York, departing from the prevailing neoclassical tenet of choosing subjects from antiquity or the Bible, selected a theme from America's frontier experience; he portrayed a young woman, nude and bound to a tree stump, awaiting her fate at the hands of her Indian captors. *The White Captive* inevitably rekindled the controversy of nudity versus morality that had flared with the showing of Hiram Powers's *The Greek Slave* in 1843. Lacking the classical antecedents of Powers's work, *The White Captive* drew adverse reaction from a range of sources, including, surprisingly, the *Crayon,* a New York art review edited by John Durand, the landscape painter's son and a friend of the Walters family. Even though they appreciated Palmer's sculpture, William and Ellen Walters were not prepared to reconcile the robust, lifelike nude figure of *The White Captive* with their lofty concepts of the role of art. However, they did not boycott the sculptor. That same year they commissioned a marble of a more sympathetic subject, a statue of a girl holding a nest from which the fledglings had departed, known as *The Little Peasant* or *First Grief.*[42]

A New Yorker who assumed an increasing role in the development of the Walters holdings in the late 1850s was Samuel Putnam Avery.[43] A collector himself, Avery was in the habit of holding "art gatherings" at his residence in Brooklyn, to which he invited such artists as William Hart, James Brown, Thomas Hicks, Arthur F. Tait, Henry Peters Gray, and Kensett, all of whom were eventually represented in the Baltimorean's collection. In the winter of 1859–60, Avery helped compile an album of drawings and paintings on paper by American artists. *Original Sketches,* which may have contained as many as one hundred works, was to be "the greatest book of the season," Walters anticipated.[44] Avery also interceded for Walters in dealings with artists. In one instance, he settled a

disagreement between Walters and Jasper F. Cropsey, the Hudson River school painter who had received an open-ended commission, similar in terms to Durand's and Kensett's, for two landscapes of his own choosing. Unaware that the Baltimore collector preferred small paintings and was already facing limited wall space at home, Cropsey had expanded the scale of his works out of aesthetic considerations and had increased the prices accordingly.[45] The warmth of the friendship between the Avery and Walters families is demonstrated by the Averys' choice of the name Ellen Walters for a daughter born on January 1, 1861.[46]

Since the early 1800s, European Old Master paintings of varying degrees of authenticity had been trickling into the United States. Only after midcentury did works by contemporary foreigners make inroads into the New York art market. The receptive climate at this time can, in part, be credited to critics, most notably the English author John Ruskin, who struck a responsive chord among American readers with *Modern Painters* and *Academy Notes*. In the latter volume, he extolled the virtues of contemporary painting over those of the Old Masters and interpreted art in terms of morality and as an expression of religious faith. Another factor was the enterprise of several foreign dealers active in New York: Johann Gottfried Böcker, who introduced contemporary German art at his Düsseldorf Academy of Fine Arts, and Goupil et Compagnie of Paris, represented by Michel Knoedler.[47] Perhaps the wiliest dealer was a Belgian, Ernest Gambart, whose Paris gallery was touted as "the Secretariat of Exhibitions of French painters in England and U.S.A." Gambart made his American debut in the autumn of 1857 with two traveling exhibitions, one of English, predominantly Pre-Raphaelite painters shown at the National Academy of Design, and the other of modern French artists shown at the Art Union. Coinciding with a major economic recession in America, neither project was a financial success.[48]

It was at another Gambart venture, an exhibition of English and French works at the National Academy two years later, that William Walters positioned himself in the vanguard of American collectors by buying no fewer than ten French and Belgian paintings. He paid $2,500 for Jean-Léon Gérôme's *The Duel after the Masquerade* and $1,410 for the nine other works, mostly domestic genre scenes by such artists as Pierre Édouard Frère, Emile Plassan, and Adolphe Dillens, who were then at the height of fashion. The Gérôme, a replica by the artist of the *Suite d'un bal masqué* (1857) painted for the duc d'Aumale, had been exhibited at Gambart's London gallery in 1858, where it was hailed as a "finer moral lesson" than any taught since Hogarth's time (see plate 1).[49] In

June 1860, Walters also began to patronize M. Knoedler at 366 Broadway, the successor in New York to Goupil et Compagnie, the firm that would dominate the Paris market during much of the second half of the century.

The first exhibition of the works of such European artists in Baltimore was at a soiree at the Allston Association on January 10, 1860. Two hundred members and their guests, from as far away as New York and Philadelphia, took the opportunity to view paintings by the now popular Frère and Théophile Duverger of Ecouen, Philibert Couturier, Charles Chaplin, and others. These paintings were interspersed with American pictures and a few by earlier masters, notably Adriaen van Ostade and the Belgian Balthasar Ommeganck.[50]

Baltimoreans, however, had their own direct link with the Paris art market in the person of George Aloysius Lucas (1824–1909) (fig. 6). The seventh son of the owner of a local publishing and stationery firm, Lucas had attended the Military Academy at West Point for two years before dropping out to work as a civil engineer. Residing in New York, he purchased prints and other minor works of art for himself, his family, and friends. In 1857, he embarked for Europe. According to popular lore, the rigors of the voyage were such that Lucas vowed never to attempt another crossing and took up permanent residence in Paris. He soon acquired a woman companion and quickly immersed himself in the artistic milieu of the Second Empire. Apart from an occasional trip within Europe, he stayed in Paris for the remaining fifty-two years of his life, living off a family stipend supplemented by commissions earned as middleman between his fellow Americans and the Paris art market.[51]

With William H. Graham, a Baltimore banker and collector, serving as intermediary, William Walters first contacted Lucas in November 1859, asking him to "attend to a commission" for a painting from Hugues Merle, an artist known to American collectors for his large-scale figurative paintings with moralizing themes. Lucas subsequently visited the artist's Paris studio, requested that sketches be sent to Baltimore for approval, and provided, as a source of subject matter, a copy of Nathaniel Hawthorne's novel *The Scarlet Letter*, published in 1850 and translated into French three years later. The resulting work, portraying an anguished Hester Prynne, stigmatized by the scarlet *A* and clutching to her bosom her illegitimate daughter Pearl, was said to have been regarded by Hawthorne as the finest illustration of his novel, although he knew the

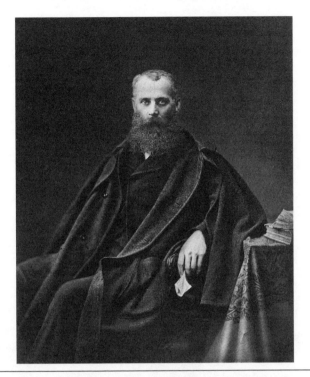

FIG. 6. Antony Adam-Salomon, *George A. Lucas,* 1869 (WAG Archives). In 1857, George Lucas (1824–1909) settled in Paris, where he served as an art agent and consultant for many leading American collectors during the second half of the nineteenth century. His services proved invaluable to both William and Henry Walters.

painting only through a photograph. Hugues Merle entered five works, including this canvas, in the Paris Salon of 1861 and received a second-class medal. Thus, with this first commission of a painting from a foreign artist, Walters set the future course for his collection.[52]

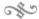

If he ever paused to take stock of his life in Baltimore, William Walters must have felt reassured. He had arrived in the city in 1841 alone and without specific economic prospects. Twenty years later, he was raising a young family in the city's most fashionable neighborhood. With a personal worth estimated at over one million dollars, he had emerged as a figure of considerable influence in the region's commercial life. Drawing on his fortune, William and his wife Ellen had assembled an art collec-

FIG. 7. In Louis Gallait's *The Power of Music to Assuage Grief,* before 1860, a brother comforts his sister, who has fallen into a sleep that brings with it "oblivion of all grief, mental and physical." On July 20, 1860, Gallait wrote to Walters that in this work he had invoked the two things within his power, his *will* and his *conscience*. Excerpts from the lost letter were published in *Collection of W. T. Walters, 65 Mt. Vernon Place* (Baltimore, 1884), 26. Oil on panel (WAG 37.134).

tion of considerable note despite certain self-imposed restraints stemming from a sense of propriety that was remarkably severe, even by the standards of the time.

That this achievement was already drawing attention is confirmed by a report in the *Cosmopolitan Art Journal* of 1858–59, which referred to the manner in which Walters gave commissions to artists "with an enlightened liberality rarely met with in America, and neither limits them to size, price or subject."[53] Farther afield, in "Art Matters in Baltimore" appearing in the *Boston Evening Transcript* on March 4, 1861, a reviewer deplored Baltimore's cultural facilities but enthusiastically praised "one of the finest private collections in the country" as embracing "some of the best works of the best modern artists." Listed in this category were Kensett's *Evening on the Hudson* and *Eagle Cliffe,* Durand's *In the Catskills* and *Sunday Morning,* James M. Hart's *Woodland Lake* and *Mountain Stream,* and Church's *Morning in the Tropics* and *Twilight in the Wilderness.* His greatest praise, however, was reserved for a dolorous work by the Belgian painter Louis Gallait, *The Power of Music to Assuage Grief* (fig. 7). The reviewer predicted that this little picture, showing a young man endeavoring to soothe with violin music his sister, who has collapsed beside a grave, would "chain our rapt attention till we forget all else about us" and that its power and beauty would "haunt our memory long after we had left this chamber of art."[54]

THE YEARS ABROAD, 1861–1865

THE FIRST CASUALTIES OF THE CIVIL WAR fell in Baltimore on April 19, 1861. While marching through the city from the Philadelphia depot to Camden station, the Sixth Massachusetts Volunteer Regiment was beset by a mob of enraged southern supporters. In the melee, twelve local citizens and four soldiers were killed and countless others wounded. Although never implicated in this incident, William Walters had attended a rally of the States' Rights Party the previous evening. Appointed a delegate by the party, he was deputized to protest to the presidents of the regional railways against the use of their lines for conveying federal troops to Washington.[1]

This was not the first such instance of civil dissidence in which Walters had come to the fore. The previous spring a bitter feud, known at the time as the railway war, had erupted between rival factions vying for the right to build Baltimore's passenger rail system. One group associated with the Republican Party was backed by northerners, primarily Philadelphians; the other group represented local interests. On March 11, 1860, while Walters and three associates were in the state capital of Annapolis lobbying on behalf of the Baltimoreans, they were attacked in the rotunda of the House of Delegates. In the ensuing fracas, one of their assailants was shot.[2]

As a native Pennsylvanian with strong financial ties to the South, William Walters found himself in an untenable position. Like many residents of the city, he probably questioned the expediency of the North's commitment to preserve the Union through military intervention, and he may have subscribed to the belief that hostilities might have been avoided. His detractors would later maintain that mercenary instincts rather than conscience motivated his actions. Though never known to have advocated the retention of slavery, Walters championed the right of the southern states to secede. With the surrender of Fort Sumter to

General Pierre Beauregard and the South Carolinians on April 14, 1861, Walters organized a subscription to fire a salute in honor of the occasion. He would rue this action four years later, when federal troops, celebrating the Union's victory, fired a hundred-gun cannonade outside his Mount Vernon Place house, shattering the windows of Union and Confederate sympathizers alike.[3]

In July 1861, an act of chivalry determined Walters's course of action. Two young sisters, the daughters of Texas Senator Louis Trezevant Wigfall, had been stranded in Massachusetts by the outbreak of the conflict. Interceding on their behalf, Walters appealed to his old friend Simon Cameron, Lincoln's secretary of war (fig. 8). Cameron arranged for Walters's brother Edwin to convey the children to Richmond via Harpers Ferry. Forty years later, the elder sister still fondly recalled the warm hospitality accorded her during her brief stay on Mount Vernon Place. How thoughtful her hosts were to place before her at the dinner table a wine glass containing a "dear little Confederate flag!" After his return from Richmond, Edwin Walters was jailed, as were many other prominent Baltimoreans in the following months. Given the political climate, William Walters and his family realized that they could no longer delay their departure from the country.[4]

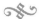

On August 8, 1861, William Walters submitted an application for a passport. He described himself as being five foot six and three-quarters inches in height, having a high forehead, blue eyes, common nose and mouth, round chin, brown (grayish mixed) hair, fair complexion, and round face. In addition to himself, he listed his wife, their two children aged thirteen and eight, and a servant, Betsey Anthony. Immediately upon issue of the document, they departed for Europe, with Walters vowing to friends that he would return on the next steamer, as soon as he had found a place for his family, a promise that for the sake of collecting he wisely did not keep.[5]

Thirteen days later, the Walters family reached France. Despite the language barrier, many factors may have drawn the family to Paris rather than London. Though England's sprawling megalopolis served as the hub of international commerce, Paris must have beckoned as a city of many diversions, with its bustling boulevards and public parks, countless shops offering luxury goods, and numerous artistic and historic monuments. An aura of glamour emanated from the capital of the Second Empire, then at its zenith. The mustachioed Napoleon III and the beautiful Eugénie, with their retinues, shuttled endlessly from the Tuileries

FIG. 8. Simon Cameron, boss of the Pennsylvania Republican Party and Lincoln's secretary of war until forced to resign in 1862, was a railroad associate of William T. Walters as well as a lifelong friend. His son, J. Donald, served as a pallbearer for William T. Walters. Volck depicted the senior Cameron as Robert Macaire, the legendary French nineteenth-century political rogue. Photograph courtesy of the Maryland Historical Society, Baltimore.

to Saint Cloud, Fontainebleau, and the fashionable seaside resort of Biarritz. Ever practical, Walters was probably swayed by financial considerations and the facility of travel on the continent. A most significant factor must surely have been his growing passion for French art.

Initially, the family stayed at the Hôtel du Louvre overlooking the

Tuileries palace. Within a few weeks, with the help of George Lucas, they were ensconced in a modern apartment at 12, rue de l'Oratoire. This small street, running between the rue de Rivoli and the rue Saint Honoré in the first arrondissement, was conveniently located for the Americans, eager to be at the center of social and artistic activity.

Accompanied by William Rinehart, who had traveled from Rome to be with them, the Walters family immediately plunged into Parisian life. They were joined by another friend, James Tyson of Baltimore, who had relinquished interests in the grain and flour trade at the outbreak of the war and embarked on an extended tour of Europe and the Near East. In their ramblings together, the little group took in the prescribed sights, including the cathedral of Notre Dame, the Renaissance-style church of Saint Eustache, and the Louvre. They sought out many of the fashionable restaurants and cafés, such as Philippe's on the rue Montorgueil and the Closerie des Lilas, renowned as a rendezvous for writers and artists of the romantic movement. The friends frequented two celebrated establishments on the boulevard des Italiens, the Maison Dorée, noted for the sumptuous design of its cast-iron balconies, and the Café Anglais. In the Luxembourg Gallery, "the waiting room of the Louvre," Walters saw the monuments of modern French art. It was there that the state displayed its acquisitions of works by living painters. On view at the time were such masterpieces as Ingres's *Apotheosis of Homer, Christ Giving the Keys of Heaven to Saint Peter,* and *Roger Delivering Angelica* and Delacroix's *The Barque of Dante, Scenes of the Massacres of Scio,* and *Algerian Women in Their Apartments,* in addition to paintings by popular artists, including Alexandre Decamps, Ary Scheffer, Horace Vernet, Charles Gleyre, Thomas Couture, and William Bouguereau.[6]

Another excursion led them to the outstanding private collection of the late Count J.-A. Pourtalès-Corgier. The count had been in the vanguard of collectors of Dutch seventeenth-century genre scenes. After erecting a *hôtel* resembling a Florentine palazzo on the rue Tronchet, his interests turned to the Italian Renaissance and he assembled a vast array of works. In addition, he explored the early Netherlandish, Flemish, German, and French schools of art. Spain was represented in his collection by two Murillos, as well as the enigmatic *Orlando muerto (Dead Soldier,* National Gallery, London), then thought to be a masterpiece of Velázquez.

Paintings were but one facet of the count's interests. Early in the century, he had traveled to Greece in search of antiquities. At the Paris sale of the contents of Malmaison in 1824, he bought ancient artifacts from the Bonaparte collections. Among other fields represented among

the Pourtalès holdings were Renaissance bronzes, carved rock crystals and ivories, Limoges enamels, and, most surprisingly, Asian art, including Japanese lacquers, Chinese and Japanese bronzes, and Ming porcelains. In its remarkable breadth the Pourtalès holdings set a precedent for a generation of collectors that included, most notably, Edouard André and his wife, Nélie Jacquemart, founders of the Jacquemart-André Museum, which is still maintained on the boulevard Haussmann by the Institut de France.[7]

One wonders what William and Ellen Walters thought of this assemblage, which in scope and depth and in its very housing could be regarded as the French antecedent to Harry Walters's endeavors some sixty years later. Did they ever extol it to their son as an exemplar for him to follow? More importantly, could it have inspired Harry, who, with his sister, often accompanied his parents on these forays? As part of their education, the children were expected to record in notebooks their impressions of what they had seen each day.

Although funds for purchases were undoubtedly limited, the Walters family accompanied Lucas to various galleries and artists' studios. Understandably, they were anxious to see *The Scarlet Letter* at Hugues Merle's atelier and to meet Jean-Léon Gérôme, whose *Duel after the Masquerade* was already their prized possession. En route to Gérôme's studio, Walters, Lucas, and the dealer Goupil stopped to admire a historical painting by the artist's master, Paul Delaroche.[8] The *Young Christian Martyr* showed a Christian maiden who, during the reign of Diocletian, had been condemned to death by drowning. This moving subject might have inspired Gérôme's *The Christian Martyrs' Last Prayers,* commissioned at that time but not completed until twenty years later.

William and Ellen Walters were also drawn to Ecouen, a small town north of Paris where Pierre Édouard Frère and Théophile Duverger resided, surrounded by an international coterie of colleagues intent on portraying rustic life.[9] The Ecouen school's genre scenes showing village children in domestic settings had been exhibited at the Allston Association in Baltimore. Although they may now seem somewhat cloying, at that time they enthralled Anglo-American viewers. When several works by Frère were included in the *French Exhibition* in Ernest Gambart's Pall Mall Gallery in 1857, the *London Illustrated News,* alluding to a picture of a child at prayer, avowed that "the meek apostrophe of the Great Incomprehensible is here audible to the heart's ear." On the same occasion a no less influential critic than John Ruskin was stirred to rhapsodize, "Who

would have believed that it was possible to unite the depth of Words-
worth, the grace of Reynolds and the holiness of Angelico?"[10]

William and Ellen Walters made at least two excursions to Ecouen in
1861. Together with Lucas, they spent an October day wandering about
the town guided by Duverger, from whom they commissioned a small
picture. As was Walters's practice, the artist was encouraged to set his
own price. In December, they dined with members of the colony, in-
cluding the Danish artist August Schenck, Frère, and Duverger and their
spouses. It was probably on this last occasion that Duverger presented
Ellen with his drawing of a girl dressing her brother, inscribed "Hom-
mage à Madame Walters par l'auteur T.E.D."

Ultimately of greater portent was an encounter with Antoine-Louis
Barye on September 13, 1861. The sculptor and watercolorist had pi-
oneered in assailing the academic hierarchy of genres in art in which
animal subjects were relegated to a minor position. For much of his
career, Barye had refrained from participating in the Paris Salons, but in
his later years his significance as one of the influential *animaliers* of the
century had gradually been appreciated. He now began to enjoy public
recognition and to benefit from state commissions. It would be William
Walters, however, who, far more than any other patron, would ensure
the animal sculptor's international success.[11]

Early in the spring of 1862, with Harry enrolled in a *lycée* and Jennie at
private school, William and Ellen set out to fulfill a lifelong ambition, a
tour of Italy. Still financially pressed, they economized, traveling second
class on trains and sharing the cost of coaches with compatriots they
encountered on the road. These were mostly Southern sympathizers,
among them a few Baltimoreans, as well as some Northerners, the last
including a new breed, war profiteers no longer welcome at home. In
their conversations, the travelers carefully avoided speaking of the hos-
tilities in America.

The primary intent of the journey, William earnestly if not ingenu-
ously noted, was educational rather than social or pleasurable. Wishing
to share the benefits of his experiences with friends at home, he kept a
lengthy and detailed journal. Unfortunately, the prose is stilted, the
spelling idiomatic, and the text plagiarized from the John Murray travel
guides. More remarkable as an exercise in diligence than for literary
qualities, the manuscript sheds light on Walters's enthusiasms, open-
mindedness, and range of interests. He seems utterly devoid of the pho-
bia of popery that cast its pall over American public sentiment at mid-

century. In addition to describing the historical and artistic monuments of each city, he commented on its government, institutions, and products. While traveling in the countryside, he discussed the history of each region, road conditions, and flora and fauna. He even found time to detail the agricultural methods used and the religious practices of the inhabitants.[12]

The journal began with their stay in Genoa, then the point of arrival for most tourists coming to Italy by sea. Walters confessed that in this city any Presbyterian or Methodist prejudices he might have harbored regarding Italy being "down trodden, priest ridden, and benighted" were quickly dispelled by the number and quality of benevolent institutions and libraries.[13] Of the former, he singled out for praise the Albergo de'Poveri, a refuge for twenty-five hundred impoverished and aged inmates, and the Ospedale di Pammantone, a celebrated hospital open to the sick of all nations.

From Genoa, William and Ellen Walters sailed to Leghorn and then proceeded by rail to Florence, where they spent three weeks with William Rinehart. Also at hand was James Tyson who, since leaving them in Paris, had visited Palestine, "the land of crocodiles and the Jordan" (journal, series 2, 5b). Walters readily acknowledged that the Pitti and Uffizi Galleries alone, with their Trecento and Quattrocento treasures, justified the trip. However, he did not endeavor to expound upon their holdings, which seem to have overwhelmed him. Apparently less intimidated by architecture, he described at length various buildings, including the Duomo. Here he stood for hours transfixed by Brunelleschi's dome, which he called "one of the most beautiful and gigantic works of man" (series 2, 7b). The natural beauty of the city and its site on the banks of the Arno, the limpid atmosphere and "azure-violet" sky, and the profusion of flowers especially enthralled the American couple. They were no less enchanted by the flower girls with wide Tuscan hats who daily deposited bouquets in their hotel rooms and affixed a boutonniere to the lapel of every male passerby, accepting in return no payment other than the gratuities left at the railway station (series 2, 5d). Among the charitable institutions, the venerable Misericordia impressed them deeply. On their allotted days the members of this six-hundred-year-old confraternity, drawn from all walks of life, donned black gowns and cowls to tend the sick and dying (series 2, 8d).

After an excursion to Fiesole and a brief trip to Pisa, the pair returned to Leghorn. Here they parted company from Tyson, who embarked on a first-class steamer for Rome. William and Ellen sailed second class to Naples.

The three weeks in the south in that "Paradise on earth" was probably the most exhilarating period in this staid couple's life. They reveled in the salubrious climate and beguiling scenery and fully indulged their antiquarian instincts. Although he found Naples overcrowded and dirty, William described the Neapolitans as "a more happy, gay and good-natured and habitually laughing people" than he had ever seen. If they were "devils," he added, they were "the most happy devils certainly anywhere to be found" (journal, series 3, 1b). Good-humoredly, he related an encounter with a pickpocket who relieved him of his watch and fled without waiting for an expression of gratitude.

One of their first escapades was the ascent of Mount Vesuvius, which only a year earlier had erupted, destroying several nearby villages. Traveling first by carriage and then on horseback, they reached the volcano's cone, rising before them at a steep sixty-five-degree angle. Ellen was carried up in a sedan chair as William gamely trudged over the volcanic stone beside her for forty-five minutes until they arrived at the summit. They were rewarded for their exertions with a spectacular, panoramic view of the Bay of Naples and a vision into "the fearful abyss, its sides covered with great knobs or blossoms of brilliant white and yellow — they seem the sulphurous blossoms of Hell" (journal, series 3, 2c). Descending inside the crater, the tourists reached a point at which the heat was sufficient to bake the eggs they had brought for lunch.

Although his knowledge was most likely based on Edward Bulwer-Lytton's *The Last Days of Pompeii* (1834), William alleged that he had read many times, and been profoundly moved on each occasion by, Pliny the Younger's account of the entombment of the city beneath layers of pumice and ash in A.D. 79 (journal, series 3, 4c). As he roamed the excavated streets, Walters was repeatedly reminded "that there was nothing new under the sun" (series 3, 6d). The roadways with stepping stones and paving blocks rutted by chariot wheels he likened to Baltimore's Light Street. The various kitchen utensils, lighting fixtures, and implements for spinning and weaving found in the excavations and displayed in the Royal Museum in Naples he compared favorably, in both design and ornamentation, to those of his own time. Nineteenth-century sensibilities came into play in his admiration for the fortitude of the Roman guards who remained at their posts and in his condemnation of those who perished trying to retrieve possessions, their fates serving as a lesson for those at home who were fixated on the pursuit of riches.

Sightseeing in the environs of Naples, the couple headed north along the coast of Baia. As they passed the remains of villas that had once dotted the shore, William recalled literary allusions to the dissolute life led there

in antiquity. The Roman matrons, he observed, arrived at this ancient "Newport" with the reputation of Penelope but left it with that of Helen (journal, series 3, 4a). Traveling in the opposite direction for several days, they stopped at Sorrento and were rowed out to the island of Capri to see the celebrated Blue Grotto. Continuing southward, they crossed the marshy wasteland, rendered uninhabitable by malaria, until they reached Paestum, which had been founded by the Greeks about 600 B.C. Appreciating Greece's primacy in classical art, William was intent upon seeing the three great Doric temples. As he wrote in the account of his travels, "I approached these mighty edifices with a religious awe I never felt before — their huge dusky masses standing alone amidst their mountain wilderness without a solitary vestage [*sic*] near of any power that could have reared them — surrounded by waste and weeds, overgrown in places by moss and vegetation — their grandeur — their gloom their majesty give them the impress of supernatural" (series 3, 5b).

Apparently the journey had been scheduled so that they would reach Rome for Easter. That spring the city teemed with British tourists, anticipating that the papacy was soon to lose its temporal authority to the Kingdom of Italy. They had gathered for what they thought would be the last display of the pageantry associated with Holy Week. Unable to obtain hotel accommodations, the couple rented rooms in a private residence. By now they were beginning to tire. Ellen desperately missed the children, and William, plagued by minor ailments, took to his bed for several days.

If the sojourn in Naples had been a leisurely respite, the intention in visiting Rome was "to be instructed" (journal, series 4, 1b). William was soon up and about, taking in the traditional sights, the Colosseum, Forum Romanum, Baths of Caracalla, Pantheon, and the catacombs. Repeatedly he reproached the early popes for salvaging their building materials from ancient structures. He primly noted that the Palatine Hill, then partially cultivated with potato patches, served as testimony to power's transiency. Although he mentioned galleries and palaces, like the Villa Borghese, that were open to the public, William apparently did not visit the studios of the many Italian and foreign artists who populated the city.

Much of their stay in Rome was taken up with Holy Week celebrations. Ellen was thrilled by the Palm Sunday procession in which Pius IX, seated on the *sedia,* was borne up the nave of Saint Peter's. Cardinals attired in scarlet and troops of various nationalities, as well as the papal guards, all in splendidly colored uniforms, served as escort. On Good Friday the couple attended mass in the Sistine Chapel and were blessed by the Pope, who passed within two feet of them. On this occasion,

William recorded, they stood for three hours, listening enraptured, while the papal choir sang the *Miserere* (journal, series 4, 9c). He made no mention of Michelangelo's overpowering ceiling and *Last Judgment*. Was it an oversight, or did the artist's heroically proportioned nude figures transcend Walters's conservative sensibilities? Easter Sunday was a full day. They arose at 5:00 A.M. to be present in the Basilica for the papal procession; at noon they witnessed the benediction in the square; they attended vespers in the early evening and later witnessed a breathtaking spectacle, the illumination of Saint Peter's by thousands of gleaming gold-and-silver lanterns.

Reluctantly leaving Rome, they continued their journey by sea back to Genoa and then overland to Venice. Northern Italy, however, did not offer the attractions of "the land of the Orange and the Vine, the Olive and Fig" (journal, series 5, 1b). Its inhabitants appeared to lack character and distinctive customs. Ancient monuments were neither as frequently encountered nor as well preserved. Apart from a stop in Parma to study Correggio's paintings, particularly his frescoes in the cupola of the Duomo, the couple made no effort to visit collections in this region so rich in paintings from the sixteenth through eighteenth centuries. This obvious lacuna in Walters's interests was shared by most of his contemporaries, who were drawn instead to the early Renaissance. Where the rail lines had been completed, they traveled by train; otherwise, they used diligences, the lumbering continental version of the stagecoach. An ardent historian and devotee of Napoleon, William recorded the battle sites as they passed: Marengo, where the French defeated the Austrians in 1800, and Casteggio, the setting for major conflicts in the Punic Wars, in the Napoleonic campaigns, and again in 1859 in the Wars of the Unification of Italy. Crossing the border into Austria's Venetian provinces just outside Mantua, William humorously saw the customs formalities as an exchange between the Habsburg double-headed eagle and the American single-headed bird, in which the latter held its own. His wife, however, was mortified by the officials' "voyage of discovery" into her wardrobe, which brought into "vulgar gaze" its contents, both washed and unwashed (series 5, 2b).

Even Venice failed to kindle unqualified enthusiasm. Admittedly, if there was "a solitary city in the world which to a greater or lesser extent would contribute to the pleasure of every sort of traveler, that city was Venice," yet it was doubtful "if the *intelligent* traveler" would "find food here, after the love of the curious" had been gratified (journal, series 5, 4a). Apart from the Palladian churches, such as San Giorgio Maggiore, which were "simple, grand and harmonious," the architecture of the city

appeared "semi Gothic" and partly Byzantine. This characterization was especially true of the cathedral of San Marco, a costly "mosque-like" structure with little to recommend it but "glitter and show" (series 5, 5c). A somewhat atypical highlight of the week in Venice was a visit to the Mechitarist monastery on the island of San Lazzaro in the lagoon. The monks, Armenian Benedictines who adhered to their ancient eastern rites, were renowned for their printing press that operated in twenty-four languages. Among the American publications, William was "deeply pained" to see Harriet Beecher Stowe's inflammatory novel, *Uncle Tom's Cabin, or Life among the Lowly* (series 5, 7a). The couple attended a mass at which they were much impressed by the longevity of the monks, many of whom could undoubtedly have recalled Lord Byron's stay among them over forty years earlier. For two hours they engaged in conversation a member of the order whom they agreed was one of "the most agreeable and instructing" individuals that they had ever encountered (series 5, 7a).

On their return, William and Ellen stopped in Milan, where they made the obligatory visits to the Duomo and to the refectory of Santa Maria delle Grazie to see Leonardo's *Last Supper.* They then continued north by way of Lakes Como and Lugano. The crossing of the Alps by the Simplon route proved an adventure in itself. Renting a carriage with another American couple, they undertook the arduous forty-four-mile trek in a single day, at one point climbing to the level of snow and glaciers. In Switzerland, they stopped briefly in Geneva, a city that lacked historical interest and was otherwise spoiled because of its association with John Calvin. The modern counterparts to this tyrannical religious reformer had turned America into "a house of mourning," added William, referring to the more resolute Union supporters (journal, series 5, 14a).

William and Ellen Walters had left Paris in the depths of winter. Returning to Paris on the last day of May, they found the Champs Elysées "gay and bright [and] reassuring" that all had gone well in their absence. To while away the long months of their Paris exile, the family relied increasingly on jaunts organized by George Lucas, who took them to various attractions, exhibitions, and artists' studios. Shortly after their return from Italy, Lucas arranged a tour of the Maison Pompéienne, Prince Louis Napoleon's residence on the avenue Montaigne.[14] This recently completed building, with its rich classical ornament and predominantly red-and-black color scheme adopted from Pompeii, would give rise to the style of interior decoration internationally popular in the

third quarter of the nineteenth century. On another occasion, they went to the Bois de Boulogne to see the famous Arabian horses of Abd-el-Kader, France's erstwhile opponent in the conquest of Algeria.

An apparent improvement in the family's financial position allowed modest purchases in the Paris art market. That June the Walterses commissioned their first bronzes from Antoine-Louis Barye. They also bought some drawings and a few small paintings from those artists with whom Lucas dealt for other American clients: Antoine Plassan, Charles Chaplin, Théophile Lemmens, Jean-Baptiste Fauvelet, and the members of the Ecouen school are the names most frequently mentioned. These were the *petits maîtres* whose domestic, interior scenes were as readily acceptable to the middle-class patrons of the nineteenth century as their antecedents, the genre paintings of eighteenth-century France and seventeenth-century Holland, had been to the bourgeois buyers of their eras.

The watercolors of Léon Bonvin represented a more singular interest on William's part (see plate 2). This little-known artist was encountered by Lucas in his dealings with the painter François Bonvin. Less fortunate than his elder half-brother, Léon had abandoned his studies after a brief stay at the private École de Dessin to support his family by operating a cabaret in the Paris suburb of Vaugirard. In addition to serving a rabbit stew said to have been unsurpassed, he entertained guests by playing selections of Beethoven on a harmonium and eventually drew a clientele that included fellow artists and members of the stage. Among these were the etcher Félix Bracquemond, the caricaturist Henri Monnier, and the celebrated *tragédienne* Mme. Agar. Usually, Bonvin could practice his art only early in the morning, portraying *natures vivants* of wild flowers growing in the meadow outside his window, or late at night by lantern, painting flowers and still lifes arranged on the kitchen table. Walters first learned of Léon Bonvin in the autumn of 1862 and continued to acquire his watercolors long after the artist, discouraged by lack of recognition, hanged himself in the winter of 1866.[15]

Wishing to utilize fully their time abroad, William and Ellen returned to Switzerland for two weeks in July 1862. On this occasion they stayed at spas in Interlaken, which is well situated between the lakes of Thun and Brienz in full view of the Jungfrau, and at Lenk, a scenic village also in the canton of Bern.

Early in October 1862, William and Ellen Walters were lured to London by the International Exhibition. Their reactions to this extravaganza

extolling civilization's progress in industry and the arts remain unknown save in one significant regard, the astonishment and pleasure they experienced on viewing the Oriental Department. Since neither China nor Japan was an official participant, these displays were drawn from the collections of British diplomats and military personnel. The rather paltry Chinese section included such items as Captain R. N. Hall's Chinese pictures, General Sir John Michel's carved screen taken from behind the emperor's throne in his Summer Palace, a backgammon board lent by C. Copland, and "a human skull richly set in gold, reported to be the skull of Confucius," lent by Captain W. Tait.[16]

Through the enterprise of the far-sighted Sir Rutherford Alcock, the Japanese exhibit proved more impressive. Alcock had originally served as British consul in China. In his efforts to encourage trade between that country and the West, he published articles in British journals and sent a selection of Chinese artifacts to the Great Exhibition of 1851. With Commodore Perry's opening of Japan in 1854, Alcock was designated H.M. Envoy Extraordinary and Minister Plenipotentiary to the Court of the Taikoon. In that capacity he immersed himself in Japanese culture, eventually writing several books on the subject. In 1862, Alcock again organized an exhibition of products to be shown in London. Included were several hundred lacquers and inlaid wood products, specimens of basketry and straw work, porcelains from Yedo and Yokohama, pottery from Osaka, bronzes and inlaid metals, and various textiles. Although the display could not be awarded prizes because the individual artists were not identified, public response was highly favorable.[17]

The "reporters" for the jury, French archaeologist Edmond du Sommerard and author Prosper Mérimée, were highly complimentary, noting that the collection was "as interesting in an artistic point-of-view as that of the most advanced industry," while the reviewer John Burley Waring commended the bronzes for "a strong sense of grotesque fun."[18] English viewers profoundly affected by the display included William Burges, otherwise an advocate of medievalism, his friend the architect E. W. Godwin, and Arthur Liberty, founder of the department store. Although William Walters had already seen Chinese and Japanese art in Paris at the Louvre and in the Pourtalès collection, it was the 1862 showing in London, unprecedented in the West in the scope of its Japanese holdings, that first prompted his interest in collecting Far Eastern art, a field that he pioneered in America.

On the fifth week of their stay in London, William and Ellen decided to visit the Crystal Palace, Sir Joseph Paxton's behemoth iron-and-glass building originally constructed in 1851 for the Great International Ex-

hibition. The structure had been dismantled and moved from Hyde Park to Sydenham south of London, where it had been reassembled and opened as a pleasure palace, featuring a range of attractions including a vast palm court, hundreds of sculptures, reconstructions of historical "courts," and the ever-popular models of antediluvian animals displayed outside in the park.

Seldom recalled is that the palace was dank and chilly much of the year, and in November it must have been particularly raw. Ellen Walters, never of sound health, contracted a chill and within a couple of days, on November 13, 1862, succumbed to pneumonia at the age of forty.[19] Her body was deposited in a vault at Brompton Cemetery until the following spring, when it was transferred to Baltimore and buried beside the remains of her infant son William in what became the family plot at Greenmount Cemetery. Three years later, a memorial statue of a woman strewing flowers, *Love Reconciled with Death*, commissioned from William Rinehart, was placed above the tomb (fig. 9). This assignment, the sculptor's sister-in-law recalled, was the "saddest, but sweetest, duty he ever had to perform."[20]

William, seeking to allay his grief, immersed himself in the Paris art market. More than ever he relied on the now indispensable George Lucas. Interestingly, the tenor of his collecting underwent a subtle change. When Ellen was alive it had been a convivial, leisurely pastime with visits to studios and meals with the artists followed by open-ended commissions. Now there was a more pronounced sense of purpose and deliberation. The range of artists expanded. As well as ordering drawings and paintings from the *petits maîtres* of genre painting patronized by Lucas's other clients, William now sought out eminent landscape painters of the day, acquiring works, albeit modest in scale, by Théodore Rousseau, François Daubigny, Charles-Emile Jacque, Jules Veyrassat, and Jacques Brascassat. From the *animalier* Antoine-Louis Barye he bought not only bronzes but also the less known watercolors. In these, the exotic animals of the Jardin des Plantes were situated in deserts and on rocky cliffs, which were actually sketches of terrain in the Gorge d'Apremont near the artist's home at Barbizon.

Visiting the studio of Jean-Baptiste Corot accompanied by George Lucas early in 1864, Walters saw in progress *L'étoile du berger*, a crepuscular landscape in which a woman standing beside a leafless tree gestures toward the evening star, while behind her a shepherd leads his flock into the dusk. The subject is an elaborate allegory alluding both to the death

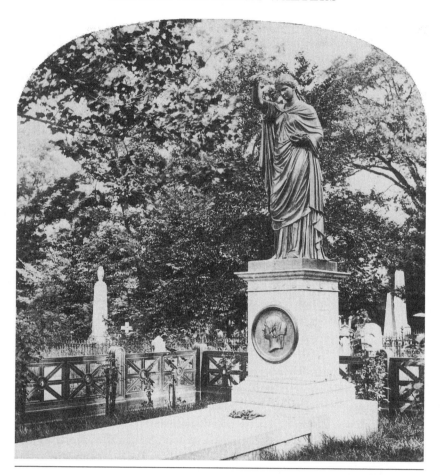

FIG. 9. The grave of Ellen Walters, Greenmount Cemetery, Baltimore (WAG Archives). William Walters commissioned this monument, entitled *Love Reconciled with Death,* in 1865. It was cast in bronze the following year.

of the young singer Maria Malibran and to Alfred de Musset's poetry mourning the tragedy. Apparently, the widower found solace in the composition. However, he declined to pay Corot's asking price and, instead, commissioned a replica. Atypically, Walters haggled over the fee and had the temerity to suggest some improvements for the composition, which the artist vigorously rejected.[21]

Though neither overtly religious nor strictly sectarian in his views, William Walters also took comfort in compiling two albums of works on paper devoted to "prayer." He initially commissioned ten "famous" artists to contribute works and then continued to add illustrations in lots of

ten. Despite the limitations imposed by the theme, the results of this endeavor provide an overview of trends in painting in the midsixties, embracing such noteworthy figures as William Bouguereau, Jean-Léon Gérôme, and James Tissot, as well as a host of lesser talents, including Auguste Anastasi, Félix Joseph Barrias, and Paul Seignac, artists whose reputations have been eclipsed with time. As a universalist in his theological outlook, William encouraged considerable latitude in the interpretation of prayer, accepting with equal enthusiasm Charles C. Bargue's and Charles Théodore Frère's drawings of Arabs undertaking their obeisances to Mecca, Alexandre Bida's *Four Jews at the Wailing Wall,* and Gustave Brion's watercolor of Breton peasants decorating a wayside shrine.[22]

His other favorites at this time were Félix Ziem, the most peripatetic of nineteenth-century painters, who is remembered for his oils and watercolors of Venice and Constantinople, and Paul Gavarni, the caricaturist and lithographic artist whose illustrations of the foibles and manners of various strata of Parisian life were widely acclaimed.

Acting on Walters's behalf, George Lucas contacted Honoré Daumier in March 1864. Two months earlier the consummate delineator of French society and its mores had contributed a wood engraving, *L'intérieur d'un omnibus,* to the journal, *Le Monde Illustré.* As a streetcar and railroad financier, Walters might have been particularly attracted to the subject. Orders were placed for four watercolors beginning with *The Omnibus* and followed by three representing train interiors: the *First, Second,* and *Third Class Carriages.* The sympathetic satire characteristic of Daumier's oils and watercolors at this time is epitomized by *The Omnibus,* which shows a row of incongruous passengers seated in a crowded car (fig. 10). At the left, a mother clutching an infant in her lap is helplessly squeezed between the car wall and a preposterously large peasant, who gazes obliviously ahead. To the right, a well-dressed matron icily glares at an elderly gentleman dozing at her side. Overhead, posters advertise benzine, mineral water, false teeth, wigs, and painting (the last bearing the signature *h. Daumier*).[23]

With his two children still in schools in Paris, William Walters increasingly occupied himself by traveling to sightsee and to search for pictures to augment his collection. Another reason would become apparent only a year later. He returned to London briefly in January 1863, visited Belgium and the Netherlands in April, and, accompanied by George Lucas, traveled to the Rhine in the late autumn. There the two stopped at Aix-la-Chapelle and at Düsseldorf, touring the studios of such local luminaries as Karl Hübner, Adolphe Tidemond, Hubert Salentin, and Benjamin Vautier. In 1864, the pace accelerated further with journeys to

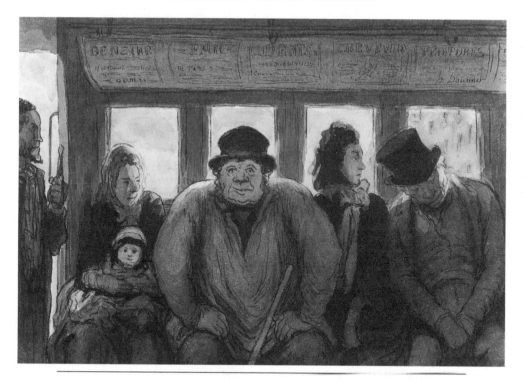

FIG. 10. Honoré Daumier, *The Omnibus,* watercolor on paper, 1864 (WAG 37.1227). Walters's decision to commission this watercolor may have been prompted by his early interests in streetcars and railroads.

London in April and October and to Vienna in July. A devotee of the seashore, Walters took his children to Dieppe each August, exchanging the Channel Coast shingle for sandy beaches like those they had enjoyed in Virginia. Early in 1865, he also returned to Florence and Rome.[24]

Unquestionably, William Walters in 1864 was far more worldly and sophisticated than when he had begun to collect American art in the late 1850s. After the experiences abroad his aesthetic discernment exceeded the meticulous verisimilitude of the Hudson River school landscapes. Intervening in the meanwhile were a sense of disillusionment stemming from the Civil War and his self-imposed exile and perhaps a feeling of alienation from those American artists whose political loyalties differed sharply from his own. Such factors, together with his acumen for profit, may have contributed to the surprising decision to liquidate much of the collection that he and his wife had so enthusiastically assembled. On

February 12 and 13, 1864, an auction was conducted in New York by Henry Leeds and Company in the Düsseldorf Gallery. Walters's name did not appear in the catalogue, which simply listed the holdings as "the property of a collector resident of Baltimore [now in Europe] and long distinguished for his taste and liberality." The American pictures were described as "wholly private orders," and the foreign works as "secured direct from the artists and purchased from the French and Belgian exhibitions held in New York."[25]

A reporter for the *New York Daily Tribune,* in reviewing the exhibition before the sale, compared the collection to that of John Wolfe, which had recently been sold in New York with much "notoriety." He anticipated that the Walters sale would arouse considerable interest, both for the works commissioned locally and for the range of pictures by artists hitherto unknown in this country. The offerings, though lacking in masterpieces, were spared at least "the lumber in the shape of Düsseldorf and other German pictures" so predominant in the Wolfe sale.[26] Genre scenes by J. Trayer, Victor Chavet, Gustave-Leonhard de Jonghe, and Théophile Duverger were singled out by the critic, but his most wholehearted praise was reserved for Charles Baugniet's *The Eldest Daughter,* a depiction of a dolorous encounter between a "ruined" daughter and her mother and sister. The reporter found the American paintings less exciting, although he cited the landscapes by Kensett, Richard William Hubbard, Gifford, and Church as representative of the advances made in the study of nature since the generation of Cole, Doughty, and Durand, also represented in the collection. Durand's *In the Catskills,* in particular, was condemned for its lack of definition in the foreground, a failing characteristic of "Byzantine art." With the early artists this flaw had resulted from "simple incompetency," he said, whereas with the Americans it was a question of incompetency "cloaking itself under the reverend name of Art."[27] Others apparently shared this opinion, for the Durand was either not sold or withdrawn beforehand. Despite this minor setback the sale was an outstanding success, netting $36,099.

Encouraged, Walters entered a month later into a commercial agreement with Samuel P. Avery, which launched the latter's career as one of New York's foremost dealers in paintings and prints. The "understanding" stipulated that Walters would provide all the funds for acquiring art both in Europe and in the United States. Of the profits made from the sale of his purchases abroad, Avery was to retain a third, whereas from the sale of purchases made in America, Walters was to receive half. As early as April 9, a collection of paintings consigned by Avery was auctioned by Henry H. Leeds and Company, again at the Düsseldorf Gallery

on Broadway. The advertisement for the sale listed a wide assortment of French and German artists. Some, including Isidore Patrois, Louis Eugène Lambert, and Victor de Bornschlegel, were described as "old favorites," although their names today would be familiar only to those well versed in the byways of nineteenth-century art. Others, like Corot and Daubigny, were listed as relative newcomers for American viewers.[28]

An objective in participating in this venture, Walters explained to his friend Benjamin Newcomer in Baltimore, was "to help Avery and his family who were poor but most deserving." Harboring some misgivings about Avery's "weight for the occasion," he requested Newcomer to attend the sale on his behalf. His doubts were unfounded. Again, over thirty thousand dollars was realized, enabling Avery to open "art rooms" at 664 Broadway. How long the agreement between Walters and the New York dealer remained in effect is not known. Avery, however, eventually conducted at least four similar auctions in 1866 and 1867.[29] Most significantly, it was in the course of these transactions that Avery formed a liaison with George Lucas, who subsequently acted as his agent in Paris. During the two succeeding decades, Lucas expended more than 2½ million francs for art on the dealer's behalf.

For Americans residing in Paris, the developments at home were inevitably of increasing concern. Once, in September 1864, Walters spent the entire day reviewing war news with fellow Baltimoreans Frank Frick and R. Snowden Andrews. As the outcome grew increasingly apparent, William began to plan his return to America. A pressing concern, he admitted to Newcomer, was the health of Betsey Anthony, his old nursemaid who had been a member of the household most of her life. At the end of 1864, in a letter to Simon Cameron, the former secretary of war, Walters announced that from the outset he had planned to remain abroad no longer than three years and that this period had expired. He also professed that he had adhered to a position of strict neutrality during the hostilities, despite prewar ties to the South, and that he was willing to submit to any measures to facilitate his return, short of swearing an oath of allegiance.[30] To his Baltimore acquaintances, however, he remained unrepentant, professing astonishment "at finding the people of Maryland had made so little resistance to military tyranny."[31] It was not until March 7, 1865, after General Sherman's troops had wreaked revenge on South Carolina, that Lucas saw William, Betsey, and the two children leave the Saint Lazare station for Le Havre and the return voyage to America.

THE POSTWAR RECOVERY, 1866–1884

A MYRIAD OF FOOTSTEPS CLATTERED against the paving stones of Mount Vernon Place on Saturday, October 26, 1866. The marchers were not soldiers but schoolchildren bearing floral tributes for their benefactor George Peabody. The ailing philanthropist had returned from London to Baltimore, which he had left thirty-three years earlier, to attend the dedication of the institution bearing his name.[1] It was his goal that Baltimore should benefit from a multipurpose facility resembling an English athenaeum, which would provide the public with a library, accommodations for lectures, an academy of music, and an art gallery. Significantly, he expressed the hope that the Peabody Institute would serve as "a common ground where all men [might meet], burying former differences and animosities, forgetting past separations and estrangements, weaving bonds of new attachments to the city, to the state and to the nation."[2] The public reception and the review of schoolchildren honoring Peabody the following day were the first large public gatherings since the end of the war. They served as positive steps in the healing process of a city that had experienced agonizing emotions and sharp divisions in the resolution of the conflict. Moreover, these events heralded a golden era of philanthropy that would culminate in the founding of the Johns Hopkins University and Hospital, opening in 1876 and 1889, respectively, and of the Enoch Pratt Free Library system in 1886.

Whether William Walters ever met Peabody or attended these ceremonies, which took place only paces from his threshold, is not recorded. Like most Baltimoreans who had absented themselves from the city during the war, he was now immersed in reestablishing himself within the community and recovering his wealth. The two succeeding decades were to prove highly productive for him in business, art collecting, and numerous other pursuits.

By nature a very private person and one who would increasingly restrict his social activities, Walters preferred the company of like-minded individuals, serious and industrious, whose ambitions were tempered by a strong sense of civic responsibility. The most remarkable, John W. McCoy, had been an ally in the "railway war" of 1860 and a companion from the early days of the Allston Association. By profession a journalist, McCoy, shortly before the war, became head of a mining company with offices in Baltimore and operations in Guilford County, North Carolina. During the hostilities, he remained at his post in the South, displaying remarkable ingenuity in keeping the mine in operation. He produced his own supplies and equipment through improvisation and experimentation and obtained provisions for the miners through barter. His was the only copper mine still functioning in the Confederacy at the end of the war. Returning to Baltimore, he joined W. T. Walters and Company, succeeding Edwin Walters, who had left to start his own distillery.

Unmarried and a chronic insomniac, the energetic McCoy found time to pursue a wide range of interests. A prodigious reader, he amassed a library of more than eight thousand volumes, focusing on literature and the natural sciences. One of the principal patrons of local artists, he promoted the careers of the sculptor William H. Rinehart and the painters Arthur Quartley and Hugh Bolton Jones. A supporter of local charities, he was not content to serve merely as a member of the board, but for several years actually spent his evenings personally attending to those in distress. This congenial and trusted colleague was not only a partner in Walters's liquor business but also occasionally assisted his friend in the purchase of art.[3]

An even closer friend was Benjamin F. Newcomer.[4] A flour merchant and banker, Newcomer had become acquainted with Walters in the early 1850s and had succeeded him as a director of the Northern Central Railway Company in 1862. During the war, rather than submit to a required loyalty oath, Newcomer, always the rugged individualist, forfeited a lucrative contract with the federal government to provide grain for Union troops. Both Newcomer and Walters were regarded by their contemporaries as exceptionally strong-willed and independent, traits that might have led to conflict. Fortunately, their respect for each other blossomed into a warm, abiding friendship that extended to their children, Harry and Jennie Walters and Mary, Nannie, Hattie, and Waldo Newcomer. Years later, Walters would confide to Nannie, "I do not forget you are your father's daughter — toward whom my love and gratitude overflows to all his children — I owe him more by far than anyone in

the world."[5] In the postwar era, the fortunes of the two friends were to remain inextricably linked.

Because of lax enforcement of loyalty oaths in Baltimore after the war, Walters was not disenfranchised and, for the only time in his life, accepted a public office. With Newcomer, he served as co-commissioner of finance for the city from 1867 to 1869 in the administration of Mayor Robert T. Banks, a conservative Democrat. Elected by the City Council, the two were entrusted with issuing certificates for stocks and bonds and with leasing city property. Their prior experience in railroad financing must have stood them in good stead when monitoring the various "sinking funds" established by the city to cover its obligations for local railroad bonds.

Banking was the industry on which Walters and Newcomer were to leave their most enduring mark in Maryland. During the course of the war, Baltimoreans, fearing for the safety of their possessions, had incorporated the Safe Deposit Company of Baltimore, the nation's second and the state's first institution of its kind. At the initial stockholders' meeting, on July 5, 1867, a local merchant, Enoch Pratt, assumed the presidency and Walters became a director. A year later, Benjamin Newcomer was elected president, a position he retained until his death, while William Walters continued on the board, eventually serving as vice-president. The company originally leased space in the basement of a bank. In 1876, it moved into its own building, architect E. Francis Baldwin's impressive brick-and-granite structure located on South Street in the financial district (fig. 11).

The pride of the company was its great vault, to which generations of Baltimoreans entrusted their family silverware and other valuables, especially during the summers. With massive walls almost four feet thick, constructed of brick, iron plates, concrete, and welded steel, and a foundation immersed four feet deep in tidewater, the vault repelled burglars and even withstood the Great Fire of 1904. Shortly after its founding, the company began to handle trusts and in 1876, in recognition of its fiduciary role, changed its name to the Safe Deposit and Trust Company. It assumed a major role in both the development of local commerce and the more far-reaching financial endeavors of Walters and Newcomer.[6]

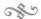

In the postwar era, capital from Baltimore flowed south. The more predatory investors were carpetbaggers routing for profit in the war's after-

FIG. 11. E. F. Baldwin, architect's rendering of the elevation of the Safe Deposit Company, about 1876. The building, which survived the Baltimore fire of 1904, could not withstand the wrecker's ball in 1986. Photograph courtesy of the Mercantile Safe Deposit and Trust Company.

math, while the more charitable sought to rehabilitate the devastated region. Railroads were now a driving force in the American economy in both the North and the South. The small lines that had originally linked the interior of the country with the port cities were being realigned and consolidated as interstate trunk lines running parallel to the coast. Walters and Newcomer were attracted to the railroads of the Carolinas. Their rolling stock destroyed and tracks laid waste, these roads represented long-term investments at best and risky ones at that. After the war, their recovery had been delayed by the corruption of local politics.[7]

An opportunity for the two Baltimoreans to become involved arose in 1867 when Robert R. Bridgers, a former Confederate congressman who headed the Wilmington and Weldon Railroad Company, turned to Bal-

timore for financing, astutely anticipating a favorable reception in a city known for its southern sympathies. His railroad, extending 161 miles, had been acclaimed the longest continuous stretch of track in the world when opened in 1840. During the war, the Wilmington and Weldon had been a vital link, "the Bread Line of the Confederacy," connecting the port of Wilmington, North Carolina, provisioned by blockade runners, to the forces in Richmond.[8] As a consequence, it had been partly dismantled by Union troops. Walters and Newcomer joined Bridgers in the purchase and resale of the railroad's bonds and were thus launched as southern railroad entrepreneurs. The trio proved remarkably adept in a field that at times seemed a veritable morass, beset with intrigues and fierce rivalries. They remained steadfast in their objectives, pooling their interests with others to hedge against personal losses and avoiding unnecessary and destructive conflicts. Withstanding substantial swings in the economy, they eventually realized their goal, the creation of a major railway system serving the southeastern coast of the United States.

Their first acquisition was the Wilmington and Manchester, a line that had fallen into receivership as a result of the vicissitudes of war. To take control of it, in 1868 they organized a syndicate known as the Southern Railway Project. In addition to Walters and Newcomer, its members included prominent Baltimore businessmen Enoch Pratt and Thomas and Joseph Jenkins, as well as some of Walters's associates from the Northern Central Railway. Among these were J. Edgar Thomson and Thomas A. Scott, two of the country's foremost railroad experts, then serving as the president and vice-president of the Pennsylvania Railroad Company. After lengthy negotiations, the North Carolina State Board of Education sold four thousand shares of Wilmington and Weldon stock to Walters and two thousand shares of the Wilmington and Manchester to the syndicate. The syndicate reorganized the latter line in 1870 as the Wilmington, Columbia and Augusta Railroad and appointed Robert Bridgers its president. To the benefit of its shareholders, the Wilmington and Weldon was now leased to the newly organized company. Other railroads soon to fall under the sway of the syndicate were the Cheraw and Darlington, a small but strategically placed road in South Carolina, and the Charlotte, Columbia and Augusta. As early as 1871, these affiliated railroads were being linked together under the designation Atlantic Coast Line.

To acquire resources for further expansion, the syndicate pooled its interests with those of the Pennsylvania Railroad, which had recently gained control of the roads operating between Baltimore and Richmond and was now planning to develop in the South. In March 1871, the

nation's earliest holding company, the Overland Contract Company, was incorporated in Pennsylvania with the stated purpose "to secure control of such Southern railroads as may be essential to the formation of through lines between New York, Philadelphia, Baltimore, Washington City, and the principal cities of the South, by ownership of the capital stock of said companies by leases, and contract relations."[9]

At the first meeting of the holding company in New York (April 1871), it was renamed the Southern Railway Security Company, and Benjamin Newcomer was elected its treasurer. Within months, the pioneer holding company had made remarkable progress, acquiring a majority of stock in eight lines operating over 1,191 miles of track in the Carolinas and Georgia and leasing additional track in Alabama and Tennessee. Despite these early successes, the routes had not turned particularly profitable when the failure of the banking house Jay Cooke and Company in New York on September 19, 1873, precipitated a catastrophic collapse in the stock market, throwing many railroad companies into receivership.[10] The Pennsylvania interests quickly disassociated themselves from the holding company, and in March 1876 Walters was authorized to liquidate its remaining assets. Personally, however, he weathered the 1873 panic. For the remainder of the decade, lean years for the railroad industry, he struggled to salvage his investments.

With the general recovery of the economy by 1880, Walters helped to organize yet another syndicate, which included many of the members of its predecessor and, in addition, Henry Bradley Plant, a Yankee financier who had moved to Florida in 1842 because of his wife's health. Those companies that had fallen into receivership, most notably the Wilmington, Columbia and Augusta, were reorganized, and agreements were reached with other, often adjoining, roads. As Plant had participated in his syndicate, Walters now joined his new colleague, together with Henry Morrison Flagler, in organizing the Plant Investment Company, which soon gained control of the lines from Charleston to Jacksonville.

Thus, by the early 1880s, three distinct systems in various stages of development served the Southeast. Those roads closest to the coast bore the insignia Atlantic Coast Line as a designation of route. Others farther inland would merge as the Seaboard Air Line, and the lines following the mountains developed into the Southern Railway Company.

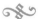

William Walters was only forty-six when he returned to Baltimore from Europe after the Civil War. Although his name was romantically linked to several women, he did not remarry, finding solace instead in his chil-

FIG. 12. Saint Mary's, Govanstown, stereoscopic view, about 1875. In the postwar era, the Walters family lived during the summer at this country estate. Courtesy of the Archives of the Peabody Institute of the Johns Hopkins University.

dren and small circle of friends. The ties to his son, Harry, always extremely close, were to develop from a paternal-filial relationship to one of companionship and friendship.

In 1866, the family's way of life was transformed by the purchase of a property, later known as Saint Mary's, on Woodbourne Avenue near Govanstown, then in Baltimore County about four miles from the city's center on the York turnpike. This area in the northern suburbs was in the process of being parceled out as "country seats" to wealthy Baltimoreans. Among Walters's neighbors were ex-Governor Bradford, A. S. Abell, W. S. G. Baker, and the popular comedian John E. Owens. For much of the year, William and the children preferred the amenities of country living, and they retained 65 Mount Vernon Place (now 5 West Mount Vernon Place) as a winter residence.[11]

Saint Mary's embraced 130 acres, stretching from Woodbourne north to Belvedere Avenue. Buildings on the property included a gatehouse, in which the tenant farmer lived; the main house, an eighteen-room, frame structure with a tower built in the Italianate style (fig. 12); a carriage house; and a hothouse. A familiar landmark for his neighbors was the

life-size, bronze mastiff mounted on a pedestal in front of the entrance. This sculpture, commissioned in Berlin by a member of the Gilmor family of collectors, had originally stood on the marble portico of Mrs. William Gilmor's house facing the Battle Monument in the heart of the city. For his pleasure and that of his children and friends, William equipped the house with a piano, billiard room, and bowling alley. In the carriage house he kept a miscellanea of vehicles — a phaeton, dayton, jump-seat jagger, park phaeton, various buggies, depot wagons, coupes, and even a sleigh. Neighbors later recalled the grounds as "a veritable garden of Eden" that abounded in flowering shrubs and trees, among them rare species of magnolias and dogwoods collected from around the world. The banks of a small lake, created by damming a stream that ran through the property, were lined with masses of daisies, violets, buttercups, and forget-me-nots.[12]

Two interests now dominated Walters's attention, horticulture and animal husbandry. The hothouse allowed him to cultivate bananas, papayas, and various varieties of grapes. Apparently, he kept one eye closed when neighborhood children sneaked in to exact their share of the fruit for which he was locally renowned. A luscious cluster of Prince Albert grapes, grown at Saint Mary's, was meticulously documented in a painting by the Maryland artist Andrew John Henry Way, known for such still-life representations. Walters's reputation was such that in 1874 he was nominated to be the founding president of the Maryland Horticultural Society, an honor that he characteristically declined, serving instead as vice-president.[13] Equally discerning in husbandry, he bred Jersey cattle and various fowl that he had ordered from France. The persevering George Lucas was kept busy as a veritable Noah, buying and shipping flocks of Crevecoeur and Houdon chickens, Rouen ducks, geese, and peafowls.

During his lengthy sojourn abroad, Walters had been duly impressed by the powerful draft horses that hauled lumbering omnibuses through the Paris streets. These, he learned, were Percherons, from the Perche region in northwestern France. Reputedly, they were the descendants of medieval chargers that had occasionally been crossbred with Arabians introduced by returning Crusaders. Appreciating their extraordinary strength, vigor, quick gait, and docile disposition, he resolved to popularize Percherons in America, where the breed had not been entirely unnoticed.[14]

At the outset, Walters sought the advice of several French experts, including Comte Emile-Félix Fleury, the head of the cavalry service, aide-de-camp to Napoleon III, and director of the state breeding estab-

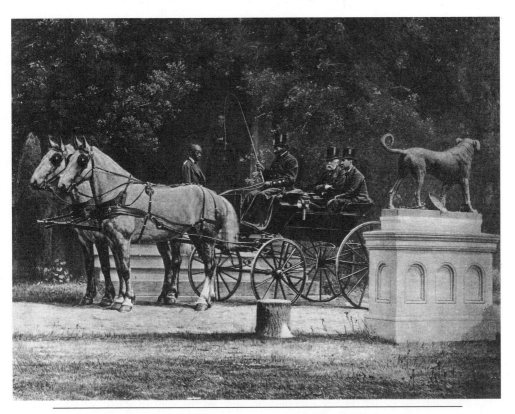

FIG. 13. *Percheron Brood-Mares Prude and Sue,* photogravure, about 1886 (WAG Archives). William and Henry Walters are seen in a carriage drawn by broodmares, sixteen hands high, that had been imported in 1878. Note the bronze mastiff on the pedestal at the right.

lishment at Pin, and Adolph Simon, the officer in charge of the stud and school of dressage at Sées. To the latter he entrusted the selection of the horses that he began to purchase as early as 1866 for his stable at Saint Mary's. An enthusiastic proselytizer, Walters subsidized the publication two years later of a treatise by Charles Du Haÿs, laboriously translated by Lucas, calling for the protection and improvement of the Percheron through selective breeding and the introduction of an official stud-book.[15] Although supporting these aims, Walters took pains to distance himself as a true breeder from those who, pursuing commercial interests, acquired the horses primarily for stud. Unlike other breeders of his time, he consistently imported more mares than stallions. Riding in a carriage drawn by these gray broodmares, Walters must have been a distinctive sight on Baltimore County drives (fig. 13). Although he

failed to win converts among his neighbors, his efforts were said to have contributed to the success of the Percheron elsewhere in the country, especially in the Midwest.

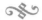

William Walters lived alone much of the time after his children went away to school. Although nominally a Protestant, he was favorably disposed toward Roman Catholicism, especially after his travels in Italy, and selected Catholic schools for both Harry, whom he enrolled in Georgetown College in the District of Columbia, and Jennie, who attended the adjoining Georgetown Academy of the Visitation.

The disciplined, highly structured curriculum provided to Harry by the Jesuits was unrivaled in the mid-Atlantic region, and the school's decidedly pro-Southern traditions undoubtedly struck a sympathetic cord. Pursuing the goal of a Jesuit education, "the training not only of the mind but of the whole man, his heart and soul," the college's students were encouraged to attend lectures at the Smithsonian Institution as well as Supreme Court sessions. Harry was enrolled in First Rudiments in 1865, and in the succeeding years progressed through various levels of humanities, rhetoric, and philosophy, receiving a thorough grounding in classical literature, as well as some training in natural philosophy (the sciences) and mathematics and a smattering of German. Fortunately, French, in which Harry excelled because of his stay in Paris, was required, and this was the subject he would later recall with warmest memories. Always a successful rather than a particularly gifted student, Harry found time to participate in extracurricular activities, like the Reading Room Association (current events), the Philistorian Society (history), the French Literary Society, and two debating clubs, the Philonomosians and the Philodemics. In his last year, he attained the rank of first lieutenant in the senior company of cadets (fig. 14).[16]

For reasons of ill health, the sixteen-year-old boy remained in Baltimore during the autumn semester of 1867, continuing his studies at nearby Loyola College. Despite an intermittent fever, he "distinguished" himself in poetry (sophomore studies) and mathematics and participated in productions of the dramatic association.[17]

July 1, 1869, the commencement day at Georgetown, must have been memorable for Harry. This was the only recorded occasion in his life when he gave a public address, which was entitled "A Plea for Manhood." The diplomas were distributed by the recently elected U.S. President Ulysses S. Grant, while the former president, Andrew Johnson, waited discreetly outside the hall. A week earlier, Harry and his fellow

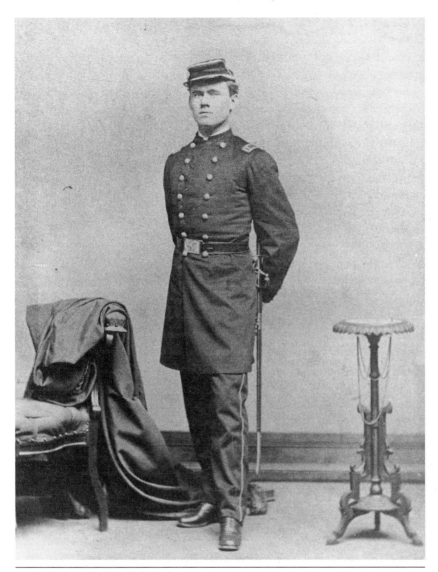

FIG. 14. Henry Walters as a cadet at Georgetown College. He was a member of the class of 1869. Photograph courtesy of a Walters family descendant.

classmates in philosophy had participated in Class Day ceremonies, which had culminated in a procession and the planting of the Class Tree. The ceremonies had concluded with a student of 1869 handing a leaf from the tree to his counterpart in the Class of 1872, thus symbolically ensuring continuity in the school's traditions.[18]

Meanwhile, Harry's sister, Jennie, proved to be a model student at the Georgetown Academy of the Visitation (now Georgetown Visitation Preparatory School). Founded in 1799 by an Irish immigrant, the academy had been restructured eighteen years later along French lines undoubtedly familiar to Jennie after her schooling in Paris. It now offered a remarkably progressive curriculum rich in mathematics and physics (termed natural philosophy). In addition to her academic subjects, Jennie pursued a varied program of courses in the domestic arts and instruction in the harp and piano. In 1870–71, her senior year, she earned the highest honors in the Senior Circle, winning "second premiums" in rhetoric and literature and commendations in the First Class of chemistry, meteorology, astronomy, geography, and botany.[19] As a token of appreciation for his daughter's comprehensive education, William Walters donated to the school a Baroque painting of Saint John the Baptist said to be in the manner of the Florentine master, Carlo Dolci. Jennie, in her choice of friends, gravitated to similarly minded young women. A family photograph shows her with her companions, including her neighbor Mary Garrett, a pioneer feminist whose support for the founding of the Johns Hopkins University School of Medicine in 1892–93 would be contingent upon its admission of women (fig. 15).

Harry Walters had left Georgetown with the classical education of a gentleman. To master a profession, he next enrolled in Lawrence Scientific School in Cambridge, Massachusetts. A leading technical institution, Lawrence had been founded at Harvard twenty-six years earlier to ensure that "industrial studies [would] get their threshold in a great university." From 1869 through 1872, Harry attended lectures in the school's Italianate building facing Kirkland Street. His arrival in Cambridge coincided with the appointment of a new president at Harvard, Charles W. Eliot. That year, the famed educator had published a revolutionary article calling for "a new education" based on pure and applied science, living European languages, and mathematics.[20] During his years at Lawrence, Harry witnessed a transformation within the school that eventually led to its consolidation with Harvard College. Little is known of Harry's academic career at Lawrence. He studied engineering except during his second year, when he was enrolled in mining and geology. He completed his courses within four years but, for reasons not recorded, he did not actually receive his Bachelor of Science degree until thirty-three years later.

One year behind Harry at Lawrence was Warren Delano III, a handsome, athletic fellow who was the son of Warren II, a pillar of Hudson Valley society and a direct descendant of Philippe de la Noye, a Huguenot who had sailed on the *Fortune* from Leyden to Plymouth colony in

FIG. 15. Jennie Walters (seated), Kate McLean, Mary Garrett, and an unidentified friend, about 1870. Photograph courtesy of a Walters family descendant.

1621 in the vain pursuit of the hand of Priscilla Mullens. With earnings derived during during his many years of trafficking in opium in the China trade, Warren Delano II bought a property overlooking Newburgh Bay and transformed a modest brick-and-stucco structure on the grounds into the forty-room villa Algonac.

Through Harry, young Warren III met Jennie Walters, who had followed her brother to Cambridge in 1872. Living in the residence of Professor James Bradstreet Greenough, a noted champion of women's education, she was attending lectures at Harvard College. A romance ensued. Although obviously a match based on love and a potential tie to one of America's most patrician families, Jennie's relationship with Warren met firm opposition from William Walters, who had intended Jennie to remain his companion in his advancing years. In what must have been one of the sorriest episodes in his life and an unfortunate reflection on a dark side to his character, he threatened to reject his daughter and imposed a two-year ban on any association or correspondence between the lovers.

With Harry's connivance, a clandestine courtship was conducted, and their engagement was announced in May 1875. The marriage took place on July 11, 1876, in the Protestant Episcopal Church of the Redeemer on Charles Street, Baltimore County. After the ceremony, the guests dispersed without a reception or an exchange of civilities. Rumors of this doleful occasion gave rise to the persistent legend of "the ever-burning lamp," which the remorseful father left burning continuously above his front entrance as a beacon for his errant daughter. Twelve days after her wedding, Jennie wrote to the Delanos at Algonac. "I never knew that life could be so bright & happy to everyone, as you all feel it is at Algonac; it is a new experience for me & one which I hope I may be able to thank God enough for: it has opened a new & a very bright world for me."[21] Warren soon resumed his post as superintendent of the Union Mining Company, a Delano family coal-mining enterprise at Mount Savage in western Maryland. The couple remained there until 1882, when Warren took a position in manufacturing in Orange, New Jersey.

William Walters apparently took solace for his loss in the companionship of Nannie, B. F. Newcomer's twenty-one-year-old daughter. The warmth of their friendship is reflected in a letter William wrote on Christmas 1875, which closed with uncharacteristic tenderness, "Fare-thee-well, always your friend." When Harry was briefly drawn to Nannie, the two fathers must have aspired to see their families united by marriage.[22] It is tempting to speculate that, when riding the train from Govans to the city in the 1870s, Harry might have encountered Sarah Green, the undoubtedly attractive girl from Warrenton, South Carolina, who, five decades later, would become his wife. Sarah was enrolled from 1873 to 1877 at nearby Notre Dame College, which shared a train stop with the Govans community.[23]

Leaving Lawrence in the spring of 1873, Harry joined his father and

sister, who were not yet estranged, in Paris. He remained abroad until September 25, one week after the brokerage house Jay Cooke and Company failed in New York. In the ensuing unpropitious economic climate, he was fortunate to find employment in 1875 in the Valley Railroad of Virginia headed by Robert Garrett, son of John Work Garrett, president of the Baltimore and Ohio Railroad and a neighbor in Mount Vernon Place. Serving in the Engineering Corps that represented the Baltimore and Ohio's southern thrust to Lexington, Virginia, he must have been away from home much of the time. Later, he transferred to the Operating Superintendent's office of the Pittsburgh and Connellsville Railroad, an integral link in the Baltimore and Ohio's western expansion. Two years later, he returned to Baltimore to join his father's firm, W. T. Walters and Company, which had been transformed from a liquor distributor to a financial house.[24]

With the unfettered capitalism of the post–Civil War era, the country fell under the sway of a plutocracy based on fortunes derived from railroading, banking, real estate, and other ventures. Art collections, reflecting this new wealth, proliferated, primarily in New York and Philadelphia, but also in Boston and Baltimore and in cities across the country like Cincinnati, Saint Louis, and San Francisco. As had been anticipated by William Walters in his dealings with S. P. Avery and George Lucas and by August Belmont, John Wolfe, and others in New York, the popularity of American art gave way to that of modern European painting, especially to the idols of the Paris Salons, whose ascendancy would remain unassailed until the Armory Show in New York over a half-century later.[25]

This development reflected the cosmopolitan aspirations of collectors who in all likelihood had traveled abroad. It was also nurtured by the European artists themselves, who provided an unstinting flow of easel paintings showing rustic landscapes and genre subjects usually far removed from the experiences of their American clients. Cabanel's unabashedly naked goddesses, Gérôme's emperors of Claudian Rome, his *Kabyles* and *Arnautes,* and Meissonier's Dutch burgomasters made their way into the picture galleries of the mansions that now lined New York's Fifth Avenue.

It has long been customary to disparage the postwar collectors as robber barons, ruthless in business and rapacious in their acquisition of art. The more enlightened members of this generation, however, were responsible for the founding of many major public collections. In Wash-

ington, William Wilson Corcoran incorporated his gallery in 1870, the same year that the first board of trustees was elected for the Metropolitan Museum of Art, and initial steps were then being taken to build the Museum of Fine Arts in Boston.

After the Civil War, Baltimore lagged culturally behind other East Coast cities. Although some arts associations had arisen, they inevitably served an overlapping clientele and had subsequently floundered.[26] The town boasted of several interesting "parlor collections," notably those of John Work Garrett and of John W. McCoy, but only that of William Walters was accorded separate treatment by Earl Shinn in his survey, *The Art Treasures of America* (1879–80). Had Shinn been writing slightly earlier, he would undoubtedly have mentioned the gallery of Colonel J. Stricker Jenkins, a coffee importer and early client of George Lucas. One of the first Americans to patronize William Bouguereau, Jenkins commissioned the large allegorical composition *Art and Literature* in 1867, and, three years later, published a catalogue of his holdings, listing more than ninety pictures, almost equally divided between American landscapes and European genre works. Ill health compelled Jenkins to auction his collection in 1876, depriving the city of the only serious rival to William Walters.[27]

With his personal and business affairs under control, William Walters could focus on his collection. He began to transform the Mount Vernon Place house from a mere residence into a private museum, eventually converting some rooms into period settings of varying degrees of authenticity. As early as 1866, Lucas had been directed to compile an ensemble of Louis XVI–style furnishings for a third-floor room, eventually known as the Marie Antoinette Bedroom.

Like so many wealthy contemporaries, Walters was now drawn to European rather than American paintings, any acquisitions of the latter henceforth being incidental. Increasingly, he relied on Lucas to ferret out works, complete the transactions, and arrange for brokerage and shipping. Lucas, in turn, faithfully corresponded with his client from Paris, keeping him abreast of developments in the market and frequently sending him photographs of potential purchases.

Lucas's diary for 1866 records visits to the dealer Adolphe Goupil to monitor progress on Charles Gleyre's reduction of his celebrated allegorical painting *Le Soir* (1843), then displayed in the Luxembourg Gallery. Purporting to record a vision experienced by the Swiss artist one evening on the banks of the Nile River, this composition, later known as *Lost Illusions,* served as a hallmark for the painter, who has been as much remembered as the teacher of the impressionists Monet, Renoir, Sisley,

and Bazille as for his own classicizing works. The replica, prepared as an *ébauche* by a pupil and then reworked by the master, was presented to Lucas for delivery to Baltimore early in 1867. In the meantime, Lucas had tracked down several bronzes by Antoine-Louis Barye and two watercolors by Paul Gavarni. The works of both artists were of abiding interest to Walters, who gave his agent carte blanche for their purchase.[28]

In March 1867, the Exposition Universelle, the largest extravaganza of its kind yet held, beckoned Walters to Paris. Stopping en route in London for several days, he was met by Lucas, and together they made the rounds of the National Gallery and the South Kensington Museum (now the Victoria and Albert Museum), as well as the studios of James Abbott McNeill Whistler and George Henry Boughton. Walters found the former's work unappealing but was much drawn to the paintings of the latter, the son of a Norwich farmer who had been raised in America and had returned to England to establish a reputation recreating scenes from America's colonial past.[29]

Continuing to Paris, they arrived in time for Walters to register at the Hôtel d'Orient, his usual *pied-à-terre* on the Right Bank, before rushing to Vincennes to attend the races. The next day, April 1, at the Champ de Mars, they witnessed the emperor's inauguration of the exposition, which was intended to glorify the Second Empire's achievements in industry and the arts. Ominously, its prize day coincided with the arrival in Paris of word of the execution of Maximilian of Mexico, a tragedy that portended the eventual collapse of the Bonaparte dynasty.

For the next two and a half months, the two men scurried about in pursuit of Percheron horses as often as of art. Frequently, they were joined by Samuel Avery, then in France as American commissioner of fine arts at the exposition. Some evenings were spent at such celebrated establishments as Phillippe's, then run by Pascal, the former chef of the renowned Jockey Club. After indulging himself for six weeks, Walters was confined to his hotel room by an attack of gout. For the remainder of his life, he was to become increasingly debilitated by this disease and arthritis.

Before sailing for home, the collector took a quick jaunt to London for the national fete, Derby Day. Although captivated by the beauty of the English thoroughbreds, he was dismayed by the swarms of people streaming from the city to Epsom Downs, traveling by every form of conveyance imaginable: four-in-hands, private carriages, omnibuses, donkey carts, coal wagons, and gigs. Many, especially the wretchedly clad children from the slums, went on foot. As his fellow travelers stopped by the wayside to unpack their hampers and jugs, he observed the food for

the upper classes being laid out by liveried and white-gloved attendants. Walters concluded that "the Englishman regards it as the great cheif [*sic*] purpose of his life — his ambition — his destiny on earth, *to eat and drink.* "[30] Such sentiments would appear to reflect his lack of affinity with the English and their institutions, a bias also manifested in his collection.

A highlight for many visitors to the Exposition Universelle in 1867, including Walters, was the presence of the Japanese empire, which officially participated for the first time. In the gardens of the Trocadéro, a Japanese farm had been recreated and in the Galerie des Machines on the Champ de Mars, there was a rest pavilion for a daimyō. Altogether, several thousand artifacts, including models of houses and paintings by the ukiyo-e artists Kunisada and Kuniyoshi, were displayed. Four months after his return to Baltimore, Walters requested that Lucas acquire (for 450 francs) a Japanese ivory carving from the exposition, which he did on October 31, 1867. This piece, yet to be identified, may have represented the beginning of Walters's collection of Asian art.

On July 9, 1870, Count Benedetti, the French ambassador to Berlin, delivered to King Wilhelm I at Ems the fateful ultimatum that precipitated war. Less than eleven weeks later, the strains of "Partant pour la Syrie," the Bonapartist anthem, faded for the last time at Sedan on the eastern frontier. George Lucas remained in France throughout the Franco-Prussian War, inconvenienced though unscathed during the siege of Paris and escaping the horrors of the ensuing Commune and its eventual suppression.

The continuing political turmoil in France jolted the art market. Among the works that became available was a well-known reduction of Paul Delaroche's celebrated mural *The Hemicycle* in the Salle des Prix of the École des Beaux-Arts in Paris.[31] Lucas purchased the painting for Walters in October 1871. The original composition, executed between 1836 and 1841, was the quintessential expression of the academic traditions fostered by the institution. Seated on a raised dais are the "Immortals of Antiquity," Ictinus, Apelles, and Phidias (see plate 3). They are flanked by personifications of Greek, Gothic, Roman, and Renaissance art. The figures appear inscrutable, with the exception of the rather voluptuous "Renaissance Art" who, overcome by her circumstances, stares, mouth agape, at the seated trinity. Arranged in appropriate groupings on either side are the most eminent artists from the thirteenth through the seventeenth centuries. Italians predominate, followed by French and several Spanish and German masters, along with a lone Englishman, the

architect Inigo Jones. On the left, Antonello da Messina, Jan van Eyck, Gerard Terborch, Rembrandt, and Bartholemy van der Helst listen attentively to the discoursing Titian; on the right, Leonardo da Vinci, the High Renaissance's principal theoretician, addresses Domenichino, Fra Bartolommeo, and Giulio Romano. All of the figures, however, given the eternal nature of the occasion, remain appropriately impassive.

Delaroche drew upon self-portraits as well as illustrations in Giorgio Vasari's *Lives of the Most Eminent Painters, Sculptors, and Architects* (1550), and when no images existed, as was true for Robert de Luzarches, master architect of Amiens cathedral, the figure was still included, although with his back to the viewer. Linking this distinguished ensemble to the modern age, the partially draped Genius of Fame leans forward from the picture plane to distribute laurel wreaths to the successful students of the École seated below in the amphitheater. The vast mural was enthusiastically received and became a principal attraction for tourists. None other than Charles Dickens pronounced it to be "the greatest work of art in the world," a view shared by Alexandre Dumas, who described it as "le plus beau morceau de peinture moderne" in the *Paris Guide* of 1867.[32]

Dated 1853 by the artist, the Walters replica is thought to have been executed in conjunction with L. P. Henriquel-Dupont's transcription of the composition to a masterly engraving, which brought the engraver the medal of honor at the Paris Salon that year, thereby even further enhancing the mural's fame. The pioneering English photographer, Robert Jefferson Bingham, photographed the replica for his much acclaimed albumen print, which he exhibited in the Paris Salon in 1859. Whether William Walters recalled seeing the replica at the outset of his collecting career in the late 1850s, when it served as a mainstay for Ernest Gambart's touring exhibitions of French and British artists in London and New York, can only be surmised. In finally obtaining the reduction of *The Hemicycle,* the significance of which would have been readily apparent to all visitors, Walters had clearly given his collection a note of serious purpose.

Lucas's purchase in February 1872 of Barye's bronze, *The Tiger Hunt,* marked the beginning of an obsession for both William and later Harry Walters: the reassembly of the principal groups from the duc d'Orléans's celebrated *surtout de table,* or table centerpiece. The original project, which had never been fully realized, entailed a host of artisans headed by the designer Aimé Chenavard. The composition embraced five large hunt groups and four smaller pairs of animals locked in combat, which were to be incorporated into an elaborate jeweled architectural and vegetal setting. Between 1834 and 1838, Barye worked on models for the

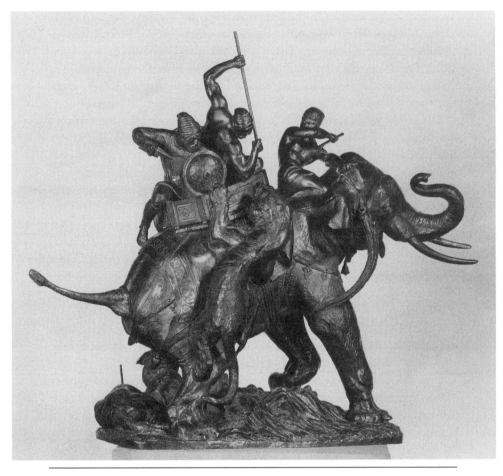

FIG. 16. Antoine-Louis Barye, *The Tiger Hunt,* bronze (WAG 27.176),
1834–37. The purchase of this sculpture marked the beginning of William's
and Henry's quest to reunite the principal groups from the duc d'Orléans's
surtout de table, delivered to Versailles in 1839.

hunts representing different locales and eras. In *The Tiger Hunt,* Indians
riding on an elephant are attacked by tigers (fig. 16); *The Wild Bull Hunt*
is set in sixteenth-century Spain; *The Lion Hunt* depicts an Arab scene;
The Elk Hunt involves Tartar warriors; and *The Bear Hunt* takes place in
sixteenth-century Germany.[33]

The bronzes were cast by Honoré Gonon and his sons employing the
lost-wax technique, a traditional process which they are credited with re-
viving in the nineteenth century, and were delivered to the Tuileries pal-
ace on April 20, 1839. It seems likely that the unfortunate duc d'Orléans

used them only once, at a costume ball held in the Louvre in the winter of 1842, the year of his death. At the duchesse d'Orléans sale held in Paris in 1853, three of the bronze hunts were acquired by Prince Anatole Demidoff, the renowned collector once married to Jérôme Bonaparte's daughter, Princess Mathilde. After the liquidation of the prince's estate at the San Donato sale in 1870, the pieces were scattered, and it was from the distinguished art critic, Philippe Burty, that Lucas ultimately bought *The Tiger Hunt*.[34]

For William Walters, 1873 was a hectic year. In March, he gave Benjamin Newcomer power of attorney and departed with his daughter Jennie for an extended stay in Europe, which took them from Paris to Vienna. His longtime friend William Rinehart joined them in Paris for what was to be their last meeting. Together with George Lucas, they visited the museums and dealers. In April, William and Jennie set out for Germany, stopping briefly in Cologne, Düsseldorf, Berlin, and Potsdam. Only in Dresden did they linger for several days, taking the opportunity to see the Japanese Palace, an early-eighteenth-century building then used to house Augustus II's renowned collection of more than ninety thousand European and Far Eastern ceramics.

Walters was traveling that year in the official capacity of U.S. commissioner to the Vienna International Exhibition. Given its exceptional site in Prater Park and its many splendid buildings, including the enormous Palace of Industry, with a 2,953-foot nave, the exhibition promised to surpass its predecessors in both scale and magnificence. Unfortunately, the collapse of the Vienna Stock Exchange several days after the opening jolted European financial markets, and the subsequent skulduggery of local hoteliers and restaurateurs, who raised their prices, brought about the financial failure of the venture. Even the American participation was tainted. The chief commissioner, General Thomas B. Van Buren, was implicated in the selling of commissionerships, charges that resulted in the hasty appointment of a second American delegation. Walters, in an honorary position, was not affected, although he did not tarry long in Vienna, arriving on May 7 and departing only six days later.

Because of Vienna's geographical location, the exhibition provided an unprecedented opportunity for East and West to intermingle. As usual, Japan was well represented by several monumental works, including two large gilded and silvered fish from the castle of Owari, cast in bronze in 1596; a papier-mâché replica of the head of the great Buddha of Kamakura; and a five-story model of the pagoda of Tenno-ji from Osaka.

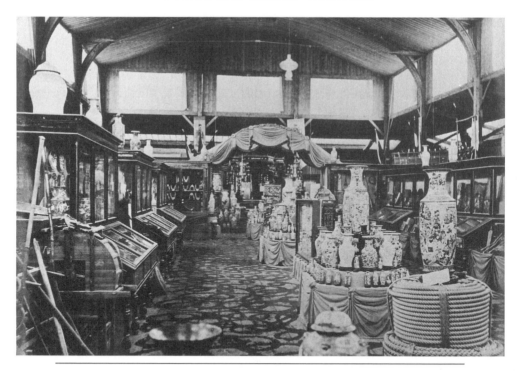

FIG. 17. The Chinese Department at the Vienna International Exhibition, 1873 (WAG Archives).

Outside the main building was the now customary Japanese village and garden.

The official participation of the Chinese Empire, which for the first time broke from its traditional xenophobia, was a novelty at Vienna (fig. 17). Curious onlookers flocked to the Chinese Court to observe such oddities as a bedstead with inwardly curving sides, suggesting, as one critic mused, that "Johnnie reposes with arms and legs out stretched." The large display of porcelains was compared somewhat unfavorably to that of the Japanese because the colors were "more opaque," the lines of drawing were "harder," and the "minuteness of decoration" was lacking. Walters, however, did not comment on these ceramics but was drawn instead to earlier porcelains from the Ming period exhibited by Prince Ehtezadesaltanet, the uncle of the Shah of Persia, several of which, set in metal mounts, Walters acquired.[35]

At the end of May 1873, father and daughter returned to Paris, where they were joined by Harry, fresh from Lawrence Scientific School (fig. 18). The family remained in France for the next five months, except for

two brief forays to London and for excursions to Belgium, Switzerland, and Italy.

In addition to serving as a commissioner to the Vienna exhibition, Walters was traveling in Europe in yet another capacity, as chairman of the Committee on Works of Art for the Corcoran Gallery of Art in Washington, D.C. Four years earlier, William Wilson Corcoran had deeded to the public his picture gallery, designed by James Renwick, together with much of his collection, acquired over the three preceding decades, and had designated Walters as one of the nine trustees. With the gallery scheduled to open early in 1874, Walters was chosen to head a committee responsible for enriching the collection, a position he held until 1877. He was assisted by his friends George Lucas and Samuel Avery. Cor-

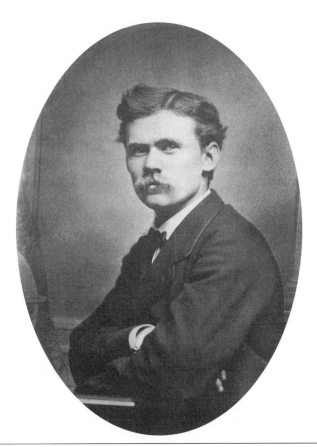

FIG. 18. Henry Walters, about 1873. Courtesy of a Walters family descendant.

coran continued to participate unofficially in the gallery's affairs until his death in 1888. Though bearing in mind the founder's views, Walters pursued his assignment with considerable latitude.[36]

From the outset, the Corcoran Gallery assumed an educational role. For any institution with pedagogical aspirations at this time, a collection of plaster casts of antique statuary was a requisite. Fortunately, a "convention" signed in 1867 by princes of the reigning houses of Europe promoted the production and international exchange of art replicas. Walters undertook two visits to London in 1873 to purchase casts of the British Museum's coveted treasures, the Elgin marbles from the Parthenon. Meanwhile, Lucas entered into negotiations with the Louvre's *directeur de moulage* for casts of such familiar monuments as the *Venus de Milo, Silenus and the Infant Bacchus,* and the *Boy with a Goose.* Altogether, forty-five replicas of antique statuary were in place for the Corcoran's 1874 opening. The Hall of Sculpture, however, was dominated by a chronological anomaly, the monumental plasters of Ghiberti's west doors of the baptistery of San Giovanni in Florence.[37]

Not anticipating the eventual availability of important original works, Walters adopted the same approach to *objets d'art,* purchasing superior facsimiles rather than actual artifacts for the Corcoran. From Christofle et Compagnie, the French silver firm, he selected electrotype reproductions of the hoard of Roman silver uncovered by soldiers at Hildesheim five years earlier, and from the firm of Lionnet in Paris he bought "galvanoplasties" of medieval and Renaissance armor and weaponry.[38]

In contemporary decorative art, his purchases included French porcelains and faience. The Corcoran's curator, William MacLeod, contrasted the "elegance" of the modern Sèvres porcelains with the "semi-barbarous" style of Moorish pottery exemplified in the Corcoran not by an original work but by a glazed earthenware adaptation made by "Decker" (actually Théodore Deck, the avant-garde Parisian ceramist).[39]

The initial Corcoran donation had included several notable European paintings, among them Anton Raphael Mengs's *Adoration of the Shepherds,* formerly in Joseph Bonaparte's Bordentown, New Jersey, collection. Otherwise, it was devoted to contemporary American works by artists such as Thomas Doughty, Jasper F. Cropsey, Frederic E. Church, and Emanuel Leutze, among others. As a foil to these holdings, Walters sought noteworthy pictures by European counterparts. An important consideration was size; a champion of small-scale pictures, Walters was now confronted with the challenge posed by the Corcoran's thirty-eight-foot-high Main Picture Gallery. In the Vienna exhibition, he found two works, a smallish view of two hunting dogs lost in a wintry landscape by

the Viennese artist Otto von Thoren, which had "elicited great praise," and a pseudoclassical subject, Night personified by a goddess on the back of an owl, by Alfred Alboy-Rebouet. A much more innovative purchase was Jean-Léon Gérôme's startlingly original *Dead Caesar,* a canvas almost ten and a half feet wide, dominated by the foreshortened body of the fallen ruler stretched across the pavement, with only a toppled chair serving to denote the drama that had recently transpired. Other large-scale, histrionic compositions that must have helped fill wall space were *The Drought in Egypt* by Delaroche's Belgian pupil, Jean Portaels, which had recently received a gold medal at the Crystal Palace exhibition in Sydenham; a lachrymose *Count Eberhard of Wirtemberg,* set in fifteenth-century Germany and painted by Ary Scheffer in his later, sentimental style; and *The Death of Moses,* a colossal "machine" measuring nine feet four inches by thirteen feet, painted by the influential professor of the École des Beaux-Arts, Alexandre Cabanel.[40]

After Walters returned to America, Lucas continued to stalk worthy purchases at the Paris Salons. In 1874, he bought Hector Leroux's medal-winning *The Vestal Tuccia* and Gaston Casimir Saint-Pierre's titillating nude *Nedjma-Odalisque.* It was Avery, however, who found C. L. Muller's painting of the heroine of the French Revolution, Charlotte Corday, languishing at her cell window.[41]

In the summer of 1873, Walters placed an order with the *animalier* Barye for a cast of each of his subjects. As the Baltimore financier later recalled, "To have been able to give this commission was one of the most agreeable acts of my life."[42] The sculptor, in turn, was moved to respond, "Ah, Monsieur Walters! My own country has never done anything like that for me."[43] Ticking off the listings in a copy of Barye's catalogue of his works as they proceeded, Walters and Lucas selected over 120 subjects, mostly small-scale works, although there were also several larger pieces, including *Theseus Fighting the Centaur Biénor* and *Jaguar Devouring a Hare.* The resulting display of so many pieces in the Washington gallery undoubtedly contributed to the popularity of Barye's sculpture in this country, and it has remained the most enduring testimony of the years of Walters's chairmanship.[44]

Another sculptor whom Walters served well was William H. Rinehart. In 1874, a week before he died, Rinehart dictated a letter to his Baltimore patron, expressing regret that he had not been able to complete "his best work" for the Corcoran. He named his "two personal friends" Walters and Newcomer as trustees, directing them to close the studio in Rome and manage his residual estate. The latter was to be used to promote "a more highly cultivated taste for art" among Marylanders and to

assist "young men" desirous of becoming sculptors. Walters saw to it that his late friend was well represented at the Corcoran, complementing the marble *Penseroso,* already owned by the gallery, with a plaster cast of the nymph *Clytie* and a marble of *Endymion,* the young shepherd doomed to eternal sleep. He also commissioned a bronze cast of the latter and placed it on the sculptor's grave in Greenmount Cemetery in Baltimore.[45]

For four years, Walters diligently undertook the responsibilities of the chairmanship of the Corcoran's Committee on Works of Art, instigating purchases in both the European and the American art markets. Though Frederic E. Church's reputation was already being eclipsed by those of younger artists, the Corcoran, at the John Taylor Johnston sale in 1876, presciently paid $12,500 for the *Niagara Falls* of 1856–57, the first of the "Great Pictures" with which the artist established his international reputation.[46] At the same sale was bought the colossal marble *The Dying Napoleon,* a replica commissioned by Johnston of Vicenzo Vela's statue, which had aroused the fervor of the Bonapartists when shown in 1867 at the Exposition Universelle. Other later additions included Édouard Detaille's *Le regiment qui passe,* which struck a contemporary note in the collection, showing French troops trudging along the boulevard Saint Martin on a dull, wintry evening, and two works by George Boughton, the Anglo-American artist. When Boughton's painting *The Edict of William the Testy,* showing an incident in Washington Irving's *Knickerbocker's History of New York,* arrived at the Baltimore Customs House, Walters was scarcely able to control his enthusiasm and rushed downtown to supervise its unpacking.[47] Surprisingly, though he was buying both for himself and for the Corcoran, conflicts of interest seldom arose. Only once, after the Robert M. Olyphant sale in New York, did William Corcoran complain, seemingly without grounds, that McCoy had better represented Walters than Walters had the Corcoran at the sale.[48]

The growth of the Corcoran's collections was not Walters's only concern. He immersed himself in many of the more mundane aspects of the gallery's operations. To the curator, MacLeod, already harried by William Corcoran, he made known his opinions on such matters as the hanging of pictures and the choice of wall colors. He recommended French gray for the Sculpture Rooms and maroon for the skylit Octagon Room, in which Hiram Powers's *The Greek Slave* was featured. Even labels identifying the art caught his attention. Ever practical, Walters opposed their use lest they detract from the sales of catalogues. Sometimes, he interceded with MacLeod on behalf of acquaintances. When the widow of his pre–Civil War friend, the artist Charles Loring Elliott,

fell on hard times and wished to sell some of her husband's portraits, he introduced her to the curator. Once, he arranged for a class of school-children from Baltimore to visit the gallery, assuming the costs of their transportation and lunches.[49]

The course that the Corcoran would follow over the next two decades was already set by the time Walters resigned from his duties in 1877. Although his contemporaries might have quibbled over individual selec-tions, they would not have faulted him and his colleagues for their em-phasis on large, historical works by fashionable European artists. These must have been the envy of many private collectors at that time. Similar salon paintings were then being garnered by the Metropolitan Museum of Art in New York and by the Museum of Fine Arts in Boston.[50] How-ever, as a harbinger of future tastes, the trustees of the former had au-thorized William Blodgett to assemble a collection of northern Old Mas-ter paintings on its behalf. The decision of Walters and the initial trustees of the Corcoran Gallery to concentrate on contemporary art and on facsimiles of historical artifacts would define the institution's future role as one of the art museums in the capital city.

For Walters, the opportunity to represent the Corcoran enabled him to remain a significant participant in the international art market at a time when he, like most individual collectors, was financially strapped by the severe economic recession. In addition, the experience would no doubt prove beneficial when he began to expand his own collection into an art gallery.

Presumably, it was due to his experience in Washington that Walters was invited in 1876 to serve as chairman of the fledgling Gallery of Art Committee at the Peabody Institute in Baltimore. The collection had been initiated three years earlier with John W. McCoy's donation of Rinehart's masterpiece *Clytie*. A collection of plaster casts, remarkably similar to that at the Corcoran Gallery, was assembled with the help of George Lucas in Paris and was funded by John Work Garrett. Since monies were otherwise not forthcoming, the Peabody committee seems to have been virtually moribund during the 1870s and 1880s. Walters's most significant personal contribution was to arrange for the transfer to the institute of the casts remaining in Rinehart's studio in Rome.[51]

Despite the recession of the 1870s, William Walters continued the pro-cess of converting his townhouse into a private museum. Behind the modest brick facade, dramatic changes were occurring. In the double parlors on the first floor, what presumably had been a typical Baltimore

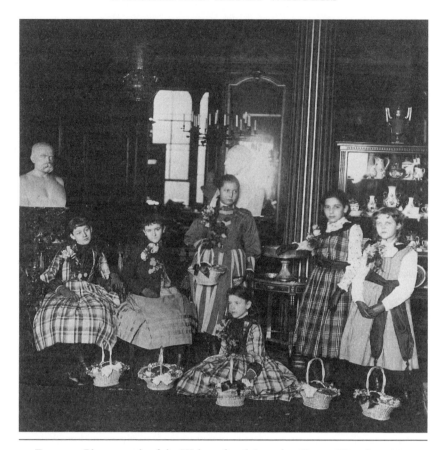

FIG. 19. Photograph of the Walters family's parlor, Easter Monday 1889.
Following his return from France after the Civil War, W. T. Walters redecorated
his house in a combination of the Pompeian and Louis XVI styles. The young
visitors are, from *left* to *right*, Jessie Hunter, Marie Albert, Sophie Easter,
Minnie Whitman, Nellye Lazarus, and Sophie Pitt. On the *left* is W. H.
Rinehart's *Bust of W. T. Walters* (WAG 28.9), and in the *center* is his bust of
S. Teackle Wallis (presented to the Peabody Institute, 1894). A mosque lamp
by Joseph Brocard hangs from the ceiling, and the vitrine contains Vincennes
and Sèvres porcelains (WAG Archives).

interior with white marble mantles gave way to the sumptuous, somber
decor associated with France of the Second Empire. Prince Napoleon's
Maison Pompéienne on the avenue Montaigne, which Walters first vis-
ited in 1862, may have come to mind in choosing the color scheme.[52]
The woodwork, including the columns separating the rooms, was ebon-
ized and gilded, and the walls were covered with a rich, reddish brown,
flocked paper. Dominating the two rooms were a pair of grandiose

chimney pieces in ebony and ormolu ordered from the Parisian foundry Barbedienne et Compagnie. These and other furnishings, including the etched-glass door panels and the stenciled ceiling decoration, echoed a medley of classicizing styles then in vogue: the néo-Grec, French Renaissance, and Louis XIV and XVI. Adding to this appearance of unbridled eclecticism were the replica of an enameled mosque lamp suspended from the ceiling and the array of Asian and European *objets d'art* displayed in vitrines (fig. 19).[53]

Upstairs, on the third floor, the Marie Antoinette Bedroom was hung with wall coverings of flowered blue satin and heavy blue curtains stamped in silver with fleurs-de-lis. An Aubusson carpet woven with the monogram *WTW* covered the floor. The furniture, all replicas, reflected the Louis XVI and Empire styles. In the Dutch Bedroom, off the landing between the second and third floors, the furnishings included a Dutch weight clock, turkey carpets, Delft sconces, Dutch pewter plates, an oak kas, and a four-poster bed decorated in marquetry and surmounted by a canopy (fig. 20).

Although many of the furnishings were undoubtedly imported, Walters also relied on local suppliers. One of the oldest businesses in Baltimore, Henry W. Jenkins and Sons, operated both as cabinetmakers and as undertakers from 1798 until 1904, when the former enterprise was discontinued. During the 1870s and 1880s, the firm provided Walters with bookcases, cabinets, and pedestals made expressly for him, as well as with imported English furniture. Jenkins also was the source for fabric hangings, including a plissé silk ceiling for Jennie's bedroom. Charles J. Knipp, who began as a cabinetmaker in 1868 but branched into interior decoration and custom woodwork, may also have assisted in furnishing the Mount Vernon Place residence.[54]

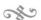

Even with the fluctuations in the economy, the art market continued to expand, a growth that was reflected in New York auction prices. Sales were conducted in rented halls, often under the direction of Samuel P. Avery, the most widely respected art expert in the city. However, in the early 1880s, Thomas E. Kirby established his suzerainty by acquiring control of the American Art Gallery, an antecedent to Sotheby's, which was located in posh quarters on fashionable Madison Square. With his flair for showmanship, the impresario soon transformed auctions into significant social events.[55]

In November 1872, Walters attended the August Belmont sale, one of the most important art auctions held in the city since the war. Belmont

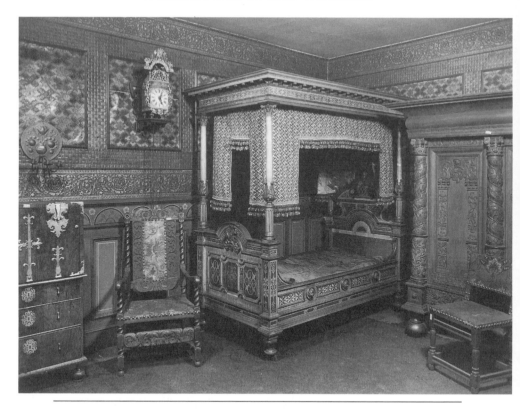

FIG. 20. The Dutch Bedroom, about 1934 (WAG Archives), with
seventeenth-century revival-style furniture.

had settled in New York in 1837 as the representative of the Rothschild
banking interests and had consolidated his position within society by
marrying a daughter of Commodore Perry. He was to leave his mark in
pursuits including Democratic Party politics, thoroughbred racing, and
art collecting. While abroad, serving as a U.S. commissioner to The
Hague in the mid-1850s, Belmont assembled a collection of paintings
by continental artists that was unprecedented in this country. Political
rather than financial reverses motivated his decision to liquidate a por-
tion of the collection and to embark on an extended European sojourn.
At the sale, Walters purchased what had been singled out by the *New
York Times* as "a great picture," Jean-Léon Gérôme's *Diogenes,* showing
the philosopher crouching in his much mended earthenware urn sur-
rounded by his dogs.[56]

Another early collection of European art to come onto the market was
that of William T. Blodgett, a varnish manufacturer who had helped to

found the Metropolitan Museum of Art. The success of Blodgett's estate sale in early 1876 was blunted by his executors' decision to withhold key works from the auction for private disposal. It seems likely that William Walters obtained *The Bear Hunt,* the second and perhaps the most dynamic of Barye's five hunt groups, as a result of this contrivance.[57]

Even more consequential was the John Taylor Johnston sale conducted by Avery in Chickering Hall in December 1876. Johnston, the president of the Central Railroad of New Jersey and principal benefactor of the Metropolitan Museum of Art, had assembled within his marble mansion on Fifth Avenue a gallery of American and European pictures deemed second to none. When his railroad seemed doomed to collapse as a result of the prolonged recession, Johnston, an individual of the utmost probity, decided to sacrifice his art collection in order to pay creditors and safeguard his employees. The sale of 327 lots brought $327,792, reaffirming the solidity of the art market. The failure of a few pictures to realize expected returns, most notably Thomas Cole's grandiloquent series *The Voyage of Life* (which brought only $3,100), undoubtedly reflected changes in taste. The highest price, $12,500, was paid by the Corcoran Gallery for Church's *Niagara Falls.* The owner of the *New York Herald,* James Gordon Bennett, gave $11,500 for a meticulously detailed genre painting by J.-L.-E. Meissonier. A major purchaser, John Work Garrett, returned to Baltimore ironically with Church's *Twilight in the Wilderness* (now in the Cleveland Museum of Art), the "fire worksey" sunset view that had once adorned the Walters's parlor.[58]

William Walters attended the Johnston sale in a dual capacity, representing the Corcoran Gallery and acting in his own interest. In the latter role, he bid successfully for six pictures, paying $10,110 in all. The dearest was *Brigands Surprised by Papal Troops* by King Louis Philippe's battle painter, Horace Vernet.[59]

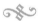

By 1876, Walters's interests had become equally focused on the art of Europe and that of the Far East. In that year, Okubo Toshimichi, Japan's minister of the interior, and his commissioners made a concerted effort to export their country's products at the Centennial International Exhibition.[60] Fifty freight cars were required to transport the supplies from San Francisco to Philadelphia's Fairmont Park. The Japanese presence immediately became apparent to visitors entering the exhibition grounds through the main entrance; a bazaar and teahouse in which kimono-clad attendants dispensed various curios stood next to the Public Comfort Building near the Main Building. Overlooking the grounds

on George's Hill, near the West Gate, was one of the most unusual buildings in the exhibition, a two-story "dwelling" erected by Japanese workmen using materials imported from their homeland. The bulk of Japan's products — lacquers, ceramics, bronzes, painted screens, silks, and other goods — however, were shown in a large section of the Main Building. Some artifacts of historical significance were interspersed among the modern productions, and most of the objects were intended to appeal to Western tastes. Possible anomalies included examples of "heavy" furniture which, rather than representing a concession to Western customs, reflected a preference for foreign furnishings emerging among some Japanese. As part of their proselytizing efforts, the commissioners published a catalogue providing excellent accounts of the history and technology of the various arts and manufactories.[61]

Immediately to the west of the Japanese exhibit in the Main Building, occupying about one-third as much space but easily recognizable by the flaring roofs on the gates and cases, was the Chinese exhibit. In addition to porcelains and textiles, the highlights of the Chinese display included a brightly painted pagoda, or joss house, and three enormous bedsteads elaborately carved with intertwined dragons and inlaid with ivory. Unlike the Japanese attendants attired in Western dress, much to their apparent discomfort, the Chinese wore their national dress. The appearance of the "almond-eyed, pig-tailed celestials" in their native costumes gave to the visitors the impression that they had "suddenly landed in some large Chinese bazaar."[62]

Both Japan and China were still largely dependent on manual labor, with the result that their goods made a pleasing contrast to the machine-made products being touted by the industrialized nations of the West. As at Vienna three years earlier, the Japanese entries elicited the more favorable reviews. One critic extolled their porcelains as surpassing in "beauty of forms and ornamentation the combined exhibit of every other nation in the building." Another cited the "vigor," "creative imagination" and "riotous humor" of the Japanese productions, whereas, with the Chinese, it was the "extreme patience and conscientiousness" of the artisans that drew his attention.[63]

The centennial exhibition set off a wave of Japanomania that would eventually affect many American households. Often it was merely a matter of introducing an Oriental curio into a room, but occasionally entire interiors were transformed. The most well-known examples of the latter were the Japanese Room designed by the Herter Brothers for William H. Vanderbilt's Fifth Avenue mansion between 1879 and 1882 and a similar interior, dating from 1881–84, by Manly N. Cutter in the Henry G.

Marquand house on Madison Avenue. The exhibition and the subsequent liquidation of the Centennial displays would flood the market with wares, which were sometimes of questionable quality.[64]

A few far-sighted institutions and collectors recognized the Philadelphia exhibition as an opportunity to initiate or augment their holdings of Japanese art at a reasonable cost. Abroad, the South Kensington Museum acquired a representative series of older Japanese ceramics, and Edinburgh's Museum of Science and Art took comparable steps. In this country, the precursor to the Philadelphia Museum of Art, the Pennsylvania Museum and School of Industrial Art, bought a selection of carved ivories from the Chinese exhibit and many more from the Japanese exhibit. Among individual collectors, the most cited was Henry O. Havemeyer, the future pioneer patron of the impressionists, who acquired some Japanese brocades, lacquer boxes, and sword-guards during a visit to Philadelphia with the painter Samuel Coleman.[65]

William Walters's long-standing interest in Far Eastern art and his familiarity with European collections in the field were to stand him in good stead in 1876. Fortunately, Harry, now in his late twenties and increasingly a full partner in many of his father's ventures, shared his enthusiasm for Chinese and Japanese art. The buying spree at the Centennial International Exhibition, though unprecedented in the senior Walters's career, was to become a frequent practice for the son. That summer, brimming with excitement at what he had seen in Philadelphia, William wrote to MacLeod at the Corcoran announcing that he had spent ten thousand dollars buying bronzes, chiefly from Japan. Harry tallied the purchases in a notebook, listing them by vendor rather than medium. Over two-thirds were Japanese and were mainly from two sources: Minoda Chōjiro, an exhibitor from Tokyo, and Wakai Kanesaburō, who was listed as an "attaché" to the exhibition and served as vice-president of the Kiriu Kōshō Company, a firm very influential in promoting Japanese culture in France.[66]

A veteran visitor to international exhibitions, William Walters must have been deeply influenced by his previous experiences in London, Paris, and Vienna. Lacquers, in addition to the bronzes mentioned to MacLeod, seemed to have captured his attention in 1876. Their appeal may have rested on the relative unsusceptibility of lacquer, inherently a conservative medium, to Western influences.

Harry's notebook abounds with references to "lac" boxes of all shapes and sizes, cabinets, trays, and bowls. Some he took for glove boxes; others, identified as medicine boxes, were actually *inrō,* the little cases for seals and medicines worn suspended by a silk cord from the waists of

Japanese men. Some of the works were modern, but as a result of the recent social upheavals in Japan, many examples of some age were also included. These, though dating mostly from earlier in the nineteenth century or from the eighteenth century, Harry recorded as being 100, 150, or 250 years old. By cross-referencing his entries, sometimes illustrated with cursory pictograms, with paper labels still attached to some pieces, it has become possible to identify some of the 1876 purchases. An early-nineteenth-century *kōgō* (a small box used for storing incense), showing deer and maple trees in gold and black on its fan-shaped lid, is listed under the Minoda Chōjiro section as number 531, "Lac box very old 250 years, $50.00," whereas another small box, a *kō-bako* in the form of two overlapping shells in gold lacquer with touches of color, coincides most closely with Harry's notation: "1215 Lac Box 2 shells 50 yrs $45.00. Been broken and mended. called sun and moon shell. they always found together one red one white."[67]

In his notebook, Harry also recorded purchases of metalwork in bronze, silver, and iron. Some items he specified as being worked with gold and silver alloys, which he identified, respectively, as *shakudō* and *shibuichi*. Listed were bowls, vases, teapots, bells, several figures of turtles, a pagoda, a few swords, small knife handles (*kozuka*), and a sword-guard (*tsuba*). Fifty dollars was paid for what was purported to be a two-thousand-year-old mirror taken from a tomb (already an illegal practice, as Harry noted). One of the more intriguing objects, a silver cup with enamels in gold cloisons, signed by the artist Gen-ō, has recently been identified in a photograph of the Japanese display in 1876 (see plate 4).[68]

A preponderance of the ceramics fell into the category of the so-called Satsuma wares. This yellow-tinged stoneware, gilded and enameled in red, green, blue, purple, and black in finely detailed designs, had become extremely popular in Paris in 1867 and Vienna in 1873. Though originally produced in Satsuma province (modern-day Kagoshima Prefecture), much of it, by 1876, was being made or decorated in Kyoto, Yokohama, and Tokyo for export. Next in frequency in Harry's list were the "Hizen" pieces. He was undoubtedly referring to porcelains mass-produced in Arita, Hizen province, with traditional Imari, Kakiemon, and Nabeshima decoration. Also appearing in the notebook were references to ivories, works in wood and bamboo, and a very few pictures. Japanese painting, whether on scrolls or screens, was an art yet to be appreciated in the West.

In the Chinese section, William Walters indulged his taste for porcelain. Dealing with four vendors, of whom only one, Hu Kwang Yung of Shanghai, was listed in the official catalogue, he bought about ninety

pieces, mostly decorative vases, for a total of $4,352.[69] Some were celadon-glazed; others were distinguished by their "crackle" glazes, which particularly intrigued Walters. The majority, however, were glazed with various shades of red, blue, green, or yellow. These monochrome wares must have starkly contrasted with the other porcelains in the Chinese exhibit, as well as with the blue-and-white and the polychrome export wares that had begun to inundate the United States almost a century earlier.

Purchases of Egyptian, Tunisian, and Russian artifacts also appeared in Harry's notebook of 1876. Of these, the most interesting were the hard-stone vases and cups bought from Hoessrich and Woerffel, a Saint Petersburg firm, which later provided carved animals for both Fabergé and its Parisian rival Cartier.

After 1876, William and Harry, continuing to share their enthusiasm for Asian art, turned increasingly to Paris. Since midcentury, Japanese and Chinese artifacts had been trickling into France through such establishments as *À la Porte Chinoise,* a teahouse on the rue Vivienne, and E. Desoye's *boutique de curiosités* on the rue de Rivoli. As early as 1868, a coterie of French amateurs linked by a common interest in Japanese culture assembled each month as the Jing-Lar Society in the home of Marc-Louis Solon, the director of the Sèvres Manufactory. Although most of these enthusiasts of Japanese culture derived their knowledge of Japan from the study of artifacts, particularly the *ukiyo-e* prints, a few of the more resolute journeyed to the Orient. Among them, in the 1870s, were the industrialists Henri Cernuschi and Emile Guimet, after whom two museums in Paris were named.

Significantly, Parisian dealers began to specialize in the field. Philippe and Auguste Sichel returned from a trip to Japan in 1874 with 450 crates of artworks and books. Three years later, Walters used Lucas as his agent to purchase a white lacquered elephant at Sichel's. The dealer who eventually emerged as the most influential purveyor of Japanese wares was Siegfried Bing, the son of a Hamburg merchant. Bing held a successful auction of Oriental goods at the Hôtel Drouot in 1876 and subsequently opened shops specializing in the field at increasingly fashionable addresses.

With the opening of the Exposition Universelle in 1878, the Japanese influence on France, which had initially been confined to progressive circles, reverberated through every level of the bourgeoisie. Japan's participation was, as usual, ambitious. The pavilion on the rue de Nations,

erected by artisans using imported materials, impressed viewers with a severe elegance. The Japanese farm in the gardens of the Trocadéro aroused equal interest, and an exhibition of historical wares organized by Wakai Kanesaburō was shown in the Trocadéro Palace along with works borrowed from French collectors, including Bing and Guimet.[70]

The Exposition Universelle was his goal when William Walters embarked on his fourth trip to Europe in the spring of 1878. Arriving in Paris, he joined cronies Lucas and Avery on a hasty tour of the Lowlands and several German cities, visiting artists' studios, dealers, and collectors. Given his involvement with Oriental art, William must have taken particular interest in the splendid porcelains of the Morren collection in Brussels, the holdings of the Japanese Museum at The Hague, and the ceramics, bronzes, and *ukiyo-e* prints gathered in Nagasaki in the late 1820s by the pioneer Japanophile, Dr. Philipp Franz von Siebold (1796–1866), which were housed in a museum in Leyden.[71]

In Dresden, the party returned several times to the Japanese Palace, a general art museum deriving its name from its pseudo-oriental architecture. The principal attraction, the nearby Johanneum, as of 1876 housed Europe's most comprehensive collection of porcelain, including eleven galleries of Chinese and Japanese objects. Meanwhile, Avery, who had been conducting transactions with various dealers and artists, departed, leaving Walters and Lucas to proceed alone as far as Vienna.

Back in Paris in early July, Walters toured the Exposition Universelle. Wakai Kanesaburō, a familiar contact from the Philadelphia fair, was by this time one of two directors of the Grande Compagnie Kôchô-Kouaïcha, which had its main salesroom in Paris on the fashionable boulevard des Capucines and a *succursale* in New York at 863 Broadway. An invoice drawn on July 26 itemized 129 purchases by William Walters for the sum of $2,752.50. There were many lacquers, including 21 *inrō*, as well as other works attributed to the renowned Kōrin and Ritsuō. Among the few metal objects listed were works by Seimin and Tōun, names familiar from the Centennial Exhibition. The majority of works listed were ceramics. Wakai's firm dealt in both Japanese and Chinese wares. Among the former were several Takatori tea caddies and numerous examples of Satsuma, Kyoto, and Kochi (*kōchi-yaki*) pottery and Imari and Kutani porcelain. There were also references to Hirado (Mikawachi) wares, the lustrous white porcelain with delicate blue decoration once produced under the patronage of the feudal lords of Hirado province. Many of the Chinese porcelains were loosely identified as "Nankin," a misnomer referring to Nanking, the port of exportation.[72]

Leaving Lucas to complete some transactions, most notably with

Wakai and Sichel, Walters joined Avery and his eldest son, Samuel Jr., on a five-day trip to London, visiting Lawrence Alma-Tadema's studio, Henry Wallis of the French Gallery, the Bethnal Green Museum, and the city of Windsor. He then continued alone to Ireland to vacation for a few days before embarking at Queenstown (Cobh) for the eight-day voyage home.[73]

The highlight of the 1878 tour, Walters would later recall, was the *Exposition rétrospective.* Housed in the aisles of the Trocadéro Palace, this exhibition, drawn from the holdings of major European collectors, traced the evolution of the arts from prehistoric times to the post-Renaissance era. Many of the fields that would eventually be represented in the Walters collection were featured, including antiquities from Egypt, Greece, and Rome, manuscripts, Limoges enamels, armor, Islamic art, Renaissance bronzes, the arts of the Far East, and even pre-Columbian sculpture. William was particularly drawn to a group of treasures borrowed from the Royal Armory in Madrid, as well as to Islamic art lent to the Galerie Orientale by such notable collectors as Albert Goupil, Alphonse de Rothschild, Eugène Piot, and the painter Jean-Léon Gérôme. He boasted to MacLeod that he had spent twenty-five days familiarizing himself with the display. Though undoubtedly an exaggeration, this statement reaffirmed William's growing interest in the art of the past, an enthusiasm that he undoubtedly imparted to Harry.[74]

Proselytizing zeal, as much as pride of ownership, ultimately motivated William Walters to provide the public with access to his collections housed on Mount Vernon Place. Initially, visitors tended to be limited to artists and critics, but over the years, perhaps as an outcome of his service at the Corcoran Gallery and the Peabody Institute, he would welcome an ever-increasing range of individuals and groups. On Thanksgiving morning in 1872, for example, there was a reception for local artists, among them Alfred J. Miller. Three years later, John F. Weir, while on a lecture tour in the city, took the opportunity to visit the collection, which had recently been rehung in a gallery reaching into the stable adjoining the back of the house; in a letter to his brother, the artist J. Alden Weir, he pronounced Walters's to be "the best Gallery in America full of the finest things by the best French artists."[75]

A particularly gala reception took place on March 6, 1879. Recent purchases of Oriental art and European paintings, most notably of Jean-François Millet's *The Potato Harvest,* Ludwig Knaus's *Mud Pies,* and Alphonse de Neuville's monumental Franco-Prussian War scene *The Attack*

at Dawn, had necessitated changes in the installation. Over 125 individuals from Washington, Baltimore, and New York were issued formal invitations from "Mr. W. T. Walters and his Son." Thoughtfully, the hosts reserved the rear coach of the 9:30 A.M. northbound train for the convenience of the Washington contingent, which included William Wilson Corcoran and the officers of his gallery; Professors Baird and Marsh of the Smithsonian Institution; representatives of the Japanese, Turkish, and Spanish legations; the minister from China and two of his secretaries; and General Horace Capron, formerly U.S. commissioner to China. Among a large party of artists and critics from New York were Arthur Quartley and William M. Laffan of the Tile Club, R. Swain Gifford, John La Farge, James Hart, and Thomas Moran. Local guests mentioned in the press were President D. C. Gilman and Professors Silvester and B. L. Gildersleeve of the Johns Hopkins University, the Honorable S. Teackle Wallis and Reverdy Johnson, fellow financiers John W. McCoy and Enoch Pratt, and artists Frank B. Mayer and John R. Tait. After several hours of viewing, the dining-room doors were thrown open to reveal "an elegant collation of every delicacy and the choicest wines."[76]

A month later, a party of women copyists with their instructors from the Corcoran Gallery descended upon the house. They visited the picture gallery and rooms of Oriental art but were particularly taken with the Marie Antoinette Bedroom, with its blue hangings and Louis XVI–style furniture, and with the Dutch Bedroom, with its Delft china. Although neither William nor Harry was present on this occasion, they provided an elaborate lunch served with fine wines and arranged for each of the copyists to be presented with a bouquet of flowers from their Govans country estate, Saint Mary's.[77]

Using art collections in the service of charity was a long-standing tradition in the United States. During the Civil War, both August Belmont and John Taylor Johnston opened their New York residences to raise funds for the U.S. Sanitary Commission, a precursor to the American Red Cross. In Baltimore, a charity art exhibition was organized in the Fifth Regiment Armory in January 1874, with Colonel J. Stricker Jenkins presiding. In addition to the French and German pictures borrowed from his collection, the exhibition featured such curiosities as a Scottish ram's head mull (used to contain snuff), a Japanese bronze dragon, and a collection of South American butterflies. Although William Walters's name appeared along with that of Benjamin Newcomer in the list of

executive committee members, he did not actively participate in the venture. Instead, two months later he held a preview party in his house and subsequently opened his collection to the public every Wednesday during April and May. Nearby art dealers (Myers and Hedian, and Freyer and Bendann) sold fifty-cent tickets for admission, and the proceeds were contributed to the Baltimore Association for the Improvement in the Condition of the Poor.[78]

The 1874 opening of the Walters gallery, which was repeated in the spring of 1876, represented the initial step in what would become a venerable tradition. Beginning in 1878 and continuing for fifty-three years with few interruptions, the Walters gallery would be opened for the benefit of the Poor Association on Wednesdays and Saturdays of the first four months of the year and on Washington's Birthday and Easter Monday. The fifty-cent rate would never vary.[79]

Most likely, it was in conjunction with the 1878 opening that the first catalogue of the pictures was issued. *W. T. Walters' Collection: A Descriptive Catalogue Prepared for "The Poor Association"* was a modest, amateurish booklet of fifty-six pages intended to serve as a guide for visitors as they proceeded counterclockwise around the gallery. For the most part it contained only sufficient information to identify the works, although occasionally the author, identified as a "well-known critic connected with the press," was moved to rhapsodize. François Millet's masterpiece, *The Potato Harvest* (fig. 21), left him wondering "why we stand so long, and when we turn to leave we ask ourselves if this does not embody the highest attainment of art; refinement, simplicity and truth to nature — no trickery, no gaudiness, no exaggeration."[80]

William Walters did not confine his philanthropic gestures to Baltimore. In 1881, he anticipated the struggles between the Sabbatarians and the more progressive forces that would rock the trustees of New York's Metropolitan Museum in the mideighties. His offer of ten thousand dollars to John Taylor Johnston to defray the costs of opening the museum on Sundays for a trial period was declined without being discussed by the board of trustees. Not until a decade later did the Metropolitan Museum institute Sunday openings.[81]

After his journey to the Exposition Universelle in 1878, William Walters did not return to Europe for five years. Meanwhile, Harry, representing the family interests, undertook two visits, the first in the spring of 1879.[82] On the morning of his arrival in Paris, he accompanied Lucas to the first exhibition of the Société d'aquarellistes français, which proved an agreeable experience judging from later purchases, and then continued to the *Indépendents,* the fourth impressionist exhibition, which

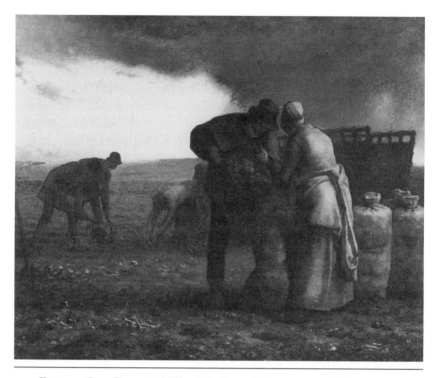

FIG. 21. Jean-François Millet, *The Potato Harvest*, 1855. Oil on canvas
(WAG 37.115).

apparently had little effect on him.[83] For several days, he and Lucas made
the rounds to the Sèvres Manufactory and to the studios of various art-
ists, including Ernest Meissonier, Édouard Detaille, Adolphe Schreyer,
Raymundo de Madrazo, and Léon Escosura. Walters then went to Rome
and backtracked to London, where he met S. P. Avery, before returning
to Paris. The remainder of the stay was spent buying Oriental art at three
firms prominent in the field, Sichel, Bing, and Malinet.

The circumstances of Harry's next trip in the winter of 1880–81 remain
unknown.[84] Given the rigors of such off-season travel, particularly of
transatlantic crossings, it is unlikely that he was merely vacationing. By
mid-December, he had reached Vienna, where he bought crystal and
enameled bibelots from the jewelry firm of H. Ratzersdorfer, a mecca for
all visitors to the capital city. In early February, Harry left London for
Paris, stopping en route at Sées to look for Percheron horses. In Paris,
it was the estate of the illustrator and watercolorist Jules Jacquemart,
scheduled to be auctioned that April, that seems to have preoccupied
both Harry and Lucas. An early Japanophile and a member of the Jing-

Lar Society, Jacquemart had assembled an exceptional collection of bronzes, enamels, weaponry, porcelains, furniture, lacquers, and Mughal miniatures. Before returning to London, Harry selected several of Jacquemart's own works, as well as a Japanese incense burner and a Malayan kriss, and arranged for Philippe Sichel to bid at the auction.[85]

In the early eighties, Lucas, representing the Walters interests, continued to buy Oriental art, mostly the Chinese porcelains offered by Sichel, as well as significant European paintings. A major coup was the purchase of Théodore Rousseau's *Effet de givre,* a pivotal work in the landscape painter's career. Executed outdoors during an eight-day stretch in the winter of 1845–46, the picture shows warm sunlight breaking through clouds to illuminate the Valmondois hills, glistening with hoar frost. Lucas had first encountered this remarkable picture at the Beurnonville sale in April 1880 and had subsequently tracked its whereabouts for two and a half years, finally retrieving it at Goupil's for 112,000 francs.

In the London market, several works by English painters were purchased from Paul Durand-Ruel's representative, Charles Deschamps, most notably John Everett Millais's Crimean War subject, *News from Home.*[86] Most of the pictures bought in London were by artists only tangentially related to English artistic traditions. Included among the latter were a couple of anecdotal genre scenes by George H. Boughton, an Anglo-American already patronized by William Walters on behalf of the Corcoran Gallery. Boughton, in turn, was largely responsible for introducing the work of Lawrence Alma-Tadema, the cosmopolitan artist from Friesland, to such notable American collectors as Walters and his New York contemporary, Henry G. Marquand.

Like Edward G. Bulwer-Lytton, who in his novel *The Last Days of Pompeii* (1839) had sought "to treasure the gulph [*sic*] of eighteen centuries and to wake to a second existence — the City of the Dead," after a honeymoon in Italy in 1863, Alma-Tadema dedicated himself to the pictorial recreation of daily life in antiquity. With his technical virtuosity and seemingly inexhaustible knowledge of archaeology, the artist readily transported viewers to Pompeii before the fatal night in A.D. 79 and, occasionally, to ancient Etruria and Greece. This transition was facilitated by Alma-Tadema's preference for views of life of the wealthy bourgeoisie, the ancient counterparts to his contemporary patrons, and by the markedly modern appearance in both bearing and countenance of the individuals portrayed. The artist's success was assured, despite the caveats of a few critics including John Ruskin, by a retrospective exhibition at the Grosvenor Gallery in London in 1882.[87]

William Walters, whose interest in ancient history had probably been sparked by his travels in Italy during the American Civil War, was inevitably drawn to Alma-Tadema and soon emerged as the artist's principal American backer. The earliest picture he acquired was *Catullus at Lesbia's* (1865), showing Catullus in the house of Lesbia, who in actuality was the poet's mistress Clodia. This painting had launched Alma-Tadema on his early Pompeian phase, characterized by dark, richly colored views of Pompeian interiors rendered with seeming veracity. Walters held this work and another, a maternal scene, only briefly,[88] replacing them with weightier, historical subjects more in keeping with his serious nature. These included *A Roman Emperor — Claudius* and *The Triumph of Titus*. The former was the artist's response to Gérôme's *The Death of Caesar*, exhibited in Paris in 1867 at the Exposition Universelle. His other purchases included Alma-Tadema's humorously anecdotal *My Sister Is Not at Home*, a couple of watercolors, and *Sappho*, the artist's consummate display of archaeological erudition, which was entered in the Royal Academy exhibition of 1881. Borrowing the subject from a fragment of verse by the early-fourth-century B.C. poet Hermesianax, Alma-Tadema portrayed the poetess Sappho, her daughter, and several companions seated on a marble exedra on the island of Lesbos, listening enthralled as Alcaeus played his kithara. When the painting was bought by Walters, the critic for the *Art Journal* glumly observed, "The light of the summer blue-sky, the gold of the poet's lyre, the sun-warmed marble are now only memories in England, for the picture has found a far-away home."[89]

With these ongoing additions, the collections inevitably outgrew the Mount Vernon Place premises. Buoyed by the surging economy of the eighties, William Walters resolved to add a picture gallery to his town house. Since the lot was fully occupied, he decided to bridge the alley in the rear and build a gallery structure in the backyard of his adjoining property, 606 Washington Place. The existing residence on Washington Place he continued to operate as a roominghouse, which is said to have included among its tenants the twenty-seven-year-old Woodrow Wilson, then a student at the Johns Hopkins University.[90]

The expansion gave rise to yet another trip abroad and further purchases of both paintings and Oriental art. Early in the spring of 1883, William Walters embarked alone for Europe. He was able to persuade Lucas to join him in London for a week, and together they called on Walters's current enthusiasms George Boughton and Lawrence Alma-Tadema. In addition to seeing the latter at his Pompeian-styled residence, Townshend House, they visited his show at the Grosvenor Gallery. One evening, while they were dining at their hotel, they were joined

by Whistler and his mistress Maud. Whistler undoubtedly wanted to see Lucas, who served as a liaison with S. P. Avery and with American collectors. A reflection of William's ongoing interest in historical collections was a stop at the South Kensington Museum, which had recently been enriched with the collection of French eighteenth-century furniture, porcelains, and bibelots assembled by John Jones in the 1870s.[91]

Continuing to Paris, Walters first focused on Oriental art, making extensive purchases both at Bing's and at the gallery of Philippe Sichel, who allowed him carte blanche to select wares from his personal holdings.[92] An intimation of mortality may have prompted the sixty-four-year-old collector to commission portraits of himself both from Charles Camino, a fashionable miniaturist at the Paris Salon, and from Léon Bonnat, whose starkly realistic portraits have remained among the principal records of Third Republic society. Bonnat's life-size, three-quarter-length portrait of William Walters is a riveting image, conveying a sense of the subject's determination and energy.[93] Sittings for the painting were interrupted by excursions on the continent, the first to Rome and Florence, from which Walters returned stricken with gout and hobbling on crutches, and the second to Dresden and the Lowlands. Between trips, he attended the opening of the Salon and saw a Japanese exhibition, presumably the *Exposition rétrospective de l'art japonais,* organized by Louis Gonse at Galerie Georges Petit. The show of more than three thousand items borrowed from Paris collections coincided with the publication of Gonse's two-volume *L'art japonais,* the most comprehensive survey of Japanese art in France to that date.[94]

By June 5, Bonnat had finished the portrait, freeing Walters to leave for England. He planned to sail for America eighteen days later but was instead confined to bed in his London hotel room by another severe outbreak of gout. Summoned to London a month later, Lucas found him surrounded by doctors and dealers. Treatment consisting of medicines, daily warm water-potash baths, and brandy twice a day was approved by Dr. William Whistler, the artist's brother. Despite the regimen, the patient recovered sufficiently to spend a few more days shopping before returning home in mid-September.

Drawing on his experience at the Corcoran Gallery, in his 1883 purchases Walters obviously selected works that would serve as focal points in the installation of the new gallery. Gérôme was finally induced to deliver *The Christian Martyrs' Last Prayers,* commissioned twenty years earlier (see plate 5). The third in a sequence of sensational subjects set in ancient arenas, this picture shows a majestic lion emerging from a subterranean den. The artist admitted to having difficulty in resolving the

composition, which he had to rework several times. In the other pictures of the group, the *Ave Caesar, Morituri Te Salutant,* and *Pollice Verso,* Gérôme did not sacrifice archaeological exactitude for dramatic effect. Perhaps assuming his client to be the same guileless individual who had visited his studio twenty years earlier, Gérôme wrote a patronizing letter in which he identified the setting as the Circus Maximus, the race track of ancient Rome (hence the chariot tracks in the foreground and the brazen capped *metae,* or posts, terminating the *spina,* or course divider). Though no classical scholar, Walters, an experienced traveler, undoubtedly recognized the amphitheater as the Colosseum and the citadel in the background as approximating in appearance the Athenian Acropolis rather than Rome's Capitoline or Palatine hills.[95]

The most monumental 1883 addition to the holdings was Corot's *Saint Sebastian Succored by Holy Women,* bought in London through Thomas Wallis, a son of Ernest Gambart's successor, Henry Wallis. In a glade in the foreground of a towering landscape, two women remove arrows and dress the wounds of the saint as his executioners ride off at the horizon. Overhead, angels hover, bearing a wreath and a martyr's palm. Although the passage of time and the deterioration caused by the artist's overreliance on bitumen may have lessened its original appearance, this painting embodies the subtle play of color values and harmonies so admired by nineteenth-century critics. One of Corot's more labored compositions, it was revised by the artist after being exhibited in the 1853 Salon and again after the 1867 Exposition Universelle.

Only slightly smaller was another purchase of 1883, *The Edict of Charles V* by Alma-Tadema's Antwerp teacher, Baron Hendrik Leys. Promoted by Gambart and his nephew Deschamps, Leys was ranked as Belgium's preeminent master and was represented in several major American collections, including those of August Belmont and William H. Vanderbilt. The Walters picture, which had originally been commissioned by Count Liedekerke, shows a herald reading to a scowling population assembled in a town square an edict of Charles V proscribing the Protestant faith in the Netherlands. Painted in the artist's archaic style, in which one-point perspective is consciously distorted and the lighting is kept uniform and restrained so as to resemble Flemish and German sixteenth-century prototypes, Leys's picture was misunderstood and drew adverse reviews when first exhibited at the Antwerp Exposition of 1861.

By 1883, Walters had come to appreciate that, with paintings such as the Corot and the Leys, their history, particularly their provenance and exhibition record, was a factor in determining value. This awareness was

reflected in his interest in the *Cent Chefs-d'Oeuvre* exhibition held at Galerie Georges Petit in the summer of 1883. Thirteen Old Masters, primarily Dutch seventeenth-century pictures borrowed from such distinguished personages as Edouard de Pourtalès and the Princess de Sagan, were interspersed with eighty-seven nineteenth-century works drawn from no less prestigious collections. Public curiosity and social pressures inevitably assured that this unique collection, made up of the best of many family galleries, this congress of crown jewels, insured like a diamond shop, policed like a fort, should draw the most distinguished crowd of judges and notables in Europe.

Though it was a charity venture held to raise funds for the French Free Schools, the show eventually benefited its organizers because some of the works would be dispersed at Petit's within a few years. Walters might well have delayed his departure to accompany Lucas to the opening of the exhibition had his health permitted. Instead he subscribed to the catalogue, a deluxe folio published by Ludovic Baschet, with etched illustrations and a text by the noted author and critic Albert Wolff.[96] Subsequently he would derive great satisfaction in procuring at least four of the world's alleged hundred masterpieces.

Chapter Four

THE YEARS OF FRUITION, 1884–1894

THE FINAL DECADE OF WILLIAM WALTERS'S life was marked less by new departures than by the coalescence and conclusion of earlier endeavors. In 1884, he was elected vice-president of the Safe Deposit and Trust Company, a position he would hold until his death. With William Walters directing finances and Harry serving in operations (figs. 22 and 23), the southern railroad lines were gradually consolidated. At the 1884 meeting of the board of the Wilmington and Weldon, the principal holding company, an overall executive department was established for the affiliated lines. Three years later, the creation of the Atlantic Coast Line Association furthered the process of unification. William Walters headed its board, which comprised the presidents and vice-presidents of the eight member railroads.[1]

In the summer of 1884, thirty-six-year-old Harry moved to the railroad's headquarters in Wilmington, the port city on the Cape Fear River in North Carolina. As general manager, he proved to be a conscientious and progressive administrator. He oversaw the introduction of more powerful coal-burning locomotives and the conversion of the last holdouts in the association to the four-foot nine-inch gauge already standard in the North. Occasionally, as when, for safety's sake, he sought to replace iron wheels on passenger cars with wheels rimmed in steel, he had to overcome the objections of his more conservative and frugal father. While Harry was general manager, substantial improvements in routing were undertaken, including the Fayetteville cutoff, which dramatically shortened running time by by-passing Wilmington. Track was also opened between Rocky Mount, North Carolina, and port facilities in Norfolk, Virginia.[2]

Other improvements at this time included the creation of the Atlantic Coast Despatch, a consortium of coastal railroads that pooled freight cars, thus expediting the transport of produce from the "winter gardens"

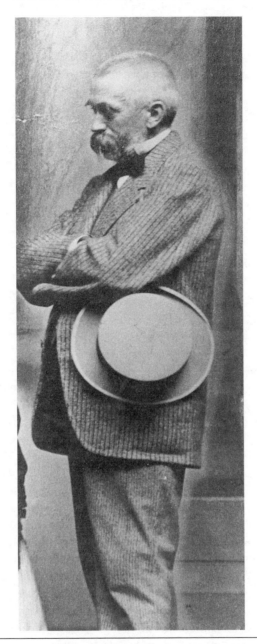

FIG. 22. William T. Walters, photograph undated. Courtesy of a
family descendant.

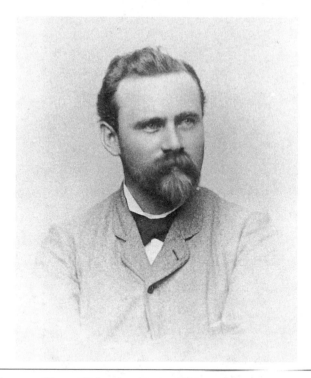

FIG. 23. Henry Walters in the 1880s. Photograph courtesy of a
Walters family descendant.

in the South to the cities in the Northeast. The associated lines similarly
enhanced passenger service when they linked forces with the Florida-
based Plant system of railroads and hotels to cater to winter tourists.
Beginning in 1888, passengers could travel the 1,074-mile route between
New York and Jacksonville in thirty hours on the Florida Special, cos-
seted in cars embellished with pale blue upholstery, Spanish mahogany,
and veneered paneling of bird's-eye maple. An additional luxury, electric
lighting, was generated by dynamos attached to the axles of the baggage
cars.[3]

In 1891 the North Carolina legislature, responding to pressure from
agrarian interests, moved to repeal exemptions from taxation and reg-
ulation that had benefited the industry's growth since the Civil War,
necessitating a major reorganization of the system. William Walters,
Benjamin Newcomer, and their Baltimore associates looked to Connect-
icut, a state known for its lenient corporate laws. Acquiring the charter
of the American Improvement and Construction Company, they pro-
ceeded to turn it into a holding company for their railroad securities. Of

the $10 million in stock issued by the reorganized company, $8 million was retained by William and Harry Walters and their partners. In January 1893, the Connecticut General Assembly passed an act changing the company's name to the Atlantic Coast Line Company, under which it would continue to operate well into the twentieth century.[4]

A milestone in the history of the Walters collection was the opening of the new picture gallery at the rear of the Mount Vernon Place residence on February 26, 1884. A writer for the *New York Mail and Express* rhapsodized that, along with the Johns Hopkins University, the Peabody Institute, and the Enoch Pratt Free Library, the Walters gallery completed "a quadrilateral of educational fortresses of which even an European capital might be proud."[5] The occasion was marked by a reception for two hundred guests, all male, as then befitted the widower host. The ministers of Great Britain, France, and Germany attended, as did representatives of the Italian, Dutch, Spanish, and Russian legations. Cheng Tsao Ju, the Chinese minister, and K. Naito, the Japanese chargé d'affaires, introduced an exotic note by appearing in national dress. Among the contingent of visitors from New York came fellow collectors Henry G. Marquand and Cyrus J. Lawrence, as well as members of the Tile Club, including artists William Merritt Chase, Arthur Quartley, Julian Alden Weir, and R. Swain Gifford. Mayor Ferdinand C. Latrobe was present along with prominent members of Baltimore's business and cultural community.[6]

Arriving at 65 Mount Vernon Place, the out-of-town guests must have been struck by the unprepossessing facade of the house, which, in contrast to those of the mansions then being erected by Walters's counterparts in New York, seemed indistinguishable from its neighbors. Only the Barbedienne bronze replicas of Jean Goujon's reliefs of water nymphs, applied to the vestibule doors, suggested the treasures to be found within.[7] Once they had been greeted by William Walters at the entrance and their eyes had adjusted to the dim, gas-lit interior, visitors were free to roam. At their left, in the somber double parlors, stood Rinehart's marble busts of family members and vitrines containing European porcelains. Upstairs were the Marie Antoinette Room, the Dutch Bedroom, and the study devoted to a menagerie of bronzes and watercolors by Antoine-Louis Barye.

Visits to the second floor library must have been a memorable experience. An elaborately carved French Renaissance-style chimney piece dominated the interior. The shelves lining the walls were filled with

richly bound volumes. Their gilt edges and colored bindings, often embossed in gold, glimmered in the gas light.

The square gallery over the stable, in which paintings had been displayed during the 1870s, was now the Oriental Gallery. A large *kōro*, or bronze incense burner, said to have been removed from the Temple of Kanei-ji in Ueno, Tokyo, in 1867, occupied its center. Lining the walls were ebony cases brimming with more than fourteen hundred Chinese and four hundred Japanese porcelains, interspersed with Japanese swords and metalwork, arranged to maximize the visual effect through contrasts of color and medium. Suspended on the walls above the cases, scarcely decipherable from a distance, were scroll paintings, described by one journalist as "kalsomines with colors as soft and beautiful as those of the Persian rugs upon the floor."[8] Adjoining this gallery was a smaller room devoted to the watercolors and drawings in the collection that had not been bound in albums. William Rinehart's life-size marble statue, *The Woman of Samaria,* had been moved to this room from its initial location in the entrance hall.

A room bridging the alley connected the residence with the new gallery. On one side were cases of Chinese and Japanese bronzes, and on the other were additional selections of metalwork, together with some of the most prized porcelains, including the Chinese peach-bloom wares (fig. 24).

Through deep-green velvet portières, guests entered the eighty-foot-long, sky-lit picture gallery, where Harry was stationed as their host. What a marvelous medley of Victorian colors it presented! The walls were covered in plum damask woven with sea-horse motifs; the ceiling coves, plastered in Louis XVI designs, were painted olive green with gilt highlights, and the floor was carpeted with red-and-green Indian runners (fig. 25). All the woodwork, including the wainscotting, had been ebonized. Cases of Japanese lacquers, alternating with benches masking heating coils, divided the room. In the center, a pedestal carrying a large porphyry vase arose from the center of a circular divan upholstered in green velvet. Even by nineteenth-century standards, the paintings were densely displayed, doubled or tripled over one another. Occasionally, the smaller works were hung four deep with a larger work, of carrying power, placed at the top level. To draw the eye, the largest paintings were located on the central axes; at the ends, for example, Corot's *Saint Sebastian Succored by Holy Women* faced Van Marcke's *The Approach of a Storm* hung over Delaroche's *Hemicycle.*

For the edification of the public, two catalogues were distributed. In the more ambitious, *Oriental Collection of W. T. Walters, 65 Mount Vernon*

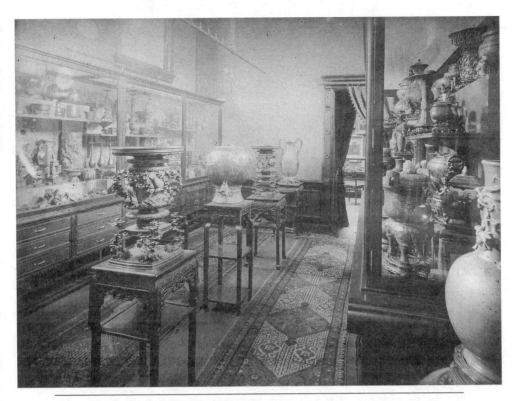

FIG. 24. The Bridge Gallery spanning the link between the Walters house and the 1884 Picture Gallery was used to display Chinese and Japanese bronzes and some porcelains, including the peach-bloom wares (WAG Archives).

Place, William Walters reminisced about his twenty years of collecting. A compendium of writings freely borrowed from a variety of sources, this small volume bound in black leather bore testimony to both father's and son's diligence in their studies of Far Eastern art and of ceramics in general. In addition to containing such useful aids as a bibliography, comprehensive for its time, and illustrations of the Buddhist and Taoist symbols most frequently encountered, the catalogue included selections of Père d'Entrecolles's observations on China in the early eighteenth century and key passages taken from more contemporary studies by Alexandre Brongniart, Stanislas Julien, and Spiro Blondel, all presumably translated from the French by Harry Walters. A survey of the history of Western ceramics from prehistoric times to the present completed the little volume.[9]

A new painting catalogue, incorporating the thirty-four additional entries since 1878, was also issued. In both content and appearance, *Collection of W. T. Walters* closely resembled a catalogue published for

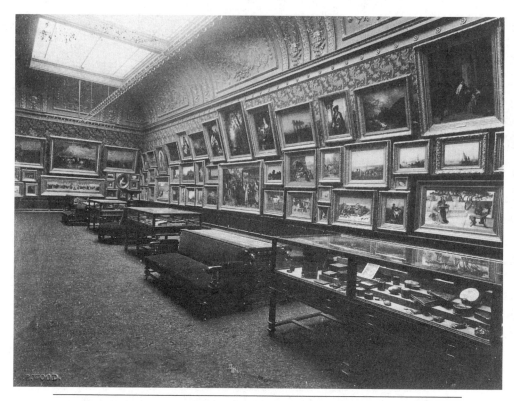

FIG. 25. The 1884 Gallery (WAG Archives). On the end wall Émile Van Marke's *The Approach of a Storm* (WAG 37.77) hangs above Paul Delaroche's *The Hemicycle* (WAG 37.83). In the center of the side wall, Asher B. Durand's *In the Catskills* (WAG 37.122) is suspended over Hendrik Leys's *The Edict of Charles V* (WAG 37.123). Alma-Tadema's *Sappho* (WAG 37.159) is recognizable at the bottom right (WAG Archives).

William H. Vanderbilt's trove of artworks two years earlier. Both publications were printed with red-and-black typography and presented identical information: a list of the artists, their teachers, medals and other awards, the paintings' dimensions, occasionally their provenance, and excerpts from artists' letters and critics' reviews. That William Walters wrote his catalogue with scissors and paste is borne out by the presence in the Walters Archives of a much mutilated copy of the Vanderbilt publication.[10]

Although he was a private individual who kept his own counsel, especially in matters pertaining to business, William Walters was a proselytizer when it came to art. Wishing to share with the public his pride in the collection, he invited to the opening those members of the press who

were inclined to be favorably disposed to his interests, and he reprinted their comments in a commemorative booklet, *The Art Collections of Mr. Wm. T. Walters.*[11] A positive review could be expected from the *Philadelphia Ledger,* published by former Baltimorean George W. Childs. The *New York Sun* sent its multitalented art-and-drama critic, William M. Laffan, an authority on Chinese porcelains and former editor of the Baltimore *Daily Bulletin.* Comparing the Walters gallery to the Vanderbilt mansion in New York, which had been opened to the press with great fanfare in 1882, Laffan dismissed the latter as representing in its voluptuousness "nothing more serious than a desire to be magnificent which some upholsterers have fully gratified."[12] At least one reviewer writing for the *New York Mail and Express* noticed the absence in Baltimore of the impressionists, whose paintings had appeared briefly at the Foreign Exhibition in Boston the previous year, and wrote applaudingly: "There is no room in this serious assemblage of masters for the mountebanks of modern art. The painters represented are the worthy posterity of those who gaze calmly down the ages out of the canvas of Delaroche at the far end of the gallery."[13]

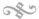

After the completion of the gallery in 1884, William Walters continued to augment his holdings, although at a lesser pace. Two sources were the collections of Mary Jane Morgan and Henry Probasco; when auctioned in 1886 and 1887, respectively, they provided a stimulus to the New York art market. From Probasco came *Day Dreams,* an allegory of vanity by Thomas Couture, who is remembered as the teacher of Edouard Manet and a number of Americans. Walters undoubtedly was pleased to have such a representative work by the artist who was credited with ending the domination of French painting by the Greek (classical) tradition that had emanated from Jacques Louis David's studio.[14]

The aging collector's last journey abroad was to visit London in August 1888. His purchases on that occasion, if any, were not recorded, although he might have been looking for works by Joseph Mallord Turner, an artist whom he was anxious to have represented in his collection.

Meanwhile, in Paris, George Lucas continued to act on Walters's behalf. Although he had followed the emergence of impressionism, Lucas knew too well the limitations of his old friend to try to interest him in the new movement. Instead, he sought to enhance Walters's existing holdings. Looking for sculptures and paintings by Antoine-Louis Barye, he visited Barye's widow and sought out his former companions in Barbizon, including the Swiss artist Karl Bodmer and the American William

Babcock. A spectacular purchase was an enlarged silver cast of the *Walking Lion,* Barye's renowned composition of 1835–36. Napoleon III had awarded the silver statue as a trophy, together with a 100,000-franc purse, to Count Fréderic de Lagrange, owner of *La Fille de l'Air,* the winning horse at the Longchamps races in April 1865. The trophy had remained with the count until his death in 1884, when it was acquired by J. Montaignac, a dealer who offered it to Lucas for 10,500 francs. Any doubts regarding the piece's authenticity were alleviated when Mme. Barye identified the silver bars affixed to the underside of the sculpture as those that her scrupulous husband had added to fully utilize the metal provided by the state commission.[15]

From Montaignac, Lucas also obtained Barye's *Wild Bull Hunt,* showing two mounted huntsmen in sixteenth-century Spanish costume rescuing a third, unseated by the bull. The sculpture was intended to serve as one of the two side groups in the duc d'Orléans *surtout de table* commissioned in 1834. Walters now owned three of the principal elements of this celebrated project.[16] In his travels, Walters accumulated his share of bibelots comparable to those found in curio cabinets in well-furnished residences elsewhere in the country. Viennese porcelains and carved rock crystals in painted enamel mounts, Roman cameos and micromosaics, and various ornaments from Paris usually fell into the category of expensive souvenirs. Of a far different order were three Sèvres vases in a distinctive coral red color that had been purchased from Philippe Sichel in 1891 for twenty thousand francs.[17] Not known at the time was the fact that this set of porcelains had been ordered in 1782 by Louis XVI for the Porcelain Dining Room at Versailles.

Perhaps tardily, William Walters came to appreciate the paramount role in French romantic painting of Barye's friend, Eugène Delacroix. Walters had bought his first work by the master in the spring of 1883. The *Collision of Arab Horsemen,* dating from forty years earlier, nearly replicated a painting that Delacroix had exhibited at the Paris Salon in 1834, two years after he had accompanied the Count de Mornay's diplomatic expedition to the Sultan of Morocco. Late in 1886, Walters authorized the purchase of a far more consequential canvas, Delacroix's *Christ on the Cross.* When it was exhibited at the 1847 Salon, Delacroix modestly commented that he had not done too badly with the *Christ.* The critic Théodore Thoré, likening it to the music of Beethoven, mellifluously intoned, "All the notes were rounded out in dominant harmony and danced in chorus."[18]

In November 1886, Lucas entered in his diary a casual reference to buying a "Delacroix boat." *Christ on the Sea of Galilee* is now recognized

as the culmination of an exceptional series of religious paintings. None other than the drama critic Paul de Saint-Victor had hailed the work as the most beautiful marine painting of the French school. Together with *Christ on a Cross,* this canvas had been included in the much-publicized *Cent Chefs-d'Oeuvre* exhibition masterminded by the dealer Georges Petit in 1883, a coincidence that undoubtedly imparted a luster to them in Walters's eyes.[19]

The fascination for Napoleon that had moved the young William Walters to spend his first pocket money on a representation of the *Grande Armée*'s retreat from Moscow proved not to be youthful whim. At the age of sixty-seven, Walters bought Jean-Louis-Ernest Meissonier's *1814* (WAG 37.52), a melodramatic image of the resolute, somber emperor on a promontory, overlooking a field of impending battle. Originally painted for Prince Napoleon Bonaparte, the subject's nephew, this work was particularly esteemed by Walters, who displayed it on an easel in the center of his gallery.

Fittingly, among the last works to enter the collection during William Walters's life were several miniatures painted by Jean-Baptiste Isabey, showing the Empress Josephine and her daughter Hortense de Beauharnais, Queen of Holland. These had been bequeathed by Napoleon to Maréchal Henri-Gratien Bertrand, who had served in Egypt and followed Napoleon into exile on the islands of Elba and, later, Saint Helena. In the autumn of 1893, Lucas negotiated the purchase of the miniatures from the count's grandson, using the Paris dealer Philippe Sichel as intermediary.[20]

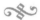

For William Walters, who assiduously avoided publicity as a matter of course, the notoriety associated with his involvement in the Mary Jane Morgan sale in the spring of 1886 must have proved a searing experience. Mary Jane, wife of Charles Morgan, a wealthy shipping line owner, had led a life of utmost propriety and frugality until liberated by her husband's death in 1878. She then embarked on a shopping spree that ended only with her demise seven years later. The widow had indulged herself by buying orchids, diamonds, and art, and for the last she did not have far to travel. Her residence faced the American Art Association salesrooms, the New York antecedent to Sotheby's, on Madison Square, and the major New York dealers Samuel P. Avery, Cottier and Company, M. Knoedler, William Schaus, and Reichard and Company were all conveniently located within walking distance on Fifth Avenue.[21]

Mary Jane Morgan's collection of 240 paintings may have been more

remarkable for its size and for the speed with which it was assembled than for the perspicacity displayed in its selection, but it did contain important holdings of Diaz de La Peña, Millet, Corot, and the popular Düsseldorf-trained genre specialist Johann Georg Meyer (Meyer von Bremen). Her favorite pictures included Gérôme's *The Tulip Folly,* a seventeenth-century scene in which a Dutchman gallantly defends his prize bloom as soldiers lay waste the surrounding tulip fields in a vain attempt to stabilize the market for the flowers. The subject was said to kindle sympathy in Mary Jane's heart for the plight of a fellow collector.[22]

Late in her career she turned to Oriental art. Herter Brothers, who had been retained to refurbish her living quarters, purchased on her behalf a collection of porcelains, lacquers, and bronzes assembled by Count Kleczkowski of Paris. Her Chinese snuff bottles, bought from the Count de Semalle, a former member of the French legation to Peking, constituted the "finest collection in the world" according to the *New York Sun* (March 10, 1886), which cited as its authority none other than William T. Walters. Many of the objects were acquired from James F. Sutton, a partner in the American Art Association, who was, in turn, supplied by R. Austin Robertson, a trader in Far Eastern artifacts.

The dispersal of the Morgan collection was directed by Thomas F. Kirby of the American Art Association in twelve sales held over ten days, beginning March 3, 1886. Kirby saw the sales as an opportunity to elevate auction-going from a purely commercial experience, frequently marred by shady practices, to a fashionable, social occasion. To promote the event, he issued a catalogue in both octavo and commemorative folio editions. The latter, bound in simulated vellum and resplendent with photogravures and autographed etchings, set a new level of opulence for such publications.

From the outset, the public was mesmerized by lot 341:

> Vase of graceful ovoid shape with slender neck slightly spreading at top, perfection in form, color and texture. Height exclusive of carved stand, 8 inches, diameter 3 inches. Mark of the Kang-he [*sic*] period, 1661–1722.
>
> The above from the private collection of I Wang-ye, a Mandarin Prince, has a world-wide reputation as being the finest specimen of its class in existence.[23]

Modern scholars now identify the vase as one of a limited number produced at the imperial kilns at Ching-te chen during the later part of K'ang-hsi's reign. These porcelains were destined for the emperor, a noble, or a scholar to put on a writing table. Their most distinguishing

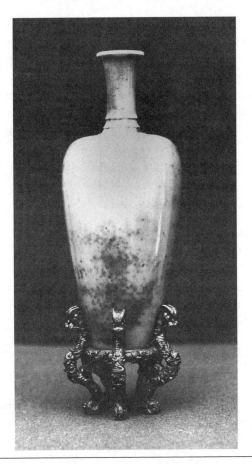

FIG. 26. The Peach-Bloom Vase, porcelain, circa 1710–22 (WAG 49.155).
The sale of this Chinese, eighteenth-century vase in March 1886 sparked
the manufacture of reproductions in glass and ceramics.

feature is the lovely, variegated pink glaze flecked with green, described
at the time of the sale as "peach blow" or "peach bloom," "crushed
strawberry," or "ashes of rose" (fig. 26). The *Art Amateur* gave the first
account of the vase in October 1885, noting that Mary Jane Morgan had
paid an astronomical fifteen thousand dollars for it.[24]

In the ensuing imbroglio, rival newspapers, the *New York Times* and
the *New York Sun,* took opposing points of view. The latter, owned by
Charles A. Dana, himself an ardent collector of Chinese ceramics and
reputedly already the owner of a peach-bloom porcelain, championed
the vase, whereas the *Times* entertained its readers over the next month
with a campaign of ridicule and invective waged against it. On March 1,

1886, the *Times* observed that "the public does not own peachblow vases, and is in no hurry to, but it sympathizes with those who, owning one or two, therefore seek, with effrontery truly amusing to boom the peach blooms as they boom a stock in Wall Street."[25]

William Walters was present when the sale opened with great fanfare at Chickering Hall on March 3. With hindsight, a clue to his intentions could have been found in his successful bid of seventy-one hundred dollars for *The Rare Vase,* a little watercolor showing an eighteenth-century connoisseur self-consciously posed beside a large *famille rose* vase on a rococo stand, painted by the Catalan artist Mariano Fortuny y Marsal (WAG 37.148).

On the fourth night (March 9), the sale was transferred to the American Art Galleries in Madison Square. Meanwhile, William Walters had returned to Baltimore, but Harry was present, seated next to James Sutton. Amid hushed tones the bidding for lot 341 began at $5,000, rose in $1,000 increments to $10,000, and continued with $500 increases to $12,500. It then jumped to $15,000, stirring general applause, and finally closed at $18,000. The vase had been knocked down to Sutton, who was representing an undisclosed client.[26]

The following day, William Walters, in a rare error of judgment that he would later rue, categorically denied to the Baltimore press that he had bought the vase. Harry, meanwhile, unwittingly authorized Sutton to tell the truth. These conflicting accounts intensified the controversy between the newspapers. The *New York Sun* proclaimed that a natural destination for the vase was the Walters gallery, which "with one or two exceptions, is of greater importance than any of its kind that belongs to any European government or private individual in any part of the world" (March 14, 1886).

On March 24, 1886, the *New York Times,* in a particularly vituperative article addressed to "collectors generally, and to Mr. William T. Walters particularly," condemned the vase. Citing as its authority a well-known gentleman recently returned from China, whose modesty precluded the publication of his name, "Not Even a Peachblow" denied that peachblows were accepted as a genuine category of porcelain in China, belittled the quality of the Morgan vase, and ridiculed the claim that the piece had once belonged to the mandarin prince I Wang-ye by noting that the titles "mandarin" and "prince" were mutually exclusive. Citing the same demure authority, the *Times* reported that R. Austin Robertson, representing the American Art Association, had bought the vase in Peking the previous year for 250 Mexican silver dollars and suggested that the high price paid by Mary Jane Morgan resulted from the salesman's misreading

of the $2,000 price tag as $12,000. In a lighter vein, several days later the *Times* devoted almost a full-page column to *The Rime of a Peachblow Vase,* a parody of Samuel Taylor Coleridge's *The Rime of the Ancient Mariner* (see appendix).

Subsequent visitors to the Walters Art Gallery failed to ferret out the Morgan vase among the other displays. Had William Walters placed it among his other ceramics of the same color, or did he quietly store it until the furor died? Most likely, he simply removed the telltale, carved teakwood dragon stand that had appeared in all the published illustrations and incorporated the vessel into the existing installation.[27] The mystery persisted, and some six years later (December 5, 1894) the *New York Commercial Advertiser* sarcastically advanced the theory that Charles A. Dana had been the purchaser. Only an owner of crockery, the writer reasoned, would support the government's extravagant expenditures on coastal defense and modern warships then being advocated by Dana's *Sun.*[28] Meanwhile, the controversial vase spawned an industry in replicas. The most frequently encountered was the glass copy of the vase and stand patented in 1886 by Hobbs and Brockunier and Company of Wheeling. In the same year, a line of "Peach Blow" cosmetics was offered by B. D. Baldwin and Company.[29]

William Walters did not attend the Exposition Universelle held in Paris in 1889. However, Harry traveled abroad that summer accompanied by Samuel Avery Jr., the son and namesake of his father's early associate. Together with Lucas, they visited the Monet-Rodin exhibition organized by Georges Petit. The show featured a selection of 145 canvases representing the impressionist painter's career and 36 works by the sculptor, including *The Burghers of Calais,* being exhibited for the first time. They continued to the Exposition Universelle. What Harry purchased on this occasion is not recorded. He returned, however, with three small Japanese teabowls monogrammed in enamel with his own and his father's initials.

Lucas continued to represent the Walters family in the Paris art market. At the M. Marquis sale in February 1890, he bought several Chinese porcelains.[30] However, after 1890, the number of references in his diaries to his Baltimore clients declined.

William Walters did not attend the World's Columbian Exposition in Chicago in 1893, but Harry went in his stead. The year before, the Walters name had been mentioned as a possible director of the Department of Fine Arts and as a member of the Executive Committee on Awards,

but whether the organizers were proposing William or Harry remains unclear and whether either was actually approached is unknown.[31]

William Walters's rate of acquisitions may have slackened as he aged, but his zeal for promoting various art-related causes did not. An abiding interest in Léon Bonvin's watercolors of *nature vivante* prompted him to commission from the critic and collector Philippe Burty a biographical essay on this hapless artist, who had committed suicide eighteen years earlier. The article, "Leon Bonvin," was translated by Theodore Child, an English art critic and friend of Lucas living in Paris, and appeared in *Harper's New Monthly Magazine* in 1885.[32]

The artist whose posthumous fame owed most to William Walters was Antoine-Louis Barye. Walters donated five Barye bronze sculptures to the city of Baltimore in 1884 to be installed in the park outside his house on Mount Vernon Place. They included casts of the *Seated Lion* and four allegorical groups, *War, Peace, Order,* and *Force* (1852–57). The former replicated a monumental statue placed in the Tuileries Palace gardens in 1846, and the latter were reductions, one-third original size, of the groups incorporated by the architect Hector Lefuel into the facades of the Richelieu and Denon Pavilions of the Cour de Carrousel of the New Louvre in the 1850s. Each group comprised a classical male nude with a youth and an animal, either domesticated or wild. The five bronzes were commissioned from the Barbedienne foundry in the summer of 1884 and unveiled the following January.[33]

These groups initially stood on granite bases around a circular fountain decorated with bronze bulrushes, inspired by a fountain in the Point-Rond des Champs Elysées in Paris, whereas the *Seated Lion* stood separately and slightly to the east, facing the Washington Monument (fig. 27). This arrangement, which presented a more cohesive appearance than the current installation, led the *Baltimore Sun* to boast that the bronzes constituted "the most impressive monument to the memory of Barye which exists outside the catalogue of his works." In Baltimore, the *Seated Lion,* placed apart, basked in a majestic grandeur that the original sculpture had lost in 1867 when it had been paired with a duplicate cast flanking the quai-side entrance to the Flore Pavilion of the Louvre. Amused by the location of Barye's lion in relation to the sixteen-ton marble statue of George Washington perched on its high column overlooking Mount Vernon Place, Woodrow Wilson, then a postgraduate student at Johns Hopkins University, observed that this was the only time the first president had ever been treed.[34]

FIG. 27. W. P. Snyder, *Unveiling at Baltimore of the Barye Group.*
From *Harper's Weekly,* February 7, 1886, 82.

Subsequently, Walters embellished Mount Vernon Place with two additional statues. In the western arm, to counterbalance Barye's *Seated Lion,* he placed a cast of *Military Courage* by Paul Dubois, who had popularized the *néoflorentin* style in French sculpture in the 1860s.[35] In 1887, Walters added a bronze cast of William Henry Rinehart's monument to Roger Brooke Taney, the Chief Justice of the United States Supreme Court whose name is associated with the Dred Scott case of 1837. This work, showing the Chief Justice seated and wearing his judicial robes, had been commissioned in 1870 by the General Assembly of Maryland for the grounds of the State House in Annapolis. Using Lucas as his agent, Walters ordered from the foundry that had cast the original a replica, which was installed in the northern extension of the square.[36]

The *Baltimore Sun* of January 28, 1885, reported that the unveiling of the Barye sculptures in Mount Vernon Place was timed to coincide with the reception for the annual winter opening of the Walters house and collections. The highlight of the occasion, billed as a "Barye Inauguration," was the introduction of a room in the residence devoted to the sculptor's work. Because of its limited size, the room was to be accessible only to artists and students. To mark the occasion, Walters published *Antoine-Louis Barye: From the French of Various Critics.*[37] An octavo volume of 102 pages, it contained Léopold Flameng's steel-engraved portrait of Barye after an early daguerreotype and a collection of reviews and articles by noted critics, including Théophile Silvestre, Gustave Planche, and Charles Blanc, many of which had appeared in the French journal, *L'Art,* at the time of the artist's death in 1875.

In his preface to this book dedicated to the "Young Artists of America," Walters noted the three-quarter-length portraits of Barye and Lucas hanging in the Barye Room, which had been painted by Léon Bonnat, an ardent admirer of the sculptor, and took the opportunity to set down "in print" his heartfelt gratitude to his "long-time friend" Lucas. "The debt I owe him for his good judgment, mature experience and cheerful co-operation in nearly all I have accomplished as amateur and collector, I find only less than the value I place upon his sterling truth, and upon his worth as a man and a friend."[38]

As usual, some visitors came to the opening from out of town. The members of the Tile Club and the Art Students League, who traveled on a special "boudoir" car provided by the Pennsylvania Railroad Company, arrived from New York. This time, William and Harry ventured to invite women, among them Sara Tyson Hallowell who, as secretary of the art department of the International Industrial Expositions held annually in Chicago, had already been largely responsible for introducing

modern French art to the public in the Midwest. As a confidante of Bertha Honoré Palmer, she would figure prominently in the organization of the Chicago World's Fair of 1893.[39]

When Lucas and Bonnat initiated in 1887 a program to erect in Paris a monument to Barye's memory, William Walters pledged in advance a five-thousand-franc subscription.[40] A committee was formed and the decision taken to hold a benefit exhibition in the French capital in the spring of 1889 to draw viewers from the crowds attending the Exposition Universelle. Lucas served on the subcommittee responsible for the selection of more than 855 sculptures, watercolors, and other related works by the artist. Unfortunately, the exhibition, which was opened by President Carnot of France at the École des Beaux-Arts on May 20, 1889, and continued through the month of June, failed to raise adequate funds.

The sculptor's American fans rallied to the rescue, however, and organized the Barye Monument Association in New York. William Walters, the acknowledged dean of collectors in the field, was chosen president, and Harry was listed among the auditors. The press was well represented; Charles De Kay, the art critic for the *New York Times,* acted as secretary, and William M. Laffan of the *New York Sun* and Alexander W. Drake of *Century Magazine* served on the publication committee.

The association began to organize a New York benefit exhibition. Cyrus J. Lawrence, a widely esteemed and well-connected New York financier, chaired a "committee on selection and catalogue." During an extended sojourn in France in 1872–76, Lawrence had become interested in art, and subsequently he had formed an outstanding collection, particularly rich in Barye bronzes, which reportedly rivaled those of Walters in quality though not in number. His holdings also included works by Honoré Daumier and Mary Cassatt.[41]

To prepare for his assignment, Lawrence attended the Paris benefit exhibition with George Lucas. *Barye Bronzes and Paintings* opened at the American Art Galleries on East Twenty-third Street on November 15, 1889, and remained on view for two months. The ground floor was devoted to 526 sculptures, paintings, and drawings loaned mainly by Walters, the Corcoran Gallery, Cyrus Lawrence, and James F. Sutton. Dominating the entrance to the galleries was a plaster cast of the celebrated *Lion Crushing a Serpent,* originally exhibited as a plaster at the Paris Salon in 1833 and subsequently cast in bronze for the Tuileries gardens. Lawrence had seen a bronze cast in the Paris exhibition and,

through Lucas, had persuaded the French government to donate a plaster rendition to the Metropolitan Museum of Art, with the provision that it be included in the New York benefit. Unlike their French counterparts, the Americans did not limit the exhibition to Barye. Perhaps recalling the popular display of modern European painting at the *Pedestal Art Loan Exhibition* held six years earlier to raise funds for the base of Bartholdi's *Statue of Liberty,* they showed in the second floor galleries 122 paintings by a group of Barye's contemporaries known as "the phalanx of 1830." These included a single, modest painting by Géricault and works by Delacroix, Decamps, Corot, and the Barbizon artists Millet, Rousseau, Diaz, Dupré, Troyon, and Daubigny.[42]

Most of the country's major collectors were represented, either by Barye sculpture or by his friends' paintings. Among the contributors were Dr. H. C. Angell and Quincy Shaw of Boston, John G. Johnson of Philadelphia, Potter Palmer of Chicago, and the New Yorkers George Seney, Cornelius Vanderbilt, Jay Gould, William Rockefeller, Brayton Ives, and John Taylor Johnston. The irrepressible outdoorsman Theodore Roosevelt lent two Barye bronzes, *Panther of Tunis* and *Elephant of Asia.* One name notably absent was Henry Havemeyer, owner of several of the artist's finest watercolors. Apparently he was abroad when the show was being mounted.

In addition to a handsome catalogue, the Barye Monument Association also published a comprehensive biography of the sculptor. Three years earlier the author Charles De Kay had contributed a lengthy article on the sculptor to *Century Magazine.* Appropriately, he dedicated the biography to William Walters, "first to honor the genius of Antoine-Louis Barye with bronzes erected in America" and "foremost of those who would raise his monument on the Seine." To commemorate Barye worthily, the finest press of the period, that of Theodore Low DeVinne, printed De Kay's book. The illustrations included woodcuts printed on especially prepared Holland paper and artotypes, or collotypes (printed from a plate coated with gelatin), which actually conveyed the gradations in tone of the various patinas. A souvenir edition, bound in vellum, was embossed in gold with the medallions, *Milo of Croton Devoured by a Lion* and *Elephant Running.*[43]

The care lavished on the Barye publications was symptomatic of an emphasis on printing as a craft that was emerging in America as part of the arts and crafts movement. In 1884, the Grolier Club was founded in New York for the "promotion of the arts pertaining to the production of

books," and small, specialty presses were appearing in eastern and midwestern cities.[44]

Walters's initial contribution to this new interest in fine printing pertained not to art but to horses. In the spring of 1886, in what was to be his last venture in breeding, he imported twenty-five Percherons from France. The following year the stables at Saint Mary's were closed. As a "Memorial of 25 years' experience as Importer and Breeder of the Percheron Horse," Walters privately printed a deluxe, quarto edition entitled *The Percheron Horse*. Included as its text was a translation of the treatise on the subject by Charles Du Haÿs from the 1868 Orange Judd edition of *The Percheron Horse*.[45] Walters took this opportunity to introduce occasional pithy footnotes castigating other breeders, particularly those in the Midwest, for their profiteering through indiscriminate importations.

It was his friend William M. Laffan who introduced Walters to Gilliss Brothers and Turnure, the Art Age Press, which specialized in fine publications. For *The Percheron Horse* the elegant type was printed in rich ink on creamy white paper set with wide margins and delicate, ornamented headbands. Replacing the crude woodcut illustrations of the earlier editions were photographic portraits of horses by Schreiber and Sons of Philadelphia, the foremost livestock photographer of the period. These, printed in sepia by a collotype process on sheets of Japanese tissue, were then tipped into the book. The binding, in pseudovellum, was stamped in gold and red with equine motifs and the monogram *WTW*. The 1886 edition of *The Percheron Horse* has been ranked among "the early masterpieces of conscious fine printing in America, in the craft-oriented milieu of the late nineteenth-century."[46]

The same year, Gilliss Brothers and Turnure produced *Notes upon Certain Masters of the Nineteenth Century, by Albert Wolff et al*. Wolff's text had been prepared for the original catalogue of the *Cent Chefs-d'Oeuvre* exhibition held in Paris in 1883 and published in English two years later. One change made by Walters in the contents of the publication was the replacement of the Géricault chapter with an essay on his cherished Barye, translated from an earlier article by Gustave Planche. Though less ambitious than *The Percheron Horse,* this octavo book was also produced using fine, handmade paper. The title page was printed in red and black with ornamental headings and initials using motifs derived from German and Italian thirteenth-century manuscripts.

Late in life, William Walters embarked on his two most significant ventures in printing, but he did not live to see them realized. In 1892, Richard Gruelle, a member of the Indiana "Hoosier Group" of artists,

visited the collector's house and subsequently wrote an article on the collection for Joseph M. Bowles of Indianapolis, who was about to launch the first issue of *Modern Art,* a quarterly that would serve to introduce the arts and crafts movement to the United States. Gruelle's text, written with tempered enthusiasm in a factual style, captivated Walters, who wrote to the author, praising him as a writer of "word paintings" such as he had been waiting twenty-five years to meet. Gruelle was subsequently given unlimited access to the house, where he worked until July 1894 preparing a commentary on the paintings in the collection.[47]

Notes Critical and Biographical was printed by Joseph M. Bowles of Indianapolis in 1895 (see plate 6). Walters, impressed by the typography of *Modern Art,* which recalled the publications of William Morris's Kelmscott Press, requested a similar treatment for his publication. Bowles's designer at the time, young Bruce Rogers, was responsible for the title page, initials, and headbands printed in red and black. The type employed was Old Style Antique, a name that, Bowles acknowledged, aroused hilarity among his friends outside the printing world. It reminded them, he noted, of the man who ordered café-au-lait with milk. Sheets were mailed to William Morris, who corrected the color of the red ink, which he regarded as too pink. *Notes Critical and Biographical* subsequently attracted the attention of Daniel Updike, the Boston publisher, who launched Bruce Rogers's career as one of the country's foremost typography designers.[48]

About 1889, Walters initiated one of the most ambitious ventures in the history of American printing, a lavishly illustrated history of Oriental porcelain. A young physician attached to the British legation in Peking, Stephen Wootton Bushell, had recently translated several key Chinese treatises on the production of porcelain. An accomplished sinologist as well as a connoisseur of ceramics, Bushell had avoided the pitfalls of many earlier translators. Walters invited the physician to Baltimore and persuaded him to write a history of Oriental ceramics incorporating information gleaned from his translations and illustrating the text with porcelains in the Walters collection.[49] Ironically, Samuel Clemens (Mark Twain) had initially hoped to publish the history and reported to his partner, Charles Webster, that the Baltimorean was prepared to pay a quarter of a million dollars for the project and that the publisher would be allowed to retain the profits.[50]

The accuracy of the illustrations was of overriding concern to Walters. He first consulted lithographers in France but eventually settled on Joseph Bowles's friend Louis Prang of Roxbury, Massachusetts. Prang's firm specialized in "chromos" of paintings by American landscape paint-

ers and in Christmas cards. As Prang subsequently recalled: "Mr. Walters would have nothing if he could not have what to the eye seemed realistic perfection . . . I was to have carte blanche in regard to expense, but nothing would be accepted that could not pass his severest criticism, which I am happy to say, he always tempered with encouragement, ending eventually in most hearty approval."[51]

The artists chosen to execute the preliminary watercolors, James Callowhill and his sons James Clarence, Sydney Thomas, and Percy James, were members of a large English family that had been associated with the Worcester Royal Porcelain Works and were known for their Japanese- and Chinese-inspired designs. Walters provided them with accommodations in his house and converted the second-floor library into their studio, with the windows facing north for light. Curiously, the Callowhills frequently recorded reflections of the buildings across the square as highlights on the glazed surfaces of the porcelains (see plate 7). Easily identifiable in some of the illustrations are two Cathedral Street houses and the spire of the First Presbyterian Church several blocks away. The Prang plates have been acknowledged as masterpieces in the art of color lithography. To capture the nuances in tone and the glossiness of the glazes, Prang used as many as thirty-two lithographic stones for each plate. Overall, two thousand stones were employed in the project.[52]

Bushell's text, more than 400 black-and-white, halftone illustrations, and the 116 full-page color plates were divided in ten sections, each set in yellow covers printed in gold, green, and red, with a coiling dragon and a composition incorporating a vase, a book, and painted scrolls. The sections, in turn, were paired and enclosed in five portfolios covered in green damask woven with Chinese characters. These were then bound by red silk cords attached to ivory spindles. A brief preface written by William Laffan was dated May 1896, the year that D. Appleton and Company copyrighted the publication. Although an edition of five hundred was intended, it is unlikely that more than two hundred were actually produced. Because of the cumbersome nature of the large folio, Appleton and Company produced a more convenient, separate text edition two years later.[53] In January 1893, for recognition of their contributions to fine printing, both William Walters and Louis Prang were elected members of the Grolier Club, the most prestigious institution for bibliophiles in this country.

During his last years, William Walters made his presence felt in New York as well as in Baltimore. Although he did not routinely lend works from

his gallery—the Barye exhibition being an exception—Walters did participate in the exhibitions of Oriental art held at the Union League Club in New York in the late 1880s. He took a particular interest in the development of the Metropolitan Museum of Art, of which he had been an honorary fellow since 1881. In May 1891, coincidentally the first month that the museum opened on Sundays, a cause he had long championed, Walters donated a collection of Japanese swords to the museum.[54]

In Baltimore, in addition to the annual spring openings held for the benefit of the Poor Association, he occasionally welcomed special groups, especially students, artists, collectors, and, increasingly, critics and journalists. Laudatory accounts of these visits subsequently appeared in the press. Perhaps conscious of his mortality, Walters wished to ensure that his accomplishments would be seen in the most favorable light. Among the more astute guests was Joseph Jefferson IV, the popular actor and accomplished painter. Jefferson listed among his favorite pictures Decamps's *Suicide,* Troyon's *Cattle Drinking,* and Millet's *Sheepfold, Moonlight,* which he regarded as "one of the world's greatest paintings." He contrasted Millet with the much admired Jules Breton, dismissing the latter as "theatrical."[55]

Shortly before his death, in what may have been intended as a valedictory statement commemorating a lifetime of commitment to the arts, Walters observed that

> the collection has been made by me personally. [These] have been to me very agreeable years, as they have brought me in contact with much that is beautiful and ennobling, and gained for me the friendship of distinguished artists. I have visited every international art-exhibition for thirty-years and have done all in my power to promote the growth of art in this country.[56]

Despite declining health, Walters remained involved with local art matters (fig. 28). He served as vice-president of the Peabody Institute and took particular interest in both the Gallery of Art Committee and the Rinehart Committee. Under his management, the sculptor's bequest more than doubled in value within a few years.[57] In 1894, Walters donated to the Peabody Institute Rinehart's marble bust of Severn Teackle Wallis, the prominent Baltimore lawyer. Several weeks before Walters died, in what may have been a final bid for his collection, the Peabody trustees elected him president.

Dr. John F. Goucher recalled Walters's concern for the Woman's College in Baltimore (now Goucher College). Walters hoped that an art school would be established to attract students from other states, and he

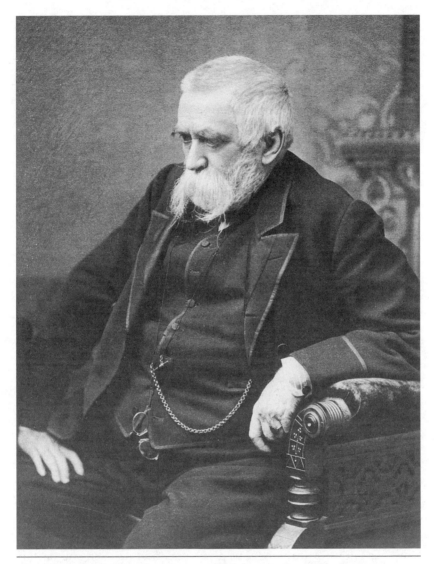

FIG. 28. Photograph of W. T. Walters taken shortly before his death in 1894 by Bachrach and Brothers, Baltimore (WAG Archives).

supported plans for a museum on the original campus on Saint Paul Street. Likewise, he contributed to the Johns Hopkins University and, in 1889, when the institution's finances were jeopardized by the rail-roads' failure to pay dividends, he subscribed five thousand dollars for an emergency fund.[58]

Walters grew increasingly isolated by infirmities of age. His expres-

sion, a reporter observed, "was that of a man whom it would not be wise to apply to for a loan, especially when the gout which pinched his toes sent sympathetic twitches to his face." This painful affliction, not surprisingly, failed to respond to a home remedy of terrapin soup and madeira. Walters was partially reconciled with his daughter Jennie, but as his granddaughter Laura recalled, visits to Mount Vernon Place remained daunting experiences for which white gloves and black stockings were *de rigueur*.[59]

Though he had deprived himself of the close companionship of his daughter, Walters found solace in friendship with Nannie Newcomer, the thirty-eight-year-old daughter of his old associate Benjamin. She visited him when he was confined to the house, exchanged gifts of books, and together they went through the albums of drawings devoted to prayer compiled in the 1860s and 1870s.[60]

In mid-November 1894, a bad tumble on his front steps sent William Walters to bed. His condition deteriorated, and Harry, fearing the worst, commandeered a locomotive to rush back to Baltimore from Wilmington and join Jennie at his father's bedside. On the morning of November 22, the seventy-five-year-old Walters succumbed to Bright's disease (kidney disease).[61]

Three days later, the funeral party assembled at the family residence and walked to nearby Grace Protestant Episcopal Church. The choice of honorary pallbearers reflected Walters's varied interests in the arts, politics, and business. Walters's body was laid beside Ellen's remains beneath Rinehart's haunting statue *Love Reconciled with Death* on the crest of a hill in Greenmount Cemetery, overlooking the city.[62] As Walters had outlived many of his contemporaries, mourning was more a matter of public observance than of personal grief. The Atlantic Coast Line draped its depots and locomotives in black for thirty days, and the quarterly *Modern Art* published a paean to Walters in verse by Meredith Nicholson.[63]

Walters's reserve had long piqued the public's curiosity. Few revelations were now forthcoming. The press concurred regarding his probity and "correctness of judgment," citing as an illustration of these traits his decision to forgo a visit to the Chicago World's Fair out of sympathy for the plight of the railroad employees during the harsh recession of 1893, a gesture of compassion that he tempered by sending Harry in his stead.[64] The *New York Times* reported that William Walters was "a very diligent student of the best qualities of everything," but qualified its praise by noting that he was not necessarily "a brilliant man" and that he did not "shine in conversation." Given his many accomplishments, it is most likely that the *Times*'s observation stemmed from the collector's apparent

discomfort on social occasions. In actuality, he had been remarkably taciturn. When a visitor once vociferously lavished praise on the collection, Walters retorted, "You have yet to learn either how much or how little you know." On another occasion, late in life, he complained to a friend who was nearly as close-mouthed as himself, "Everybody talks too much, even you and I." As George Davis noted, Walters's "whole life was lived under the law of rugged toil and anxious care. Trivial amusements and fashionable fads he despised."[65]

The value of the estate and the destination of the collection were of greatest local interest. Speculation regarding Walters's net worth ranged as high as $10 million; the actual value was only $4½ million.[66] Rumors abounded that his friend Henry G. Marquand had persuaded him to bequeath the collection to the Metropolitan Museum of Art. Baltimoreans hoped that he might have followed the lead of Enoch Pratt, the founder of the Enoch Pratt Free Library (1886), in providing for a public institution. Indeed, it was recalled that he had once offered to subscribe $50,000 for the purchase of the Thomas mansion (now Hackerman House) to be used for such a purpose.[67]

The press reports were misleading. Citing a will dated 1874, they announced that Harry would inherit the Mount Vernon Place residence and Jennie would receive Saint Mary's and that the collection was to become the joint property of the brother and sister, with the recommendation that one buy the other's share. Subsequently revealed, however, was a codicil dated 1883 that repudiated the earlier will and gave the collection outright to Harry, leaving Jennie with a cash settlement and a trust. Behind these changes lay Jennie's marriage to Warren Delano, the unwelcome son-in-law. In addition, the close bonds between father and son and their collaboration in the formation of the collection would probably ensure continuity in its future growth.[68]

THE SON SUCCEEDS HIS FATHER, 1894–1909

HARRY, OR HENRY AS HE HAS NOW BECOME KNOWN, was forty-six years old when William died. Like his father, he was short in stature, already inclined toward portliness, and masked his face with a full mustache and trimmed beard. Although he was seemingly inscrutable, the glint in his eyes, visible beneath bristling brows, betrayed his strength of character. He shared his father's reserve and nurtured an aversion to publicity, remaining essentially unknown to the public and, in some circles, assuming the reputation of a mystery man. Nonetheless, those closest to him, including his nieces and their children, fondly recalled him as a courtly gentleman and a generous and kindly uncle.

In later years Henry's relationship with his father had developed into that of an almost-equal partner. He had not shared William's extraordinary vigor and determination but more than compensated for such deficiencies with a well-organized mind and an uncanny flair for business. Self-assured and positive in outlook, he was capable of bold and decisive action both in business and as a collector. Reared in privileged circumstances and well educated, he held more far-reaching aspirations, and his achievements in business, collecting, and philanthropy would eventually overshadow his father's accomplishments.[1]

Henry Walters, unlike William, did not shy away from social occasions but seemed to enjoy the company of his peers. Perhaps because of his family's known sympathies and long association with the South, he had been warmly received in Wilmington, North Carolina. The town still mourned the "Lost Cause," though it was gradually recovering from the travails of war. Henry immersed himself in the community, developed a keen interest in sailing, and took a cottage adjacent to the yacht club on Wrightsville Beach.[2]

The state was not known for its cuisine. Years earlier, when Robert R.

Bridgers, head of the Wilmington and Weldon Railroad, had confessed at a makeshift dinner party that more men had died there from bad cooking than had been killed during the whole of the Civil War, William Walters had replied that he had enjoyed "a very satisfactory meal indeed — a Georgia watermelon, deliciously ripe and sweet." Was it happenstance that Henry's arrival in town coincided with the opening in the railroad depot of one of the South's most elegant restaurants? Its wainscotted walls were hung with paintings reputedly borrowed from the Walters family collection, and the French chef, Marius Becheras, gained renown for his preparations of the latest European delicacies.[3]

When stricken with typhoid shortly after his arrival, Henry recuperated in the house of a recently married couple, Sadie (Sarah) and Pembroke Jones. Sadie, the daughter of Colonel Wharton Jackson Green, a Confederate veteran wounded at Gettysburg, may have met Henry in Baltimore as early as the 1870s, while she was enrolled at the College of Notre Dame close by the Walters family estate, Saint Mary's, in Baltimore County. When her father was elected Democratic representative from North Carolina in the Forty-eighth and Forty-ninth Congresses (1882 and 1884), she accompanied him to Washington to substitute as hostess for her ailing mother and, while there, developed a lifelong obsession with entertaining. Regarded as "one of the most popular belles in the South," Sadie dominated social gatherings with her overwhelming presence and strength of character (fig. 29). Her particularly lavish wedding to Pembroke Jones at her father's estate, Tokay, near Fayetteville, North Carolina, on Thanksgiving Day 1884 portended a lifestyle appropriate for the proverbial Joneses in the saying "keeping up with the Joneses."[4]

Sadie's husband, known as Pem, was the son of a Confederate naval hero. Junior by ten years to Henry Walters, Pem, with his *bon vivant* effervescence and hearty humor, provided a perfect foil for the Baltimorean. An inheritance and an income from rice milling and cotton exports enabled him to maintain his family in prosperous, if not luxurious, circumstances. A keen sailor, Pem served as the commodore of the Carolina Yacht Club.[5] In addition to their common interest in sailing, he and Henry both doted on Sadie. The Joneses' hospitality toward Walters soon became open-ended, and so frequently were the three of them seen together that Wilmington wags alluded to Sadie as "the woman with two husbands."[6] Through the Joneses, Henry became acquainted with their neighbors William Rand Kenan Sr. and his family. He took a special interest in the son, William Rand Kenan Jr., and followed the young

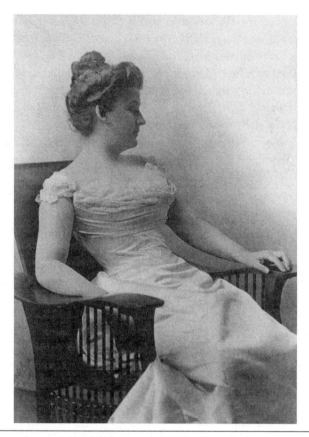

FIG. 29. Sarah Green (Mrs. Pembroke Jones and the future wife of
Henry Walters) of Warrenton, South Carolina. Photograph courtesy of
a Walters family descendant.

man's career. Young Kenan, who would become one of the developers of
the Union Carbide Company and a key figure in the development of the
Flagler fortune, admired Walters intensely and regarded him as a "sec-
ond father." In particular, he recalled gifts of the latest technical journals
from France, which proved invaluable as he prepared for a career in
engineering. When Kenan was first stationed in New South Wales, Aus-
tralia, in the 1890s, Henry Walters contributed a £100 purse to get him
established and continued to correspond with him, exchanging views on
free trade and other timely subjects.[7]

The Walters-Kenan friendship was to have far-reaching but not neces-
sarily happy consequences for William Kenan's older sister, Mary Lily.

During a visit to the Joneses, she met railroad financier Henry Morrison Flagler. Legend has it that she obliged her fellow guest by sewing a button on his jacket. Despite the thirty-seven-year difference in age and his marriage, Flagler became infatuated with the raven-haired young woman. For the next ten years, Flagler's energies were directed to the development of railroads and luxury hotels catering to the influx of tourists in Florida. In 1901, he turned his attention to Mary Lily. Acting with characteristic decisiveness, he had his wife declared insane, moved his official residence from New York to Florida, and bulldozed a bill through the Florida state legislature legalizing divorce on the grounds of insanity. On August 24, 1901, eleven days after his divorce, Flagler married Mary Lily. Four months later, the newlyweds wrote to Walters expressing the hope that they would soon have their "good friend" under their roof at Whitehall in Palm Beach. The friendship could only have been reinforced by the close ties that now existed between the Atlantic Coast Line and Flagler's Florida East Coast Railroad.[8]

In 1913, Henry Flagler died, leaving his widow an estate worth over $100 million. She subsequently married Judge Robert Worth Bingham of Louisville, Kentucky, but died, succumbing to mysterious causes, after nine months in an unhappy marriage. Bingham later drew on his inheritance of $5 million from the Flagler fortune to launch the fabled Bingham family newspaper chain.[9]

By the 1890s, the railroad business kept Henry in New York much of the time. The Joneses, apparently having outgrown Wilmington society, decided to join him in New York and took a house at Glen Cove, Long Island, and another, later, at 13 West Fifty-first Street in Manhattan. Initially, Henry stayed at Hoffman House, a hotel on Madison Square. Though living alone, he now enjoyed the companionship of an extended family, dividing his spare time between the Joneses and their two children, Sarah and young Pembroke, and his brother-in-law and sister, Warren and Jennie Delano, and their five offspring, Lyman, Laura, Ellen, Jean, and Sara. The Delanos lived in Orange, New Jersey, until 1894, when they inherited the family's rambling country estate, Steen Valetje, at Barrytown on the Hudson River. Henry was a doting uncle and a great favorite with children. On one occasion, he wrote to his young niece Sara, assuring her that he would have done all in his power to have prevented an "ugly old vase" from falling over and breaking her leg. He wished that he knew a fairy who could make her well, but "alas,"

he observed, "fairies are things of the past and don't come to us anymore not even to good little girls like Sarah [*sic*]." During a visit of the Delanos, he intervened, dissuading Sadie Jones, who was less adept at dealing with children, from sending his great-niece Sheila upstairs to admire her shoe collection while the adults talked downstairs.[10]

Despite his reserve, Henry was an inveterate clubman. By 1895, he was already listed as a member of the Manhattan Club, the largest social Democratic club in the city; the Players, dedicated to theater and the fine arts; the Grolier; the Racquet and Tennis Club; and the Atlantic Yacht Club, based at Bay Ridge, New Jersey. Eventually, he would be affiliated with almost thirty such organizations both on the East Coast and abroad. Many were devoted to sailing, and others emphasized the arts and social intercourse.[11]

Undoubtedly, the most exceptional of these associations was the Zodiac Club. It was founded by twelve individuals representing the signs of the zodiac who came together in 1868 with the worthy objective "to dine together and dine well." The members met on the last Saturday of the month from November to April at various New York clubs, usually the Union or Metropolitan, or at fashionable Sherry's Hotel. Each member, in turn, catered a meal subject to the review and criticism of fellow members. They prided themselves both on raising the standards of dining in New York and on discouraging "the dreary multiplicity of dishes" then still in vogue. At the beginning of the century, Libra (J. Pierpont Morgan) was the guiding spirit and some of the members were his yachting companions. The most frequent topic of discussion, apart from the quality of the wines, was the proper way to prepare terrapin.[12]

Henry Walters was elected Capricornus early in 1907 (fig. 30). Catering his first dinner, meeting no. 233 at the Union Club in March 1908, he provided the following menu:

Caviar	Roast guinea chicken
Oysters	Salade escarole
Clear green turtle soup	Camembert
Terrapin	Ice-cream
Saddle of lamb au jus	Café
Célery braisée	Clos de Vougeot Blanc, 1890
Fresh asparagus	Veuve Clicquot, dry, 1899
Hollandaise sauce	Richebourg, 1875

Brother Sagittarius (George S. Bowdoin), an ardent oenophile, completed the wine list, donating the following: Newton Gordon (1827);

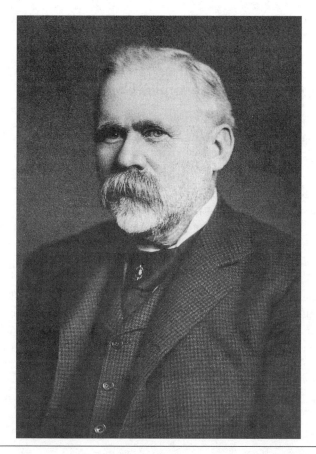

FIG. 30. Capricornus at the Zodiac Club, about 1908. From *Records of the Zodiac Club as They Appear in the Minute Books,* privately printed, New York, 1916. Courtesy of the Pierpont Morgan Library, New York.

Fine Champagne, Habersham (1840); and East India sherry. As the Minute Books revealed, the total expenses for the meal were $80.21, of which the club covered $60.00, and the remaining costs were shared by the Signs present at $2.89 a head. At his next dinner, in February 1912, Capricornus provided a much more economical repast featuring "celery-fed fowl à la Walters." His consummate presentation was the 260th meeting held at Sherry's in 1913. On this occasion, the menu assumed a French cast, featuring such items as "terrapin Morgan," "langue de veau Mornay," and "suprême de pintade." The meal's unusually high cost, $143.40 for seven, could be attributed to the rare libations: Krug

(1898), Haut Brion (1881), Musigny (1870), Barnum's Hotel Madeira (1832), and Old Bignon (1800) brandy.

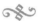

In 1896, Henry joined the New York Yacht Club and became a member of that rarefied fraternity of seamen who owned large steam yachts. The club, in those halcyon days of the Gilded Age, listed in its roster thirteen such vessels over 200 feet in length, the largest being William K. Vanderbilt's *Valiant* (332 feet) and Ogden Goelet's *Mayfair* (320 feet). Though somewhat smaller, Henry Walters's well-appointed *Narada,* which he acquired in 1896, was regarded as one of the premier "show boats" in this exclusive fleet, and it would subsequently serve as his summer mailing address (fig. 31). The *Narada* was a steel-hulled, screw-rig brigantine, 224 feet long (only 20 feet shorter than J. Pierpont Morgan's flagship *Corsair II*), with a gross tonnage of 505 and a cruising speed of fourteen knots.[13]

Henry regularly took weekend jaunts to Newport, the New York Yacht Club's Number 6 anchorage, or cruised up the Hudson River to Roundout, and sometimes he ventured out along the Atlantic Coast. Often, in the spring, Captain Brand and his crew would sail the *Narada*

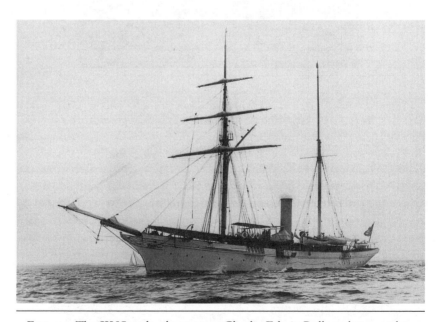

FIG. 31. The SY *Narada,* about 1903. Charles Edwin Bolles, photographer. Mystic Seaport, Rosenfeld Collection, Mystic, Connecticut.

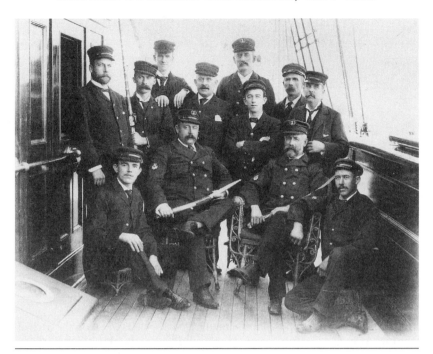

FIG. 32. Captain Brand and the crew of the *Narada,* about 1900. The captain is seated at the *center left.* Photograph courtesy of Mary Kane Hendrikson, New London, Connecticut.

across the Atlantic to be met at Southampton by Walters and his guests, who had traveled by liner (fig. 32). The party would then cruise the Mediterranean. In 1898, for example, they visited Venice and continued to Egypt, stopping in Giza, where Henry shopped for antiquities.[14]

The longest and most memorable of the voyages began late in the summer of 1900 when the Delanos joined Henry and the Joneses in Southampton, crossed the English Channel to steam along the coast of Belgium and the Netherlands, and stopped in Amsterdam, Marken, and The Hague. They then sailed north through the Kiel Canal, exchanging salutes with Kaiser Wilhelm's yacht *Hohenzollern,* and entered the Baltic Sea. Their destination was Saint Petersburg, where Julia, Ulysses Grant's granddaughter, eagerly awaited their arrival. Two years earlier, Henry Walters, "the kindest of friends," had arranged for the *Narada* to convey Julia and her husband Prince Michael Cantecuzene from Newport to New York to embark on their honeymoon voyage abroad. Julia conducted the visitors to the recently opened, granite-faced headquarters of the house of Fabergé on Morskaya Street. For members of the Walters

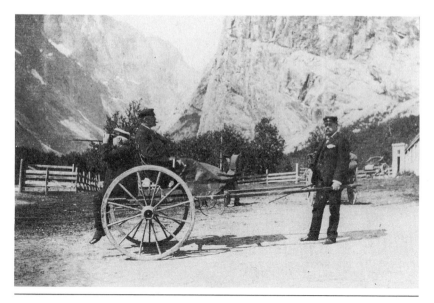

FIG. 33. During a visit to Romsdal, Norway, in 1900, the male passengers traveling on the *Narada* posed for Laura Delano: Uncle Harry is on the back of the cart, Warren A. Delano is seated in the middle, and Pembroke Jones stands in front (WAG Archives).

party who had undoubtedly admired Fabergé's display of miniature replicas of the Russian imperial regalia as well as the imperial Easter eggs at the Exposition Universelle in Paris, this stop must have been a highlight of the tour. Walters bought several jeweled and enameled parasol handles for his companions and some carved hardstone animals and other objects of fantasy for himself. Similar small sculptures, produced by Fabergé's gem-cutters, were to become prize possessions of Edward VII and Queen Alexandra, who later commissioned a stone menagerie based on their livestock at Sandringham. The return trip took the *Narada* along the Swedish and Danish coasts and included several sightseeing trips in the Norwegian fjords (fig. 33).[15]

The summer of 1903, when both King Edward VII on the *Victoria and Albert* and Kaiser Wilhelm II on the *Hohenzollern* visited the Pope, proved to be one of the most memorable yachting seasons on the Mediterranean. Cornelius Vanderbilt Jr. recalled his family, on their steam yacht *North Star,* entering the Naples harbor past the large fleet of men of war at the mouth and the hulking battleships escorting the king, to moor alongside the *Narada*. That night, "Mr. Walker" invited the

Vanderbilts to share his box for a gala performance at the opera, and in the course of the evening their presence was acknowledged by King Edward.[16] The *Narada,* flying the Walters's orange-and-black burgee, cruised as far as Istanbul that summer. There, Henry Walters and Sadie Jones visited R. S. Pardo, the manager of the Oriental Museum, a purveyor of arms and artifacts made for "luxurious Shahs and Sultans" of Turkey. On that occasion, Walters purchased several damascened sword blades, ceremonial spoons, and a Chinese porcelain mounted as a water pipe.[17]

In the summer of 1905, Walters, the Jones family, and the Delano children assembled in Paris to shop for clothes, except for Henry, who went "looking at things made B.C."[18] Joining the *Narada,* the party embarked on a Mediterranean cruise, stopped at Naples and Venice, traced the Dalmatian coast, passed through the Corinth Canal, and moored in the harbor of Piraeus near King Edward's yacht, the HMS *Victoria and Albert.* After visiting the principal sights in Athens, they proceeded to the Greek islands of Agenta, Aegina, Delos, and Crete (fig. 34). The route back included Sicily, Pisa (where Henry posed for his niece Laura on top of the famed leaning tower), and a visit to the lake district in the north of England.

The excitement of yacht racing captured Henry's imagination. As a member of the New York Yacht Club, he was committed to defending the America's Cup, the oldest trophy in international sport. On five occasions between 1899 and 1930, the British grocery-and-tea merchant Sir Thomas Lipton of the Royal Ulster Yacht Club unsuccessfully challenged the Americans with his vessels, invariably named the *Shamrock.* In 1900 Henry joined a syndicate to build the *Constitution,* which failed to become the defender the following year.[19] Subsequently, in 1902, he participated in Cornelius Vanderbilt's syndicate, along with such prominent yachtsmen as Oliver Iselin, William Rockefeller, and Peter A. B. Widener, in building the *Reliance.*[20] With a length of 143 feet 8 inches, the *Reliance,* designed by the renowned naval architect Nathanael G. Herreschoff, carried an extraordinary sail spread of 16,610 square feet, an amount never equaled before or since. The following year, the *Reliance* handily won the first two races, and during the third a heavy fog set in, causing the *Shamrock II* to lose her way. Spectators near the finish were alerted to the approach of the victorious *Reliance* only by a clap, as its immense, ballooning jib topsail hit the deck. As a result of his participation, Henry Walters was elected vice-commodore of the New York Yacht Club from 1903 to 1906 and was presented a silver trophy in-

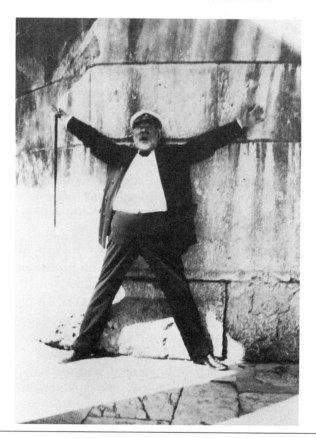

FIG. 34. "Martyr to the Cause" (WAG Archives). Presumably recalling Jean-Léon Gérôme's *The Christian Martyrs' Last Prayers,* Henry Walters poses for Laura Delano during a visit to Spalato (Split) in 1905.

scribed: "This cup presented to Henry Walters, Esquire, Vice Commodore of The New York Yacht Club, 1903–1904–1905 and 1906, by the members of the Club as a mark of esteem and a token of esteem."

Walters, also an avid motor car enthusiast, enjoyed touring abroad. He joined the American Automobile Club and kept abreast of the latest car models. In the spring of 1906, he set out with his sister and a couple of nieces on a three-month European tour in a Hotchkiss chosen because its elevated seating permitted passengers to peer over hedgerows and walls. Driven by their chauffeur, Rivollet, they proceeded from Fontainebleau to the châteaux region of the Loire and then headed south to Avignon and along the Mediterranean coast to Mentone and Monte

Carlo. They reached Genoa before returning to Paris via Turin, Chammonix, and Rouen. Later, Walters wrote to George Lucas expressing regrets that he had been unable to give his elderly friend a ride in the Hotchkiss but assuring him that the Mercedes he planned to buy the following spring would suit Lucas's shape exactly.[21]

Meanwhile, the Joneses, with Henry in tow, made their foray into the top echelon of New York society, no mean feat given the still-prevailing antisouthern sentiment. For this pursuit they enlisted the support of Henry Lehr, a social gadfly and protégé of Mrs. William Astor. They heeded Lehr's advice that New Yorkers could be won over by being fed and hired a Russian chef, who, with a cook brought from Wilmington, prepared a range of continental and southern dishes that were served with a copious supply of fine wines and liquors. The Joneses soon became celebrated for their lavish hospitality.[22]

A social requisite at this time was a summer address in Newport, Rhode Island. Beginning in 1898, Pembroke and Sadie rented several villas before settling on Friedheim, a picturesque Victorian cottage on Bellevue Avenue, which they initially leased from Theodore A. Havemeyer. Eventually, they bought the house, renamed it the Sherwood, and transformed it into a Georgian revival structure reminiscent of the White House in Washington (fig. 35). The architects Hoppin, Koen, and Huntington provided a large, Doric-style hall and a vast dining room appropriate for large receptions. Its other features included a billiard room lined with cases for Pembroke's racing trophies and Sadie's elegant Louis XVI–style bedroom fitted with *blanche-brêche* marble mantles and crimson hangings.[23]

There was ample opportunity for Pembroke to indulge his passion for sailing in Narrangansett Bay and Buzzards Bay. His reputation as a sailor was formidable. On one occasion, the Duke of Marlborough, apparently less intrepid than his illustrious forbear, declined an invitation to sail with Pembroke.[24]

The Joneses' entertaining at Newport became legendary. On August 23, 1901, the *New York Times* noted that "few social functions ever given in Newport have exceeded in elaborateness the dinner dance given [the night before] by the Joneses at Friedheim." The decorators and illuminators, it was reported, had toiled for weeks preparing an immense, temporary ballroom lined with tarlatan (muslin) and festooned with garlands of pink roses and strings of lights. Sadie confided to Eliz-

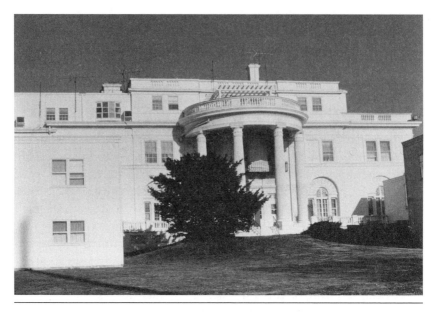

FIG. 35. Sherwood, Newport, Rhode Island. The house was originally in the Gothic style but was converted to a neo-Georgian structure by the firm of Hoppin, Koen, and Huntington. Photograph by the author, 1986.

abeth Lehr that she allocated $300,000 for entertaining each summer.[25] The frequent appearances of Henry Walters on the *Narada* played an integral role in her activities and, on one occasion in August 1903, a party was given in the yacht's spacious quarters. The guests included the Oliver H. P. Belmonts, the George B. DeForests, and the Henry Lehrs, with entertainment provided by Malini the magician.[26]

The Joneses and Henry did not abandon the South but returned annually to Wilmington, North Carolina, for the Christmas holidays and again each spring when the azaleas were in bloom. As early as 1884, Pembroke Jones joined a land development company that acquired a salt-water resort with a hotel on nearby Bradley's Creek. Two years later, title to the Sea Side Park Hotel was transferred to Sadie, and the process of transforming the building into a residence was begun. By the early 1900s Airlie had grown into a rambling, multigabled, "wooden Colonial style" country house with over thirty bedrooms and a combination ballroom and theater (fig. 36).[27]

A local resident recalled that "social life would come alive when the Pembroke Joneses were in town." Airlie would be opened, "the tally-ho would be sent dashing into town, and cousin Nellie Dick would start

making the list for the children's Christmas party." As the highlight of the festivities, the young guests were given baskets and paraded in to pick toys out of sacks from F.A.O. Schwarz of New York. Among the adults present were guests from the North who marveled at the endless supply of oysters, johnnycakes, and pickles.[28]

If this were not property enough, Pembroke in 1902 bought a 1,230-acre tract of land nine miles outside Wilmington on a bluff overlooking Wrightsville Sound. There, nestled among the magnolias, Norway pines, and live oaks, he built the Lodge, also called the Bungalow, a two-story building with wings made of concrete, the preferred local material. It was designed by his friend Stewart Barney as a "French pavilion." The imposing entrance to the grounds, a gate flanked by low walls surmounted by lions and urns, and a Temple of Love were added by Pembroke's future son-in-law, John Russell Pope, who would later gain renown as the architect of the National Gallery of Art in Washington, D.C.[29]

The Joneses held their more intimate parties at the Lodge. On one occasion their superintendent remembered erecting a platform high in the limbs of an old oak tree, so that dinner could be served in the treetops. Another time, two-hundred-pound blocks of ice were distributed across the lawn for the comfort of northern visitors not accustomed to the hot and humid Wilmington summers.[30]

When time permitted, Henry attended the Joneses' gatherings. Whether he actually enjoyed these activities or was simply humoring Sadie with his presence remains open to question. Given the austerity of

FIG. 36. Formerly the Sea Side Park Hotel, this building was transformed into a private residence known as Airlie. It served as the Pembroke Joneses' principal residence in Wilmington, North Carolina (WAG Archives).

his upbringing and the unremitting emphasis on diligence and gravity of thought in the Walters's household of his youth, the light-hearted self-indulgence of the Joneses may have fulfilled some long-repressed need.

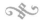

Since Baltimore offered few attractions to the Joneses, Henry came to his native city alone. Although he would never again reside in Baltimore, he retained ties with the city, regularly attending board meetings of the Safe Deposit and Trust Company, traveling from New York in his railway car. A small office managed his personal affairs in town, and for many years the Mount Vernon Place house remained the only residence listed in his name.[31]

In Michael Jenkins, president of the Safe Deposit and Trust Company and son of William Walters's close associate Thomas Courtney Jenkins, Henry found a trustworthy friend and alter ego. The younger Jenkins would fulfill much the same role for him that Benjamin Newcomer had for his father. The two were in almost daily contact by letter, telegraph, and telephone.[32]

Henry willingly accepted philanthropic responsibilities in Baltimore. He faithfully continued his father's practice of opening the art collection to the public each spring to raise funds for the Poor Association. For the benefit of his visitors, within weeks of his father's death he replaced the gas fixtures with electrical lighting.[33] He also took an interest in local educational institutions and in 1902 donated $100,000 to the endowment fund of the Johns Hopkins University. Two years later, the grateful university established in his honor the Henry Walters Professorship of Zoology. He gave to the fledgling art collection of the Woman's College (later Goucher College) a series of watercolors by local artist Frank B. Mayer. These were based on drawings made by Mayer while attending the Treaty of Traverse des Sioux in 1851.[34]

The local art school was another concern. Modeled after Philadelphia's Franklin Institute, it had been incorporated in 1825 as the Maryland Institute for the Promotion of the Mechanical Arts. Twice the institute was ravaged by fire, and after the 1904 conflagration it was rebuilt to the north of downtown on a site provided by Michael Jenkins. Walters was willing to make a sizable contribution to ensure that the new structure be "absolutely fireproof," but the unexpected generosity of Andrew Carnegie relieved him of this responsibility.[35]

Henry Walters, however, served as an intermediary in bringing to the institute George A. Lucas's personal collection. In the course of advising

clients over a half-century, the expatriate had bought for himself, tentatively exploring both the byways and the main currents in the art of his time. Although he focused on prints, he also acquired paintings and sculptures, particularly those of Barye. Two early Pissarros, a Johan Jongkind canal scene, and a small oil by Daumier, *The Loge,* were among his more prescient purchases. Walters, encouraging Lucas to bequeath the collection to the institute, stressed the building's safety features, such as its fireproof construction and its location in an open lot, removed from the danger of collapsing structures. He also emphasized the unlikelihood that Lucas's donation would ever be eclipsed by other such holdings.[36]

Ultimately, Lucas appointed Walters his executor and bequeathed the collection to him. In accordance with the wishes of his old friend and mentor, Walters transferred the works to the institute, Lucas's second designated legatee. In doing so, he charged the managers of the institute with the responsibility of realizing Lucas's desire that the gift would serve as "a continuing example and incentive to earnest, ambitious effort of art students" and would be "dedicated to sincere art education in his native city." Walters undoubtedly assumed that the Lucas holdings would serve as a teaching tool, much like the collection then being assembled with Morgan's backing for New York's art school, the Cooper Union.[37]

In other art matters, Walters served with Michael Jenkins, John Work Garrett, and Theodore Marburg on an advisory committee for an exhibition commemorating the twenty-fifth anniversary of the Charcoal Club; the exhibition opened at the Maryland Institute on January 9, 1909. The Charcoal Club did not restrict membership to artists and amateurs, but included many local arts patrons. Also during that year, Henry joined the local art dealer Faris Pitt and General Lawrason Riggs, a collector of Oriental ceramics, on a committee at the Peabody Institute which decided to commit the resources of the recently established George C. Irwin fund to purchases of American art.[38]

Henry Walters also took a lively interest in the Rinehart scholarships established to enable young sculptors to study abroad. Funding for their travel had largely been made possible by his father's astute management of the Rinehart estate. Henry not only contacted the students during his visits to Paris, but also acquired examples of their work. In 1897 he obtained from Alexander Phimister Proctor, the first recipient of the award, a bronze statuette of a bison, an appropriate subject for the sculptor who later modeled the four colossal buffalo on the Q Street

Bridge in Washington, D.C. Likewise, Walters commissioned from Hans Schuler a marble of *Ariadne,* a statue that earned the young American a gold medal at the Paris Salon in 1901.[39]

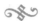

The first building in Baltimore to bear the Walters name was not an art museum but a public bath. H. L. Mencken once sardonically observed that there was some truth, but not too much, to the literary tourists' reports extolling Baltimore's home life, which was "spacious, charming, full of creature comforts, and highly conducive to the facile and orderly propagation of the species." Despite its reputation for "gracious charm," Baltimore seriously lagged in the development of civic amenities. At the turn of the century, untreated sewage seeped into the harbor, creating a stench in the hot summer months, and a preponderance of houses in the working-class neighborhoods still lacked adequate plumbing. Thomas M. Beadenkopf, a social activist and pastor of a Congregational church in the port district of Canton, had opened a public bathing beach on the waterfront in his neighborhood in 1893 and then began to agitate for a system of public baths such as those in England and Germany. He succeeded in persuading Mayor Latrobe to establish a Bath Commission consisting of concerned citizens, including Dr. James Carey Thomas, Eugene Levering, and William H. Morriss. In 1899, Henry Walters was approached by the commission for funds. Citing the appalling lack of hygiene that he had encountered the previous year in Egypt and his dismay at learning that similar conditions prevailed at home, Walters agreed to pay for two bathhouses, but eventually provided for four.[40]

Walters Public Bath Number 1 opened in May 1900 on South High Street in a particularly congested district inhabited by migrant workers, sailors, and oystermen and their families. On the second floor, separate halls were provided for men and women with individual stalls, and downstairs a laundry with steam dryers was available. A fee of three cents was levied for soap and a towel. In the first seven months of operation, more than forty-eight thousand baths were taken (an average of more than two hundred a day).

Bath Number 2, the only example still extant, although no longer active, was built in 1901–2 on Columbus Avenue (now Washington Boulevard) in downtown Baltimore to serve a manufacturing neighborhood, particularly the local women (figs. 37 and 38). The architect, George Archer, employed the Free Colonial style with brickwork laid in

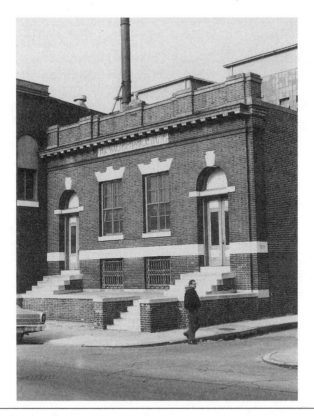

FIG. 37. The Walters Public Bath Number 2, Columbus Avenue (now Washington Boulevard), Baltimore, designed by George Archer in the Free Colonial style, 1901. Photograph by the author, 1970.

Flemish bond and trimmers of Maryland limestone. A third bath, completed in 1905 on Argyle Avenue in the northwest corner of the city, served a predominantly African-American clientele. Later additions to the system included Number 4 on Marshall and West Streets and Numbers 5 and 6, both on Eastern Avenue, which were partially funded by Walters.[41]

Elsewhere, Walters, concerned about the welfare of American students abroad, agreed to become a founding benefactor of the American Academy in Rome. At a meeting in New York in June 1897, a board of trustees was elected composed of prominent architects, sculptors, painters, and five lay members, among them Henry Walters. True to form, he initiated a campaign to raise an endowment of $750,000 by pledging $62,600, conditional upon the balance being raised in full.[42] His fel-

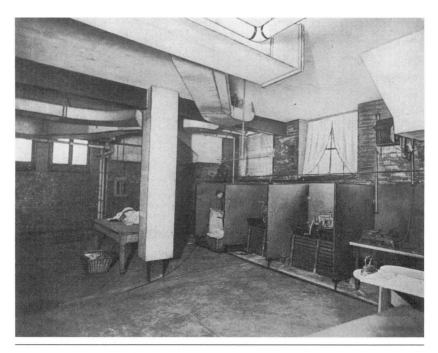

FIG. 38. Interior of the Walters Public Bath Number 2, laundry facilities, about 1930 (WAG Archives).

low financier, J. Pierpont Morgan, was not yet prepared to contribute but agreed to join Walters in issuing the following public appeal in November 1901:

The American Academy in Rome

France, Germany and other countries have owed their artistic development for generations to National Academies fostering the Fine Arts, established by them in Rome.

In view of the success attending the beginnings of the AMERICAN ACADEMY IN ROME, founded on the same general lines, privately supported since 1894, incorporated 1897, and lately endorsed by the State Department of the National Government,

We, the undersigned, believe the time has arrived when this country is ready for its permanent establishment and endowment and that such an institution would prove of incalculable value in building up the national standards of taste.

J. P. Morgan
Henry Walters[43]

In 1904, when the academy decided to relocate from its cramped rented quarters in the Villa Aurora on the Pincian Hill to a more spacious building of its own, Henry lent $130,000 without interest for the purchase of the Villa Mirafiori, located just outside the Porta Pia. The endowment campaign still faltered. When approached that autumn with a plan to persuade ten patrons to subscribe $100,000 each, Walters replied, "I hope you will give me the privilege of being the first of ten Founders." Morgan's response was less forthcoming; he demanded to know what Walters was contributing and brusquely agreed to match it. The self-effacing Henry characteristically suggested that Morgan's name head the list of founders, and the academy was incorporated by Congress as a national institution in 1905.[44]

Though Morgan was eleven years Walters's senior, many parallels can be drawn between the careers of the two men. They were both sons of forceful fathers and had spent a considerable number of their formative years abroad. Likewise, they were well advanced into middle age when they succeeded their fathers as financiers and became collectors and philanthropists in their own right. Both had been drawn to art and rarities in their youths. Morgan began by collecting bishops' autographs, but while a student at Vevey and Göttingen had progressed to medieval stained glass fragments, which he scraped from the soil beneath cathedral windows.[45] Walters, from the outset, had participated in his father's collecting. So regularly did their paths converge in business, yachting, and philanthropic and cultural endeavors that one wonders whether a genuine friendship grew between these two very private individuals. Morgan's personal life seemed to be circumscribed by his family and church, and his despotic nature and egocentricity, which were said to match his wealth, apparently precluded close ties. However, a rapport developed between them, perhaps begrudgingly, based on shared values and mutual respect. Morgan must have enjoyed Walters's companionship for, on one occasion, he proposed that they return from Europe together on the *Oceanic*.[46]

Not surprisingly, when Morgan assumed the presidency of the Metropolitan Museum of Art, Walters contributed one thousand dollars to become a "fellow for life" and was designated a trustee. The following year, he was appointed to the museum's executive committee and began to serve on other committees, including those concerned with objects of art (as opposed to paintings), buildings, purchases, and Oriental antiquities. It is difficult to assess the extent of his contributions to the museum at this time, since he usually expressed his generosity anonymously,

but he apparently served effectively and continued to be reappointed to key committees, acting as chairman for a number of them.[47]

Henry Walters became president of the Atlantic Coast Line Company in June 1894. Far more than his father, he was personally engaged in its operations, and he even continued to participate in periodic inspection tours of the entire trackage.[48] Characteristically, he avoided drawing attention to himself or to the company and escaped being targeted by the public and the press, both of which were becoming increasingly resentful of the railroads' unfettered power. Under his leadership, the Coast Line flourished in the 1890s and in the early twentieth century expanded at a pace inconceivable a generation earlier. Two factors contributed to this growth. State and federal regulations were not yet excessively onerous, although Walters did admit that, despite his disinterest in the forthcoming federal election of 1909, he was eagerly anticipating getting "rid of Theodore Roosevelt and his methods." Three years earlier, the Republican president had aligned himself with the Democrats to pass the Hepburn Act, which granted the Interstate Commerce Commission power to set maximum rail rates.[49] Also assuring the Coast Line's prosperity was its amicable relationship with its principal rival in the Southeast, the Southern Railway Company controlled by J. P. Morgan. The two companies frequently collaborated, sharing track and exchanging information, sometimes to the detriment of their third competitor, the Seaboard Air Line.

The independent operations of the member railroads, however, remained cumbersome, and in 1897 a decision was reached to merge them. Not until April 23, 1900, after complex negotiations with the states served by the lines, was the process completed. The newly established Atlantic Coast Line Railroad Company of Virginia now operated 1,676 miles of track and held assets of over $63,516,067. Among the directors elected were Baltimoreans Henry Walters, Benjamin Newcomer and his son Waldo, and Michael Jenkins, together with eight others drawn from Virginia and North and South Carolina. W. G. Elliott, formerly president of the Wilmington and Weldon Railroad, was appointed president, and Henry Walters served as first vice-president. Over 70 percent of the stock of the new company was held by the Atlantic Coast Line Company of Connecticut and was controlled by Henry Walters and the Baltimore investors.

In July 1902, the Coast Line acquired the vast Plant System embracing

2,235 miles of track as well as holdings in real estate, hotels, and shipping. Henry Plant had been among the first to appreciate Florida's potential for growth. In the late 1870s, he began to invest in small railroads within the state, and in 1882 he organized these holdings as the Plant Investment Company, chartered in his native Connecticut. Minority subscribers included William Walters, Benjamin Newcomer, and the Jenkins family of Baltimore, as well as the New York–based financiers, Morris K. Jesup and Henry Flagler. Plant had chosen Tampa as his headquarters and built the Tampa Bay Hotel to rival Flagler's posh establishments in Saint Augustine. Plant's railroads extended along Florida's west coast and joined the Louisville and Nashville Railroad in Montgomery to serve the American Midwest.

As death approached, the elderly Plant consolidated his wide-ranging investments into the Henry Bradley Plant Company. He intended that ownership of the company would be held in trust until the death of his grandson, then aged four, an entailment permitted by Connecticut law but not by New York State, his official residence. Plant died in Manhattan in June 1899, several days after house-hunting in Connecticut. When his widow, who had been left an annuity of only thirty thousand dollars, successfully contested the will, the heirs were free to dispose of their shares. In March 1902, Henry Walters and Michael Jenkins, after three months of intense negotiations with the Plant representatives, concluded a merger of the two systems. With the addition of 2,235 miles of track, it became necessary to restructure the railroad. In July, R. G. Erwin, who had headed the Plant System, was elected president of the Atlantic Coast Line Railroad Company. Henry Walters became chairman and subsequently maintained his office at the Atlantic Coast Line's finance department at 71 Broadway in New York.

The Plant merger was dwarfed that year by the purchase of control of the Louisville and Nashville Railroad, or "Old Reliable," as it was affectionately known.[50] This railroad, incorporated in Kentucky in 1850, had staked as its home territory Kentucky, Tennessee, and Alabama. By 1903 it owned 3,444 miles of track and carried over six million passengers and thirty-eight million tons of freight annually. The chairman, August Belmont, wishing to capitalize improvements, issued fifty thousand shares of common stock that April. Apparently oblivious to measures being taken at the same time by Edwin Hawley, the president of the Minneapolis and Saint Paul and the Iowa Central Railroads, and by the notorious speculator John W. ("Bet-a-Million") Gates to corner the market, Belmont inadvertently launched a bull-raid on the railroad's

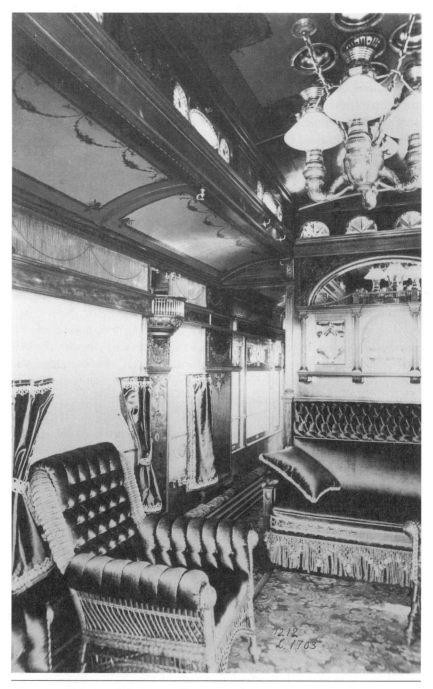

FIG. 39. Interior of the Louisville, Henry Walters's business car from 1902 to 1931. Courtesy of the Adirondack Museum.

stock.[51] Prices soared, but fortunately, to stabilize the market, J. P. Morgan and Company intervened, taking control of the stock on behalf of both Belmont and the Hawley-Gates pool.

That autumn, Morgan brokered a deal with Henry Walters and the Atlantic Coast Line Railroad Company whereby Walters, with the backing of the Safe Deposit and Trust Company of Baltimore, acquired 51 percent of the Louisville and Nashville's capital stock for $47,750,000. Walters paid $156.05 for shares that earlier in the year had sold for as low as $103. It was a bold and far-sighted move on Walters's part, but with the subsequent economic downturns of 1903 and 1907, he would not be fully vindicated for a number of years. A personal bonus that came with the railroad was the Louisville, Belmont's particularly elaborate Pullman car equipped with such accessories as silver coathooks in the shape of staghorns and a Carrara marble tub and basins, which would subsequently serve as Henry Walters's "business car" (fig. 39). He could now rest assured with the knowledge that he presided over a combination of highly profitable railroads operating over nine thousand miles of track in the Southeast, a formidable accomplishment.

In 1883, the American art amateur and writer James Jackson Jarves urged American financiers to follow the example of their Renaissance precedent, Giovanni di Pagolo Rucellai, by surrounding themselves with great works of art. Although he was "not the highest type of man," Jarves noted, there was in the fifteenth-century Florentine "a public spirit which may be studied to advantage by many of our merchant princes whose fortunes are far superior to his self-made one as America is a land of greater diversity of gifts and promise than ever was Italy."[52] Some Americans did, but unlike the legendary Florentine banker, who assembled in his palazzo the works of such contemporaries as "Domenico Veneziano, Fra Filippo Lippi, Verrochio, Giuliano da Majano, Castagno, Paolo Uccello, Desiderio da Settignano, Pollaiuolo and Finiguerra," they bought the art of the past rather than patronizing the artists of their own time. The trickle of Italian and Flemish primitives, Old Master paintings, and British society portraits coming into the United States grew into a torrent by the turn of the century, despite a 20 percent tariff levied on imported art until 1909. Undoubtedly, much of the frenzied buying represented an exercise in conspicuous consumption rather than an abiding commitment to the fine arts. This commerce was facilitated by sophisticated dealers, including the arch rivals Duveen and Knoedler, and they, in turn, drew on the advice of eminent scholars who were will-

ing to sell their expertise, most notably Bernhard Berenson and Wilhelm von Bode.

To provide settings for their Old Masters, the new Maecenases assembled appropriate antique furniture, majolica, early bronzes, and other decorative arts. Some individuals even erected "palaces" to house their possessions. In 1884, Henry G. Marquand, a contemporary of William Walters and a fellow railroad financier who had been characterized as having bought like an Italian prince of the Renaissance, employed Richard Morris Hunt to design an immense residence on Madison Avenue complete with a music room in the Greek style furnished by Lawrence Alma-Tadema, a Moorish smoking room, and a Japanese chamber. Catholina Lambert, whose tastes ranged from Italian Renaissance paintings to English society portraits and, atypically for his generation, to the works of the French impressionists, built a baronial castle in 1892 on the crest of a hill overlooking his silk mills in Paterson, New Jersey. In Boston, Isabella Stewart Gardner, the doyenne collector of Italian primitives who reconciled claims of descendance from the Scottish hero Robert de Bruce with spiritual kinship with Isabella d'Este of Mantua, used architectural fragments imported from Venice to build Fenway Court, modeled after the Palazzo Barbaro. Similarly, the omnivorous acquisitor J. Pierpont Morgan preferred to conduct business seated beneath brocades embroidered with the crest of the Roman banker Agostino Chigi in the West Room of his palazzo-like library, itself a monument to American Renaissance architecture.[53] Walters, however, did not share such princely aspirations, nor did his ambulatory living arrangements permit such a lifestyle.

Unlike many of his contemporaries, who were relatively advanced in age when they began to collect, Henry had been steeped in art since childhood. The discipline of transcribing in a journal his impressions of visits to the museums and monuments of Paris during his adolescence had undoubtedly left its mark, and the years of close association with his father had not only imbued him with a zeal to acquire, but also honed his aesthetic sensibilities. Although the senior Walters had confined his purchases to the art of his own era, except in the field of Oriental art, he also was interested in the art of Europe's past, as was reflected in his visits to Naples and Pompeii during America's Civil War and was further demonstrated by his extended visit to the historical exhibition in the Trocadéro in 1878. The enthusiasm prompted by these occasions was undoubtedly shared with his son.

Henry's interests in the ancient world, for example, were demonstrated as early as 1884, when he joined prominent Baltimoreans John W.

McCoy, Charles J. Bonaparte, Severn Teackle Wallis, and W. W. Spence in founding the first local chapter of the Archaeological Institute of America, and among his first purchases were a group of Near Eastern cylinder seals bought nine years later in Chicago.[54] Far more ambitious were negotiations in 1902 to acquire the famed *Maiden of Anzium,* a marble discovered in 1878 among the ruins of a Roman villa off the coast at Anzio. The Italian government intervened, foiling his attempt to purchase the statue, then regarded as a masterpiece of Greek sculpture dating from the third century B.C. The piece, now demoted to the status of an early Roman copy, resides in Rome in the Museo Nazionale Romano.[55]

Henry Walters does not seem to have been particularly introspective. He is not known to have discussed with anyone his motives and intentions as a collector. However, a casual reference to the death of William Laffan, a friend and trusted advisor, as a loss to "our art movement" implied that he was imbued with a sense of mission and saw himself within the context of the burgeoning cultural life of America's Gilded Age.[56]

Henry Walters did not particularly concern himself with documenting purchases. Any records of transactions kept in his New York office have long since been discarded. He left behind few letters and, to the dismay of friends, he tended to rely on the telegraph rather than the mail, even for personal correspondence.[57] Only a few invoices survive in Baltimore, and many of these have had the prices systematically effaced. As Walters explained to the dealer Germain Seligmann, "I don't want anyone in later years to talk of my collection in terms of money spent. That is my business, they'll have the works of art and their pedigrees."[58]

After his father's death, Henry desultorily began to augment the collection. He frequented the New York galleries and auctions but bought mostly abroad. Annual spring trips to Paris began with visits to his father's elderly friend and advisor George Lucas, who, until his death in 1909, continued to seek appropriate items. One of Lucas's most notable successes was locating Barye's *Lion Hunt,* which was finally reunited in Baltimore in 1898 with other hunt groups from the duc d'Orléans *surtout de table* dispersed almost half a century earlier.[59] Lucas focused more on *objets de vertu,* ranging from commemorative medals to portrait miniatures in gold frames set with gems and precious snuff bottles, and on examples of contemporary bookbinding.

Toward the end of the century, Walters's interests broadened and the pace of his buying accelerated. In a seemingly random fashion, he might acquire an Egyptian antiquity or an Old Master painting and then turn to modern bookbindings and porcelains. It was as if the full spectrum of

artistic achievement throughout history had become his to explore. That Walters was losing neither his focus nor his sense of purpose soon became apparent.

On September 29, 1900, the *Baltimore Sun* reported that Michael Jenkins had purchased, on Walters's behalf, three houses adjoining 606 North Charles Street. Walters's intent, the newspaper disclosed, was to erect a new gallery vastly more substantial than the paintings gallery located to the rear of the Mount Vernon Place residence. This move initiated a buying campaign that, in scope, would rarely be surpassed in the annals of collecting in America. Walters interested himself "in more totally dissimilar types of art" than had any other collector that America had yet produced. His was no "magpie" assemblage, but one in which he showed his "independent judgement," asking advice when he required it, yet blaming no one if he bought a work "simply to satisfy his own curiosity."[60] Walters's purchases were directed to a goal, never publicly acknowledged, the creation of a comprehensive art collection appropriate for a museum. Whether he already envisaged a public institution can only be surmised.

Walters's initial purchases of paintings reflected a dual policy: he aimed for historical and chronological breadth, while continuing to strengthen the nineteenth-century holdings with works either predating or postdating his father's acquisitions. In 1899, he bought Delacroix's *Sketch for the Battle of Poitiers* (1829–30) through Lucas. A preparatory study for the painting in the Louvre, this work exhibits a bravura of brushstroke and an intensity of color that would have dismayed William Walters. Another of the early additions was Ingres's *The Betrothal of Raphael and the Niece of Cardinal Bibbiena* (1813), bought in New York in 1903 at the Mrs. S. D. Warren sale. At the same auction, he also successfully pursued paintings by Daumier, Troyon, and Decamps in addition to several by early masters, including a *Madonna and Child* by Raphael's teacher, Perugino.[61]

Henry Walters had ample opportunity to become familiar with French impressionism in both Paris and New York. In April 1886, Paul Durand-Ruel, the principal dealer for the movement, brought to New York a mammoth exhibition of 289 works by its leading exponents. The show opened at the American Art Galleries on Fifth Avenue and, after being augmented with pictures borrowed locally, it was moved to the National Academy of Design for the month of May. Considerable controversy was generated by the exhibition, which *Cosmopolitan* acclaimed as "one of the most important artistic events that had ever taken place in this country."

Although the merits of impressionism would be debated well into the next century, a generation of influential American patrons emerged. Many of them, including Henry and Louisine Havemeyer, James F. Sutton, and Cyrus J. Lawrence, were acquaintances of Walters and shared his interests in Barye bronzes and Asian ceramics.[62]

Walters, however, remained obdurately unreceptive to the new movement. Only in 1900, and then probably out of recognition of its historical significance rather than for any appreciation of it, did he buy his first impressionist work, Alfred Sisley's magnificent sweeping view of the Seine valley painted at Saint-Germain-en-Laye in 1875. Over the next few years, Walters added a pair of riverscapes by Fritz Thaulow, Claude Monet's Norwegian friend who had won a second-class prize at the Carnegie International Exhibition in 1897 and whose views of swiftly eddying waters were successfully promoted in this country by the New York impressionist dealer, L. Christ Delmonico.[63] In April 1902, during a stay in Paris, Henry Walters accompanied Lucas on a visit to Mary Cassatt at her rue de Marignan apartment. She persuaded him to buy two pictures from her own holdings. One, now ranked among his coups as a collector, was Monet's painting of his wife Camille seated beneath a lilac bush in their garden at Argenteuil. The other, by Cassatt's mentor Edgar Degas, is a small, haunting portrait of Degas's cousin and one-time sister-in-law, Estelle Musson Balfour.[64]

Henry Walters's successes in the field of Old Masters were mixed. In 1898, through the New York dealer T. J. Blakeslee, he purchased two canvases attributed to Sir Anthony Van Dyck, a large *Virgin and Child* that had once belonged to the Duke of Marlborough and an imposing, life-size portrait from the artist's studio which was thought to represent Prince Maurice, Count Palatine, although the subject has since been identified as Maurice's younger brother Rupert.[65]

At this time, Walters frequently dealt with Julius D. Ichenhäuser, a dealer who had maintained a gallery on Maddox Street in London before moving to New York in 1895, dropping the umlaut in his name, and opening an establishment on West Twenty-third Street. Walters's trust in him may have been misplaced. The attributions of many paintings acquired through Ichenhauser in 1901 and 1902 have not been upheld. Ichenhauser, however, figured in one of Henry's boldest and most controversial purchases — that of Raphael's *Madonna of the Candelabra*. Two pioneer collectors of Renaissance art, Thomas Bryan and James Jackson Jarves, failed in their attempts to obtain a work by the master, but in 1896 Isabella Stewart Gardner bought a version of Raphael's *Portrait of*

Tommaso Inghirami, and four years later she added a predella panel by the master to her collection. In both instances, her advisor, Bernhard Berenson, traced the works for her.

The most coveted of Raphael's subjects at that time, the Madonna and Child, continued to elude American collectors. The first example to enter the country had been the *Madonna of the Candelabra* (1514) (see plate 8). The painting had passed through the collections of the Borghese family and Lucien Bonaparte, among others, and been reduced in format before being bought by a Scot, A. H. N. Munro of Novar. In 1882, Munro shipped it to the Metropolitan Museum of Art with the expectation that the fledgling institution would purchase it. After being touched-up by the landscape painter, Frederic E. Church, the Raphael was displayed in the museum. Although initially enthusiastic, the press gradually turned tepid in its support, especially after the disclosure that another version of the composition had been located in England, and the painting was subsequently returned to its owner. Munro's nephew later mortgaged the painting for ten thousand pounds, and eventually his creditors determined to dispose of it. On June 19, 1900, Ichenhauser paid a mere four thousand pounds for the masterpiece. The following day, Warren Delano recorded in his diary that, just as his brother-in-law and party were about to embark on the *Narada* for a cruise of the Baltic, "Ycky" delivered the Raphael to the pier at Southampton.[66]

Much as Raphael's Madonnas were revered, Murillo's paintings of the Virgin of the Immaculate Conception were likewise prized during the nineteenth century. When he acquired a large, elaborately framed version showing the young Virgin soaring heavenward at the P. C. Hanford sale in New York in 1902, Henry Walters may have recalled his father's copy of the subject bought in Baltimore at the Oldfield sale fifty-seven years earlier. Sometimes Walters undertook his own bidding, usually employing a pseudonym. As "H. William" at the David H. King sale in 1905, he bought a Romney portrait and an alleged Gainsborough portrait. On this occasion, however, he left the bidding for the most costly lot, Jean-Marc Nattier's painting of the Marquise d'Argenson, to his representative, Julius Ichenhauser.[67]

Although he had not been particularly receptive to progressive movements in contemporary painting, Henry Walters took a lively interest in modern decorative arts. His purchases reflected a preference for small, highly refined works, a trait underlying his career as a collector. He was drawn, for example, to the sensuous qualities of carved ivory and through George Lucas bought statuettes by the leading practitioners of the art, notably Moreau-Vauthier and Clovis Delacour. The most ex-

ceptional of his modern ivories, however, was a figure of Amphitrite mounted on a jasper plinth, which had been exhibited by the French silver company Christofle et Compagnie at the Paris Exposition Universelle in 1900.[68] Showing the nereid wearing a gold banderole and holding aloft a sprig of coral, the ivory was based on a silver prototype, Marius Mercié's centerpiece made for the Duke of Santonia in 1878. Lucas also listed in his diaries purchases of ceramic figures, particularly those produced in biscuit at Sèvres.

In recognition of his appreciation of the various arts of the book — typography, calligraphy, illumination, illustration, and binding — Henry Walters was elected a member of the Grolier Club in 1895. As his bibliophile interests widened, he began to select works from widely ranging historical periods. At an unidentified estate sale during the 1890s, for example, he initiated his collection of Books of Hours, a field in which he would eventually excel, by paying thirty-five dollars for a minor French manuscript of the late fifteenth century.[69]

In 1897, Walters purchased some Americana and English poetry, as well as a few incunabula (books printed with movable type before 1501) from the bookseller George H. Richmond. Among them was a copy of the earliest dated edition of *Libri factorum dictorumque memorabilium* (*Memorable Deeds and Sayings*), written by the Latin author Gaius Valerius Maximus, printed in Mainz in 1471 by Johann Gutenberg's pupil Peter Schoeffer. Its splendid red morocco binding is stamped in gilt with the arms of Louis XV and the portraits of the Caesars. Although atypical of his work, the cover is impressed with the initials of the celebrated eighteenth-century binder, Antoine-Michel Padeloup. Richmond, bidding for Walters at the Marshall C. Lefferts sale in New York in 1901, bought forty books, including volumes of British and American literature, early printed books, and several illuminated manuscripts. When and where Walters acquired the first (1623), second (1632), and fourth (1685) folios of Shakespeare found in his Baltimore library after his death is not recorded, but they represented one of his earlier interests.[70] Although he gradually turned away from Americana, one of the most highly contested fields for New York collectors, Walters in 1907 acquired the draft of *The Star-Spangled Banner* that Francis Scott Key had given to his brother-in-law, Judge Joseph Hopper Nicholson. It was Nicholson who had suggested setting Key's words to the music of *Anacreon in Heaven* and arranged for the printing of the handbill bearing what would become America's national anthem.[71]

Of particular interest were the dramatic transformations then occurring in France in *reliure,* or the art of bookbinding. Under such masters

as Henri Marius Michel, Charles Meunier, Emile Carayon, and Petrus Ruban, *reliure* was undergoing a surge of creativity. New techniques and materials, including mosaic work with chiseled, incised, stained, and painted leathers and insets of often incongruous materials, such as porcelains, medallions, and prints, were exploited to their fullest. Walters shared the enthusiasm for *reliure* with several prominent American collectors, including Robert Hoe III, the founding president of the Grolier Club and most notable bibliophile of his generation. Walters's holdings assembled with Lucas's assistance, though not as comprehensive as Hoe's, included important examples of binding by most of the leading craftsmen in the field.[72]

In the early nineties, Walters patronized Tiffany and Company, the New York jewelry and silver firm that had been the recipient of acclaim at international exhibitions since 1889. Tiffany's success could largely be attributed to the collaboration of two gifted employees, George F. Kunz, a gemologist who championed the use of stones of American origin, and George Paulding Farnham, the firm's artistic director for jewelry. Their combined talents are demonstrated by a remarkable large corsage ornament in the form of an iris, exhibited at the 1900 Paris Exposition Universelle. The life-size blossom is rendered in brilliants, topazes, and Montana sapphires, meticulously graduated by hue to achieve a naturalistic effect. At this exhibition Walters also selected a large, lifelike frog of nephrite carved in the firm's lapidary studio in New York.[73]

Four years later, Henry Walters arrived at the Louisiana Purchase Exposition in Saint Louis, enthusiastic and in an expansive frame of mind. Again he gravitated to jewelry, choosing no less than nine pieces by René Lalique, one of the foremost proponents of Art Nouveau. As is implied by the title of the designer's exhibit, *Objets et bijoux d'art,* Lalique's creations were intended less to serve as articles of personal adornment than to be displayed as works of fine art, and most conveyed a remarkable sense of monumentality. Lalique's novel practice of combining precious and nonprecious materials, selected solely for their aesthetic properties, is amply illustrated by the *Pansy Brooch,* in which blossoms of molded glass and plique-à-jour enamel flank a large faceted sapphire. In its symmetrical design and use of glass, the brooch forecasted Lalique's abandonment of the Art Nouveau movement and his shift from jewelry to glass as a principal vehicle of artistic expression.[74]

Henry Walters's most audacious purchase at the outset of his career was the large cast of Auguste Rodin's *Thinker* that had been made for the

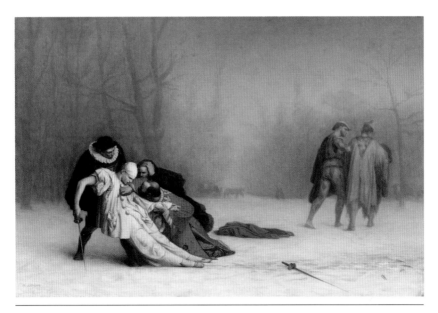

PLATE 1. Jean-Léon Gérôme, *The Duel after the Masquerade,* 1857–59, oil on canvas (WAG 37.51) (replica of the *Suite d'un bal masqué,* 1857, Musée Condé, Chantilly, France). Walters reprinted on various occasions excerpts from a review published in the London *Athenæum,* January 30, 1858. The London critic, undoubtedly alluding to the state of French morality, closed his review noting that "a finer lesson than this of M. Gérôme's has not been taught since Hogarth's time."

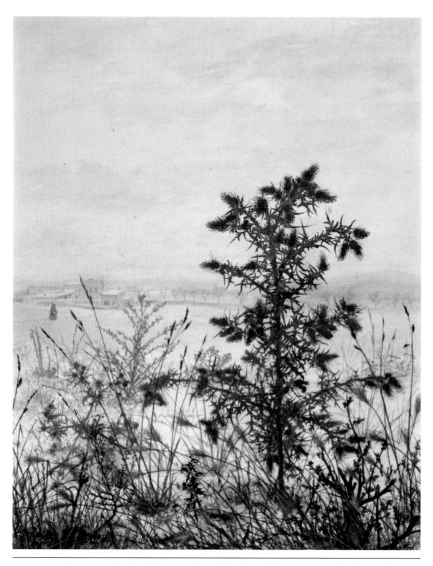

PLATE 2. Léon Bonvin, *Thistles and Weeds,* watercolor on paper, 1864 (WAG
37.1519). Walters favored the watercolors of this luckless artist who was obliged
to maintain a family café in Vaugirard on the outskirts of Paris and to restrict his
painting to off-hours, usually at dawn or dusk. After Bonvin's suicide in 1866,
Walters continued to collect the artist's works and to promote his memory.

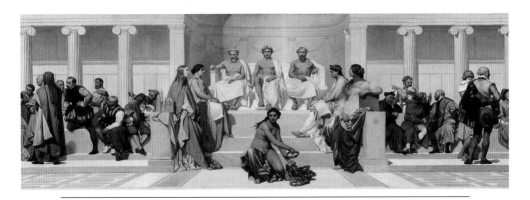

PLATE 3. Hippolyte Paul Delaroche, *The Hemicycle*, 1853, oil on canvas (WAG 37.83). In this detail showing the central section of the composition, the great artists of antiquity, Ictinus the architect, Apelles the painter, and the sculptor Phidias are seated on a raised dais. Flanking them are personifications of Gothic, Greek, Roman, and Renaissance Art. In the foreground, the Genius of Fame leans forward to bestow laurel wreaths on present-day artists.

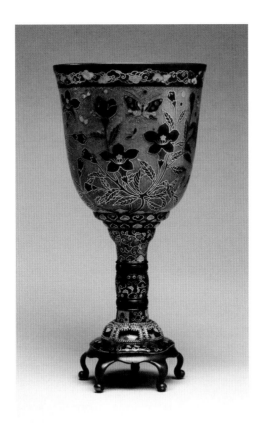

PLATE 4. The silver-and-gold goblet by Gen-ō of Kanazawa (WAG 44.531) was exhibited at the Centennial International Exhibition, 1876.

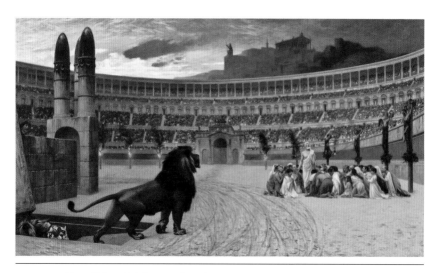

PLATE 5. Jean-Léon Gérôme, *The Christian Martyrs' Last Prayers,* oil on canvas (WAG 37.113), 1863–83.

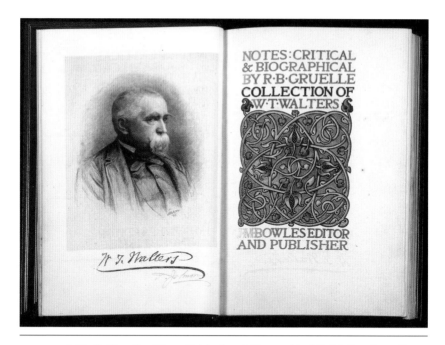

PLATE 6. R. B. Gruelle, *Notes Critical and Biographical,* J. M. Bowles, editor and publisher, from the press of Carlon and Hollenbeck, Indianapolis, 1895 (Walters Art Gallery). Bruce Rogers designed the headbands, initials, and title page. This unique copy is illuminated and contains as a frontispiece an 1893 etching of William T. Walters by F. Johnson.

PLATE 7. S. W. Bushell, M.D., *Oriental Ceramic Art, Collection of William T. Walters,* New York, 1897, section 5, pl. 16: Flambé quadrangular vase, Ch'ien-lung period, 1736–95 (Library, Walters Art Gallery). The lithographer, Louis Prang, reproduced the watercolorist's rendering so faithfully that the buildings opposite the Walters residence are reflected on the surface of the porcelain.

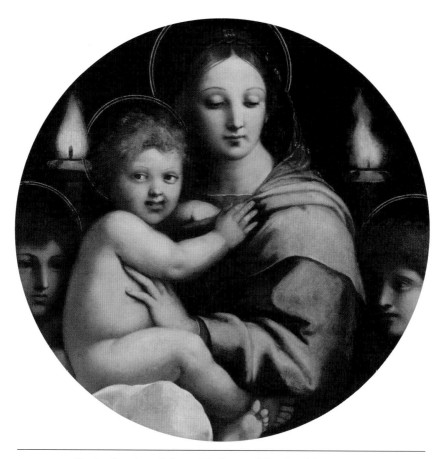

PLATE 8. Raphael and workshop, *Madonna della Candelabra* (WAG 37.484), 1513–14. This panel was the first Raphael *Madonna* to enter the United States.

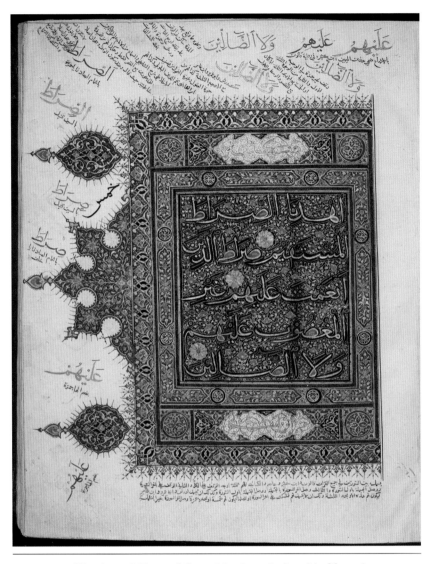

PLATE 9. Illuminated Koran, folio 9, Northern Indian (?), fifteenth century, tempera and gold on paper (W. 563).

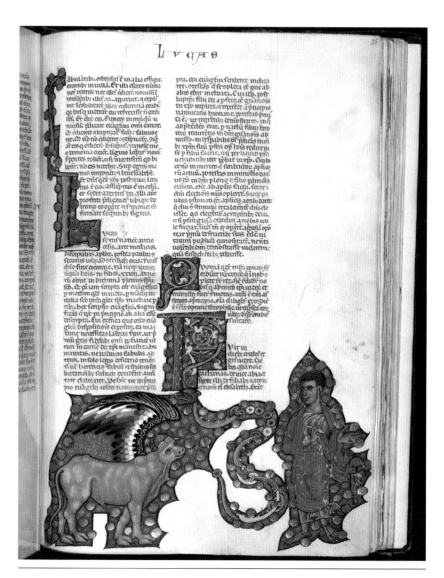

PLATE 10. Saint Luke, from the fragmentary thirteenth-century Bible
associated with Conradin, the last reigning Hohenstaufen
(WAG W.152, folio 75).

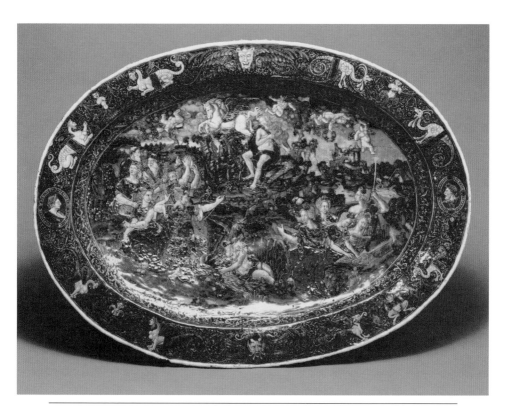

PLATE 11. Walters purchased the platter by Jean de Court showing Apollo and the Muses from George R. Harding in 1901. Painted enamel (WAG 44.207).

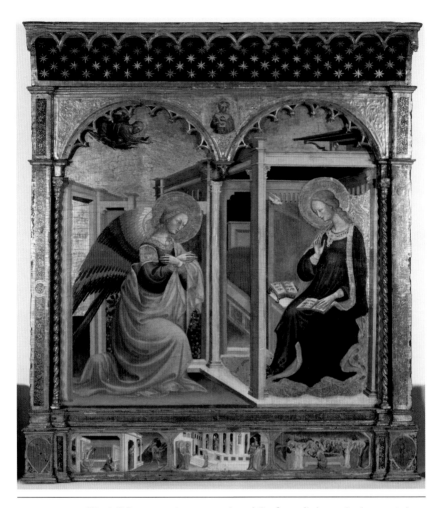

PLATE 12. Bicci di Lorenzo (1373–1452) and Stefano di Antonio (1407–83), *The Annunciation,* oil on panel (WAG 37.448). This remarkably intact, Florentine altarpiece was selected for the Walters collection by Bernard Berenson in 1912.

PLATE 13. It was a far-sighted decision by Henry Walters to purchase this jar (WAG 49.2281) at the Panama-Pacific International Exposition in San Francisco in 1915. Itaya Hazan would become one of Japan's foremost potters of the twentieth century.

PLATE 14. This small, South Italian bronze dating from the mid–fifth century B.C. (WAG 54.2291) was purchased at the John E. Taylor sale in London in 1912.

PLATE 15. Netherlandish master, about 1400, *Annunciation,* oil (and tempera?) with gold leaf on panel (WAG 37.1683a). This *Annunciation* is the outer wing of an altarpiece that belonged to the Carthusian monastery of Champmol near Dijon. Scenes of the *Baptism* and *Calvary* from the altarpiece are preserved in the Walters, whereas the *Resurrection* and *St. Christopher* are in the Museum Meyer van den Bergh, Antwerp.

PLATE 16. T'oros Roslin, Cilician Armenia, mid–thirteenth century, *Gospel Book: Letter of Eusebius,* tempera on parchment (WAG W.539, folio 2 recto).

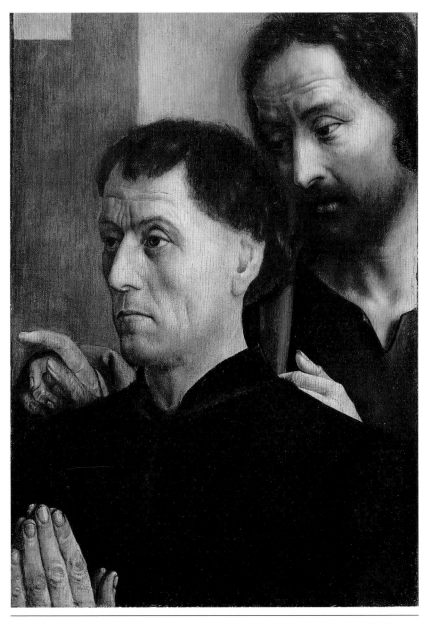

PLATE 17. Hugo van der Goes, *Donor with St. John the Baptist,* panel, about 1475 (WAG 37.296). One of the master's few surviving works, this panel was purchased from Jacques Seligmann in 1920.

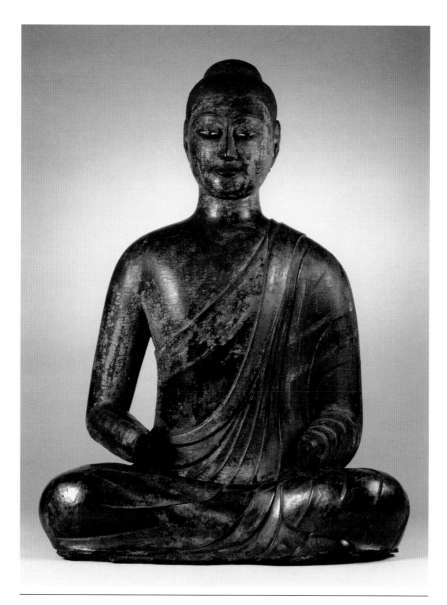

PLATE 18. *Buddha*, China, Sui Dynasty, about 690, painted lacquer over wood (WAG 25.9).

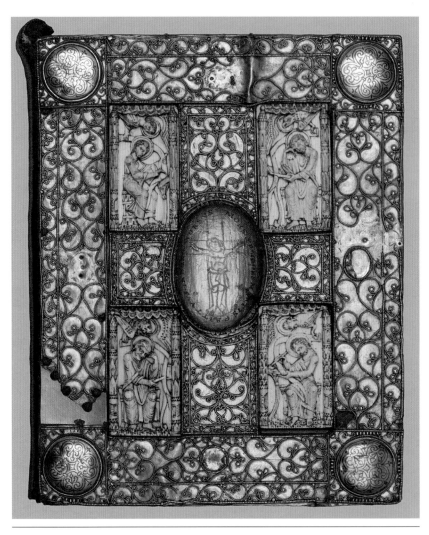

PLATE 19. The Carolingian lectionary (WAG W.8) is thought to have
come from the Benedictine Abbey of Saints Peter and Michael at Mondsee,
Austria. It was purchased from Leo Olschki's cousin, Jacques Rosenthal
of Munich, in 1926.

Saint Louis exhibition. The celebrated figure had evolved from the image of Dante on the lintel of the *Gates of Hell*, a masterpiece commissioned twenty-four years earlier. Of the *Thinker*, Rodin declared "the fertile thought slowly elaborates within his brain. He is no longer a dreamer, he is creator."[75] Walters probably regarded the controversial sculptor and most celebrated pupil of A.-L. Barye less as a modernist than as a representative of the apogee of the romantic tradition in French art. Not until two years later, when a similar cast was unveiled in front of the Panthéon, would Parisians have an opportunity to view the statue.[76]

Henry Walters systematically continued his father's practice of patronizing the Oriental displays at international exhibitions. Among his few Japanese purchases in Chicago in 1893 had been several eggshell porcelains with translucent decorative motifs by Higuchi Haruzane of Hirado. In Paris in 1900, he sought out carved ivories, including a graceful figure of a woman holding a scroll and brush by Meidō Asahi. Also acquired at the Japanese exhibit in Paris was a bronze statue representing a fisherman carrying the unconscious figure of a young woman whom he has rescued from the waves, rendered in a starkly realistic vein calculated to appeal to Western tastes. Although listed in the name of Unno Bisei, it is identified by an inscription as having been modeled by the sculptor Numata Ichiga after a drawing by Unno Bisei.[77]

At the Japanese Pavilion in Saint Louis in 1904, Walters confined his attention to major works by contemporary artists. The grand-prize winners included a tapestry entered by the workshop of Kawashima Jimbei II, a porcelain flower vase with plum tree and nightingale motifs by Miyakawa Kōzan, and Okazaki Sessei's large bronze urn. Walters paid six thousand dollars for the most expensive item, the tapestry. Depicting a thirteenth-century battle in which Japanese forces repelled the invading Mongol hordes of Kublai Khan, the tapestry demonstrates an intermingling of Eastern and Western and ancient and modern traditions. The borders incorporate Japanese stylized wave and cloud motifs, whereas the central narrative panel recalls European battle paintings both in the treatment of subject and in the illusion of spatial recession. Kawashima Jimbei II had visited France, training briefly at the Gobelins Manufactory. Walters's other outstanding purchases at the Japanese section included works by gold-medal recipients: a Satsuma-style bowl decorated in enamel by Yabu Meizan and a lacquer by Akatsuka Jitoku.[78]

Walters's interest in historical Japanese art became readily apparent at a sale held in New York by Bunkio Matsuki in February 1906. Matsuki

was one of several dealers who immigrated to Boston, drawn by the prevailing interest in Japanese art fostered by such eminent collectors as Edward Sylvester Morse, Ernest Fenollosa, and William Sturgis Bigelow. In addition to selling from his Boylston Street shop, Matsuki occasionally auctioned goods en masse.[79]

In 1906, Henry Walters, using the pseudonym "Harrison," was the successful bidder for an assortment of Japanese armor, including a couple of complete suits and a number of individual pieces—breastplates, helmets, mail sleeves—the earliest dating from the twelfth century. At the same sale he obtained two important woodcarvings, one of a snarling Buddhist guardian lion of the thirteenth or fourteenth centuries and the other of a figure of a sacred monk, dated 1347, both thought to have come from Bukkōji, a temple of the Jodo Shinshu sect in Kyoto. Also from the same source came a pair of seventeenth-century temple doors carved with peacock designs and brightly painted, and two *ramma,* or horizontal architectural panels, decorated with legendary Chinese figures and phoenixes.[80] His Chinese holdings were further enriched with purchases at the Auguste F. Chamot sale in New York in 1907. Chamot, a veteran of the Boxer Rebellion seven years earlier, had obtained early Chinese jades and several articles of dress, including an imperial ceremonial headdress of kingfisher feathers encrusted with pearls and gems.[81]

It was Dikran Kelekian, a commissioner for the Persian Pavilion, who had sold Henry Walters the ancient Near Eastern cylinder seals at the World's Columbian Exposition in 1893. Eventually, Kelekian would become one of Walters's principal sources both for ancient and Near Eastern artifacts and for Islamic art (fig. 40). The son of an Armenian goldsmith from Kayseri, Cappadocia, Kelekian and his brother Kevork opened a shop in Istanbul in 1892. After appearing in Chicago, Dikran Kelekian also established businesses in New York and Paris, which were patronized by prominent American collectors, notably Henry and Louisine Havemeyer and Walters. At the Saint Louis World's Fair in 1904, Kelekian mounted a large display, in addition to representing Persia as commissioner general, an office for which he was awarded the title Khan. In both France and America, the Kelekians flourished as vendors selling textiles, sculpture, Islamic manuscripts, ancient coins, and jewelry. Dikran Kelekian's interests were diverse, and in France, where he was known as the "Persian satrap," he assembled a remarkable collection of paintings by the Paris avant-garde and also maintained a racing stable at Chantilly.

Walters began to frequent Kelekian's Fifth Avenue establishment in

FIG. 40. Dikran Khan Kelekian. From a copy of *The Kelekian Collection of Persian and Analogous Potteries, 1885–1910* (Paris, 1910), presented to Henry Walters by Kelekian (WAG Library).

the spring of 1897, buying in a range of fields. Among his most spectacular purchases at this time was a large, early-fifteenth-century Koran said to come from the Ottoman collections in Istanbul (see plate 9). An exceptionally lavish copy, it is written in *thuluth* script in black with certain gold, red, and blue characters and is preserved in its original, blind-tooled morocco binding.[82] With this acquisition, Walters found himself in the vanguard of collectors of Islamic manuscripts, a field just beginning to open in America; a neighbor in Baltimore, Robert Garrett, started to collect after a visit to Syria in 1899, and fellow railroad financier and Atlantic Coast Line associate Morris K. Jesup financed Yale University's purchase of 843 manuscripts from Carlo, Count Landberg of Sweden.[83] What distinguished Walters from many of his contemporaries was his focus on the artistic rather than the textual aspects of

manuscripts. Undoubtedly, given his tastes, he found the emphasis on exquisite craftsmanship and exacting detail inherent in Islamic art particularly congenial.

Kelekian had been among the first dealers to recognize a potential market for Persian ceramics after excavations begun in Raqqa, Syria, in 1896 and Sultanabad and Veramin, Iran, in 1905. He assembled a large personal collection and, in 1909, published *The Potteries of Persia,* one of the earliest surveys of the field written in English. Of the thirty-six works illustrated in this study, most were from his own collection, but he also included examples belonging to H. O. Havemeyer, Charles L. Freer, and Theodore M. Davis, among others. Only four of the ceramics were from Henry Walters's collection: a fifteenth-century Nishapur turquoise plate, a mid-sixteenth-century mosque lamp decorated with *thuluth* script, and two Hispano-Moresque dishes.[84] Among the most striking of Walters's early Islamic acquisitions was a large seventeenth-century Turkish polychromed tile decorated with Koranic verse and a bird's-eye representation of the Great Mosque at Mecca. Kelekian alleged that the tile had been taken from the Hirka-i Saadet Dairesi, or the Pavilion of the Holy Mantle, in the court of the Topkapi Palace in Istanbul.[85] The dealer's invoices from this period also listed Persian and Italian textiles, a Byzantine icon, ancient Greek rings, miscellaneous Turkish and French goldsmith's work, a fifteenth-century Armenian psalm book, and some jewelry and intaglios.

In his first major foray into the antiquities market, the W. H. Forman sale held in London in 1899, Henry Walters was represented by Kelekian. Three Egyptian objects were acquired, among them a New Kingdom bronze cat with a gold scarab inlaid in its forehead, gold earrings, and eyes inset with glass pupils. In addition, Walters obtained eleven Etruscan, Greco-Roman, and Roman bronze statuettes at the London sale.[86]

The most momentous event in the international art market that year was indisputably the dispersal of the Marlborough gems. The renowned collection had been derived from several sources, its core being the cabinet of ancient and Renaissance carved and engraved gems assembled in the early seventeenth century by Thomas Howard, the second Earl of Arundel. Through a circuitous route, the Arundel gems, in 1762, passed down to George Spencer, the fourth Duke of Marlborough. A distinguished collector in his own right, Spencer also acquired the vast gem collection of William Ponsonby, Viscount Duncannon (later the second Earl of Bessborough). The combined collections descended through the Marlborough line to John Winston Spencer, the seventh duke, and were finally dispersed at a sale at Christie's in June 1899.

Henry Walters later regretted not having attended the auction in person. Instead, he sent Kelekian, whom he regarded as a "quasi-expert" on the subject. The limits for the key lots that they had set beforehand consistently proved to be too low, but the dealer, bidding at his own discretion for the lesser items, succeeded in obtaining 107 gems for prices ranging from ten to forty-five pounds. Some of these were of exceptional beauty and historical significance, including a sixteenth-century lapis lazuli cameo showing Hercules and Omphale, which originally had belonged to the noted sixteenth-century philologist Fulvio Orsini before passing through the Arundel and Marlborough collections. One wonders whether Walters, examining his purchases in the Fifty-first Street library, derived satisfaction from the knowledge that they provided a tangible link to the greatest eighteenth-century antiquarians and dilettanti, as well as to the humanists of the Renaissance.[87]

By the end of the century, Walters had adopted a routine that he would follow the rest of his life, annual spring trips in Paris. Unlike Morgan, who ensconced himself in the Hotel Bristol to await the dealers during his visits to Paris, Walters preferred to make the rounds to a few select shops. He usually began at Kelekian's, where he not only negotiated directly with the dealer himself, but also met with other dealers and their agents, the pickers, who ferreted out artifacts for the market. In this category fell some of Kelekian's compatriates, including the Gurekhians, Minassians, and Altounians, who recently had left Istanbul for Paris. As they displayed their goods, Kelekian, standing behind them, would nod to Walters his approval or disapproval.[88]

Equally cordial relations were established with Seligmann and Company, a firm specializing in medieval and Renaissance art founded by Jacques Seligmann in 1880. Since 1900, it, too, had been located on the fashionable Place Vendôme. Among Seligmann's specialties were French Gothic ivories and champlevé enamels, Italian majolica and Limoges painted enamels, and sculptures and tapestries from the Renaissance period through the eighteenth century. Walters's lasting association with the firm began in 1902, when he purchased several Limoges enamels, including a pair of salts decorated with scenes from the story of Actaeon by the sixteenth-century master Pierre Reymond. Like much of Seligmann's early stock, these pieces had come from the Frédéric Spitzer collection of over four thousand *objets d'art,* which had been dispersed in Paris in 1893. In 1902, Seligmann dispatched Emile Rey to New York as his American representative. Rey lost no time in contacting J. Pier-

FIG. 41. *Léon Gruel,* etching; signed *C. Jacquemin, fils,* inscribed
L. Gruel, 27 mai 1911 (WAG Archives).

pont Morgan and Henry Walters, both of whom became steadfast clients, buying in New York works comparable to those offered at the Paris headquarters.[89]

Léon Gruel, whose venerable house traced its roots in Paris to 1811, was on much the same footing with Henry Walters (fig. 41). Located on the rue Saint Honoré, Gruel listed himself as a specialist in deluxe book-bindings, manuscripts, rare books, and marriage and communion albums. Gruel, like Kelekian, had participated in the 1893 Chicago Exposition, exhibiting a case of deluxe bindings in the book department. As early as 1896, Walters, preferring Gruel's craftsmen to those of the Grolier Club's bindery, founded a year earlier, commissioned the Paris firm to bind several of the club's own publications.[90] During the early years of the twentieth century, the largest payments recorded by Lucas on behalf of Walters were to Gruel, often for sums in excess of eighty thousand francs.[91] One invoice from 1903 listed as many as forty-eight items, including a late-tenth-century Gospel Book thought to have come

from the Benedictine Abbey at Saint-Benôit-sur-Loire, numerous Books of Hours of the fourteenth and fifteenth centuries, a large Missal completed in Paris in 1425–35 for use in Nôtre-Dame, several incunabula, and even a couple of carved ivories of the Virgin from the seventeenth and eighteenth centuries.[92] Many of the codices acquired at this time contained bookplates with the names of Gruel and Engelmann, suggesting that Gruel's stepfather, Jean Engelmann, might also have been involved in the transactions. Whenever their condition warranted it, Gruel had the manuscripts rebound in various antiquarian styles, often using a distinctive crimson velvet.

The dealers whose shops Walters normally patronized conducted their business with rectitude and decorum; bickering over prices seems not to have been an issue. With Leo S. Olschki, however, dealings were less direct. One of the most influential booksellers of his generation, Olschki had emigrated from eastern Germany to Verona in 1883 and opened a shop. In 1890, as business prospered, he moved to Venice and then to Florence, where he established the Libreria Antiquaria Editrice Leo S. Olschki near the Ponte Vecchio. A loquacious salesman, he customarily sought to ingratiate himself with his clients and at the same time to negotiate prices, a practice that for some was off-putting.[93]

In the autumn of 1903, Walters first encountered the firm. The following January, Olschki wrote to the collector to introduce himself as "a connoisseur so expert that the discernment will never be wrong" and also to assure the American that the book trade had no unscrupulous Italian forgers and restorers, such as those who abounded in the other arts, notably painting and sculpture. Two months later, Walters ordered several incunabula and a manuscript, a Burgundian fifteenth-century chronicle.[94] Even the intrepid Olschki, however, must have been unnerved when Walters marched into his shop in the summer of 1905 and bought the "wallfull" of incunabula then in the process of being catalogued. This collection of more than one thousand titles represented virtually the dealer's entire stock. Walters insisted that Olschki finish the catalogue and enhance the holdings with additional purchases. That October, in accordance with these instructions, the dealer bought at the Franz Trau sale in Vienna two block books (books printed from engraved wood blocks, a technique paralleling the development of typography).[95]

Olschki and Walters continued to correspond, adding to the collection and exchanging page proofs. A handsome publication, *Incunabula Typographica,* was printed in Aldine Florentine type on "handwriting" paper and bound in calfskin in a Renaissance revival style.[96] Walters wrote a brief preface placing the publication within the context of stud-

ies that had already been undertaken by French and German biblio-
philes. He not only sent copies to libraries and museums in both this
country and abroad, but also subsequently continued to present the
book as a special gift to fellow financiers and collectors, including An-
drew Carnegie in Pittsburgh and Charles Lang Freer in Detroit, and to
prominent members of the scholarly and cultural community.

In 1905, Olschki also provided Walters with one of his most spec-
tacular manuscript purchases, a portion of a large, richly ornamented,
thirteenth-century Bible (see plate 10). According to a note, no longer
extant, the manuscript had been commissioned in Sicily for Conradin,
the last of the Hohenstaufen line in Italy; the hapless boy-emperor was
beheaded by his Guelph opponent after the battle of Tagliacozzo in
1268. The Conradin Bible verifies the existence in southern Italy in the
thirteenth century of a school of illumination that drew upon Byzantine
sources.[97]

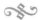

Although Olschki hoped that he would serve as Walters's sole European
supplier for rare books, this was not to be. Walters continued to patro-
nize the Florentine bookseller, especially for printed books and Italian
manuscripts, but he also occasionally dealt with such noted London
dealers as Martin Breslauer and Bernard Quaritch.

In the spring of 1899, the art and architectural connoisseur Russell
Sturgis wrote to General Charles G. Loring, director of the Museum of
Fine Arts in Boston, ruefully noting that Ferdinand Ongania, a noted
Venetian publisher-turned-dealer, had for sale "some splendid carved
ivories" but that, unfortunately, the "omnivorous collector, Mr. Walters
of Baltimore," had snapped them up three days earlier. Although only a
few works in the collection can be documented as coming from Onga-
nia, Walters's relationship with the Venetian must have been extremely
cordial. In 1906 a small book, *A Glance at the Grimani Breviary*, pub-
lished by Ongania, was dedicated to Walters, a "lover and collector of all
things beautiful in art and letters."[98]

For reasons never stated, Henry Walters did not fully delve into the
London art market. He relied almost solely on George Robinson Har-
ding, whose shop on Saint James's Square, off Pall Mall, in the heart of
the fashionable club district was much patronized by collectors. The
Saint Petersburg jeweler Peter Carl Fabergé once stopped at Harding's
during a visit to London and was astonished to see displayed a portion of
Catherine the Great's imperial dinner service commissioned from Wedg-
wood. Listing himself as a "buyer and cataloguer of collections," Har-

ding specialized in metalwork and enamels. His earliest invoice to Walters, in 1899, listed four items, including one of Henry Walters's first medieval purchases, a mid-fifteenth-century iron tabernacle door from the abbey of Saint Loup near Troyes in eastern France.[99] Its intricately chiseled iron trelliswork serves as a memento of Saint Loup's extraordinarily rich, flamboyant, late Gothic abbey church dedicated in 1425.

In 1901, Harding provided Walters with his first significant early Renaissance enamel, a large oval platter painted in Limoges in the third quarter of the sixteenth century by Jean de Court, an artist then extolled as the French court's "new Apelles." On Mount Helicon, Apollo plays a viol, surrounded by the Muses, a river nymph, and putti and with Pegasus flying overhead (see plate 11). Such works evoke Renaissance garden landscapes, with settings of rock formations and a grotto. The platter had been damaged in the 1870 fire in the Pantechnicon, the Belgrave Square art bazaar, but nevertheless had passed through the superb medieval and Renaissance collection which Sir Richard Wallace assembled in the 1870s for Hertford House, London's future Wallace Collection.[100]

The following year, Walters found himself competing with J. Pierpont Morgan for a controversial work, the *Vierge ouvrante de Boubon,* which he might well have assumed would truly launch his medieval collection. The monumental, carved ivory of the enthroned Virgin and Child, said to date from the second quarter of the thirteenth century, opens to form a triptych showing scenes from the Passion and Resurrection of Christ. One of several such statuettes, this particular example is thought to have belonged to the Priory of the Convent of Boubon, near Oradour-sur-Vayres in Limousin, until the French Revolution. Rediscovered by Maître Sailly, a notary in Limoges in the late nineteenth century, the ivory was exhibited at the Exposition Universelle in 1900 and was then sold by Jacques Seligmann to an English collector. When the ivory appeared on the London market in 1902, the dealer Durlacher placed an unsuccessful bid on Morgan's behalf, and the ivory was subsequently acquired by Walters through George R. Harding for an undisclosed price.[101]

Lapses in judgment were inevitable. The Nuremberg Castle collection of torture instruments remains Walters's most anomalous purchase (fig. 42). Was he swayed by twinges of Gothic romanticism from childhood reading or by the collection's purported value as a lesson in man's inhumanity to man? The collection's implied associations with Germany's reigning house, the Hohenzollerns, undoubtedly enhanced its appeal.

The previous history of the collection remains enigmatic. A nineteenth-century German antiquarian named Geuter is thought to have assembled the conglomeration of more than 625 implements, including

FIG. 42. The Torture Chamber, Nuremberg Castle, early-nineteenth-century engraving (WAG Archives).

gallows hooks, iron branks or masks, executioners' swords, manacles, thumb-holders, whips, and pillories, and an equal number of prints illustrating their use. These he exhibited in the Burg, by then a municipally owned castle, providing Nuremberg with one of its principal tourist attractions.[102] The *pièce de résistance,* from all accounts, was the "Celebrated Original Iron Maiden," a "terror-inspiring," two-part, wooden contraption fitted with iron spikes, which, when closed, would impale the occupant. It was said to have been removed from Nuremberg during the Napoleonic Wars, only to be recovered five decades later by Geuter

in Eisenach, Thuringia. According to Dr. Kehlen, Geuter's son-in-law, the wooden device had so deteriorated that it had to be reconstituted using many of the original materials. Fortunately, there were a sufficient supply of these to fabricate not one but two maidens, the more original version that was sold with the collection and a largely duplicate copy that was retained for the castle. Whether either instrument was genuine or whether any such device had ever been employed in Nuremberg remains open to question.[103]

As agent for the eighteenth Earl of Shrewsbury and Talbot, Julius Ichenhauser purchased the collection in 1890, and with the earl's permission he sent it on an exhibition tour in Great Britain, showing it in London in Louis Tussaud's Maddox Street Galleries. As was customary with such enterprises, the press plaudits were reprinted in a souvenir booklet. The *London Times* (November 9, 1891), for example, proclaimed it "an attractive exhibition . . . will no doubt be visited by all who are interested in the history of a happily bygone age," and the more sanguinary *London Morning Advertiser* (May 18, 1891) reported that "it may be safely affirmed that there is no more comprehensive and reliable collection of its kind in the world."[104]

Five years later, Ichenhauser shipped the instruments to New York and launched a marketing campaign that would have been the envy of a contemporary museum publicist; an illustrated catalogue and special stationery were printed, press passes were issued, and a program of lectures was organized, all to entice the public to pay twenty-five cents to view the horrors at the dealer's West Twenty-third Street address. In early 1905, Ichenhauser induced Walters to pay an undisclosed amount for the collection, together with the "Criminal Library" accompanying it.[105] Walters soon realized that he had made a mistake. According to local lore, in deference to the wishes of his Charles Street neighbor, James, Cardinal Gibbons, he never displayed the instruments in the Baltimore gallery.[106]

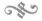

The year 1902 was momentous for Henry Walters; even while masterminding various railroad coups, he found time to negotiate the purchase of the Massarenti collection of over seventeen hundred works of art. In scope, it was an acquisition then unprecedented in the annals of American collecting and one that provided Walters with the core for a museum of European art from ancient Etruscan times through the eighteenth century.[107]

Though frequently identified as an archbishop or cardinal, Don Mar-

cello Massarenti was, in fact, a priest from the central Italian town of Budrio. During the 1848 republican uprising, he helped Pius IX escape from the Quirinal and flee south to Gaëta. After his restoration, the grateful pope welcomed Massarenti to the papal court and appointed him a *sotto elemosinere* or under-almoner, a fiducial agent in the Apostolic Aumbry. In this position, Massarenti traveled extensively in Italy and abroad, receiving as international recognition an Austrian knighthood and the Order of the Red Eagle of Prussia. His affable personality was said to have facilitated dealings with archaeologists and art dealers. Massarenti was recalled as a passionate collector and a typical Roman prelate of the period, "jolly, corpulent, not too tall, and intelligent," characteristics conveyed in his portrait bust by the fashionable sculptor, Leonardo Bistolfi (fig. 43). Wilhelm von Bode, director of the Kaiser Friedrich Museum in Berlin, presented a less flattering image of the priest, whom he remembered as a wily individual who had ingratiated himself with the highest ranks of the clergy and then, exploiting their weaknesses, amassed the wealth to indulge his taste for art.[108]

Massarenti resided in a tiny apartment in the Vatican on the top floor of the courtyard of San Damaso. From his window he overlooked the dome of Saint Peter's, which he frequently maintained "could only have been created by a pious individual fearful of God." He stored his collections in space rented in the Palazzo Accoramboni at number 18 Piazza Rusticucci, a structure that was demolished by the Fascist government to make way for the via di Conciliazione.

The second half of the nineteenth century was a fortuitous moment to be collecting in Italy. During the upheavals of the Risorgimento, many old families became impoverished, religious houses were suppressed, and their possessions dispersed. Furthermore, archaeological discoveries had become frequent, and the dispersal of finds had yet to become the subject of rigorous government regulation.

Little is known of the early history of Massarenti's collection. In 1881, when he contemplated selling it to Prince Hohenlohe of Strasbourg, Massarenti published a catalogue listing 233 Italian masters, 66 northern artists, and 10 contemporaries.[109] At a time when the connoisseurship of early Italian painting was still in its infancy, the works were assigned attributions that usually cannot be reconciled with current scholarship. This early publication, however, provides a few rare clues to sources for the collection. Among eight important paintings listed as having belonged to Prince Hercolani of Bologna, for example, were three by Bolognese masters Bartolomeo Passerotti, Lavinia Fontana, and Antonio Pirri (listed as Lorenzo Costa the Elder). Other pictures came from

FIG. 43. Leonardo Bistolfi, *Bust of Don Marcello Massarenti,* bronze, about 1887 (location unknown) (photograph, WAG Archives).

the Convent of the Magdalene in Pesaro, the Agostini family of Sasso-
ferrato, the church of San Francesco in Perugia, and Count Piccolomini-
Scarelli of Siena. Undoubtedly, many agents served as intermediaries in
these transactions, although the names later recalled by Massarenti's
servant were limited to "Ruggeri, Filippo Tavazzi, and Camponi."[110]

Massarenti continued to buy and, in 1897, issued a much expanded,
two-part catalogue. The first section, written by Edouard van Esbroeck,
a Belgian painter of religious subjects and recipient of a *prix de Rome,*
included entries for 478 pictures by Italians, 12 by Spanish, and 365 by
northerners. The author unequivocally disclosed the intent of the cata-
logue with his announcement that, "after having examined most of the
galleries of Europe, he would not hesitate to declare that the collection
in question would enhance the renown of any foreign city."[111] His ten-
dencies to err on the side of optimism in his attributions and excessively
to invoke the names of Raphael, Michelangelo, Tintoretto, Poussin, and
Rembrandt cast a pall over the reputation of the collection. James Henry
Duveen recalled a visit to the Accoramboni Palace that quickly termi-
nated when his uncle Joseph stalked out, muttering that everything was
ghadish (Hebrew for *new,* but implying imitation).[112]

Although Joseph Duveen may have refused to recognize any of the
paintings as worthy of being marketed as "Duveen pictures," the collec-
tion abounded in outstanding works by less familiar and anonymous
artists. By cross-referencing catalogue entries with photographs of the
dimly lighted, cluttered interior, one can still identify many items. Two
works, for example, were attributed to Margaritone d'Arezzo, an artist
once disdained as "a rude follower of the Byzantine school" who was
responsible for "crucifixes, portraits of Saint Francis, etc., of a repul-
sive type." Even J. A. Crowe and G. B. Cavalcaselle, the noted late-
nineteenth-century art historians, dismissed Margaritone as a represen-
tative of a "degenerate style" and maintained that he would "never have
emerged from obscurity had not Vasari been moved by a laudable desire
to rescue the art of his native city from oblivion." One, a large altarpiece,
is now valued as an important example of Florentine art produced under
the influence of Cimabue in the late 1280s. The other picture ascribed to
Margaritone, a fragmentary panel showing the mourning Virgin, fared
better: it was listed as *un de plus beau spécimens de la peinture italienne
avant Cimabüe et Giotto* and is presently identified as being by a late-
twelfth- or early-thirteenth-century artist working close to Alberto di
Sotio of Spoleto. Likewise, the *View of the Ideal City,* depicting a town
square flanked by monumental buildings, was originally attributed to

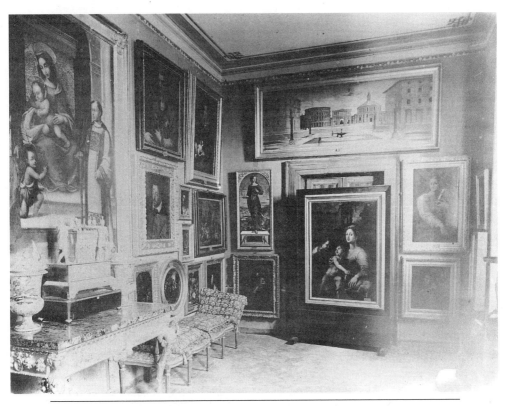

FIG. 44. Interior of Palazzo Accoramboni, Rome, about 1902. Readily identifiable on the end wall are the *View of an Ideal City* by an unidentified artist (WAG 37.677), Giulio Romano's *Madonna and Child with St. John the Baptist* (WAG 37.548), and Pietro Orioli's *Sulpicia* (WAG 37.616) (WAG Archives).

Pinturicchio (fig. 44). The authorship of this astonishing illustration of perfect, one-point perspective has continued to confound art historians and is now assigned to a Central Italian artist of about 1500.[113]

Among the northern works was a vast *Panoramic Fantasy with the Abduction of Helen of Troy* reputed to be by Paul Bril, the Antwerp artist much noted in nineteenth-century literature (fig. 45). The painting is now recognized as a masterpiece by a then less familiar figure, Maarten van Heemskerck. Listed in the catalogue without comment is a dramatic, candle-lit representation of Judith beheading the Assyrian general, Holofernes. It is attributed no longer to Gerard Honthorst, but to a French painter known as the Candle-Light Master who worked in Rome under the influence of Caravaggio. Such a painting must have seemed an

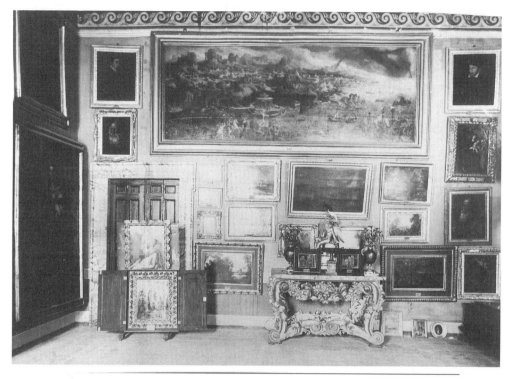

FIG. 45. Maarten van Heemskerck's *Panoramic Fantasy with the Abduction of Helen* (WAG 37.656) dominates the back wall of the gallery. Monsù Desiderio's two small paintings *Saint Paul Preaching to the Athenians* (WAG 37.328) and *The Head of Saint John the Baptist Presented to Salome* (WAG 37.329) are discernible on the table (WAG Archives).

anomaly to an American collector, given the prevailing aversion to Italian Baroque art, which had been nurtured by John Ruskin and his influential American disciple, Charles Eliot Norton of Harvard University.[114]

The second half of the 1897 catalogue, devoted to the "Museum," was written in a slightly more informative manner by authors identified only as "U.e M.P." Its subdivisions included "Roman and Etruscan artifacts," "Renaissance and Modern Works," and "Marbles." Clearly recognizable in the early photographs are the pride of the "Museum," seven marble sarcophagi dating from the mid-second to early third centuries (fig. 46). These had been unearthed in the spring of 1885 in a triple burial chamber under the via Salaria on the outskirts of Rome. The excavation had also yielded three other sarcophagi and sixteen portrait heads, along with some inscribed funerary altars, connecting this private cemetery to the Licinii and Calpurnii Pisones families. The sarcophagi can be linked

to a mystery cult centered on the worship of Dionysos-Sabazios and are carved in relief with scenes illustrating the god's birth, growth, and decline in the annual cycle of nature, his triumphant appearance in the world, his marriage with Ariadne, and his permanent victory over evil and death. The largest and most magnificent example shows Dionysos's return from his victorious campaign in Ethiopia and India.[115]

After their discovery, the sculptures were removed to the residence of Clemente Maraini, an engineer and director of the Banca Italia di Costruzioni, which owned the site. In 1887, Maraini offered the sarcophagi to Carl Jacobsen, the Danish brewer and founder of the Ny Carlsberg Glyptothek, who had already acquired the portrait busts from the tomb, including the ancestor portrait of Pompey the Great (106–48 B.C.). When this sale failed to materialize, Maraini sold them to Massarenti.[116]

The "Museum" also excelled in its holdings of Etruscan and Roman

FIG. 46. The "Museum" of the Palazzo Accoramboni showing sarcophagi of the Calpurnii Pisones family and miscellaneous sculptures, about 1902. On the end wall is the sarcophagus with the Triumph of Dionysos-Sabazios (marble, WAG 23.31) (WAG Archives).

bronzes. Among them were two fragmentary remains of haunting, imperial portraits. One is unmistakably a likeness of Augustus in early middle age, and the other depicts a Julio-Claudian prince, perhaps Tiberius. Both were part of a cache discovered in Rome in 1880 during construction of the English Church on the via Babuino. They may have been concealed to prevent their destruction after the fall of Nero in A.D. 65.[117]

Other remarkable fragments with imperial associations include a partially gilded horse head and a sword and sheath believed to be remnants of an equestrian monument. Related to an 1881 find at Castelleone di Suasa on the Adriatic coast, these pieces are thought to have been sold to Massarenti by the owner of the site, Emmanuele Spiroli.[118]

Highlights of Massarenti's "Museum" from earlier periods included five cistae from Praeneste (now Palestrina), a Latin-speaking city located about twenty miles east southeast of Rome (fig. 47). These cylindrical, bronze toilet cases, dating from the third and fourth centuries B.C., are set with cast bronze feet and handles in the form of nude men and are incised with mythological and battle scenes which, in subject matter, seem oddly at variance with the function of the vessels. Even older were several large bucchero (thick, black, unglazed ware) vessels with molded zoomorphic and anthropomorphic decoration, originally catalogued as Phoenician but subsequently identified as Etruscan, seventh century B.C.[119]

The Renaissance and modern holdings were fewer but included items of great rarity and historical interest. In this category fell a copper box with peculiar figurative and animal motifs, chased and worked in repoussé, which has continued to frustrate scholars, who have assigned to it various Near Eastern and Caucasian origins, even though it was listed as having been found near Pescina in south central Italy. Interspersed among mortars and door knockers were two rare bronze plaques from a church door, one showing in high relief a three-turreted castle and inscribed CASTRUM FARE DABRILE (the castle of Fare d'Abrile) and the other bearing a geometric design. They had been commissioned for the church of San Clemente a Casauria in Abruzzi by Abbot Joel in the late twelfth century.[120] The collection of terra cottas included several glazed sculptures, a wall tablet from Deruta, and some historiated plates, all of which would serve as the nucleus of a majolica collection. Most of the furniture, as well as the clocks listed in the catalogue, would eventually be withdrawn from the sale.

By the end of the century, the aging prelate had determined to dispose of the entire collection. Unable to persuade Bode and the Berlin Museum to buy it, he turned to America, where he hoped that it might be

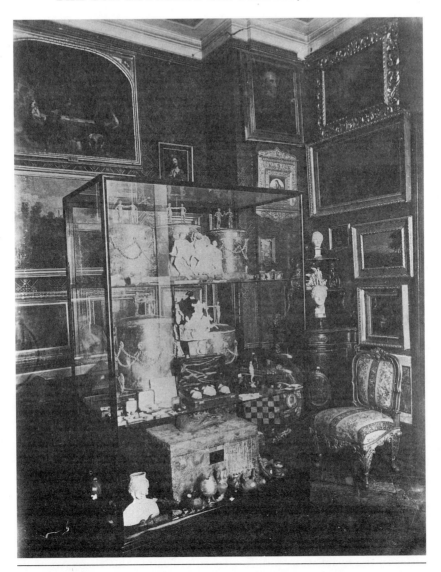

FIG. 47. Displayed on the upper shelves of the vitrine are the Praenestine cistae dating from the fourth to third centuries B.C. and on the bottom shelf is a copper box of unknown origin believed to date from the twelfth or thirteenth centuries (WAG Archives).

preserved intact as a personal memento. For unknown reasons, Massarenti retained as his representative Dr. Joseph H. Senner, a journalist and former commissioner of immigration for New York.[121] Senner initially sought a New York buyer, and then, either directly or through the journalist–art expert, William M. Laffan, notified Walters of the availability of the collection.

Laffan, Charles Dana's successor as publisher of the *New York Sun*, was an influential figure in matters of taste at the turn of the century. Also an artist and a critic with wide-ranging interests, the Irish-born journalist moved with ease at different levels of New York society. With his glass eye, Van Dyke goatee, and invariably formal attire, he could readily be identified at any gathering. Ever since supporting the purchase of the peach-bloom vase at the Mary J. Morgan sale in 1886, he had remained on a "Dear Harry" basis in his correspondence with Walters. He had also served as an advisor to J. Pierpont Morgan for his purchases, particularly those in the field of Chinese porcelains. Grief-stricken by Laffan's unexpected death in 1909, Walters would join Morgan, Thomas Fortune Ryan, and other leaders of the business and arts communities in riding out to Lawrence, Long Island, to attend the publisher's ecumenical funeral service. Reflecting Laffan's breadth of culture, it included Buddhist and Confucian texts and passages from the Egyptian Book of the Dead, interspersed with psalms and the Lord's Prayer.[122]

Once the Atlantic Coast Line–Plant System merger had been finalized in March 1902, Henry Walters and Laffan hastened to Rome. They stopped in Paris en route only long enough to visit the dealer Raoul Heilbronner at 3, rue du Vieux-Colombier, to examine what would become the largest item to enter the collection, the more than twenty-two-foot-high, partially gilded wrought-iron gate from the choir screen of the cathedral of Saint Pierre in Troyes.[123] In Rome, a daunting task awaited them. The pictures were hung floor to ceiling in high, dimly lit rooms on the Accoramboni Palace's *piano nobile*. There was no apparent order to the installation and, further complicating this chaos, some of the works had undoubtedly received the overly attentive ministrations of the painter-restorer Filippo Laurenzi and his colleagues. Erratically scattered throughout these rooms were quantities of furniture and cases containing the "Museum's" assorted holdings. Only the "Marbles" were relatively accessible for viewing in an annex adjoining the palace.

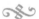

Although he would later maintain that he spent a month studying the collections, Walters must have acted in blind faith when he completed

the purchase in slightly over a week. By the terms of the contract signed on April 16, 1902, Senner was to deliver the art, crated for shipment, to Rome's port, Civitavecchia, by July 1, and Walters was to furnish a ship for its transportation to America. Jacques Seligmann's associate Émile Rey was designated Walters's representative, and the price finally accepted was five million French francs, or about one million dollars. Both parties agreed to donate to the Italian government several of the collection's pearls, chosen by Adolfo Venturi, the Roman art expert. In return, the government would waive export taxes. Wilhelm von Bode, Venturi's German rival, caustically claimed that the selection included a Raphael self-portrait later acknowledged to be a modern forgery and a Philippe de Champaigne *Portrait of Bernini* that proved to be a copy of a painting in the Louvre. Other works withdrawn for the government were a bronze bust of Caracalla, a fragment of a male torso showing genitalia, and an inscribed Roman tablet.[124]

True to character, Henry Walters postponed the announcement of his purchase until long after rumors trickling from abroad had become an embarrassment. The news was greeted with enthusiasm by the American newspapers. The foreign press, however, particularly in Berlin, expressed skepticism. A correspondent for a daily paper ridiculed the pretentious attributions in the 1899 catalogue but conceded that the collection included some worthy early pictures, citing Crivelli's *Madonna and Child with Saints*. He concluded that Herrn N. N. of Baltimore had been duped by an ignoble, cheeky German academic into paying thirty to fifty times too much.[125] Likewise, another journalist, almost a year later, must have been alluding to the Massarenti collection when he assailed Americans for decorating their living rooms with sarcophagi. He also reported that the Italian capital, fearing the onslaught of foreign looters, was trembling as it had at the tread of myriads from Gaul and Carthage.[126]

On July 16, 1902, the SS *Minterne* docked in New York with a cargo of 275 crates of art, some weighing over three tons. These were transferred to warehouses in Manhattan, where their contents were laid out for thorough examination. Walters anticipated disposing of at least 25 percent of the Massarenti collection.[127]

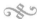

By now a gallery building to house the Walters holdings was essential. Whether overly committed by the takeover of the Louisville and Nashville Railroad or out of concern for the 1903 economic downturn, Walters moved deliberately. In Venice that summer, he encountered William Adams Delano, who happened to be visiting Cornelius Vanderbilt on

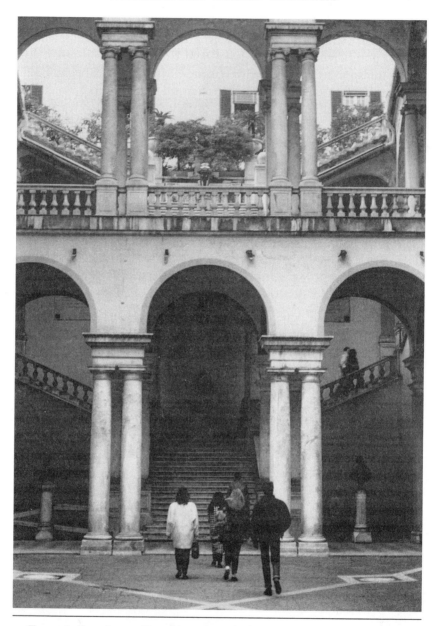

FIG. 48. Bartolomeo Bianchi, courtyard of the early-seventeenth-century
Collegio dei Gesuiti (Palazzo dell'Università), Genoa. Courtesy of
Robert Bergman, 1986.

the yacht *The North Star,* which was moored next to the *Narada.* Delano had recently received a diploma in architecture from the École des Beaux-Arts and was touring northern Italy. Impressed with the young architect and aware of his close friendship with Warren and Jennie Delano and their daughters, to whom he was affectionately known as "Uncle Billy" even though their blood ties were remote, Walters invited him on rounds of the Venetian antique shops.[128]

Delano returned to New York and joined Chester Holmes Aldrich in establishing the firm of Delano and Aldrich. That winter, shortly after the disastrous fire that ravaged twenty-four blocks of downtown Baltimore, Walters invited him to lunch. Inevitably, their conversation turned to the Italianate marble library, designed by Charles F. McKim, then being erected for J. Pierpont Morgan on a site adjoining his Madison Ave-

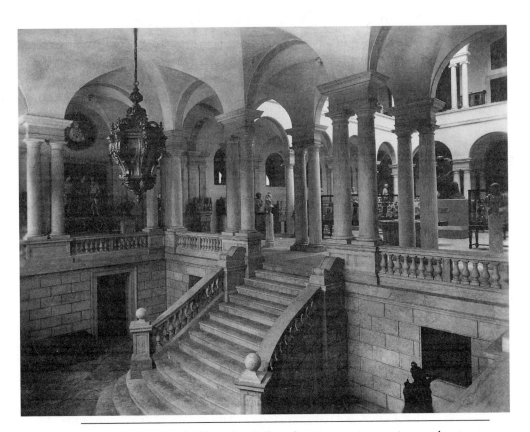

FIG. 49. Interior of Walters Art Gallery showing entrance staircase, about 1909 (WAG Archives).

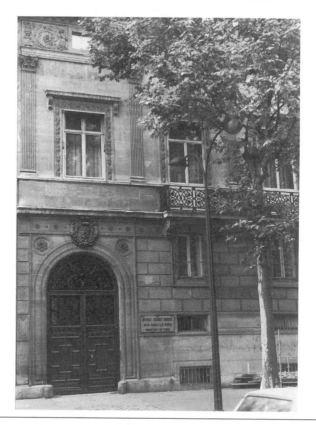

FIG. 50. Hôtel Pourtalès, rue Tronchet, Paris. The hôtel was constructed after the designs of Félix Duban for Count James Alexandre de Pourtalès in 1836. Photograph by the author, 1997.

nue residence. Delano recalled Walters's comments as follows: "Now McKim, I think, is the greatest architect in this country, but he is too damned stubborn. I want to build a gallery in Baltimore for all the treasures my father and I have collected, and I am going to give you boys the chance, provided you do what I tell you." "It was an outstanding example of faith, hope and courage," Delano remarked, since neither he nor Aldrich "had built even a chicken-coop."[129]

A palazzo-like structure was proposed. The steep incline on Washington Place reminded the architect of Genoa, where Baroque palaces were similarly sited. He therefore took as a model the early-seventeenth-century Collegio dei Gesuiti (now the Palazzo dell'Università) built by the Balbi family for the Jesuits after plans of the architect Bartolomeo

Bianchi (fig. 48). The core of Delano's building is the sky-lit courtyard which, in its articulation of marble, paired columns, arches, and pilasters and its divided staircase, approximates the Genoese prototype. The loggia on the upper level is flanked on three sides by large, sky-lit picture galleries rather than the study halls found in the Genoese building, and on the ground floor the court is surrounded by a series of smaller rooms. Incorporated on the south side is a coffered wooden ceiling carved by two Milanese artisans, Ambrogio da Ello and Gianpietro Alfieri, in the middle of the sixteenth century. This ceiling from the Palazzo Aliverti in Milan was acquired by Walters through the Venetian dealer Guiseppe Piccoli in the summer of 1903.[130]

During the project Delano frequently consulted McKim, an old family

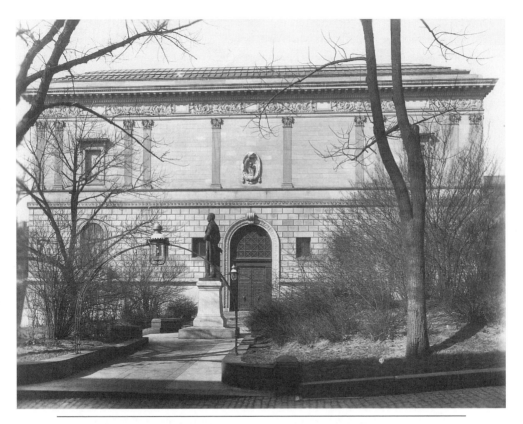

FIG. 51. The Walters Art Gallery, 1909. Laurent Marqueste's statue of Severn Teackle Wallis, a prominent Baltimore lawyer, was moved away from the museum entrance on the south branch to the east branch of Mount Vernon Place about 1921 (WAG Archives).

friend. When they looked together at plans for the steep staircase con-
necting the vestibule to the first floor, the elder architect's mind seemed
to wander and he began to ruminate on the nature of stairs in general.
Delano assumed, at the time, that his friend was growing senile. Only
later did he realize that McKim had been tactfully cautioning him about
the pitch of the stairs. "So there they are," Delano ruefully recalled,
"those brutal stairs of mine, because McKim was kind and I was obtuse"
(fig. 49).[131]

For the exterior, Delano looked to Paris. In the mid–nineteenth cen-
tury the Hôtel Pourtalès, on the rue Tronchet behind the Madeleine,
housed one of France's richest private art collections. When opened to
the public, this collection was an attraction for countless visitors, includ-
ing the Walters family on their first trip abroad in the early 1860s. The
Hôtel Pourtalès is the masterpiece of the architect, Félix Duban, who
is remembered for his ultra-refined neoclassical style based on studies
of Florentine Renaissance architecture (fig. 50). Features that Delano
adopted from its facade include the division of ashlar and rusticated ma-
sonry, the Corinthian pilasters separating the bays in the upper story,
and the frieze of Roman scroll panels set with confronting winged
putti.[132] The magnified scale of the Baltimore gallery and the lack of
windows in the upper level proved problematic. In several drawings for
proposed elevations, he experimented with the placement of blind win-
dows in the facade. One significant departure was the oval niche, framed
by a cartouche, above the doorway. It was to contain a bronze bust of
William Walters, a subtle clue that Henry intended the building to serve
as a memorial to his father.[133]

Unlike Morgan, whose marble library epitomized an era of opulence,
Walters weighed considerations of practicality and economy. His gallery
was built of modern materials — brick and steel as well as terra cotta.
Even in the central court, marble was used sparingly, primarily for such
key architectural elements as the columns and arches. The masonry exte-
rior, rugged Milford pink granite below and Indiana limestone above,
was simply a facing (fig. 51). Concern for security was reflected in the
massive bronze doors and in the window shutters of sheet iron filled
with cement, each weighing a ton. Of particular interest were the sky-
lights in wire glass, framed in steel, copper, and brass to allow for expan-
sions caused by the sun's heat and to prevent condensation within.

The site for the gallery was cleared in April 1905. A contract was
awarded, reportedly for half a million dollars, and completion was pro-
jected fifteen months later. Unfortunately, an underground stream dis-
covered beneath the foundations necessitated the use of wooden pilings

and raised the costs to almost a million dollars. Providentially, by the summer of 1907, the building was ready to begin receiving art. In January 1908, two months after the move was completed, fire struck the Parker Building, in which the bulk of the collection had been temporarily stored in New York.[134]

Chapter Six

THE WALTERS GALLERY, 1909–1919

THE ECONOMIC AND SOCIAL CLIMATE that had been so conducive to business expansion in the early 1900s gave way during the second decade of this century to worldwide strife and economic uncertainty. The death of Michael Jenkins in 1915 was a painful loss for Henry Walters, who succeeded his friend and associate as chairman of the Safe Deposit and Trust Company, the bank that had helped to underwrite the Atlantic Coast Line's consolidation. For American railroad tycoons, a golden era was drawing to a close; government regulation and taxation together with the demands of organized labor now exacted their toll. Nevertheless, under Henry Walters's chairmanship, the Atlantic Coast Line continued to thrive. A combination of careful management and conservative capitalization enabled the railroad to weather downturns and to expand in boom times. Florida's rapid development and burgeoning population contributed to the line's success, as did its lucrative phosphate mines operated by a subsidiary, the Atlantic Land and Improvement Company. Also profitable were several steamship lines controlled by the Atlantic Coast Line's Connecticut-incorporated holding company. These included the Peninsular and Occidental, serving Jacksonville, Key West, and Havana, and the Old Dominion, operating out of Norfolk, Baltimore, and New York.[1]

Inevitably, there were changes in the management of the Atlantic Coast Line. Its longtime president Thomas Emerson was succeeded in 1913 by John Reese Kenly, an experienced engineer who, like Walters, had begun his career at the Pittsburgh and Connellsville Railroad. Of concern, however, was Kenly's age; he was already sixty-six years old and Walters's senior by one year. Fortunately, younger blood was in the offing; Jennie Delano's son Lyman seemed destined for a career in the railroad. Several years earlier, he had taken for granted his uncle's support and requested a position in the Atlantic Coast Line's operating

department. The ever punctilious Henry chided him for his presumption in a gentle but firm letter of admonition: "If you are going to stay in the railroad business, unless you are going to be satisfied with an easy berth, you have to work, no matter who your friends are. It would be just as idle to expect to excel as a football player if you did not play the game for all there was in you."[2] Lyman apparently heeded the advice and rose through the ranks.

At one point, Walters, wearying of the constant pressure, might have contemplated retirement, as is intimated in Bernard Baruch's memoirs. Baruch confessed to fellow financiers Thomas Fortune Ryan and James Duke that, ever since early childhood, when he used to wave at passing trains, he had longed to have his own railroad. "Why don't we buy the railroad for Bernie and let him operate it?" Ryan responded.[3] Several days later, Duke invited Henry Walters to dinner at his Seventy-eighth Street house (now the Institute of Fine Arts, New York University). Afterward, over a game of bridge, Duke offered to purchase the Atlantic Coast Line. Walters, though initially taken aback, agreed to sell control of the railroad for $1.65 a share. The next morning, however, the deal was vetoed by the Morgan interests, fearful that Baruch would transfer the railroad's finances to the house of Kuhn, Loeb.

Meanwhile, the Louisville and Nashville Railroad, operating under Henry Walters's chairmanship, was functioning as a separate entity. It, too, flourished in the early twentieth century, extending tracks to newly opened mines in eastern Kentucky and in the Cumberland Valley, Virginia. Hauling coal would become a mainstay of its operations. A principal beneficiary of these developments was the Kentenia Corporation, which held vast mining and timber interests in Bell and Harlan Counties, Kentucky. Walters's brother-in-law, Warren Delano, served as its vice-president, in addition to being a director of the Louisville and Nashville. He inspected the corporation's land holdings on horseback, sometimes accompanied by a young nephew, Franklin Delano Roosevelt.[4]

Though the outbreak of World War I did not immediately affect the railroads' profits, adverse repercussions were quickly felt by those industries in the South dependent on foreign investment. Deeply concerned, Walters hastened to Washington to meet with Woodrow Wilson, an acquaintance from their early days together in Wilmington. He urged the president to adopt a policy of stringent economy for the South and to back an emergency pool of $150 million for stricken cotton planters.[5]

With America's entry into the conflict in 1917, Wilson placed the nation's railroads under the control of William McAdoo, director general of railroads and secretary of the treasury. Young Lyman Delano was

appointed the federal manager for the Coast Line, and Walters was relegated to a supervisory position representing shipping interests on the director general's staff.

Meanwhile, Walters diversified his interests, which now included steel, an industry closely linked in its prosperity to that of the railroads. In 1910, he succeeded John D. Rockefeller Jr. as a director of the United States Steel Corporation. The announcement of his appointment evoked considerable mirth on the part of the *Wall Street Journal,* which observed in its "News Bulletin," "Walters might be called the Wall Street Mystery, if enough were known about him to stimulate general curiosity. But he has succeeded so completely in effacing his personality and his acts, that he is not even a mystery. He is unknown." The article noted that Walters had last been photographed when he was four years old.[6]

Domestically, life with the Joneses continued uneventfully at 13 West Fifty-first Street until 1913, when the threesome moved ten blocks north to 5 East Sixty-first Street. That their unconventional living arrangements had become common knowledge is intimated by the *Town Topics'* droll account of a crisis precipitated by young Sadie Jones's decision to pursue a career on the stage. "In vain Mr. Jones threatens. In vain Mrs. Jones implores. In vain Mr. Walters advises. Sadie is obdurate," the gossip column reported. Fortunately, serenity was restored when the daughter abandoned her Thespian aspirations to marry the architect John Russell Pope.[7] With the passage of time, the Joneses' social activities underwent subtle changes. Lavish balls for which they were renowned gave way to dinner parties followed by games of bridge. On the rare occasions when she was alone, Sadie Jones busied herself with jigsaw puzzles, the more challenging the better.

When not traveling abroad, Henry spent summers with the Joneses at Sherwood in Newport and winter and spring holidays at Airlie. Inspired by a visit to the renowned Magnolia Plantation in Charleston, South Carolina, Sadie determined to improve Airlie's grounds. Under the direction of Rudolph Augustus Topel, formerly the Kaiser's gardener, 700,000 azalea bushes in a multitude of colors, together with camellias and Banksia roses, were planted among the moss-covered live-oak trees, and the lakes were stocked with both black and white swans.[8]

Walters usually came to Baltimore alone to attend the board meetings of the Safe Deposit and Trust Company. When time permitted, he would visit the gallery, but even though the Mount Vernon residence was still staffed, he seldom remained overnight, preferring instead to

return to New York on his railroad car. At Saint Mary's, the country estate, the main house stood vacant. In 1924, with the city gradually encroaching upon it, the property was sold for suburban development.[9]

Inevitably, America's entry into World War I called for personal sacrifices. Walters responded by lending the *Narada* to the U.S. Navy for use in conducting experiments with underwater listening apparatus. The Fifty-first Street house still listed in his name was lent to the White Cross Committee of the American Club for use as a temporary shelter for women left destitute by the economic upheavals resulting from the war. Overseas, Walters supported a French military hospital at Passy, on the outskirts of Paris, a contribution for which he was awarded the rank of *chevalier* of the *Légion d'honneur* in 1918; two years later he was presented with the *Medaille de la Reconnaissance française*.[10] Pembroke Jones, meanwhile, served as vice-president of the Carolina Ship Building Corporation, which produced steel-hulled freighters for the government. He placed the Sixty-first Street residence at the disposal of the Royal Italian War Mission.

Even though his commitments were far reaching, Walters acquired a reputation for tempered liberality in each of the cities with which he was associated. In Wilmington, he was tapped for a contribution to install a statue of George Davis, the attorney general of the Confederacy. Davis had served as general counsel of the Wilmington and Weldon Railroad, the progenitor of the Atlantic Coast Line. When the Cape Fear Club moved to new premises on Chestnut and Front Streets, Walters supplied it with leftover paintings from the Massarenti collection. To this day, members of this venerable male institution peruse their newspapers in the Henry Walters Library, beneath the gaze of the goddess Juno depicted by a Venetian sixteenth-century artist as she squeezes her breast to give birth to the Milky Way.[11]

In Baltimore, Henry Walters's pragmatic side was reflected in his dealings with the Johns Hopkins School of Medicine. Founded in 1893, the school soon emerged as one of the country's premier teaching institutions. Its success could largely be attributed to the research and publications of its early faculty, William H. Welch and William Osler, and such outstanding surgeons as Howard A. Kelly, Thomas S. Cullen, William S. Halsted, and Harvey Cushing. They, in turn, relied upon the skills of the Leipzig-trained anatomical artist Max Brödel to document their work.

Although Brödel had been allocated a studio in the hospital upon his arrival in 1894, he was dependent upon the faculty members for an

income. In 1910, a threat that the artist might join the Mayo brothers in the Midwest prompted Dr. Cullen to propose the establishment of a department devoted to medical illustration. At Michael Jenkins's suggestion, Cullen approached Henry Walters for support, citing the Prang illustrations for the Oriental collection as a worthy precedent. Initially, he wrote to the "hard-headed business man with a deep interest in art" requesting a $100,000 endowment and, as inducement, enclosed two volumes of Kelly's *Operative Gynecology* illustrated by Brödel. That was a mistake! Walters replied that not only was he was not interested in medical illustration, but that, while a graduate student in Cambridge, he had attended twenty lectures in medicine and had "nearly vomited [his] boots up." Nevertheless, he pledged $15,000 over three years and offered to double that amount if the school could raise the full endowment. Though the campaign failed, Walters continued to pay Brödel's salary, allowing the opening of the Department of Art as Applied to Medicine. On a Sunday afternoon in May 1920, Cullen was aroused by John J. Walsh, Walters's office manager, who appeared on his doorstep bearing a check for a $110,000 endowment. The source of the funds could not be disclosed until after the donor's death. Meanwhile, the department, the first and foremost of its kind, continued its mission of supplying medical illustrators for America's teaching hospitals.[12]

More characteristic of Walters's philanthropic endeavors were his contributions to his Georgetown alma mater. Alphonsus J. Donlon, S.J., the rector of the college, required funding to build a preparatory school at Garrett Park in Montgomery County, Maryland. Walters responded immediately and decisively, donating the eighty thousand dollars necessary for the construction. In doing so, he insisted that "under no conditions do I desire my name to appear in association with this gift."[13] A year later, while attending the laying of the cornerstone of the Georgian Revival building, he pledged an additional fifty thousand dollars for further expenses. The only recognition to which he would consent was an inscription above the main entrance reading "Gift of the Class of 1869." Inside the doorway, a bronze plaque lists the six classmates.

Even though he seldom stayed in Baltimore, Walters retained a lively interest in local matters, especially those related to the arts. A master plan prepared by a citywide congress in the wake of the 1904 fire recognized the limitations of existing institutions and called for a new municipal art museum. Of the fifteen largest cities in the country, eleven, many of them smaller than Baltimore, already had public art museums. In 1911, Walters agreed to serve on the Committee on Founding an Art Museum and wrote to the chairman Henry H. Wiegand:

In regard to this movement for a city art museum, it seems to me that it is in general line of the progress of the age and that nearly all the cities of importance in the United States will have museums of that character, where gifts of art objects can be safely housed and where exhibitions of contemporary or other art could be held. I can assure you that such a building and home for art could in no possible manner conflict with what I have done at my galleries or with any plans which I have for the future.[14]

Three years later, Walters joined Michael Jenkins and six other prominent citizens as incorporators of the Baltimore Museum of Art. Once the institution opened its doors in the Garrett mansion at the west end of Mount Vernon Place in 1923, he declined to provide additional support, citing the needs of his own gallery.[15]

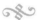

In truth, Henry Walters was most closely linked with New York's cultural institutions. He contributed to the support of the New York Public Library and the American Museum of Natural History, but his principal commitment remained to the Metropolitan Museum of Art. Not only did he serve on its executive committee but, in 1913, he succeeded Robert W. DeForest as second vice-president, a position he held the rest of his life. In addition, Walters was active on committees dealing with the building, finances, purchases, and various curatorial departments. For many years, he presided as chairman of the committees for both the departments of European decorative arts and Oriental art, associations that proved mutually advantageous; the museum benefited from his support, and he broadened his knowledge by the experience.[16]

Given his desire for anonymity, Walters frequently preferred to contribute partial payments for objects that might otherwise have exceeded the museum's resources. One such instance was in 1909 when, with Morgan reluctantly agreeing to share costs, he undertook the purchase of John La Farge's *The Muse of Painting,* a large allegory showing the personification of the art posed against an obviously Rhode Island setting. The sociable and popular La Farge was one of the few living artists represented in the Baltimore gallery.[17] Walters's conservative taste in modern art was further exemplified by a gift made in his own name, Daniel Chester French's *Memory.* The statue represents a gracefully reclining nude with proportions recalling "classic traditions" and a face that is "purely American, and American of the loveliest and most refined type." French, a fellow trustee, had been known for his public monuments since the 1880s. Fortunately, Walters did not try to impose his

views on others, abstaining, for instance, at the March 1913 meeting of the purchasing committee, which approved by a single vote the acquisition of Paul Cézanne's *La colline des pauvres*.[18]

In general, Walters remained committed to art of a more historical nature. Since its founding in 1905, the museum's Egyptian department had undergone phenomenal growth fueled by excavations at a time when the Khedive's government was still willing to share the finds with foreign archaeologists. The department's success could also be attributed to the personality of the curator, Albert Lythgoe. He is remembered as "a truly self-effacing man and an exceptionally kind one," just the type of individual to cultivate wealthy donors, among them J. P. Morgan and Edward S. Harkness, and one to whom Walters could readily relate. When Lythgoe sought to buy a group of items uncovered in 1914 in the burial chamber of Princess Sit-Hat-Hor-Yunet at the pyramid of Senwosret II at El Lahun, Walters agreed to supplement the museum's acquisitions fund. The find, unrivaled at the time (although eclipsed eight years later by the discovery of King Tutankhamon's tomb), was divided between Cairo and New York.[19]

In 1919, Walters enabled the Metropolitan Museum to complete the purchase of seven monumental statues of the lioness-headed goddess, Sekhmet, from the temple of Mut erected at Karnak in the early fourteenth century B.C. These had first appeared on the London art market in 1833 when they were sold by Sotheby's, not from their premises, but from Waterloo Bridge, to where they had been removed because of their weight. His generosity to a museum department would be very much determined by his relations with the curator. Walters never established a rapport with Wilhelm Valentiner who, in turn, did not hold the collector in particularly high esteem. In April 1910, the curator of the recently established Department of Decorative Arts testily wrote to his mentor Wilhelm von Bode, the director of the Kaiser Friedrich Museum in Berlin, who had ridiculed the purchase of the Massarenti collection: "Unfortunately Mr. Walters, who since Laffan's death [William Mackay Laffan, 1848–1909] has almost the greatest influence and buys for his collection in Baltimore more fakes than genuine items, interfered at the last moment in a most foolish manner in the Yerkes auction and took 2/3s of the carpets from the list for which we intended to bid. I acquired because of this, only three carpets."[20]

In Baltimore, on the morning of February 3, 1909, after a hiatus of two years, the annual openings of the Walters collection for the benefit of the

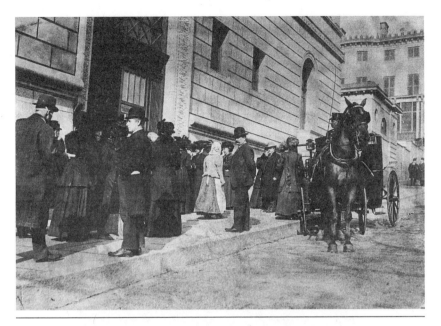

FIG. 52. Opening Day, February 3, 1909 (WAG Archives).

Poor Association resumed in the new building (fig. 52). Standing in the crowd of more than a hundred persons who had assembled at the entrance was James G. Huneker, art critic for the *New York Sun*. He had positioned himself so as to be the first person to cross the threshold, a distinction he was forced to yield to a "large determined-looking lady" whose identity remains unknown. Over one thousand visitors were admitted, among them Mrs. Theodore Roosevelt, who arrived incognito. True to character, Henry Walters remained in New York that day. Members of the press seemed nonplused by the amount of art exhibited but concurred in praising both the wealth of the holdings and the gallery's welcoming atmosphere. Huneker experienced a "shock of admiration" upon his arrival and departed with a lasting impression of "rich satisfaction." The *Baltimore Sun* observed that, elsewhere, very few museums offered such wide-ranging displays. The hometown newspaper also predicted that the city would become a "Mecca" for art lovers and connoisseurs from all over the world.[21]

Two years earlier, in the spring of 1907, Henry Walters had begun the daunting task of organizing the galleries. He was assisted by Faris C. Pitt (fig. 53), a dealer in Chinese porcelains and European paintings and silver, whose shop was conveniently located within a block of the new building.[22] The mandate given to Pitt is not recorded, but Walters, satis-

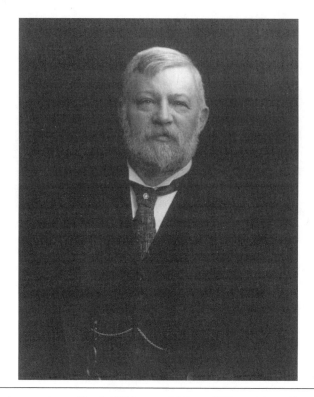

FIG. 53. An associate of both William and Henry Walters, Faris Chapell Pitt in 1900 opened an art gallery on Charles Street within a block of the site of the Walters gallery. He subsequently served as curator of Henry Walters's gallery. Photograph by Meredith Janvier, 1904 (WAG Archives).

fied with the results, designated him curator. Much of the installation, however, seems to have been orchestrated by Walters working from blueprints in his New York office. His early training as an engineer was reflected in the detailed drawings for pedestals and bases and for heavier objects and in the specific instructions he gave for unpacking and assembling the vitrines ordered from Paris. On a number of occasions, Walters attempted to lay out the Massarenti paintings in appropriate groupings on the floor in the New York warehouse, but several small, accidental fires interrupted these endeavors. That summer, as he was departing on his annual summer trip abroad, he informed Pitt, "It is my intention to arrange these [pictures] upon the walls in a certain sense according to schools, and to this end as a starter, I will take 'The old man in the tower's' [Massarenti's] catalogue and divide the galleries into sections and allot to each one of these sections, by the numbers of the catalogue,

which also are on the pictures, so that, as the pictures are delivered in Baltimore at the Galleries, they can be at once placed on the floor in front of the proper division."[23]

Fourteen months later, though the paintings were hung, Walters was still endeavoring to arrange the installations "in some kind of order." He strove for chronological sequence tempered by considerations of practicality. His intention, he informed George Lucas, was to publish a catalogue illustrating in black and white all the modern (nineteenth-century) and earlier Italian paintings together with a selection of those from other schools. The other works would be treated in a series of monographs similar to those issued by the South Kensington Museum (Victoria and Albert Museum) in London, in which every work served as an "object lesson." Only a preliminary handbook, listing 759 paintings and 90 watercolors and drawings, was actually printed. The "bric-a-brac," Walters finally conceded, was very eclectic and defied categorization. For the benefit of visitors, however, he prepared a four-page summary of the objects in the collection.[24]

Walters's efforts at imposing order on the installations are not apparent in photographs. In their density and heterogeneity, the displays recalled those of a generation earlier. The sculpture court on the first floor was dominated by Rodin's *Thinker* placed on the central axis and flanked by rows of large cases containing Renaissance and later decorative arts — Italian majolica, Hispano-Moresque pottery, Limoges enamels, and carved ivories (fig. 54). An ancient Roman statue stood under each arch, and lining the walls were sarcophagi and miscellaneous statuary, including Pietro Francavilla's masterpiece of 1591, *Apollo, the Victor over the Python,* as well as four colossal eighteenth-century garden sculptures.[25]

Along the north side of the court (to the right as the visitor entered), four rooms devoted to various historical epochs beginning with the Gothic era and continuing through the reigns of Francis I, Louis XIV, and Louis XVI reaffirmed the gallery's didactic role. Far more ambitious than the Marie Antoinette Room and the Dutch Bedroom in the Mount Vernon Place residence, these elaborate settings were created by the venerable New York firm L. Marcotte and Company, which for several generations had provided Americans with furnishings and entire interiors in the latest Parisian tastes. Long accustomed to working in historical revival styles, the Marcotte firm would have had little difficulty in realizing these interiors, which were furnished with reproduction furniture supplied mostly by Durand et Compagnie of Paris, interspersed with a few genuine articles, usually ceramics and sculptures.[26]

Perhaps the most fanciful was the Gothic Room, with its *grand che-*

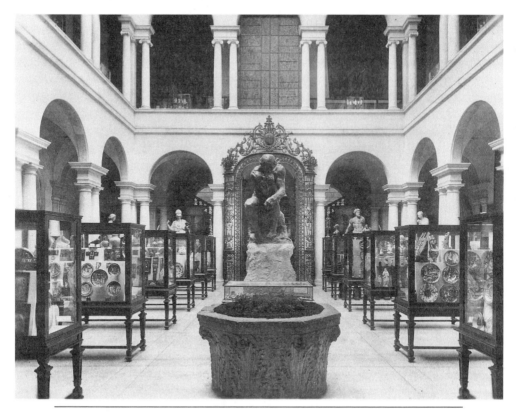

FIG. 54. Interior of the court, Walters Art Gallery, 1909 (WAG Archives). On the central axis of the court are the Verona marble wellhead dated 1494 (WAG 27.203), Auguste Rodin's *The Thinker,* and the mid-eighteenth-century iron gate from the cathedral of Troyes (WAG 52.283).

minée and linenfold wainscotting (fig. 55). Mounted against the wainscotting was a minstrel's gallery, from which leaned effigies of ladies wearing hennins, the fifteenth-century conical headdress. An odd assortment of objects can be discerned in early photographs of this interior, including several pseudo-Gothic altar tabernacles in silver and *verre eglomisée,* a fifteenth-century marriage-casket in bone and wood produced by the Embriachi workshop in Venice, and a North Russian walrus-ivory writing desk, which had the merit of looking old even though it dated from the early nineteenth century.

Across the court, on the south side of the building, a stronger sense of authenticity was realized in a large room incorporating the Milanese coffered ceiling and sixteenth-century choir stalls, as well as other early

woodwork. On either side, small galleries were devoted to ancient art and to the watercolors and bronzes of Antoine-Louis Barye. A two-story room set aside as a working library in the southwest corner remained closed to visitors.

Paintings were exhibited throughout the four large galleries on the second floor. Walls were hung with brocades of a rich henna hue, which complemented the ebonized woodwork. Runners of turkey carpet extending parallel to the walls introduced additional colors, directed the flow of visitors, and provided comfort underfoot.

The Italian primitives, the early Northern paintings, and the more monumental pictures that could not be accommodated elsewhere were allocated to the foyer, or west gallery. Tiepolo's *Scipio Africanus Freeing*

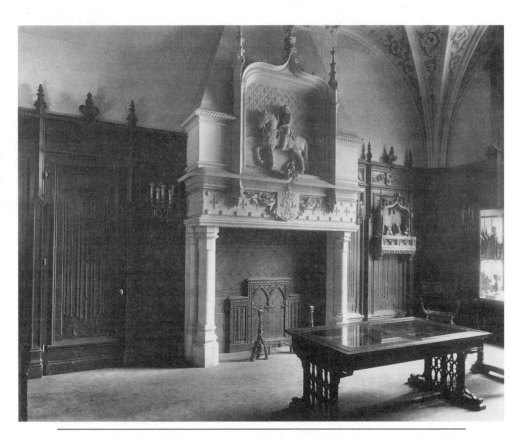

FIG. 55. The Gothic Room was one of four pseudoperiod rooms produced by L. Marcotte and Company for the ground floor of the Walters gallery (WAG Archives).

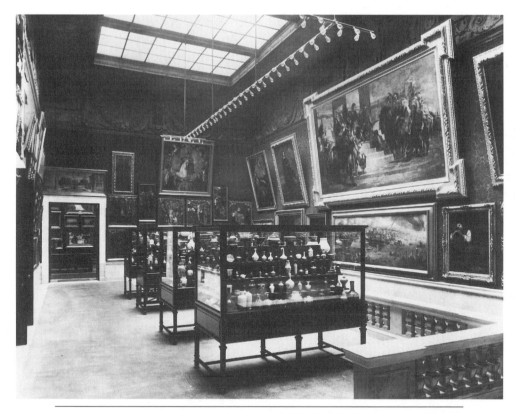

FIG. 56. The west wall of the West Gallery (above the divided staircase) was devoted in 1909 to G. B. Tiepolo's *Scipio Africanus Freeing Massiva* (WAG 37.657) and Maarten van Heemskerck's *Panoramic Fantasy with the Abduction of Helen* (WAG 37.656) (WAG Archives).

Massiva, for example, loomed over Maarten van Heemskerck's *Panoramic Fantasy with the Abduction of Helen* above the marble staircase (fig. 56).

Moving counterclockwise, guests proceeded through the south gallery, devoted to the art of the nineteenth century; the east gallery, holding a motley array of Spanish, German, Dutch, French, and English paintings; and the north gallery, which featured the Italian Renaissance. Rows of benches alternating with vitrines containing various European and Asian objects selected without regard for their chronology or origins extended down the center of each gallery. Displayed in a remaining small corner room were nineteenth-century watercolors and drawings, including twenty works that had been misattributed to Joseph Mallord Turner, representing one of Walters's least successful forays into the market.

Henry Walters continued his support of the Poor Association with the proceeds from spring openings, expanding the season starting in 1910 to include January. Although he did not appear in person, he took an interest in these occasions. The court was decorated with plants: miniature palms were placed in the sixteenth-century, Verona marble wellhead, and various species of croton and ferns adorned a large Florentine urn. Recent purchases were often prominently featured near the entrance, and pamphlets devoted to these additions were inserted in the handbooks. Various local artists were persuaded by the Poor Association to volunteer their services as guides. To whet the public's enthusiasm, Walters, despite his reserve, acquiesced to a poll to identify Baltimore's fifty-five favorite art works, taken in the winter of 1909–10. Baltimoreans, in retrospect, did not seem to have been exceptionally progressive in their tastes. Gérôme's *The Duel after the Masquerade,* purchased by William T. Walters in 1859, headed the list, followed by Reynold's *The Strawberry Girl,* Alma-Tadema's *Sappho,* Raphael's *Madonna of the Candelabra,* Meissonier's *1814,* and Riviere's *Night Watch, Syria,* all from the Walters collection. Despite such efforts, attendance at the spring openings never equaled that of the 1909 opening.[27]

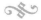

A confirmed acquisitor, Henry Walters continued to augment the collections regardless of the density of the existing installations. Occasionally, he considered refining them, but given his strongly retentive instincts, additions continued to far outweigh deletions. Early every summer, he shopped abroad, usually accompanied by the Joneses and members of the Delano clan. Even in the tense international climate of May 1914, he embarked for Europe on the *France.* Though his trip proved uneventful, his sister and her children lingered. Stranded by the outbreak of hostilities, they were forced to flee to Geneva, returning to America in the company of John G. Johnson, the distinguished jurist and art collector from Philadelphia. For several months after each trip, barrels and crates holding anywhere from 600 to 1,000 items continued to arrive in Baltimore. In most instances, the contents were inventoried by the building superintendent, repacked, and assigned to the basement. Sometimes Walters left instructions for displaying specific works, and occasionally he installed them himself. On a visit to the gallery in April 1911, for instance, he insisted on personally placing a large freshwater pearl on the white pad used for displaying the Lalique and Tiffany jewelry, and the following December he arranged several cases of English porcelains.

One of the most pressing challenges Walters faced after the 1909 open-

ing was the refinement of his early Italian holdings. As he wryly admitted to George Lucas, he was "to a certain extent discriminating" and therefore proposed to keep less than half of the Massarenti pictures. Ninety of the pictures to be retained, he anticipated, would be early Italian panel paintings.[28]

For advice in this task, Walters turned to Bernhard Berenson. By 1909, the renowned scholar had realized many of his most significant contributions to scholarship and was gradually immersing himself in the art market, both as a consultant for collectors and as a retainee of several dealers, roles that culminated in his association with the Duveen firm, beginning in 1912. Berenson may have accepted the Baltimore assignment with misgivings. Previously, he had questioned Raphael's hand in the *Madonna of the Candelabra* and generally disparaged the Massarenti collection.[29] A visit to the old gallery in 1904 inauspiciously coincided with the devastating fire of that year. While much of downtown Baltimore was being consumed by flames, Bernhard and Mary Berenson whiled away their time examining the Walters collection; they left with an overriding impression of "horrors everywhere," relieved only by the examples of Oriental art. In 1907, however, Berenson tacitly recognized the Walters gallery for the first time by including six of its works in *The North Italian Painters of the Renaissance,* his fourth in a series of surveys of regional Italian painting.[30] He had already begun to request duplicate sets of photographs of the gallery's pictures in the costly platinum prints, which provided sharper definition and greater permanence, as well as in the more tonal silver prints.

When Henry Walters appeared in Florence late in the spring of 1910, the Berensons were captivated by the "jolly, good-natured, shrewd old bachelor of 61."[31] A close rapport ensued, and they made an agreement whereby Berenson, for a year beginning July 1, 1910, was allotted seventy-five thousand dollars to spend for pictures, mainly Italian, to fill out the "historical value and increase . . . the average quality" of the collection, with a restriction that photographs be submitted for approval beforehand. It was further stipulated that the purchases be in Berenson's name to ensure Walters's anonymity. For his efforts, Berenson would receive a 10 percent commission. The contract proved satisfactory and was renewed for at least nine years.[32]

In 1911, Mary Berenson mentioned to her mother that Walters, now their "cheifest [*sic*] buyer" and one of the most congenial of the millionaires, had arrived at their villa in Florence, I Tatti, and had been put to work viewing the paintings set aside for him. Apparently, he was pleased with the selection and the prices. Reversing roles, Berenson produced an

Islamic manuscript for which he had paid Siegfried Bing in Paris sixteen hundred francs and expressed delight that Walters, a self-styled "great collector of Persian things," found the price very reasonable.[33]

The task of furbishing I Tatti had placed the Berensons in financial straits. They were, therefore, much relieved when Walters agreed to accept a painting previously turned down by another client, John G. Johnson. It was a *Madonna and Child* attributed to Bernardo Daddi, a prolific but gifted early fourteenth-century follower of Giotto.[34]

Berenson also took this opportunity to propose a work from his own collection, a *Madonna* by the later Florentine artist Cosimo Rosselli, which his wife Mary, he noted, "has the bad taste not to like . . . altho' it is one of the best things that this not inconsiderable artist ever did (in his day he not only trained most of the younger men who grew to fame but ranked with Botticelli & Ghirlandaio & Perugino as worthy of working in the Sistine Chapel where indeed he painted three frescoes which are still there)."[35] If Walters wanted it for five hundred pounds, he was to cable Berenson *yerosselli*. Likewise, if he accepted at the same time a small panel then assigned to the fourteenth-century Venetian Guaroleagrele (Niccolo da Guardiagreli), his message should be *yegrele*. To enhance the High Renaissance holdings, Berenson offered a *Holy Family with Saint John the Baptist,* which had previously passed as a Raphael but which he reattributed to Lo Spagna, an artist whom he regarded as the most gifted of Raphael's fellow pupils under Perugino and as the probable artist of the *Marriage of the Virgin* in the Duomo in Perugia.[36]

Berenson may also have played a role that year in Walters's purchase of four panels by Giovanni di Paolo from the Florentine restorer-dealer, Luigi Grassi. Representing the *Resurrection of Lazarus,* the *Way to Calvary,* the *Descent from the Cross,* and the *Entombment,* the panels have since been identified as coming from a family chapel in the church of San Domenico in Siena. These works, which are now recognized as highlights of the collection, vividly demonstrate the endurance in Siena during the fifteenth century of the late Gothic traditions emanating from the studios of Duccio, Simone Martini, and Ambrogio Lorenzetti.[37]

In 1912 Walters was unable to return to Italy, much to the disappointment of Berenson, who had planned to take him on a motor tour of Urbino and the Marches. Instead, Berenson mailed photographs of his selections for the year. Most were small, modestly priced, fifteenth-century panels. That November, however, he proposed a purchase of a very different order: it was a remarkably intact altarpiece showing the *Annunciation* with scenes from the life of the Virgin in the predella (see plate 12). Largely the work of Bicci di Lorenzo, an early-fifteenth-

century heir to the Giottoesque traditions in Florentine painting, the altarpiece conveys in its gracefully attenuated figures the rhythmical patterns and vibrancy of color associated with late Gothic painting. Obviously pleased with his find, Berenson characterized it as "one of the most delightful works painted soon after 1400," and as one of the most satisfactory works to appear on the market in some time. Ironically, this work, costing twenty-two hundred pounds, had been obtained from Fairfax Murray, a much maligned artist and agent for Agnew's in London, whom Berenson had supplanted as Peter Widener's advisor.[38]

The Berenson-Walters relationship continued to blossom. The Berensons received an invitation to attend the marriage of young Sadie Jones to John Russell Pope in New York in 1912. Perennially malcontent with the times in which he lived, Berenson felt free to unburden himself to Walters with complaints about Italian politics, the Turkish government, the decline of the Republican party at home, and even the travails of growing old, the seventeen-year disparity in their ages notwithstanding. During a brief encounter in London in 1913, it was Walters's turn to be downcast; he was gloomy about conditions in America and concerned about the rise of socialism.[39]

The Berensons returned to America in the winter of 1913–14, spending a week in early March in Baltimore. Mary Berenson reported their impressions of the collection to Isabella Stewart Gardner: "He has some *splendid* things — Greek, Egyptian, Aztec, Persian, early French, Turkish, American, Coptic, even Italian, and good modern pictures (a few) but hopelessly lost and buried in masses of indifferent stuff and actual *rubbish*. It is very mysterious. However, we've had a most interesting instructive time."[40]

Berenson proposed dividing the works into three categories — "good, bad and indifferent" — and disposing of the "rubbish and the forgeries." As many as 119 paintings fell into the last category but, as Mary Berenson observed, Walters "loves them all" and could not bear to part with more than 23. The more egregious copies, however, were withdrawn from view, and Berenson's opinions were incorporated into the revised edition of the Walters handbook, eventually published in 1922. Interestingly, both Bernhard and Mary Berenson had been much taken by some recently acquired pre-Columbian artifacts which, they believed, shared certain aesthetic qualities with early Chinese sculpture. As they were departing, Henry Walters delighted Mary by handing her a gold eagle pendant as a souvenir of her stay.[41]

The outbreak of hostilities in Europe in 1914 and the resulting recession in America brought Berenson's buying campaign to a halt, although

a few paintings would trickle into Baltimore during the war years. Walters had once urged Berenson to find a Sassetta "at a poor man's price," a remark that characterized his frugality in the purchase of paintings. This was a trait that precluded him from ever joining the ranks of his fellow millionaires as a client of Joseph Duveen. In this respect, he also differed from someone like Henry Clay Frick, who could rely on one dealer (in his case, Charles Carstairs of M. Knoedler and Company) to secure major Old Master works.[42]

Berenson, apparently relishing the challenge of working within the financial restraints imposed by Walters, sought to stretch the funds by choosing paintings which, though usually of some consequence, tended to be small and by secondary artists, often by pupils rather than their masters. In retrospect, he might have left a more pronounced mark on the collection had he focused on fewer, more costly works. Of the more than thirty additions for which Berenson was responsible, some have been reattributed, generally being downgraded in importance, others have been found to have problems of condition, and several may simply have represented mistakes. A *Saint George and the Dragon,* for example, which was probably acquired through Berenson, who first published it in 1916 "as in every probability the work of Vittorio Carpaccio's son Pietro," has subsequently proven to be a modern forgery painted over an old canvas.[43]

For the northern schools, Walters found no counterpart to Berenson as a consultant. Instead, relying seemingly on intuition, he bought haphazardly, often at auctions. One such occasion that must have rekindled bittersweet associations was the estate sale of his old friend and consultant, William M. Laffan. The pictures acquired at the Laffan sale in January 1911 were admittedly of secondary historical significance, but they have retained their aesthetic appeal. A landscape then attributed to Jan Brueghel, for example, has since been reassigned to Lucas van Valckenborch, a follower of Pieter Brueghel the Elder. Likewise, a portrait originally listed as a Dutch primitive has since been recognized as the work of a German sixteenth-century artist, Barthel Bruyn of Cologne.[44]

Walters's other attempts at obtaining major Old Masters paintings, presumably inexpensively, proved fruitless. Gerard Terborch's *The Glass of Lemonade,* bought at the Yerkes sale in New York in 1910, turned out to be a replica of a work in Saint Petersburg, and a Velázquez *Water Carrier of Seville,* sold as a variant of the famous picture in Apsley House, London, is now dismissed as an inferior copy.[45] Of greater interest was a

Madonna Nursing the Child which, at the outset, was attributed to the fifteenth-century Flemish artist known as the Master of Flémalle (Robert Campin), but which is presently regarded as from the workshop. This roundel mysteriously appeared in Baltimore along with two other paintings in a crate shipped from Italy in the spring of 1915.[46]

In augmenting his father's collection of nineteenth-century art, Henry Walters strove to be comprehensive and sometimes acquired works that he might not have been predisposed to like. In 1909, Paul Durand-Ruel sold him a river view by Alfred Sisley. Painted in a rich impasto with vigorously applied brushstrokes arranged in rhythmical patterns, this canvas typifies the artist's retention of impressionist techniques long after he had withdrawn from Paris to work alone in Moret-sur-Loing. Similarly, Walters could scarcely have ignored Edouard Manet's revolutionary role in the realist movement and, the following year, he added to his collection Manet's *At the Café*. One of a series of paintings showing figures seated at the bar of the Cabaret de Reichshoffen, this masterpiece conveys the isolation experienced by the individual in modern urban society. Ironically, Walters might well have seen the Manet twenty-four years earlier in New York, where it appeared in *Works in Oil and Pastel by the Impressionists of Paris,* Durand-Ruel's pioneering exhibition. In their techniques, both the Sisley and the Manet represent a radical departure from the preference for highly finished picture surfaces shared by Henry Walters with his father, and both pictures were promptly allocated to the basement.[47]

More to his liking may have been the small Normandy coastal scenes with their distinctive moisture-laden atmospheric skies painted by Eugène Boudin. Using the pseudonym "Henry Chester," Walters successfully placed bids for four Boudins at the Cyrus J. Lawrence auction in New York in 1910. The same sale yielded Edgar Degas's small panel, *Before the Races,* a Stanislas Lépine, a Jean-François Raffaëlli, and a couple of Daumier watercolor drawings. Walters kept two Boudins and the Raffaëlli in New York and sent the other works to Baltimore.[48]

So thoroughly had Walters been imbued in his youth with the taste for French salon paintings that he continued to buy examples long after they had ceased to be fashionable. He recalled a visit to Gérôme's studio while the artist was working on the 1867 *Death of Caesar,* compositionally an expanded version, although reduced in scale, of the 1855 *Dead Caesar* that his father had selected for the Corcoran Gallery. While leafing through a sales catalogue when confined to bed during a brief illness in April 1917, he was delighted to find illustrated the dramatic work, which he had always longed to see again. At the sale that month, he

bought not only the 1867 *Death of Caesar*, but three other works by the master. Again, he reserved one of them, *The Duet*, an orientalist scene, for Sixty-first Street and assigned the others to his Baltimore gallery.[49]

After the 1909 gallery opening, the thrust of Henry Walters's collecting shifted from paintings to other works of art. What he had once characterized as his bric-a-brac would develop over the next two decades into one of the most wide-ranging collections, private or public, in the country. Spanning three millennia, these objects would confirm his remarkable receptivity to the arts of disparate cultures. His activities as a collector, however, passed largely unnoticed by many contemporaries, a result of his practice of now storing rather than displaying the most recent purchases.

Although Walters retained a lifelong interest in Far Eastern art, his attention gradually veered from Japan to the early epochs of Chinese history. Two exceptional opportunities to expand his holdings in this area arose in 1911. At his friend Laffan's estate sale, he bought twenty-four Chinese porcelains, mostly the celadons and other monochrome wares that he and Laffan had favored. The most remarkable piece was an exception, a Ming blue-and-white vase bearing an inscription in almost indecipherable Portuguese identifying it as having been commissioned in 1552 by Jorge Alvares, the mariner who accompanied Saint Francis Xavier, the Apostle of the Indies, to Sang-chuan, off the coast of Canton. The other occasion was the liquidation of Robert Hoe's vast collection, which yielded Chinese cloisonné enamels and bronzes, a couple of small Tibetan deities in gilt-bronze, and a Siamese seated Buddha.[50]

In 1911, Walters also first dealt with Yamanaka and Company, a firm of antiquarians from Osaka that had opened branches in New York (1893) and Boston (1895), as well as in London. Yamanaka became a source for some of the most spectacular and historically significant works in his collection.[51] In 1912, for example, at an auction held by Yamanaka at the American Art Association in New York, Walters obtained several earthenware mortuary tomb figures from the T'ang dynasty (618–906) and, five years later, he bought directly from the firm a rare T'ang gilt-bronze Kuan-yin, a Bodhisattva worshipped in Yunnan province.[52]

Unlike the Detroit collector Charles Lang Freer and the Bostonians Edward Morse, Ernest Fenollosa, and even Isabella Stewart Gardner, Henry Walters lacked either the time or the inclination to travel to the Far East. Therefore, international exhibitions remained for him, as they

had for his father, his only opportunities to follow the Far Eastern art market. The Panama-Pacific International Exhibition held in San Francisco in 1915 to commemorate the completion of the Panama Canal was no exception. In the Japanese section in the Palace of Arts, he gravitated to modern works by medal winners. His acquisitions included a grotesque, crouching figure of a wind god in repoussé iron by Yamada Chōzaburō and a ceramic vase with "carved" floral decoration and enameled views of Kinkakuji and Nikko entered by Sobei Kinkozan of Kyoto; both artists were gold medal recipients. A statuette of a family had been carved in ivory by Tomioka Hōdō, a silver medal winner. Perhaps his most spectacular purchase was a large jar swathed in bamboo leaves rendered in pigment-stained porcelain (see plate 13). It was one of three works exhibited by Itaya Hazan, who would become one of the most renowned Japanese potters of this century. Continuing to the Chinese Pavilion, he attempted to assemble a representative collection of Chinese paintings. Of the sixty-four books, hand scrolls, and hanging scrolls he selected, few proved to be of exceptional interest.[53]

Henry Walters remained remarkably receptive to unusual areas of collecting. His purchases of pre-Columbian art were especially innovative. Although collections had been formed during the second half of the nineteenth century at Chicago's Field Museum of Natural History, the Natural History Museum in New York, and the Smithsonian Institution in Washington, this field was regarded as having anthropological rather than artistic significance. Henry Walters was undoubtedly aware of the keen interest in pre-Columbian art and archaeology in France in the aftermath of Napoleon III's incursion in Mexico on behalf of the ill-fated Emperor Maximilian (reigned 1864–67). At the *Exposition rétrospective* in the Trocadéro in 1878, a small display of early Mexican terra cottas and sculptures captured the public's imagination and conjured up such concepts as the lost content of Atlantis and prehistoric connections between Europe and America.[54]

Walters's interest in pre-Columbian metalwork may have reflected a preference for fine craftsmanship, especially in precious metals, as well as a commitment to comprehensiveness. In 1910, Tiffany and Company provided him with several Mayan jadeite amulets from the western highlands of Guatemala together with sixty-seven gold ornaments from the Tolima region of Columbia. George Frederick Kunz, Tiffany's gemologist who had long championed American products, probably drew the

collector's attention to the field. The following year, Kunz sent an additional twenty-eight items to Baltimore. These were cast, zoomorphic ornaments in gold and copper alloy, which had been unearthed at a burial site near Diquís on the Panama–Costa Rican border three years earlier. Unable to travel abroad during the war years, Walters toured in this country. After a visit to Arizona in the winter of 1915–16, he returned to Baltimore with ten examples of contemporary Navajo jewelry in silver and turquoise.

Walters's interests in the tribal arts of North America may have been sparked by his access as a youth to Alfred Jacob Miller's watercolor drawings recalling the 1837 fur-traders' rendezvous, which his father had commissioned. *The North American Indian,* Edward S. Curtis's twenty-volume collection of photographs, may be regarded as the twentieth-century parallel to Miller's work. Sponsored by Theodore Roosevelt and funded by J. P. Morgan, Curtis's powerful images both documented and romanticized the vanishing lives of the indigenous Americans. Walters subscribed to the publication in 1915, and portfolios continued to be delivered to Baltimore for the next fifteen years.[55]

Occasionally, Walters broke with his usual practice of selecting small, finely crafted objects and bought works that, through their scale or historical significance, gave a sense of monumentality to the collection. In this category fell two early-thirteenth-century stained-glass windows, both over twelve feet high, showing the prophets Habakkuk and Joel. At the time of their purchase, they were thought to have been commissioned by Étienne Bécard Penoul for the Tour de Plomb of Sens cathedral, but they have since been identified as being part of the stained-glass program at Soissons cathedral supported by King Philippe Auguste in the early thirteenth century. The source for these windows, Raoul Heilbronner, a Paris dealer on the rue Colombier specializing in medieval and Renaissance *objets d'art* and *de haute curiosité,* sold Walters some of the larger objects in the collection.[56]

The following year, over fifty crates passed through U.S. Customs en route to Baltimore. The contents of no. 45, shipped from Kelekian in Paris, were listed as Persian miniatures, Egyptian artifacts, and "2 Stone Heads of Kings from the Cathedral of St. Denis 12th Centy" (fig. 57). The last proved to be remnants of columnar statues of Old Testament rulers; before the French Revolution they had flanked the west portal of Abbot Suger's great abbey church of Saint-Denis, as recorded in drawings published by Bernard de Montfaucon in 1729. Freed of their nineteenth-century restorations, the heads now document the stylistic

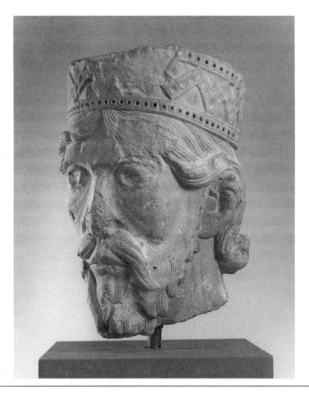

FIG. 57. This head (WAG 27.21) is one of two showing Old Testament kings that were purchased from Dikran Kelekian. They had been removed from the column figures flanking a portal of the Abbey Church of Saint-Denis, vandalized during the French Revolution.

transition of Île de France sculpture during the 1140s, when the rigid forms of the Romanesque style yielded to the softer, richer modeling of the Gothic era.[57]

George R. Harding of London continued to supply Walters with important medieval and Renaissance items including, in 1911, a silver medallion enameled in white and gold on dark blue. Known as the Ara Coeli medallion, it shows on one face the Emperor Augustus and on the other the vision of the Madonna and Child experienced by the emperor when he posed the question of whether there was "any so great and like him in the earth, or if any should come after him?" Walters was undoubtedly drawn to the exceptional quality of the enameling but could not have anticipated that the medallion would later be recognized as the earliest surviving example of the painted enamel technique developed in the Netherlands in the early fifteenth century.[58]

During World War I, Harding opened a New York branch on East Fifty-sixth Street, which was directed by his son, H. Wareham Harding. It was a blessing for Henry Walters, whose travel was curtailed by the war, and was his source for many Renaissance and later decorative arts. Among the New York selections in 1916 were majolica, including a dish emblazoned with the Montmorency arms and decorated with the story of Apollo and Daphne (Ovid's *Metamorphoses* I). This piece had been commissioned from the workshop of Guido Durantino of Urbino in the 1530s for Anne of Montmorency, later constable and marshal of France.[59]

The Seligmann brothers increasingly figured in Walters's purchases. In 1911, the firm shipped from Paris a twelve-foot-wide, polychromed and gilded oak retable carved with scenes of the Passion of Christ. Because of its size it was dismantled and packed in five separate crates. Such pieces had been produced by the Brabant guilds of sculptors and painters for individual commissions or for sale on the open market. Jean d'Estouteville, Grand Master of the Crossbowmen for Louis XI, is thought to have ordered this example for the high altar of the collegiate church of Blainville-Crevon in Normandy in 1492.[60]

As a result of a family rift, the Seligmann firm subdivided shortly before World War I, with Jacques Seligmann dealing from the former Palais Sagan on the rue Saint Dominique in Paris as well as from an Old Burlington Street address in London and at 705 Fifth Avenue in New York. His brother Arnold and an early associate, Emile Rey, remained at the Place Vendôme shop and opened their New York branch at 7 West Thirty-sixth Street. Walters continued to patronize both Seligmann firms, but perhaps because of the assistance provided by Emile Rey in closing the Massarenti purchase in 1902, the preponderance of his purchases were through Arnold Seligmann, Rey and Company.

Dikran Kelekian's Place Vendôme establishment, on the other hand, continued to serve as a principal source for ancient Near Eastern and Egyptian antiquities and for Islamic art. In the wake of Walters's 1912 summer buying campaign, fifteen crates were shipped to Baltimore. Characteristic of the diversity of their contents were such items as a small, late period sculptor's model for a left foot said to have come from Dendera, Upper Egypt, and a colossal marble head of Serapis, the god of fertility, particularly venerated in Egypt during the Greco-Roman era.[61] That autumn, Kelekian represented Walters at the combined Jean P. Lambros of Athens and Giovanni Dattari sale and obtained an addi-

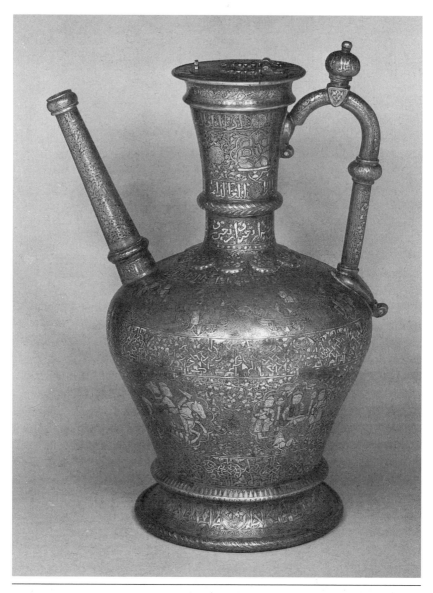

FIG. 58. Yunus ibn Yusuf al-naqqash ("the decorator") al Mawsili, *Ewer,* dated 644 (1246–47), brass inlaid with silver (WAG 54.456). Although the artist signed his name as coming from Mosul, Iraq, the piece could have been made in Syria.

tional seventy-five Egyptian and Greco-Roman artifacts in terra cotta, stone, bronze, and glass.[62]

Not one for stinting in praise, Kelekian wrote Walters in May 1915, congratulating him on his Persian holdings, which were "amongst the few most noted in the world." However, he chided the collector for a comment that Persian ceramics were to be had at moderate prices in New York. As the author of the study *The Potteries of Persia,* Kelekian took a proprietary interest in Islamic ceramics, particularly those of thirteenth-century Persia. He assured Walters that, as one who was in continuous contact with the archaeological excavations at Fustat, Egypt; Raqqa, Syria; and Sultanabad and Rayy in Iran, he could attest to the fact that these sites were depleted. He also cautioned him about buying fragments misassembled for the market, advice that Walters should have heeded more than he did.[63]

Although pottery was scarce, Kelekian could provide Walters with some important examples of metalwork. Among the most magnificent was a large thirteenth-century Syrian or Iraqi ewer richly decorated with bands of inscriptions and scalloped medallions enclosing musicians, enthroned figures, and huntsmen (fig. 58). Years earlier, Kelekian had acquired it in Istanbul from Moukhtar Pasha, the distinguished Ottoman general and diplomat who governed Yemen in the early 1870s.[64]

It is not recorded who represented Walters that summer at the auction of the collection of John Edward Taylor, proprietor of the *Manchester Guardian.* A bronze statuette that had generated considerable scholarly interest ever since it had been discovered in 1866 at Vienne, near Poitiers, was acquired on this occasion. Representing a bearded divinity with a wolf skin knotted around his neck and mounted on a base to which is attached a peculiar malletlike attribute encircled by spokes, the statuette was identified as an extremely rare representation of the Gallic Jupiter or the Dispater, the ancestral father of the Gauls recorded by Julius Caesar in *The Gallic Wars.*[65]

Also from the same source came a whimsical, little statuette of Silenus, a companion of Dionysus, struggling with a heavy amphora on his shoulder (see plate 14). Dating from the mid–fifth century B.C., this early Italic bronze, unlike many others collected by Walters, is thought to have been produced in Campania rather than in the Etruscan north. It must have been a favorite piece because both Henry and Sadie retained it in New York during their lives.[66]

The following year, Dr. Hirsch, the Hôtel Drouot's expert for the

Lambros-Dattari sale, sold Walters a marble relief of a procession of twelve Greek deities, which was reputed to have originated in Tarentum (Taranto, Sicily) in the early sixth century B.C. Walters made a point of being present when it was unpacked in Baltimore two years later. The dating of the relief has subsequently been disputed, and it is now attributed to an Athenian workshop of the first century of our era; its deliberately archaic style may have been used to deceive the original purchaser.[67]

During his rushed trip abroad in 1914, Walters, again dealing with Hirsch, contemplated a transaction that might have been the major coup of his career, the purchase of a monumental, archaic statue of an enthroned agricultural goddess, which like the relief of the deities, was thought to have come from Tarantum. As recorded by Bernhard Berenson, who recommended the purchase, Walters wavered and eventually declined the piece, fearing a socialist outcry against such spending on "mere" works of art.[68]

THE FINAL YEARS,
1919–1931

FOR HENRY WALTERS, SEVENTY-ONE YEARS OLD IN 1919, advancing age as much as World War I's social and economic repercussions determined the scope of his activities. As he gradually began to shed business responsibilities, he allocated more time to collecting, making some spectacular acquisitions during his later years.

When the Atlantic Coast Line was returned to private control in 1920, Walters resumed the chairmanship, but responsibility for general operations fell to Lyman Delano, the vice-president. Although he may have been a competent manager, Delano did not enjoy an easy rapport with labor. His stringent, cost-cutting measures ran counter to the Coast Line's traditionally paternalistic policies. A legacy of bitterness ensued, partly as a result of a decision not to rehire workers who had been displaced by "scab" replacements during a nationwide strike in 1922, and was further exacerbated by a lockout of union telegraphers three years later.[1]

Until the 1920s, the Atlantic Coast Line had continued to expand despite competition from automobiles and trucks. New tracks were laid, major routes double-tracked, rolling stock and locomotives upgraded, and additional companies absorbed. These improvements eventually came to nought. The railroad's halcyon days ended with the collapse of the Florida real estate market in 1926. That September, a hurricane struck the Florida coast, devastating Miami, killing hundreds, and leaving thousands homeless. Other natural disasters followed: storms racked the Southeast in 1928, and the following winter an infestation of Mediterranean fruit flies hit the citrus crops. The Atlantic Coast Line's revenues began to spiral downward, ominously forecasting the Great De-

pression. For Walters, to see the railroad that he and his father had so vigilantly stewarded decline must have been a bitter pill.

In early 1918, Pembroke Jones died after surgery. For propriety's sake, Walters moved from the Sixty-first Street residence into the nearby Belmont Hotel. Three years later, on April 11, 1922, he and Sadie astonished their friends with an announcement issued from their suite on the *Aquitania:* they had privately married that afternoon in her daughter's house and were embarking on a two-month European trip.[2] After their return, life for Henry and Sadie, aged seventy-four and sixty-three, respectively, resumed at its usual pace. Just as when Pembroke had been alive, summers were spent at Sherwood in Newport, holidays at Airlie in Wilmington, and when not traveling abroad or cruising on the *Narada,* the couple participated in New York's social life.

The publication in 1925 of Edith Wharton's *The Mother's Recompense* must have infringed upon their coveted privacy. In the novel, Horace Maclew is characterized as "the conscientious millionaire who collects art and relieves suffering" and who has been reared by "equally conscientious parents, themselves wealthy and scrupulous, and sincerely anxious to transmit their scruples with their millions, to their only son."[3] Maclew, an elderly Baltimore bibliophile, was further identified as owning the finest Italian antiphonals in the world. Like Walters, Maclew married late in life, to a Lilla Gates from South rather than North Carolina.

Despite his now legendary reserve, Henry Walters did not shrink from speaking out when a situation warranted it. In 1923, as second vice-president of the Metropolitan Museum of Art, he responded to charges leveled by a disgruntled dealer that some of the fakes flooding the American art market had made their way into the institution. Rather than denying the accusations, Walters conceded that mistakes were inevitable and assured the press that, upon investigation, works found spurious would be withdrawn and those heavily restored would be labeled as such. He also admitted that he had reserved a vitrine for those of his own purchases proven to be forgeries. It contained at least thirty items, which, he reckoned, represented a cost of over $100,000.[4]

Henry and Sadie seldom visited Baltimore together. After Michael Jenkins's death in 1915, the city offered few attractions for them as a couple. Henry, however, still attended board meetings of the Safe Deposit and Trust Company and continued to open the gallery each spring for the benefit of the Poor Association, a tradition begun by his father over forty

years earlier. He also retained a lively interest in the city's appearance, particularly in the Mount Vernon Place distict. In 1921, he joined his neighbor Dr. Henry Barton Jacobs and writer Henry L. Mencken in opposing a site chosen for a monument to General Lafayette in the square. The plans of Thomas Hastings, the architect for the project, called for moving Laurent Marqueste's bronze statue of Severn Teackle Wallis, the "pride of the Maryland Bar," from its location in front of the entrance of the Walters gallery to the east square and erecting in the south square an equestrian monument to Lafayette by the Irish-American sculptor, Andrew O'Connor, ironically one of the few contemporary sculptors whom Walters had patronized at the turn of the century. Walters's concerns that the Lafayette statue, mounted on a fourteen-foot-high pedestal, would obscure the Washington Monument proved groundless, and O'Connor's work, seen dramatically silhouetted against the sky, remains to this day one of the most imposing sculptures in Mount Vernon Place.[5]

At the end of the war, the U.S. Navy returned the *Narada*. Under the command of a younger skipper, L. B. Goss, it now cruised along the Atlantic seaboard and in the Caribbean.[6] Walters's great-nephew, Frederick Adams, recalls accompanying his uncle to Cuba in 1923, when they docked at Cayo Mambí in Oriente Province. Often, however, the steam yacht was used just for day trips up the Hudson or from Newport to Campobello, Frenchman's Bay, or Bar Harbor. Her arrival could be a festive occasion, especially for children. Jennie's grandson Warren Delano recalled the *Narada* entering Buzzard's Bay, Cape Cod, where his family had taken a cottage in the summer of 1924. She dwarfed all the other boats that had sailed out to welcome her. Everyone rushed on board to be greeted by Uncle Harry, a "jolly, rotund figure, bearded and mustached," who offered a five-dollar piece to the "kid" who could run around the yacht first. There were even shorter trips; years later, Lyman Delano's wife, Leila, who had apparently grown accustomed to reaching Coney Island under steam, professed astonishment upon learning that her niece, Laura Eastman, had taken the subway to the beach.[7]

An enthusiastic supporter of the New York Yacht Club, Henry Walters became a life member in 1911. At the club's October 1913 meeting, he agreed to join a syndicate to build the defender for the following year's America's Cup race, but with the outbreak of war, the event had to been postponed.[8] In 1920, the *Resolute,* entered by the syndicate headed by Walters, faced Sir Thomas Lipton's *Shamrock IV* off Sandy Hook, New

Jersey. The match pitted America's finest helmsman, Charles Adams, against his British counterpart, William P. Burton. It began ignominiously for the Americans when the *Resolute* failed to complete the first race and lost the second. These were Lipton's only victories throughout his career. Fortunately, the *Resolute* then won three straight, retaining the trophy in New York.

Walters and Lipton may have met for the last time in 1930. The highly popular Irishman, nicknamed the "World's Greatest Sweetheart" by the humorist Will Rogers, remained undeterred by his four defeats and again challenged the New Yorkers. Walters joined Cornelius Vanderbilt, Junius S. Morgan Jr., and other pillars of the yachting establishment in commissioning the *Weetamoe*. However, after bitterly contested preliminary trials, Harold S. Vanderbilt's *Enterprise* won the right to be that year's defender.[9]

After their marriage, the Sixty-first Street residence assumed greater prominence in Henry's and Sadie's shopping forays (fig. 59). The taste for the highly refined arts associated with the eighteenth-century French court and aristocracy had never entirely fallen out of favor in France or Great Britain but was only now making inroads into more egalitarian-minded America. Precisely when the salon paintings of William Bouguereau and Jean-Léon Gérôme began to give way to the bucolic fetes of François Boucher, Jean-Honoré Fragonard, and Hubert Robert and to the tapestries of Gobelins and Beauvais is not recorded. Sadie already had demonstrated a predilection for eighteenth-century furnishings in her bedroom at Sherwood in Newport. Possibly, the friendship between the Joneses and Henry Lehr's companion, Elsie de Wolfe, was a factor. The actress turned interior decorator, who is remembered for introducing chintzes and lattice-trellises to the Colony Club in New York, exerted considerable influence upon the fashions of her day. It was she who, in the spring of 1914, extricated Henry Clay Frick from a game of golf to inspect that portion of the celebrated furniture collection assembled by the Fourth Marquess of Hertford and Sir Richard Wallace that had been retained at 2, rue Lafitte in Paris; on this occasion, the steel magnate made some of his most exceptional purchases.[10]

In the Jones-Walters New York residence, masterpieces of eighteenth-century *ébénistes* and *menuisiers* and earlier Italian works were interspersed with fine reproductions, often of chairs produced by Durand et Compagnie and other Parisian cabinetmakers. Similar melanges could be

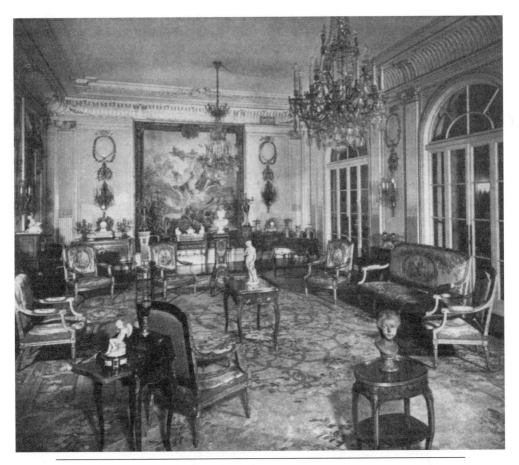

FIG. 59. Interior of the Sixty-first Street residence, New York, 1941. From the Mrs. Henry Walters Art Collection, Park-Bernet Galleries, Inc. (auction catalogue), New York, May 2–3, 1941, vol. 1, frontispiece.

found in the Frick and Morgan mansions in New York and had occurred earlier; Hertford, for example, had supplemented his unsurpassed period holdings with copies of eighteenth-century furniture made by the firm of Dasson.

Some Walters furniture dated from the early eighteenth century, including a commode with chinoiserie gilt-bronze mounts and a pedestal bearing the arms of Charles Albert of Bavaria and his wife Marie Amalie, both attributed to Charles Cressent, the most distinguished master of the French *régence*. From midcentury came a writing table veneered in tulipwood and inlaid with marquetry of floral sprays, which bore the

stamp *B.V.R.P.*, since identified as Bernard II Vanrisamburgh, a principal supplier of furniture to the French crown. Most of the pieces, however, reflected the more restrained, classicizing style from later in the century, and many were rich with historical associations. A commode by Jean-François Leleu had once belonged to George III, who had bought it at a sale in Versailles after the Revolution. Likewise, a mahogany *bureau à cylindre*, originally commissioned from François Ignace Papst for Marie Antoinette, had passed through the Hertford-Wallace collections at the château de Bagatelle and at 2, rue Lafitte, but whether Walters had seen it or the collection exhibited in Paris in 1914 is not known.[11]

Displayed on mantles and *bonheurs-du-jour* and other small tables were garnitures of Sèvres porcelains, often in the prized *roze* and *bleu celeste* colors, as well as statuettes in biscuit porcelain. Equally abundant were exotic combinations of Chinese and European ceramics mounted in gilt-bronze, the imaginative conceptions of the *marchands-merciers*, the purveyors of the chic in eighteenth-century Paris. Some of these furnishings had been purchased at the firm of Wildenstein, but most were acquired through the Seligmanns. Other rooms reflected more eclectic interests and contained eighteenth-century English society portraits, Chinese jades and porcelains, and sculptures ranging from Renaissance bronzes to the stylized figures of the contemporary American sculptor, Paul Manship.

A predilection for the precious and the exquisite was apparent in the many small *objets de vertu* scattered throughout. These included various manifestations of eighteenth-century goldsmithing: presentation and snuff boxes, gold and enameled watches and chatelaines (or decorative clasps), *nécessaires* (used to contain toilet articles), and other bibelots. There were also early boxwood figures, ivory carvings, and Renaissance jewels and enamels.

The criteria in deciding whether an object would be retained at Sixty-first Street or sent to the Baltimore gallery can only be conjectured. Sadie's interest in lace and textiles in general may have accounted for the many fine tapestries and Oriental carpets in New York. Of the latter, two of the most exceptional were a sixteenth-century Turkish floral rug woven at the looms of the Sultan Selim in Istanbul and a seventeenth-century Persian pictorial rug woven with silk, silver, and gold threads showing Western personages.

Perhaps the most beautiful of the early paintings kept in New York were two panels (one was painted on both faces) showing the Annunciation, Baptism, and Crucifixion of Christ, which had once been part of

an altarpiece presented by Louis XV to Cardinal Charles Antoine de la Roche-Aymon for the Chartreuse de Champmol, in Dijon (see plate 15). The panels were acquired from the New York branch of Arnold Seligmann, Rey and Company for eighteen thousand dollars.[12] These panels, painted in the International Gothic style at the beginning of the fifteenth century, were traditionally regarded as French but have since been recognized as masterpieces of early Netherlandish art.

The library in New York excelled in French literature of all periods and also reflected Walters's interests in English and American literature, incunabula, bookbindings, and manuscripts. In addition, he kept in New York autographed documents pertaining to French royalty and to the American Civil War. His most prized items, however, may have been several books bearing the anchor device of the Aldine press founded in Venice in the early 1490s. These included a 1535 edition of Jacopo Sannazaro's *Opera Omnia* bound in morocco leather for the great sixteenth-century bibliophile and statesman, Jean Grolier (WAG 91.1494).

Among the last additions to the library in New York was a Gospel Book that had been copied and illuminated in 1219 by the priest T'oros Roslin at Hromklay, a fortified town on the Euphrates River (see plate 16). Roslin is regarded as the most gifted and innovative artist of Armenian Cilicia's golden age of manuscript production, the twelfth to fourteenth centuries. Adapting images and motifs from Western and Byzantine sources and working with a light palette, he revitalized Armenian illumination. The Walters example, the most richly illuminated of the seven surviving manuscripts signed by the artist, was removed in the early seventeenth century to Sivas, Turkey, where it remained until the Armenian deportations in 1919. Ten years later, Walters, whose long-standing interest in Armenian art may have been rekindled by the recent tragic events, purchased the manuscript in Paris. It was subsequently misplaced, not to be relocated until 1935, when Sadie Walters donated it to Baltimore, where it serves as testimony to a people decimated and a culture obliterated.[13]

The consummate example of the taste for the precious and refined, and one with which Walters would not part, even for his Baltimore gallery, was a large, late antique, agate vase carved with deeply cut grape-vine motifs and acanthus-leaf motifs and satyr-head handles (fig. 60). When he obtained this extraordinary object at the Francis Cook sale at Christie's in 1925, he must have derived satisfaction in knowing of its likely association with the Flemish painter and diplomat Peter-Paul Rubens, who had also been a distinguished collector of antiquities. That it

FIG. 60. The Rubens vase, Early Byzantine (Constantinople?), fourth century, agate and gold (WAG 42.562).

had also passed from the collection of the fabulously wealthy and eccentric William Beckford, the builder of Fonthill Abbey, to that of his son-in-law, the Duke of Hamilton, could only have added to its luster. Only after Walters's death, however, was the full history of the piece unraveled: a product of a fourth- or fifth-century workshop in Constantinople, the vase had been taken as booty by French crusaders in 1204 and was subsequently listed in the inventories of Louis I, Duke of Anjou; his brother, Charles V of France; and the Treasury of the cathedral of Notre Dame in Paris. Comparison with an engraving after a Rubens drawing confirmed its ownership by the artist who, when financially pressed, sold it with other antiquities to Daniel Fourment; Fourment, in turn, offered

it to Jahanghir, Grand Mogul of India. On the voyage east, the vase was temporarily lost in a shipwreck off the Australian coast, only to reappear mysteriously in Beckford's collection in 1818.[14]

A subtle change in the growth of the Baltimore collection occurred during the 1920s; Walters appeared to focus more on items of exceptional artistic and historical importance. His frequent stops in Baltimore during the war years had given him an opportunity to assess the collection and to reflect upon its future, bringing to bear his years of experience on various committees of the Metropolitan Museum of Art. Whatever the cause, many key works acquired during this decade would substantially enhance both the value and the reputation of the collection. In a rare attempt to refine his holdings, Walters finally consented to part with the sixty-seven Massarenti paintings bearing the most egregious attributions.[15] Much of his shopping was now undertaken in this country rather than abroad, although he still depended on his familiar sources in Paris. In the wake of World War I, the art market burgeoned, and with the influx of European dealers, New York's Fifty-sixth Street was transformed into a major hub for the international art trade.

In the earlier schools of painting, Henry Walters's most astute purchase was a Hugo van der Goes offered for sale for 650,000 francs in 1920 by Jacques Seligmann's son Germain (see plate 17). Several months earlier, it had been auctioned in Amsterdam for 40,000 florins, a sum at that time beyond the means of the Rijksmuseum. A panel from a diptych, this masterpiece shows a praying donor being presented by Saint John the Baptist, presumably to the Virgin and Child who would have appeared on the missing wing. A consummate realist, the Flemish fifteenth-century master painted the subject in meticulous detail, capturing the donor's expression of intense reverence. Aware of the significance of the purchase, Walters departed from his policy of never lending and allowed the work to be included in a benefit exhibition of early Flemish paintings held in 1929 at F. Kleinberger Galleries. Social pressure may have been a factor; the exhibition organized under the auspices of Mrs. William Randolph Hearst included pictures lent by such eminent collectors as Jules S. Bache, Andrew W. Mellon, John D. Rockefeller, and Mortimer L. Schiff.[16]

As a concession to the importance that the public attached to Rembrandt's works, Walters sought to buy an example without paying a Duveen price. A head of an old man acquired in 1919 from the estate

of the French painter François Flameng proved to be spurious. More promising was *The Woman at the Window,* offered for sale in 1925 by F. Kleinberger for fifty thousand dollars. Reputedly a portrait of the artist's companion, Hendrickje Stoffels, the painting had passed through important collections and been published by Wilhelm von Bode and William R. Valentiner. Its authenticity remained unquestioned during Walters's life, but it has since been reclassified as the work of a Rembrandt follower.[17]

Demonstrating an affinity for Italian art, Walters bought some exceptional paintings during the last decade of his life. He acquired Paolo Veronese's full-length, life-size *Portrait of the Countess Livia da Porto Thiene and Her Daughter Porzia* in 1921. Though its surface is abraded, it still illustrates the rich palette and sumptuous textures associated with the influential sixteenth-century Venetian master. A particularly attractive, fifteenth-century panel painting of the *Madonna and Child Flanked by Angels,* with one angel playing the vielle and the other a lute, came from Munich in 1925. Depicted on the ledge in the foreground is a card identifiying the artist as Giorgio Schiavone, the Dalmatian pupil of Paduan master Francesco Squarcione. Two years later, Walters bought at auction a major work by Sofonisba Anguissola, a Cremonese artist much admired by Michelangelo. Her subject, the nine-year-old Marchese Massimiliano Stampa, portrayed with an intensely melancholic expression, had recently succeeded his father as marchese of the city of Soncinco, his accession to power being denoted by a sword and folded gloves.[18]

The holdings of Renaissance sculpture also grew. Among the additions was a bronze statuette of Saint John the Baptist acquired in 1926 from Germain Seligmann. When it had been exhibited in the Schloss Friedrichshof as the property of the Empress Frederick (the Kaiser's English mother, Victoria, the Princess Royal), Wilhelm von Bode listed it as being "in the manner of" the sixteenth-century sculptor and architect, Jacopo Sansovino, but the noted Viennese art historian Leo Planiscig, to Seligmann's delight, subsequently upgraded it to a work of the master.[19]

Among Walters's last purchases was a bronze statuette with gilded hair and silvered eyes. Known as *Venus Prudentia,* it was first published by von Bode as "in the manner of Antico," the popular name for Pier Jacopo Alari-Bonacolsi, the goldsmith and sculptor who served the Gonzagas's humanist court at Mantua in the late fifteenth and early sixteenth centuries. It is now generally accepted as a work of the master who, as a result of his experience restoring Roman statuary and collecting antiquities for Isabella d'Este, reinvigorated the classical tradition, working in

a style characterized by smooth, rounded forms and contrasts between dark patinas and partial gilding and silver inlays.[20]

In retrospect, any additions to the American holdings during the 1920s seem incidental. When Bryson Burroughs, curator of paintings at the Metropolitan Museum of Art, exhibited his own works at Montross Gallery in 1921, Walters purchased an oil, *Saint Martin and the Beggar,* and a couple of drawings. A congenial individual whom even the arch Americanphobe, Roger Fry, regarded as a great comfort in "this weltering waste of the American people," Burroughs successfully pursued for twenty-eight years a dual career, painting in the mornings and serving as curator in the afternoons. Although he specialized in scenes of classical mythology depicted in modern settings, often Central Park, which he rendered in muted tones that recalled the paintings of his mentor, Puvis de Chavannes, Burroughs championed modern art. He had been partly instrumental in the museum's purchase of Renoir's *Mme. Charpentier and Her Children* (1907) and was fully responsible for the even more controversial acquisition of Cézanne's *La colline des pauvres* (1909).[21] So highly did Walters regard Burroughs that in 1925 he bought for himself Ingres's 1842 version of *The Odalisque with Slave* simply to spare the curator the embarrassment of returning it to Paris. Burroughs had proposed the painting for the Metropolitan Museum, but Florence Blumenthal, wife of trustee and patron George Blumenthal, had so vociferously expressed her opposition to the purchase that it had been rejected.[22]

In the spring of 1924, Walters bought at Knoedler and Company his only significant addition to the American collection. This was Eastman Johnson's *The Nantucket School of Philosophy,* a painting that had attracted considerable attention when it had been exhibited in Chicago at the 1893 World's Columbian Exposition. Dating from 1887, the genre painting, one of the artist's last, shows elderly seamen seated around a stove in a cobbler's shop, reminiscing. Two years later, Johnson noted to the first buyer, the subjects, with only three exceptions, had all died.[23]

Despite his limited purchases in the field, Walters agreed to finance the publication of several monographs devoted to American artists. These were intended to be deluxe editions and might have represented his interests as a bibliophile rather than a concern for promoting American art. The art historian Eliot Clark recalled being commissioned by Frederick Fairchild Sherman in 1920 to write a biography of the pioneer American impressionist Theodore Robinson, who had the distinction of being a close friend of Claude Monet. However, the manuscript remained unfinished at Walters's death in 1931.[24]

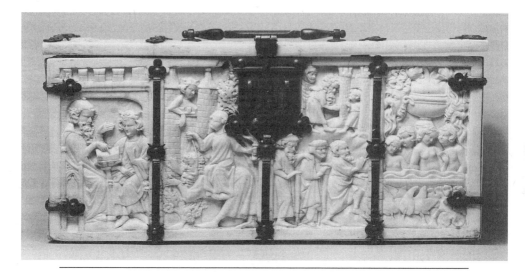

FIG. 61. Ivory casket, French (Paris), about 1330–50 (WAG 71.264). The box is carved with scenes from romances and allegorical literature representing the courtly ideals of love and heroism. On the front face, Aristotle teaches Alexander, Phyllis rides Aristotle, and men and women visit the Fountain of Youth. The Gothic-style mounts are thought to have been added during the nineteenth century, when the box belonged to Frédéric Spitzer of Paris.

During the 1920s, Arnold Seligmann, Rey and Company supplied the Walters's New York household with some of its finest French eighteenth-century paintings and *objets d'art*. Among the few examples eventually to reach the Baltimore gallery were two consummate embodiments of the rococo style: a gilt-bronze cassolette (perfumer) bearing a *blanc de chine* figure of Pu-tai Ho Shang mounted in a bower of Vincennes porcelain flowers and a pair of Sèvres *roze* vases painted by the manufactory's leading decorator, Charles-Nicolas Dodin, with chinoiserie vignettes based on Gabriel Huquier's prints after François Boucher's designs.[25]

At the same time, the firm provided the Baltimore gallery with many earlier works. Among the most noteworthy was a mid-fourteenth-century, French ivory casket carved with scenes from romances and allegorical literature (fig. 61). Its lid presents captivating views of courtly life, the Castle of Love, two knights jousting, and a mock tilt between a lady and a knight. Only the Gothic revival, iron mounts, applied for Frédéric Spitzer in the late nineteenth century, detract from this remarkable ivory. Also of interest, because it had appeared in the *Trocadéro Rétrospective* exhibition that so captivated William Walters in 1878, was an

eleventh- to twelfth-century, Byzantine ivory casket carved with scenes of Adam and Eve and of Joseph.[26]

With the purchase of the E. M. Hodgkins collection of Sèvres porcelain in October 1928, Walters departed from his usual practice of keeping his major French, eighteenth-century purchases for his New York residence and, instead, had the porcelains delivered to Baltimore. Although they had been published as though they were a private collection, these porcelains represented one of several such assemblages that the London dealer Edwin Marriott Hodgkins had gathered for sale *en bloc*. Hodgkins maintained that he had spent fifty years collecting the porcelains; most could be traced to British collections which, like that of George IV, had been compiled in the aftermath of the French Revolution. Two examples are a splendid pair of vases in the form of fountains with dolphin handles, known as *Vases à jet d'eau,* and another equally important pair, the *Vases ovales mercure,* named for the biscuit medallions of Mercury and of the Emperor Titus's daughter Julia on their lids. These four vases had once belonged to Sir Peter Burrell (1754–1820), first Baron Gwydir, a noted early-nineteenth-century collector.

Since the first publication of the Hodgkins porcelains by the ceramics specialist Xavier de Chavagnac in 1909, significant pieces had been withdrawn and presumably sold. However, among the remaining seventy-four porcelains Henry Walters purchased from Arnold Seligmann and Rey in 1928 were many remarkable ornamental vases in rare shapes, the majority of which were prepared with various intense blue ground colors: *beau bleu, bleu lapis, bleu Mazarin, bleu nouveau,* and so forth. The concentration of blue wares was a distinctive feature of the collection and one that may have accounted for it being sent to Baltimore — Sadie preferred pinks, greens, and turquoise for her furnishings in New York.[27]

Two years later, it was ostensibly Arnold Seligmann and Rey who provided Walters with an extremely impressive addition to his medieval holdings, a monumental chasse containing a relic of the bishop-saint of Maastricht and Tournai, from the Abbey of Saint-Amand-d'Elnon in Flanders. Since the saint's death in 675–79, his relic had undergone various vicissitudes. The frame of the existing reliquary in the form of a Romanesque sarcophagus may date from 1180, the year a divine light was witnessed in front of the saint's shrine. The copper plaques showing the evangelists and the apostles standing beneath arcades are clearly Gothic in style and may have been added during the third quarter of the thirteenth century when the chasse underwent an extensive restoration. This reliquary and several closely related works, including a chasse from

the church of Saint Symphorien, a village in Flanders, are now regarded as key monuments of an atelier of metalworkers that flourished at nearby Tournai during the thirteenth century.[28]

As was often customary in the Paris art market, Seligmann, in selling the chasse, had acted on behalf of another dealer; a photograph taken about 1926 shows the piece surrounded by medieval enamels in Brimo de Laroussilhe's shop on the rue Lafitte. Nicolas Brimo, a merchant from Aleppo, formed an association with his brother-in-law, Lucien Lascombes de Laroussilhe. Their firm dealt in medieval, Renaissance, and Islamic arts, operating through a network of dealers who were often either Jewish or Armenian and, like Brimo, had reached Paris via Istanbul. That many of the finest medieval enamels in the Walters collection passed through Brimo's hands has been confirmed by early photographs in the firm's archives. Almost invariably, the intermediary was the *collectionneur-marchand* Henri Daguerre, whose *hôtel particulier* on the rue Jouffroy became Brimo de Laroussilhe's headquarters in 1928.[29]

During the 1920s, Walters achieved some spectacular successes in upgrading his Asian holdings. Relying principally on Yamanaka and Company, he acquired in 1920 several large-scale, early examples of Chinese Buddhist sculpture. A nine-foot figure carved in quartz sandstone is reported to have come from the Temple of the Stone Buddhas in Yünkang, Shansi province. Dating from the late sixth century, it represents a Bodhisattva, or Buddha-to-be, possibly Kuang-yin, who attended the Buddha in the western paradise. Also purchased from Yamanaka that year was a larger-than-life-size, seated Buddha in a posture of meditation (see plate 18). It may have been taken from a Buddhist temple founded in 586 in Cheng-ting, Hopei province. Dating from the early seventh century, this work is now regarded as one of the earliest surviving examples of Chinese lacquered wooden sculpture.

In addition to these large-scale sculptures, Yamanaka provided Walters with considerable quantities of archaeological material, including Chinese bronze fittings and ornaments ranging in date from 500 B.C. to A.D. 900, as well as similar examples from Korea. Among the earliest of the latter were two first-century, horse-shaped buckles reflecting the zoomorphic style introduced to Korea from China five centuries earlier.[30]

Although Yamanaka and Company remained his principal supplier of Asian artifacts, Walters dealt with other sources, including Edward Barrett, an elusive individual who resided in Peking during much of 1925

and 1926. At that time, Barrett shipped numerous crates and bundles to Baltimore containing mostly Ming and Ch'ing porcelain vases and jars, as well as some roof tiles from Peking's imperial palaces.

A singular opportunity to buy outstanding Egyptian antiquities arose in London two years later. During the late nineteenth and early twentieth centuries, William MacGregor, erstwhile vicar of Tamworth, Stafford-shire, had assembled a collection that has been described as "one of the most remarkable . . . ever made by a private individual."[31] The vicar had generously subscribed funds to excavations, including those conducted at Meroë (modern Sudan) by the British archaeologist John Garstang, and had participated in others undertaken at Bubastis on the delta by the Swiss archaeologist Edouard Naville. In addition, he had served as one of the six members of exhibition committee responsible for organizing the landmark exhibition *The Art of Ancient Egypt* held in 1895 at the Burlington Fine Arts Club in London.

Initially, MacGregor concentrated on ceramics, and his early holdings were published in 1898 in *Egyptian Ceramic Art: The MacGregor Collection,* a pioneering study in English, written and illustrated by Henry Wallis, an artist and authority on Near Eastern ceramics. Subsequently, the collector broadened his interests to encompass such fields as sculpture, jewelry, cylinder seals, stone vessels, and papyri. The MacGregor antiquities figured prominently in the Burlington Fine Arts Club's second great Egyptian exhibition, *Ancient Egyptian Art,* held in 1922, and shortly afterward they were dispersed at a sale held over nine days at Sotheby's.

On this occasion, Dikran Kelekian, representing Walters, placed bids for thirty-nine lots (ninety-three individual items) of Egyptian faience. Of particular interest, however, was a Nubian (rather than Egyptian) votive relief showing the ruler Tanayidamani and the lion-headed deity Apedemak. In the first century B.C., this relief had been dedicated at the Lion Temple in the capital, Meroë, located on the Nile between the fifth and sixth cataracts. As well as presenting a thorough survey of the field, the purchases at the MacGregor sale included some exceptional items, among them a bicolored rhyton decorated with palmettes, wave patterns, and griffins and a bowl with molded lotus ornament. One of the most expensive items was a blue faience *senet* gaming board, inscribed for Nesi-amun-ipet, a priest of Amun at Abydos in the nineteenth dynasty, for which £176 was paid. In addition to many faiences, Kelekian provided

his client with many cylinder seals and scarabs, jewelry, some sculptures, and carved ivories, including five representing dwarfs from the predynastic period, which were said to have been excavated at Saoniyeh.[32]

For the remainder of his life, Walters continued to depend on Kelekian for most of his Egyptian holdings. Among the additions was a relief fragment from the tomb of Maya, an official at Saqqara in the Eighteenth Dynasty (about 1330 B.C.). Despite finding Egyptian art overly masculine and therefore incongenial, Mary Cassatt had bought the relief during an unhappy visit to Egypt in the company of Kelekian and the Boston collector Denman Ross in 1911.[33] Kelekian subsequently acquired the relief and offered it to Walters in 1922. Either as a result of the dealer's contacts or because of Walters's particular tastes, most of the objects from Kelekian tended to date from the Late Period (c. 750–332 B.C.) or the Greco-Roman period (332 B.C.–A.D. 395). The dealer seemed particularly adept at supplying the small objects favored by Walters — bronzes, faience, and jewelry. Among his specialities were "sculptors' models," small limestone reliefs that may have served as trial pieces, ex-votos, or models to transmit stylistic canons from one generation to the next. Presumably, most of the sixty-seven examples in the collection, carved in relief or in the round, were obtained through Kelekian.

After 1925, Walters increasingly looked for larger, more substantial objects. Among the more impressive sculptures he bought that year was a Late Period head of a queen, her regal status indicated by her vulture-headdress, which was associated with Nekhbet, the patron deity of Upper Egypt. Others included a seated statue of Sesostris III, a Twelfth Dynasty king who was renowned for his military prowess and wisdom, and a large, red granite, Early Ptolemaic fragment from a wall relief showing the martial deity, Onuris, one of seven granite reliefs purchased by Walters from the temple at Behbeit el Hagar and Samanhud.[34]

References in the Anderson ledgers to the arrival in Baltimore of crates of Egyptian artifacts purchased in Cairo in May and June 1930 suggest that Walters, at the age of 82, once more went to Egypt, although the circumstances of this visit remain unknown. From Sheikh Ismael, listed as the "Sheik of the Pyramids," came a number of bronzes and faiences. Likewise, Maurice Nahman, a retired Egyptian banker, provided Walters with a few miscellaneous sculptures in stone and faience. More consequential were the contents of a case shipped from Cairo by the Khawam brothers, which included such items as a bronze statuette of Anubis wearing a double-crown and a Nubian, late-first-century B.C. gold amulet in the shape of a reclining lion.[35]

That year, Kelekian was also the source for yet another Hellenistic

archaizing statue that purported to date from the late fifth century B.C. The figure of a maiden wearing a belted peplos had been sold thirteen years earlier at the auction of the renowned Hope Heirlooms, a collection begun in the late eighteenth century by Thomas Hope, author of *Household Furniture* (1807) and patron of the neoclassical sculptors Canova and Thorwaldsen. Subsequent scholarship has recognized that the head and body had been incorrectly matched.[36]

In the postwar era, an alternative source for many categories of ancient art became available when the Brummer Gallery opened in New York. Joseph Brummer and his younger brothers Ernest and Imre had left their native Zombor, then in southern Hungary, Joseph going directly to Paris to study with Auguste Rodin and Henri Matisse and Ernest to Budapest to prepare for a career in music before joining Joseph in Paris. After they had successfully "hawked" some Japanese prints, the brothers opened a gallery in 1906 on the boulevard Raspail and dealt in tribal arts. Their visitors included Henri "Le Douanier" Rousseau, who exhibited his striking *portrait-paysage,* actually an image of Joseph seated in a chestnut grove, at the Salon des Indépendents in 1909. Imre, a shadowy figure in the history of the firm, was the first member of the family to reach New York, where he contacted the Metropolitan Museum of Art as early as 1914. After the war, the Brummers found a space on Fifty-seventh Street in the heart of the art dealers' district. Although their gallery's masthead read "Joseph Brummer, Ancient Art," it dealt in fields including ancient Near Eastern, early Christian, and medieval art and exhibited works by such contemporay masters as Derain, Pascin, Matisse, Modigliani, Maillol, and Lachaise. Ernest Brummer, who remained in Paris, gathered stock for both the boulevard Raspail and the Fifty-seventh Street outlets. Perhaps because of Joseph's experience as a pupil of Rodin, the firm's particular strength was sculpture of all periods, especially fragments removed from architecture. Brummer Gallery was to have a profound influence on the development of American tastes and collecting at both institutional and individual levels. The Metropolitan Museum of Art acquired more than four hundred works from the brothers, and many individual collectors relied on them, including William Randolph Hearst, Bradley Martin, Grenville Winthrop, and the Baltimorean Sadie May.[37]

Walters, having been contacted by the Brummers in Paris as early as 1914, was among their first American clients. In 1921, Joseph Brummer sold him a modest selection of Romanesque and Byzantine fragments

for nine thousand dollars, and the following year he offered a varied selection of antiquities, ranging from an Egyptian Nineteenth Dynasty limestone relief of a kneeling king being suckled by the divine Hathor-cow to a Greek fourth-century B.C. funerary relief of a young girl, Sosibolis, portrayed holding a dove and fan.[38]

Many of their antiquities were impressive in scale and undoubtedly were selected to enhance the installations in Baltimore. In this category fell a large Assyrian relief of a mitered genius, or benevolent spirit, from the palace of Assurnasirpal II at Nimrud, near Mosul in modern Iraq. The palace, dedicated in 879 B.C., was excavated in the mid–nineteenth century by Sir Austin H. Layard. Clearly delineated in the embroidery on the figure's sleeve are scenes of a lion and bull hunt that conform to an illustration published by Layard in 1853. On this basis, archaeologists have identified the relief as coming from the left of a doorway leading into the royal apartments. Many of the reliefs deemed duplicates by Layard were acquired by American missionaries, most notably William Frederic Williams and Dwight Whitney Marsh, cut into sections, and transported by camel and by sea to the United States, where they were presented usually to religious-affiliated colleges. Where Brummer acquired the Walters relief remains unknown, but even more puzzling is the lack of documentation pertaining to the acquisition of a second relief, also from the palace at Nimrud. It shows a winged genius holding a typical cone-shaped object and is thought to have adorned the banquet hall in the palace's official quarters.[39]

Walters's last and perhaps his most important early Christian purchase was the Abucasem or Hama silver acquired through Joseph Brummer in 1929 (fig. 62). The visual appeal of these twenty-three pieces of liturgical silver — chalices, pattens, crosses, ladles, lampstands, and spoons — can be attributed to their restrained, graceful shapes and nielloed and partially gilded decoration. The collection was first photographed, purportedly as it was discovered in 1910, at Hama, Syria, and then sold to Brummer by Tawfic Abucasem, the director of the Ottoman Bank in Hama. Recent scholarship suggests that the display of the silver in Hama in 1910 was a ruse intended to mislead Turkish officials and that the pieces had originally been part of a large hoard that included the celebrated Antioch Chalice (Metropolitan Museum of Art, New York), once regarded as the Holy Grail. Now it is conjectured that the silver was made for the village church of Saint Sergios, Kaper Koraon (Kurin), in northern Syria.[40]

Rarely did Walters buy from private individuals rather than dealers. However, during a visit to Eustis, Florida, in 1929, he encountered

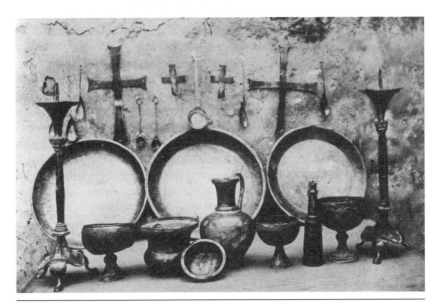

FIG. 62. The Early Byzantine "Hama treasure" was originally thought to have been found in 1910 in a cistern in the village of Krah near Hama, Syria. This photograph, taken at that time, shows the silver as it was displayed at the cathedral of Hama. Subsequent investigations indicate that the silver was part of a larger treasure found in Kurin (Greek Kaper Koraon), Syria. Photograph from Marlia Mundell Mango, *Silver from Early Byzantium,* Walters Art Gallery, Baltimore, 1986, 25.

Edgar J. Banks. Nine years after serving as field director for the Babylonian section of the Oriental Exploration Fund of the University of Chicago in 1903, Banks published a popular account of the excavations at Adab, an ancient city buried in the desert near Bismayah, Iraq. In the course of these excavations, Banks must have gathered most of the artifacts that he sold Walters. They included some Sumerian "nails," or inscribed terra cotta pegs that were driven into mud architecture as foundation deposits. Banks also provided a few later works, including a carved stone Silenus mask from Hamadan dating from the second century B.C. and a first-century painted Palmyrene portrait bust.[41]

Although Walters continued to rely on Gruel in Paris and Olschki in Florence for fine manuscripts and early printed books, one of his most spectacular late purchases was through the Munich dealer Jacques Rosenthal, whose son Erwin was Olschki's son-in-law. In his 1926 catalogue, Rosenthal published a Carolingian Gospel Lectionary that had been produced during the mid–eleventh century in the Scriptorium of Regensburg, Bavaria, and is thought to have subsequently belonged to

the Benedictine Abbey of Saints Peter and Paul at Mondsee in Upper Austria. Of particular interest is its remarkably intact, twelfth-century binding covered with silver decorated with filigree and set with carved ivory plaques showing the four evangelists (see plate 19). Exactly when Walters acquired the lectionary is not recorded, but the fact that it was delivered to Baltimore rather than to New York suggests a late date.[42]

In the wake of World War I, foreign libraries were dispersed or forced to reduce their holdings and a number of rare books became available. In 1925, Thomas Whittemore brought some early Greek manuscripts to this country from the Andreaskiti Library on Mount Athos. The abbot, no longer able to rely on funding from Russia, had been forced to sell them to raise funds for his monastery. Robert Garrett bought eight of these volumes. Walters, in what is thought to have been his last known purchase, selected a rare Byzantine book with the four Gospels, transcribed in the twelfth century by the monastic scribe Thedoulos and supplemented with miniatures during the twelfth to sixteenth centuries. About the same time, Gruel offered an important twelfth- to thirteenth-century *Praxapostolos,* or manuscript of the Acts and Epistles, from the Iviron Monastery, also on Mount Athos.[43]

From the outset, Henry Walters showed an appreciation for the aesthetic qualities of armor and weaponry, as can be traced in his occasional purchases in both the Islamic and the Japanese fields. With a few exceptions (including that of Walters, who obtained several late-sixteenth- and early-seventeenth-century wheel-lock guns and pistols at the Samuel H. Austin sale in 1917),[44] European weapons and armor had remained the exclusive domain of German, British, and French collectors. In the 1920s, when ancestral collections in Europe were being liquidated as a result of taxation, the roles were reversed, and Americans began to dominate the market. A key figure in this development was the wealthy and patrician Bashford Dean. In 1906, at J. Pierpont Morgan's request, Dean resigned his position as professor of zoology at Columbia University to become the honorary curator for arms and armor at the Metropolitan Museum of Art. Dean was not placed on the payroll until 1913, the year in which he induced William H. Riggs to part with his celebrated armor collection, thereby creating a separate department within the museum with the Riggs collection as its core.

Walters respected Dean and funded a number of purchases for the museum, including, in 1925, two sixteenth-century damascened swords, one Brescian and the other Milanese, and the following year he shared

with the curator the costs of acquiring a collection of carousel lances and pennon shafts. Walters's most significant contribution to the department, however, was an etched and gilded half-suit of armor made in 1581 by Anthon Pfeffenhauser for Christian I of Saxony. When Dean auctioned some of his personal holdings in 1921, Walters bought some items, among them a German, early-sixteenth-century Maximilian helmet characterized by its decoration of parallel rows of fluting.

Americans were presented with an unprecedented opportunity to obtain armor when the Henry Griffith Keasbey collection was sold in New York by the American Art Association in December 1924 and November 1925. Keasbey, an expatriate and true connoisseur, had attended the principal armor auctions in Europe during the 1890s. When his collection was auctioned, Walters joined the fray in bidding for the seven hundred lots with William Randolph Hearst, Clarence Hungerford MacKay, and Edward H. Litchfield. Walters obtained fifty-six pieces spanning the entire range of European weaponry: powder flasks, wheel-lock guns, crossbows, poignards, rapiers, halberds, several suits of armor, and such curiosities as a German, sixteenth-century combination battle-ax and wheel-lock pistol.[45] One of the the more outstanding examples of metalwork was a finely etched and partially gilded pauldron and vambrace (arm defense) embossed with a lion's mask identical to one appearing on a pauldron from the armor made for Carlo Emmanuele, the Duke of Savoy, about 1578.[46]

New York's domination of the armor market was demonstrated at an auction in November 1926. Of the 311 lots offered for sale, 16 could be traced to the royal armory of Dresden, 9 to the grand-ducal family of Saxe-Weimar, and 4 to the collection of Prince Carl of Prussia. The remaining lots were of "Princely Provience": they came from Schloss Vaduz and were being sold by the reigning house of Liechenstein. On this occasion, Walters bought an assortment of halberds, partisans, and other weapons and a late-fifteenth-century, German long-tailed sallet, the type of war helmet that Albrecht Dürer depicted in his renowned engraving *Knight, Death and the Devil* (1513).[47]

Walters sought out individual examples of armor as well as buying at auction. In the summer of 1925, Henri Daguerre sold him an early-seventeenth-century, elaborately enriched, ceremonial harness, or suit of armor. An annotated photograph identified the original owner as the Marquis de Mondejar of the family of the dukes of Mendoza and Medina Sidonia and the seller, in 1924, as the present duke of Medina Sidonia. That the suit can be dated on the basis of style to about 1615 has led historians to assign its ownership to the seventh duke of Medina Si-

donia, the hapless and seasick Admiral of the Oceans who commanded the Spanish Armada. Chiseled overall with compartments of interlaced strapwork, each containing the initial *M* surmounted by a ducal coronet, the suit was intended for a member of the Medina Sidonia family who held the hereditary position of Grand Equerry and therefore commanded the royal armorers. Though sometimes regarded as Milanese, the suit is now thought to have been produced in Engui, a small town in Navarre, where a few Milanese armorers were employed.[48]

Not since his voyage to Saint Petersburg in 1900 had Henry Walters shown particular interest in the arts of Russia. In 1928, an emigré dealer, Alexandre Polovtsov, rekindled Walters's enthusiasm for both the early Moscow wares and the more westernized products of eighteenth- and nineteenth-century Saint Petersburg. Before the Russian Revolution, Polovtsov had served as curator of the Stieglitz Museum of Industrial Art, the premier collection of non-Russian decorative arts in Saint Petersburg. He was reputed to have been enthralled by the memory of the *comtesse du Nord,* Maria Feodorovna, and may, in fact, have been the great-grandson of the beautiful and most artistic of the Romanov spouses.[49] In 1781–82, she and her husband, Grand Duke Paul, later Paul I, had traveled in western Europe as the comte and comtesse du Nord. Maria Feodorovna, herself an accomplished artist, was credited with overseeing the furnishing of the Pavlovsk Palace outside Saint Petersburg. During the tumultuous days of the revolution, Polovtsov, remaining true to his comtesse du Nord, stayed in Russia, valiantly trying to preserve from Bolshevik marauders the contents of the Pavlovsk and Gatchina Palaces. Only in October 1918 did he escape to Finland. Settling in Paris on the boulevard Haussmann, Polovtsov became a dealer.[50]

Henry Walters visited Polovtsov in Paris in 1928 and 1929 and bought Russian silver drinking vessels, portrait miniatures, snuff boxes, and tapestries. Among his purchases was a gold and malachite snuff box showing on its cover a replica of Maria Feodorovna's portrait drawing of her six children. More historically consequential were the purchases made during Walters's last trip to Paris in July 1930. These included early icons and a masterly example of the goldsmith's technique known as *quatre-couleurs,* in which different alloys of gold are used to obtain a range of colors. This exceptionally large, late-eighteenth-century oval snuff box is decorated with military scenes and trophies and is signed "Kolb à St. Petersburg." Other Russian rarities bought at this time included a collection of autographed letters of Catherine the Great.[51]

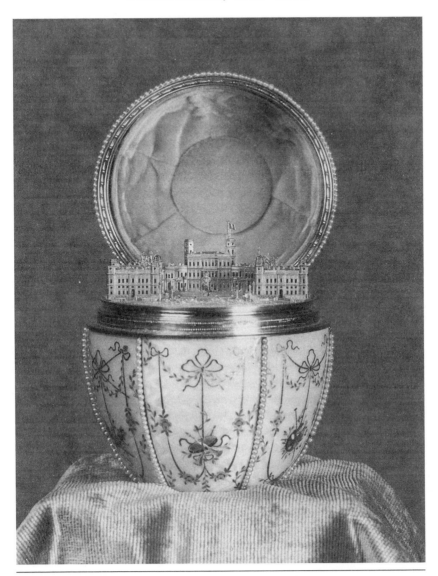

FIG. 63. Carl Fabergé (workmaster: Mikhail Perkhin), Gatchina Palace egg
(WAG 44.500). Czar Nicholas II presented this egg to his mother, Maria
Feodorovna, on Easter Day, 1901.

In his inventory of the crates that Polovtsov shipped to Baltimore, Superintendent Anderson noted, "One egg in white enamel, with a ring of little enameled pearls, one missing, Modern" and "1 copper egg decorated with enameled roses, Modern." It was only in 1932, a year after Henry Walters's death, that the eggs were unpacked and identified as imperial Easter eggs. The larger of the two is the Gatchina Palace egg; it contains, as a surprise, a miniature replica of the principal residence of Alexander III and Maria Feodorovna. It had been executed by Carl Fabergé's workmaster, Mikhail Perkhin, and presented by Nicholas II to the Dowager Empress in 1901 (fig. 63). The other was the rose-trellis egg created by Perkhin's successor, Henrik Wigström, and given by the tzar to his mother in 1907. By 1932, for Americans in the depths of the Great Depression, the eggs had lost much of their luster and served as little more than tokens of a vanished life of luxury.[52]

POSTSCRIPT

AFTER A SHORT ILLNESS, Henry Walters died in New York on November 30, 1931, at the age of eighty-three (fig. 64).[1] In deference to his abhorrence of publicity, the obsequies were kept brief. A private funeral held the next morning at the Sixty-first Street residence was followed by internment in the family vault at Greenmount Cemetery in Baltimore. The Atlantic Coast Line draped its offices in black and observed a minute of silence at the time of the burial.

Walters's confidants surely must have been aware of his intentions regarding the art collection, but the Baltimore public, in the light of his long absence from the city and his many years of involvement with the Metropolitan Museum of Art in New York, was understandably concerned about the collection's fate. Their fears were allayed a week later by the probate of Walters's remarkably brief and succinct will, which had been drafted in 1922. By its terms, he bequeathed to the mayor and city council of Baltimore, "for the benefit of the public," the gallery, its contents, and the adjoining house at Five West Mount Vernon Place. He further instructed his executor, the Safe Deposit and Trust Company, to divide the residue of his estate into twenty equal parts, directing that five-twentieths were to serve as an endowment for the gallery, with the income paid in quarterly installments. Even though the Great Depression had exacted its toll, there still remained almost $14 million, with over $2,062,000 allocated for the gallery as an endowment.[2] This exemplary act of munificence was likened to the recent benefactions of John G. Johnson, William Rockhill Nelson, Edward Drummond Libbey, Henry Clay Frick, and J. Pierpont Morgan.[3] To appreciate fully the significance of the bequest for the mid-Atlantic region, one should recall that the Virginia Museum of Fine Arts did not open in Richmond until 1936 and that the National Gallery of Art in Washington was not founded until 1937.

Other beneficiaries of Walters's estate included his widow Sadie and his sister Jennie, each of whom inherited six-twentieths. The Metropolitan Museum of Art received a mere third of one-twentieth ($137,511), undoubtedly a disappointment. Harvard College and Georgetown College also received one-third of one-twentieth each, whereas the Family and Welfare Association of Baltimore, the past recipient of the proceeds from over fifty years of gallery openings, was left half that amount. Token bequests were given to close friends and associates, with his nephew Lyman receiving the residue.

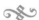

Mayor Howard W. Jackson assigned to a citizens' committee responsibility for transforming the private gallery into a public museum. Comprising mostly prominent Baltimoreans who were experienced in local, institutional matters, the committee included the donor's widow and two other members who had been personally acquainted with Henry Walters: John J. Nelligan, president of the Safe Deposit and Trust Company, and C. Morgan Marshall, whose family construction firm had maintained the gallery building since its construction.[4] Initially, Sadie Walters took a lively interest in the proceedings, and at the first meeting she reiterated her husband's desire that the gallery serve for the "promotion of the welfare, education and happiness of the people of Baltimore."[5] In response to the rumors already being circulated that the collections would be merged with those of existing institutions, she reaffirmed Walters's wishes that the gallery be preserved as a separate and distinct entity. Philip B. Perlman, one of the younger members of the commission and a gifted lawyer who would later distinguish himself as President Truman's Solicitor General from 1947 to 1952, took responsibility for drafting the various ordinances and bylaws establishing the gallery and incorporating its board of trustees.[6] A city ordinance approved by Mayor Jackson on June 16, 1933, vested control of the Walters Art Gallery in the trustees. They included the mayor and president of the city council (ex-officio), Sadie Walters (for life), John J. Nelligan (as representative of the Safe Deposit and Trust Company), and the five members of the original commission.[7]

A daunting challenge awaited the board: the building's limitations had to be addressed, a staff selected, and the more than twenty thousand works of art catalogued. Over 243 crates of objects, mostly acquired after 1919, remained unopened in the basement. From the outset, the lack of space for displaying the collections was recognized as the most pressing

FIG. 64. The last photograph of Henry Walters, 1930. Walters agreed to allow
a single, half-hour sitting for Hans Schuler, who had been commissioned to
sculpt his portrait bust. Reluctantly, Walters spared an additional three minutes
for Edgar Schaefer to photograph him. Otherwise, Schuler would have had to
work from a passport print. Photograph by J. H. Schaefer and Son
(WAG Archives).

problem. Several years before his death, Walters had confided to a colleague on the Peabody Gallery committee, General Lawrason Riggs:

> I am greatly distressed over the fact that I have now accumulated in my storeroom at the Galleries over 200 boxes of things I have bought and am unable to unpack because of having no space to put them in. They are mostly large objects and really are among the fine things that I own. I have been hoping that I would get an opportunity to spend a couple of months in the Gallery and make space by discarding objects of inferior importance. I mention this to you personally because I know of the real interest which you have taken in the Walters Galleries.[8]

An unidentified blueprint from 1930 showing plans for a proposed building expansion west of the gallery suggests that, had Walters lived, he might have addressed the challenge himself. As it was, among the first ordinances that the trustees requested Perlman to draft for submission to the City Council was one authorizing the condemnation of those properties that might be required by the gallery's growth. For the remainder of his life, Perlman would campaign for the expansion of the gallery.

In deference to Sadie Walters's wishes, the trustees consulted Herbert Winlock, an Egyptologist who had recently been appointed director of the Metropolitan Museum of Art, regarding the qualifications of a museum director. The position was offered to Henri Marceau, director of the Pennsylvania Museum of Art, and to Walter Siple of the Cincinnati Art Museum, both of whom declined.[9] To avoid further delays, the trustees designated their colleague C. Morgan Marshall as "temporary conservator" and eventually as "administrator."[10] They also retained several eminent art historians and museum professionals as an advisory committee. Among its members were Henri Marceau, Francis Henry Taylor of the Worcester Art Museum, Belle da Costa Greene of the Morgan Library, and Tenney Frank, a professor of classics at the Johns Hopkins University. George L. Stout, director of technical research at the Fogg Art Museum, later joined them. Taylor, the driving force, headed the committee and served on various subcommittees dealing with such issues as finance, the building, cataloguing, installation, education, research, and publications. Within two years, Taylor predicted, the challenges could be met, and the gallery would emerge as "the Fogg Museum of the South."[11]

Initially, Belle da Costa Greene, with her assistant Meta P. Haarsen, began an inventory of manuscripts and books. The indefatigable, occasionally imperious, but always captivating Belle Greene soon realized

that additional help was required and proposed that Dorothy E. Miner, a recent graduate from Columbia University then engaged in research at the Morgan Library, be hired on a strictly temporary basis to complete the project. The task, Belle Greene estimated, would take several months, and in 1935, Seymour De Ricci announced the forthcoming publication of a catalogue compiled by Dorothy Miner under the direction of Belle da Costa Greene; in fact, it was only partially realized six decades later when Dorothy Miner's successor, Lilian M. C. Randall, published a three-volume catalogue of the medieval and Renaissance manuscripts.[12]

Professor Tenney Frank generously volunteered to waive his committee member's honorarium of one thousand dollars with the stipulation that the funds be used to employ Dorothy Kent Hill to undertake a ten-month study of the ancient holdings under his direction. She had recently received a doctorate in classics at the Johns Hopkins University.

Given the disarray of the collection, the advisory committee recommended that the first position to be permanently filled be that of registrar. Fortunately, the Fogg Art Museum released Winifred Kennedy from its staff. She was provided with a stenographer, typist, photographer, and several cataloguers. These included Dorothy Miner and Dorothy Hill, who were already on the premises, and three other "young people": Marvin Chauncey Ross for Byzantine and medieval art and arts of other periods through the seventeenth century (jocularly known as the "subsequent arts," alluding to the arts postdating the fall of Rome); Edward S. King for paintings through the seventeenth century and for Far Eastern art; and George Heard Hamilton for paintings and decorative art after the seventeenth century.[13]

From the outset, the advisory committee was concerned with the care and preservation of the collections. As early as 1910, Henry Walters had corresponded with Edward Robinson, director of the Metropolitan Museum of Art, regarding "corroding cankers" that were beginning to appear on some of his early bronzes.[14] As for the paintings, many of them, particularly those from the Massarenti collection, had been treated in the past by overly zealous restorers, and the hot, humid Baltimore summers unalleviated by air conditioning must also have exacted their toll. A technical laboratory, the third of its kind in the country, was created in the rear of Five West Mount Vernon Place (fig. 65). At Henri Marceau's suggestion, David Rosen, a conservator then practicing in New York and Philadelphia, was hired for six months of each year to work at the gallery. His assistant, Harold D. Ellsworth, a chemist and physicist, was already familiar with the use of x-rays and infrared and

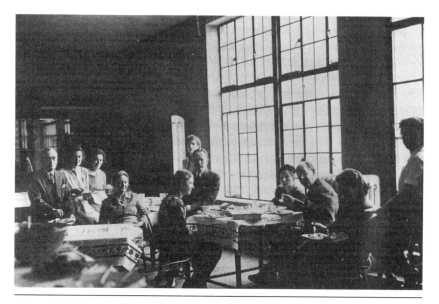

FIG. 65. Photograph of the early Walters staff in the new conservation studio, about 1939. From *left* to *right* are David Rosen, Elizabeth C. G. Packard, unknown, Mary R. Poe, Dorothy Kent Hill, Winifred Kennedy, Edward S. King, Dorothy Miner, D. Morgan Marshall, unknown (WAG Archives).

ultraviolet light in the examination of objects. At the time, each technical advisor was obliged to provide his own equipment. Working in collaboration with the Fogg Art Museum and with scientists at the John Hopkins University, the gallery laboratory soon gained distinction for its research in such fields as bronze corrosion and worm infestations in wooden sculpture.

As early as 1934, circumstances compelled the trustees to undertake their first additions to the collection. That January, the Walters estate auctioned Francis Scott Key's manuscript for *The Star-Spangled Banner.* It had been her husband's wish, Sadie reported, that his stepdaughter's husband, John Russell Pope, should design a fitting building to house the draft of the poem that Congress three years earlier had adopted as the national anthem. The trustees commissioned the Philadelphia bookseller, Dr. A. W. S. Rosenbach, to represent them at the hotly contested sale. The underbidder, Henry J. Gaisman, president of the Gillette Razor Company, went to twenty thousand dollars, hoping to be able to donate the manuscript to Franklin Delano Roosevelt as a gift to the nation. To the dismay of the Walters trustees, Rosenbach, with an eye for publicity, misrepresented himself to the press as the buyer who paid twenty-four

thousand dollars. His intent, the bookseller duplicitously announced, was to sell the manuscript either to the Walters Art Gallery or to the National Gallery of Art.[15]

The purchase of the *Star-Spangled Banner* manuscript represented a turning point in Sadie Walters's relations with Baltimore. Never had she expressed any particular interest in her husband's hometown, nor had she participated in his numerous philanthropic endeavors. Perhaps, believing that she had fulfilled her civic responsiblities, she gradually allowed her ties with the gallery to lapse. She may also have felt that the early trustees and staff had unduly pressured her to part with more of the New York holdings. With the country in the depths of the Great Depression, even Sadie Walters must have found her costly manner of living threatened and, given her age, it would not have been surprising that she harbored concerns for her own financial well-being, as well as for that of her offspring.

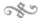

After having been closed throughout 1933, the gallery reopened on February 2, 1934, providing Baltimoreans a final opportunity to view their favorite works of art displayed in the cluttered, seemingly randomly installed galleries of Henry Walters's era. It was then closed in mid-June for extensive renovations. A cooling system was installed, lighting improved, wall coverings refurbished, and the period rooms on the ground floor, never a particularly popular feature, gutted. John Russell Pope contributed drawings for room dividers, which were introduced in the large paintings galleries on the second floor, and also designed Gothic-style frames for the stained-glass windows from Soissons cathedral that were inserted in the west wall, allowing the afternoon light to stream into the foyer (fig. 66).[16]

The most dramatic changes involved the reorganization of the collections. Victorian clutter gave way to less dense installations systematically arranged in strictly chronological sequence. The advisory committee, in consultation with the cataloguers, also determined what was to be exhibited. Francis Henry Taylor reported that 15 percent of the objects were of "first rank" and should remain on view; another 15 percent were of comparable significance and could be rotated; 50 percent were objects of "great importance" for the purposes of historical and archaeological study and for students of design and should be provided with additional space; 15 percent were only of interest to the specialist, and the remaining 2–5 percent, mostly in the classical and allied fields, were definitely spurious.[17]

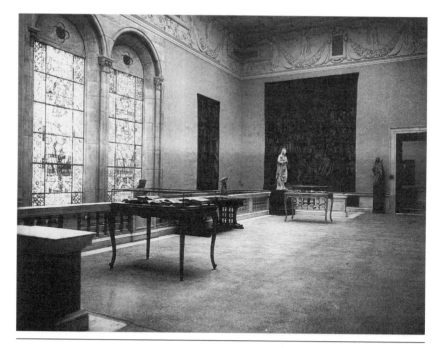

FIG. 66. The West Gallery, after 1935. Mrs. Henry Walters's son-in-law John Russell Pope designed the frames for the windows from Soissons cathedral (WAG Archives).

By October 29, 1934, the gallery was prepared to receive the press. Inevitably, obstacles arose at the last minute. When the trustees and advisory committee reviewed the final reinstallations, B. Howell Griswold Jr., president of the board and a prominent civic leader, who might easily be mistaken for "something of a stuffed shirt,"[18] became alarmed about the nudity of Francavilla's sculpture, *Apollo, Victor over the Python,* which was prominently displayed on the central axis of the court. He demanded that the 8½-foot-high marble be promptly removed. When the irrepressible Belle Greene, to his mortification, berated him for being envious, he was left no choice but to withdraw his objection.[19]

The public opening on November 3 was preceded the night before by a dinner at the Merchant's Club downtown followed by a reception at the gallery. On this occasion, the mayor and the president of the City Council attended, as did the trustees of the city's other cultural institutions. The invited guests included the directors of the country's foremost museums, as well as a number of distinguished individuals, among them the Belgian ambassador, the Prince de Ligne. The event was warmly

recalled by Meyric C. Rogers, a former director of the Baltimore Museum of Art who, six years earlier, had supervised the installation of its new building in Wyman Park, north of downtown. Although much of the day had been spent with a friend celebrating the birth of a child, Rogers nevertheless felt obliged to be present on this occasion. Before tackling the reception in the court, he and his friend withdrew to "spruce up" in the men's room, where they were joined by a short, goateed gentleman in formal attire. Correctly assuming that the new arrival was among the special guests from out of town, they enquired as to his identity. Drawing himself up as erectly as circumstances permitted, the stranger replied, "I am Lord Joseph Duveen of Millbank and who may I ask are you?" Rogers's answer that he was "God Almighty" and that his companion was "Jesus Christ" evoked a smile and Duveen's response that he had been waiting a long time to meet the two of them. A friendly conversation ensued, and a week later the Rogers family received by post a painting for the child.[20]

After having lagged behind other East Coast cities in the development of cultural institutions, Baltimore could now boast of two municipally owned art museums. The situation was summarized by the city's best-known curmudgeon, H. L. Mencken, who could never refrain from venting his spleen on modern art and who apparently preferred to attack the living rather than the dead: "So Baltimore now has two art galleries—the one superb and perhaps incomparable in the United States, and the other a helter-skelter assemblage of left-overs, largely filled with Modernist trash. The former costs the taxpayer nothing; the latter mulcts [*sic*] him more and more every year."[21]

Mencken's views notwithstanding, the two institutions have happily coexisted. Over the years, the Baltimore Museum of Art's collections, through the contributions of local patrons, have grown to dovetail with those of the Walters Art Gallery. It has assembled a significant selection of Old Master paintings, and in graphic arts, contemporary art, and Americana, areas of little apparent interest to Henry Walters, the museum has come to excel.

Almost immediately after the gallery's reopening, the Walters staff initiated the activities associated with a public museum: they began educational programs, funded a research library, and published many works of art. They even acquired a printing press for the production of labels. Meanwhile, the gallery's staff catalogued the collection, delving into the crates in storage to rediscover unanticipated treasures. The *Handbook of the Collection* appeared in 1936, the scholarly *Journal of the Walters Art*

Gallery was first issued in 1938, and it was followed in 1948 by a popular newsletter, *Bulletin of the Walters Art Gallery.* Because of the limited available space, most of the exhibitions were small and limited to works drawn from the collection. However, a number of pioneering shows, sometimes organized in collaboration with colleagues at other institutions and usually presented in the Baltimore Museum of Art, affirmed the Walters Art Gallery's international reputation as one of the most progressive museums in North America.

APPENDIX: THE RIME OF THE PEACHBLOW VASE

It is an ancient connoisseur,
And he stoppeth one of three,
And saith, "Now hearken while I tell
A tale of Ou-tsai-khi."

"Now, by our lady," whispers one,
"He hath a gruesome gaze."
"Oh, hark!" quoth he, "and list to me;
I tell of a peachblow vase.

"In the Yang-khi time, some ages back.
My tale it doth begin,
When Spring was fair in the flowery land
And the town of King-te-chin.

"There was an aged potterer —
A worshiper of the sun;
I tell about a wonderous vase,
By him one day begun.

"He molded it with loving hand,
And fashioned it with care,
And said: 'This vase shall all excel;
None with it shall compare.'

"Its body round and swelling was,
Its neck was long and thin,
Its shoulder's curve was exquisite —
This vase of King-te-chin.

"Then rose this ancient potterer,
And said with exultation:
'This rare and radiant vase shall be
For imperial delectation.

" 'No vase like this on earth or deep
Posterity shall see;
Its fame shall grow eternally
As sure as it's Tohang-khi.

" 'Around its sacred form the fire
Shall slowly upward reach,
And all its face shall blush and glow
With rare bloom of the peach.'

"Then three times round the old man went,
And three times round he went;
And winked his eye and scratched his ear,
And poked his fire with glee.

"But o'er the silent purple sea
Up rose a cloudlike mass,
And from it came a pure white squall
Of a very superior class.

"This squall it fanned the sacred fire
Until it grew too hot,
And brought upon that good old man
A most unhappy lot.

"For when the work should have been done
Upon that wonderous vase,
The old man's heart was filled quite full
Of wonder and amaze.

"He beat his breast and loud he wailed:
'I would that I were dead!
My vase has ta'en no peachblow tint,
But a third-rate strawberry red.

" 'Alas, alack, and well-a-day!
Unhappy that I am;
Instead of being a priceless thing,
It is not worth a — clam!'

"Then down went he to the sounding sea,
And standing by the shore,
The vase threw far o'er the harbor bar,
And saw it nevermore.

"But a fisherman dropped a big brown net
Just where that vase fell in,
And hauled it out with a lot of fish,
And took it to Pekin.

"And when he sold his smelts and eels,
(Not knowing of King-te-chin)
He said to a buyer who liked the vase,
'I'll chuck the blamed thing in.'

"And so this man took home the vase,
Accepted in a minute;
He placed it on his toilet stand,
And kept his cue grease in it.

"The years passed on, — the man passed off;
And the vase from King-te-chin
Was snapped up by a peddling chap,
Who lived in West Pekin.

"And over and over and over again
That strawberry vase was sold;
But never a time in the flowery clime
Was it worth its weight in gold.

"For in those days a strawberry vase
Was no better than a blue,
As all men knew, from a peddler up
To the Emperor Wun-Foo-Foo.

"A couple of centuries glided by,
And then a Western sage,
Who'd crossed two oceans in search of notions,
Suspected the vase's age.

"And he said to the man who owned it then —
A mandarin big-bug,
With a snake-like cue and parchment face —
'How much'll you take for your jug?'

"The mandarin shook his bullet head,
And said: 'He muchee old;
He nice Tchange-yao from King-te-chin;
He fetchee big heap gold.'

"The Western sage then softly smiles
As the mandarin's back he pats,
And says: 'I'll give you a hundred dollars;'
The mandarin says: 'Oh, rats!'

"The Western sage, in course of time,
The mandarin did pay
Two hundred and fifty Mexican dollars,
And took the jug away.

"Across the oceans, to dealers in notions,
The little red jug then crossed!
And they sold it off at a slight advance
Of fifty times its cost!

"But alas! the gods, who sent the squall
That blew the maker's blaze,
Had sent along a curse so strong
That it burned into the vase.

"And so it chanced that this red jug,
Of diminutive dimensions,
Will always be a fruitful source
Of very grave dissensions."

Then three times round went the connoisseur,
And three times round went he;
And he blew his nose and dropped a tear,
And sank to the bottom of the sea.

And I verily believe since I heard this tale,
With sorrow and amaze,
That the one who told it, with smirk and grin,
Was the ghost — from the town of King-te-chin —
Of the man who made the vase.

New York Times, March 27, 1886

NOTES

Chapter One: The Early Years, 1819–1861

1. The early history of Liverpool, Pa., is discussed in F. Ellis, *History of That Part of the Susquehanna and Juniata Valleys Embraced in the Counties of Mifflin, Juniata, Perry, Union, Snyder in the Commonwealth of Pennsylvania* (Philadelphia, 1886), 2:1114–1119, and H. H. Hain, *History of Perry County, Pennsylvania* (Harrisburg, 1922), 507–509.

2. Henry Walters (1795–1854) of Liverpool was married to Jane Mitchell Thompson (d. 1847) by the Rev. Thomas Smith on May 16, 1817. The children of the marriage — William Thompson, Louise Martha (1823–1901), Margaret Stuart (Mrs. Marshall Carroll, subsequently Mrs. Victor M. Friar) (1833–1911), Edwin (1834–97), Thaddeus, Mary Jane, Jane Mitchell, and Charles — are listed in A. S. McAllister, *The Descendants of John Thomson, Pioneer Scotch Covenanter* (New York, 1917), 141.

3. The Buchanan note is preserved in the Buchanan Papers, Pennsylvania Historical Society, Philadelphia, XR506.3. According to the *Harrisburg [Pa.] Morning Herald,* November 20, 1843, Walters was interred in Harrisburg.

4. The Thomson forbears of William Walters are discussed in McAllister, *Descendants,* 2–5, 80–84, 140–142, and also in Herbert S. Thompson and Theo. S. Thompson, *The Thompson Family* (Pottsville, Pa., 1887). The name *Thomson* was altered to *Thompson* about 1800. Writing to his sister, Jennie Delano, on November 12, 1912, Henry Walters conjectured that the spelling of the name was changed after one of their "people" without a *P* was "hung" (Walters Art Gallery [WAG] Archives). Thompsontown's history is given in Ellis, *History of That Part of the Susquehanna,* 874–877.

5. M. Reizenstein, "The Walters Art Gallery," *New England Magazine,* n.s. 12 (July 1895): 557, stated that W. T. Walters received a degree in civil engineering from the University of Pennsylvania, whereas *Harpers Weekly,* December 1, 1894, 1138, noted that he attended the best Philadelphia schools.

6. For the Lycoming Coal Co., see J. B. Linn, *History of Centre and Clinton Counties, Pennsylvania* (Philadelphia, 1883), 602–603. The Pioneer Furnace in

Pottsville is discussed in *The American Cyclopedia: A Popular Dictionary* (New York, 1979), 558.

7. The earliest record of W. T. Walters's presence in Baltimore was as a witness to the death of Joseph Alters, June 26, 1841 (Health Department Records, Baltimore City, 784 RE 19).

8. Raphael Semmes, *Baltimore as Seen by Visitors, 1783–1860* (Baltimore, 1953); Frances Trollope, *Domestic Manners of the Americans* (1839; reprint, London, 1984), 173.

9. For Baltimore's developing economy, see G. Browne, *Baltimore in the Nation, 1789–1861* (Chapel Hill, 1980), 142–169.

10. The partnership of Samuel Hazlehurst (1814–89) and W. T. Walters is first listed in *Matchett's Baltimore Directory* (Baltimore, 1842).

11. William Walters was married to Ellen Harper (1822–62), the daughter of Charles Alexander Harper (1783–1835) and Ann Dilworth Walker Harper, by Rev. William R. DeWitt, D.D., a prominent Presbyterian minister in Harrisburg, on January 8, 1846, in Philadelphia (*Baltimore Sun,* January 9, 1846).

12. The story about the celebratory songs is from "Harper Family," manuscript (WAG Archives). Henry Walters was born September 20, 1848.

13. Baltimore City directories listed the Walterses as residing at 80 Fayette Street (1847), 27 South High Street (1849–50), and 206 North Howard Street (1855–56). William Tiffany purchased the Mount Vernon Place property from the John Eager Howard estate in 1835 and built the house about 1848. John H. Duvall originally leased the house for ninety-nine years. Walters acquired the remainder of the lease on May 4, 1857, and then purchased the house on October 1 of that year.

14. John Rudolph Niernsee (1814–85), architect of the original Tiffany house, had been responsible for other houses on Mount Vernon Place (see "Local Matters," *Baltimore Sun,* November 9, 1848). A native of Vienna, Niernsee probably trained in Prague under Josef Andreas Kranner. From 1848 to 1855–56 and again from 1865 to 1874, Niernsee practiced architecture in partnership with J. Crawford Neilson (1817–1900) of Baltimore.

15. "A Splendid Dwelling," *Baltimore Sun,* January 24, 1851. Dr. Thomas was a great-grandson of John Hanson, the first president of Congress (1781–82). The Thomas house was praised in the *Baltimore Sun* (December 14, 1848; January 24, 1851). It was retained by the Thomas family until December 9, 1892, when it was sold by Douglas Thomas to Mr. and Mrs. Francis M. Jenks (later Jencks). In 1953, Baltimore City acquired the property from the Jencks family at a reduced price, with the family's intention that it be transferred to the Walters Art Gallery. After the gallery failed to raise the funds necessary for remodeling through bond issues in 1958 and 1960, the building was sold to Henry L. Gladding. He resided in the house until 1984. Subsequently, it was acquired by Mr. and Mrs. Willard Hackerman for the city. Mayor William Donald Schaefer placed the house under the stewardship of

the Walters Art Gallery with the provision that it be used to house the gallery's holdings of Asian art. Hackerman House, as it has been named, opened to the public on May 4, 1991.

16. Betsey Anthony, who died December 28, 1873, is buried in the Walters plot at Greenmount Cemetery.

17. Charles Harvey (1815–68) was the younger brother of Henry Darch Harvey (1813–89), who married Harriet Harper (1818–80), sister of Ellen Walters, on November 1, 1838. Edwin Walters (1834–97) joined the firm of W. T. Walters & Co. in 1857. He purchased the Orient Distillery in 1864 and later became sole proprietor of his brother's liquor business.

18. The mansion of the early settler John Donnell had stood on the site of W. T. Walters & Co. (*Baltimore Sun,* January 14, 1852). The new building, designed by architects H. R. and J. Reynolds, was erected by W. T. Walters and Charles Harvey on land leased from the descendants of John Donnell on April 12, 1851, and bought outright in April 1853 (Baltimore City, *Liber 455,* folio 112).

19. For an account of liquor production, see John C. Gobright, *The Monumental City, or Baltimore Guide Book* (Baltimore, 1858), 196–197. Peter Greig discussed the Walters ryes in *Catalogue of the Exhibition and Sale of Wines and Spirits from the Estate of Mrs. Henry Walters* (New York, 1943), 45–47. The oldest example of the Walters exclusive brand, Baker's Pure Rye, was dated 1847. Henry Walters Sr. had been listed as a dealer in spirits in 1828, and his son William had appeared with him in the 1837 listing (Hain, *History of Perry County,* 507–509).

20. Walters is listed as a director in the *Twenty-sixth Annual Report of the President and Directors of the Baltimore and Susquehanna Rail-Road Co.* (Baltimore, 1853). The fifth and sixth annual reports of the president and directors of the Northern Central Railway Co. (Baltimore, 1860 and 1861) list both Walters and Simon Cameron as board members. The Walters Art Gallery Archives contain a photocopy of a letter from Cameron to Walters dated March 29, 1853, in which the former expressed his hope that they could meet in Baltimore. Cameron (1799–1889) served as secretary of war in 1861–62 but was compelled to resign because of questionable procedures he had followed in awarding government contracts, including those to the Northern Central Railway.

21. William Walters to Simon Cameron, December 30, 1864 (formerly in the collection of Frederick Adams, Paris).

22. Semmes, *Baltimore as Seen by Visitors,* 132–133.

23. For the quotation about Peale's Baltimore Museum, see Wilbur H. Hunter, *The Story of America's Oldest Museum Building* (Baltimore, 1964), 2. Art collecting in Baltimore was the subject of two exhibitions: *A Century of Baltimore Collecting, 1840–1940,* Baltimore Museum of Art, 1941, and *The Taste of Maryland: Art Collecting in Maryland, 1800–1934,* Walters Art Gallery, 1984.

24. For Robert Gilmor Jr., see Anna Wells Rutledge, "Robert Gilmor Jr.,

Baltimore Collector," *Journal of the Walters Art Gallery* 12 (1949): 19–40, and Elizabeth Bradford Smith, "The Earliest Private Collectors: False Dawn Multiplied," *Medieval Art in America: Patterns of Collecting 1800–1940*, Palmer Museum of Art, Pennsylvania State University (University Park, Pa., 1996), 23–33. Quotations are from Gilmor's letter to George Graff in 1837 (collection of the Metropolitan Museum of Art), as quoted by Rutledge, "Robert Gilmor Jr.," 34.

25. Reizenstein, "The Walters Art Gallery," 558.

26. Only a typescript transcription of the letter from W. T. Walters to Benjamin Newcomer of Baltimore, written from Paris on March 15, 1864, is preserved in the Walters Art Gallery.

27. Reizenstein, "The Walters Art Gallery," 558; *The National Cyclopedia of American Biography* (New York, 1951), 37:288–289.

28. For purchases by William T. Walters, see *Catalogue of Valuable Paintings: The Entire Collection of Mr. Granville Sharpe Oldfield at His Residence, Mount Vernon Place*, Baltimore, May 15–18, 1855: no. 33, Bartolomé Murillo, *Madonna and Child,* copied by Vicenzo Cagliaroni, $57.50; no. 50, Salvator Rosa, *The Graces,* copied by Carlo Nerutti, $30.00; no. 95, Gerard de Lairesse, *Venus Disarming Cupid,* $25.00; no. 112, J. W. Yarnold, *Cottage at the Mouth of the Thames,* $42.50; no. 351, Rosa da Tivoli, *Juno Claims from Jupiter a Gift of Jo Disguised as a White Cow and Commands Argus to Watch over Her,* $37.50; no. 375, Thomas Sidney Cooper, *Landscape and Cattle,* $25.00; no. 423, Hugh Newell, *Guinea Pigs,* $15.00; no. 532, J. W. Yarnold, *Wreck of an Indiaman on the Nayland Rock, with Distant View of Margate, Kent,* $95.00.

29. For Henry Walters's recollections of his father's support of Rinehart in 1855, see William Sener Rusk, *William Henry Rinehart, Sculptor* (Baltimore, 1939), 14–15. It is more likely, however, that William Walters funded the 1858 trip to Rome rather than the 1855 visit to Florence. Walters commissioned *The Woman of Samaria* by William H. Rinehart (WAG 28.10).

30. William Walters's diploma of membership in the Maryland Historical Society, dated February 7, 1856, is preserved in the Walters Art Gallery. The historical society's catalogue for 1856 listed W. T. Walters's paintings by Newell as no. 24, *Guinea Pigs;* no. 41, *Stag at Bay;* no. 42, *Portrait of a Dog;* and no. 88, *The Dray Horse.* The following year Walters lent no. 9, *The Graces,* after Salvator Rosa; no. 13, *Virgin and Child,* after Murillo; no. 50, J. W. Yarnold, *Seashore;* no. 57, Edouard A. Odier, *Bonaparte's Retreat from Moscow;* and no. 77, Johann Schlesinger, *Evening, Crossing a Ferry.*

31. For Miller's career, see *Alfred Jacob Miller: Artist on the Oregon Trail,* ed. Ron Tyler, Amon Carter Museum (Fort Worth, 1982). The two hundred watercolors with the accompanying texts, commissioned by W. T. Walters, are reproduced in M. C. Ross, *The West of Alfred Jacob Miller* (Norman, Okla., 1951). In his account book preserved in the Walters Art Gallery, Miller listed on February 2, 1858, a "cabinet" portrait of Rhinehart [*sic*], $30; June 10,

1858, *Breaking Up Camp at Sunrise*, $200; and June 10, 1858, *Buffalo Hunt with Lance*, $92, all purchased by W. T. Walters.

32. W. T. Walters to John Kensett, July 23, 1860, Edwin D. Morgan Collection, New York State Library, Albany.

33. Walters noted that he had commissioned his first landscape from Durand through the artist's son, John (Walters to Asher B. Durand, June 8, 1858, A. B. Durand papers, New York Public Library). The collector enclosed payment of $1,500 in a letter of May 3, 1859 (also in New York). *In the Catskills* (WAG 37.104) and other American works of art in the collection were published by E. S. King and M. C. Ross in *Catalogue of American Works of Art* (Baltimore, 1956) and by W. R. Johnston in "American Paintings in the Walters Art Gallery," *Antiques* (November 1974): 853–861. Durand's landscape *Sunday Morning* (oil on canvas, 28 × 42 in.) was sold by W. T. Walters before 1878 and is now in the New Britain Museum of American Art, New Britain, Conn. For the quotation, see D. Huntington, *Asher B. Durand: A Memorial Address* (New York, 1887), 36–37.

34. The correspondence from W. T. Walters to John Kensett provides a rare insight into the collector's character and ambition. The letters are divided between the Edwin D. Morgan Collection in the New York State Library in Albany and the James Kellogg Collection (microfilm, Archives of American Art, Smithsonian Institution).

35. W. T. Walters to John Kensett, undated, Kellogg Collection, Archives of American Art. The collector had been moved to praise Kensett's realism in the painting *Newport*, exhibited at the National Academy of Design in 1858, no. 506.

36. None of the Kensett landscapes was retained by W. T. Walters. The following titles appear in the correspondence: *Tide in Summer* (December 24, 1858), *Willow Tree* (July 20, 1859), *Eagle Cliffe* (November 28, 1859), and *Hudson River* (June 19, 1860).

37. The Ranney sale at the National Gallery of Design was reported in the *New York Times*, December 22, 1858. For the quotation, see Walters to Kensett, December 31, 1858, Edwin D. Morgan Collection, New York State Library, Albany, N.Y.

38. *Morning in the Tropics* (WAG 37.147) was retained by W. T. Walters. A steel engraving of it by S. V. Hunt was published by S. P. Avery in 1860. The larger *Twilight in the Wilderness* was sold on February 13, 1864, at Henry H. Leeds & Co., Auctioneers, New York (no. 136), and is now in the Cleveland Museum of Art. Walters commented on the "fire worksey" quality of *Twilight in the Wilderness* (Walters to Kensett, undated letter of 1860, Kellogg Collection, Archives of American Art), and yet he still compared it favorably to *Heart of the Andes*, which had recently been shown in Baltimore (*Baltimore Sun*, May 14, 1860).

39. For the painting's political overtones, see Francis Kelly, *Frederic Edwin*

Church and the National Landscape (Washington, 1984), 102–122. *Our Banner in the Sky* is held by New York State, Office of Parks, Recreation and Historic Preservation, Olana State Historic Site.

40. The Ranney sale at the National Academy of Design in New York was recorded in the *New York Times,* December 22, 1858. For the Dogberry allusion and the "delicious little picture" reference, see Walters to Kensett, December 24, 1858, Edwin D. Morgan Collection.

41. C. L. Elliott, New York, to Walters, September 7, 1860, Walters Art Gallery.

42. For the reaction to Palmer's *White Captive,* see J. C. Webster, *Erastus D. Palmer* (Newark, 1983), 29–30, 87–89, 100–105. In a letter to John Kensett of May 24, 1860 (Kellogg Collection), Walters noted that he was forwarding to his friend Rinehart in Rome some newspaper clippings entitled "What Makes the Great Statue" and "Naked Art," which he had received from S. P. Avery. He also wrote, "The Madam says she will give you her views when you come over — but she hasn't been able to stifle the injunction yet — 'Stop the *Crayon*' though she is quite emphatic that the Captive is not a *great work.*"

43. R. Sieben-Morgen, "Samuel Putnam Avery (1822–1904), Engraver on Wood: A Bio-bibliographical Study" (master's thesis, Columbia University, 1940); *The Diaries 1871–1882 of Samuel Putnam Avery, Art Dealer,* ed. M. F. Beaufort, H. L. Kleinfeld, and J. K. Welcher (New York, 1979).

44. Walters to Kensett, March 27, 1859; by October 9 Walters boasted of having over one hundred sketches (both letters are in the Kellogg Collection). The album was eventually sent to Avery, who was expected to complete the mounting by December 20. Not all of the drawings were retained by W. T. Walters. Ultimately containing seventy-two works (some by such early-nineteenth-century artists as Washington Allston and Rembrandt Peale, but most by contemporaries), *Original Sketches* was eventually dismembered by the staff of the Walters Art Gallery.

45. Joseph P. Cropsey to S. P. Avery, June 5, 1860, in S. P. Avery, *Autograph Letters,* presented to the Metropolitan Museum of Art, New York; William Walters to Kensett, June 27 and July 20, 1859 (Kellogg Collection).

46. Sieben-Morgen, "Samual Putnam Avery," 46.

47. L. B. Miller discussed John Ruskin's influence on American tastes in *Patrons and Patriotism: An Encouragement of the Fine Arts in the United States, 1790–1860* (Chicago, 1966), 27–29. The first volume of Ruskin's *Modern Painters* was reviewed in the *North American Review,* January 1848, and an American edition of this work was published in 1850. Ruskin reviewed Gambart's "French Exhibitions" (1856–59) in *Academy Notes* (*Works,* ed. E. T. Cook and Alexander Wedderburn, library ed., vol. 14); R. L. Stehle, "The Düsseldorf Gallery of New York," *New-York Historical Society Quarterly* 58, no. 4 (1974): 305–314.

48. J. Maas, *Gambart, Prince of the Victorian Art World* (London, 1975), 110; *New York Times,* October 19, 1857.

49. The ten paintings acquired at the National Academy of Design on October 29, 1859, were Charles Chaplin, *The Prayer*, $125 (WAG 37.46); T. E. Duverger, *Toilet*, $125; P. Édouard Frère, *Girl Dressing Doll*, $300 (WAG 37.24); E. Lambinet, *Wexham Court*, $200; A. E. Plassan, *The Toilet*, $300; J. B. J. Trayer, *Convalescent*, $300; A. Dillens, *Mother's Kiss*, $100; P. É. Frère, *Little Housekeeper*, $400; P. L. Couturier, *Fowls and Ducks*, $60; and Jean-Léon Gérôme, *The Duel after the Masquerade*, $2,500 (WAG 37.51). It was not unusual for artists such as Gérôme to replicate their own works; versions of the *Suite d'un bal masqué* were also painted for Prince Alexander of Russia and for the Ali Pacha. Walters asked Robert Crofts, the manager of the exhibition at the National Academy of Design, to write to the artist requesting a letter of authentication and a comparison of the merits of the recently acquired version and the Duc d'Aumale's painting. The moral lesson of the painting was praised in a review in the *London Athenaeum*, January 30, 1858, and was reprinted by Lucas Brothers at the owner's request.

50. G.B.C., "Domestic Art Gossip," *Crayon* 7 (January 1860): 23, 82.

51. *The Diary of George A. Lucas: An American Art Agent in Paris, 1857–1909*, transcribed and with introduction by L. M. C. Randall, vols. 1 and 2 (Princeton, 1979). Lucas's early Baltimore clients included John H. B. Latrobe, William H. Graham, George B. Coale, and Frank Frick.

52. W. T. Walters to F. B. Newcomer, March 15, 1864 (photocopy, WAG Archives); H. L. Dawson, "Hugues Merle's *Hester et Perle* and Nathaniel Hawthorne's *The Scarlet Letter*," *Journal of the Walters Art Gallery* 44 (1986): 123–127. The reference to the photograph is found in *W. T. Walters' Collection: A Descriptive Catalogue Prepared for the Poor Association* (Baltimore, [1878]), 19.

53. "Domestic Art Gossip," *Cosmopolitan Art Journal* 3 (1858–59): 88.

54. H.G.S., "Art Matters in Baltimore," *Boston Evening Transcript*, March 4, 1861.

Chapter Two: The Years Abroad, 1861–1865

1. C. B. Clark, "Suppression and Control of Maryland, 1861–1865," *Maryland Historical Society Magazine* 54, no. 3 (1959): 241–271; J. H. Baker, *The Politics of Continuity: Maryland Political Parties from 1858–1870* (Baltimore, 1973); *Daily and Commercial Advertiser*, April 19, 1861.

2. In a letter to Simon Cameron written from Paris, Walters recalled the railway issue as one of unequaled bitterness in the state's history (Walters to Cameron, December 30, 1864, WAG Archives). The Philadelphia faction, which Walters also associated with the Garretts and Johns Hopkins, favored a five-cent fare, whereas the local group sought a three-cent fare. The delegation sent to Annapolis comprised J. Hanson Thomas, W. T. Walters, J. W. Jenkins, and J. W. McCoy. McCoy shot Thomas H. Gardiner (*Maryland Republican* [Annapolis], March 12, 1860).

3. W. W. Glenn recalled being visited by Walters to raise funds for the salute and General Morris's Mount Vernon Place cannonade on April 6, 1865. See *Between North and South: A Maryland Journalist Views the Civil War. The Narrative of William Wilkins Glenn, 1861–1869,* ed. B. E. Marks and M. N. Schatz (Cranbury, N.J., 1976), 27–31, 186–187.

4. D. Giraud Wright, *A Southern Girl in '61* (New York, 1905), 60–67.

5. William Walters's passport is preserved in the WAG Archives; his application, in the National Archives (vol. 212, no. 2224, dated August 8, 1861). For Walters's promise to return to Baltimore, see Marks and Schatz, *Between North and South,* 188. Before sailing for Europe, Walters was briefly detained in New York by authorities charging him with bearing messages from Jefferson Davis to the Confederate commissioners in Europe (from unidentified newspaper clipping, Jane Ridder family Bible).

6. Unless otherwise noted, information on the family's activities abroad during the Civil War is derived from L. M. C. Randall, *The Diary of George A. Lucas: An American Art Agent in Paris, 1857–1909* (Princeton, 1979) [hereafter cited as *Lucas Diaries*]. James Elliott Tyson (1816–1904), another Southern sympathizer, eventually became a shipowner and established shipping connections with South America; see *Genealogical and Memorial Encyclopedia of the State of Maryland* (New York, 1919), 221–239. See also Paul de Saint-Victor, "Le Musée du Luxembourg: Les Musées," in *Paris Guide* (Paris, 1867), 416–458.

7. The Pourtalès collection was housed in a Renaissance-style *hôtel* at 7, rue Tronchet, erected between 1845 and 1850 after the designs of Félix Duban. The collection is described in a series of articles that appeared in the *Gazette des Beaux-Arts* in 1864 and 1865: Albert Jacquemart, "Objets d'art et curiosité, la galerie Pourtalès," 17 (1864): 377–397; François Lenormant, "Antiquités grecques et romaines, la galerie Pourtalès," 17 (1864): 473–506; Emile Galichon, "Les tableaux italiens, la galerie Pourtalès," 18 (1865): 5–17; Paul Mantz, "Les peintures espagnoles, allemandes, hollandaises, flamandes, françaises, la galerie Pourtalès," 18 (1865): 97–117. The *Orlando Muerto* served as a source of inspiration for both Jean-Léon Gérôme's *Dead Caesar* (Bates Lowry, *Muse or Ego: Salon and Independent Artists of the 1880s* [Claremont, Calif., 1963], 33) and Edouard Manet's *The Dead Man* (National Gallery of Art, Washington, D.C.) (Theodore Reff, *Manet and Modern Paris* [Washington, 1982], cat. no. 78). For the history of the Jacquemart-André Museum, which was bequeathed to the Institut de France by Nélie Jacquemart in 1912, see Nicolas Sainte Fare Garnot, "The Jacquemart-André Museum," *Beaux-Arts Magazine* (*hors série*), Paris, n.d.

8. The visit to Gérôme's studio was on November 2, 1861 (*Lucas Diaries,* 2:124).

9. The Ecouen colony eventually included an English still-life painter, George Todd, and an Anglo-American, George H. Boughton; French artists Michel Arnoux, Joseph Aufray, Pauline Bourges, André Dargelas, Paul Seignac, and Paul Soyer, Mary Cassatt's early teacher; the Dane A. F. A. Schenck; a

Swiss landscape painter, Luigi Chialiva; a Belgian, Léon Dansaert; and the Bostonian Henry Bacon.

10. *London Illustrated News,* July 4, 1857, suppl., p. 17; *The Works of John Ruskin,* Library Edition, ed. E. T. Cook and A. Wedderburn (London, 1904), 14:143.

11. A fellow Baltimorean residing in Paris, Frank Frick, had preceded Walters in buying sculpture by A.-L. Barye on August 2, 1860 (Frank Frick diaries, Peabody Institute Archives).

12. William Walters's journal account of the Italian journey appears in a one-hundred-page manuscript preserved in the WAG Archives. The manuscript is divided into four series numbered two to five, indicating that an initial series has been lost. Each sheet of the manuscript bears four pages identified as a, b, c, and d. Interspersed throughout the text are good-humored though gibing references to Walters's friend Benjamin F. Newcomer and to the moral perils faced by the Baltimore merchant in his pursuit of wealth. Presumably, Newcomer was the intended recipient of the manuscript.

13. For the prevailing anti-Catholic sentiment in America, encouraged in part by the writings of John Ruskin and his followers, see George Hersey, "The Critical Fortunes of Neapolitan Painting: Notes on American Collecting," in *A Taste for Angels* (New Haven, 1987), 69–80, and Roger B. Stein, *John Ruskin and Aesthetic Thought in America, 1840–1900* (Cambridge, 1967). For the quotation, see Walters's journal, series 2, 2d.

14. A. N. Normand's Maison Pompéiennc, completed in 1860 and demolished in 1891, is best known through G. C. R. Boulanger's painting of 1861, *Rehearsal of the Flute Player in the Atrium of the House of H.I.H. the Prince Napoleon,* Musée National du Château des Versailles et des Trianons, Versailles.

15. Walters eventually acquired fifty-five watercolors by Léon Bonvin, which he had bound in an album. Indicative of his continuing interest in the artist was the fact that he arranged through Lucas for Philippe Burty to publish an article, "Léon Bonvin," in *Harper's New Monthly Magazine,* December 1885, 37–50.

16. China's display was shown first near the central transept of the main building (*International Exhibition, 1862: Catalogue of the Industrial Department* [London, 1863], 152). Twenty-five entries were listed.

17. The Japanese display was on the north side of the British nave (ibid.). Loans by Alcock, as well as those of a few firms and private individuals, are noted. Alcock (1809–97) is the subject of Alexander Michie, *The Englishman in China during the Victorian Era as Illustrated in the Career of Sir Rutherford Alcock, K.C.B., D.C.L.* (London, 1900).

18. The comments of the French "joint-reporters" were published in the *International Exhibition, 1862: Reports by the Juries on the Subjects of the Thirty-six Classes into Which the Exhibition Was Divided* (London, 1862), 12. J. B. Waring published *Masterpieces of Industrial Art and Sculpture at the International Exhibition of 1862* (London, n.d.), illustrating the Chinese and Japanese displays in

vol. 1, plate 35, and in vol. 3, plates 248, 267, 282, and 291. For the English reaction to the Japanese exhibit, see Victoria and Albert Museum, *Liberty's, 1875–1975* (London, 1975), 6.

19. *Baltimore Daily Gazette,* February 12, 1863.

20. Mrs. E. Thomas Rinehart, in W. S. Rusk, *William Henry Rinehart, Sculptor* (Baltimore, 1939), 70.

21. On June 8, 1864, George A. Lucas recorded the commissioning of *The Evening Star (Diaries* 2:171). Walters's suggestions for improvements were recorded by Alfred Robaut in *Cartons Alfred Robaut: Notes, croquis, photographies, estampes* (21: folio 645), Bibliothèque Nationale de France, Département des Peintures.

22. William Walters shared with the eminent Baltimore educator John Franklin Goucher his reminiscences of assembling the albums of prayer drawings ("William T. Walters," *Baltimore Sun,* November 24, 1894). Mounted in the albums were such drawings as A. Bida's *Four Jews at the Wailing Wall* (WAG 37.1392) and G. Brion's *Church Exterior with Peasants Praying* (WAG 37.1388).

23. George A. Lucas commissioned *The Omnibus* on March 18, 1864. On April 29, he ordered the *First* and *Second Class Carriages* and, on June 6, he noted that he paid two hundred francs for both these works (*Lucas Diaries,* 2:174, 177–179). *The Omnibus* replicates *L'intérieur d'un omnibus* published in *Le Monde Illustré,* January 30, 1864 (Bruce Laughton, *Honoré Daumier* [New Haven, Conn., 1996], 109–110 fig. 134).

24. The only references to William Walters's travels in 1863 and 1864 are notes in the George A. Lucas diaries citing the collector's arrivals and departures.

25. The only known copy of the catalogue is in the New York Public Library.

26. A clipping of the review from the *New York Daily Tribune,* February 13, 1864, is preserved in the vertical files of the Enoch Pratt Free Library Main Branch, Art Reference Room, Baltimore. John Wolfe (1821–94), a member of the hardware firm of Wolfe, Dash, and Fisher, retired from business at the outbreak of the Civil War and devoted himself to traveling and collecting. In addition to a sale of works acquired in the 1840s and 1850s held at the Düsseldorf Gallery on December 22 and 23, 1863 ($114,000), he sold a second collection at Chickering Hall on April 5 and 6, 1882, and a third collection was dispersed at the Fifth Avenue Art Gallery on April 12, 1894. Although he had been instrumental in the formation of the collection of academic paintings belonging to his cousin Catherine Lorillard Wolfe (bequeathed to the Metropolitan Museum of Art, New York), he was not esteemed by the press. The *New York Times* of April 12, 1894, alluded to him as "thoroughly commercial" in his tastes.

27. The reporter for the *New York Daily Tribune,* in alluding to "Byzantine art," was probably referring to the early Italian paintings that the prescient collector James Jackson Jarves exhibited in New York in 1860–61.

28. The contract between Walters and Avery has been lost. It was, however, transcribed by R. Sieben-Morgen in "Samuel Putnam Avery (1822–1904), Engraver on Wood: A Bio-bibliographical Study" (master's thesis, Columbia University, 1940), 46. The sales are discussed in M. Fidell Beaufort, H. L. Kleinfield, and J. K. Welcher, *The Diaries 1871–1872 of Samuel P. Avery, Art Dealer* (New York, 1979), xv–xxi.

29. William Walters to Benjamin F. Newcomer, March 15, 1864 (WAG Archives). An advertisement for the first Walters sale arranged by Avery is found in the *New York Times,* April 6, 1864. A total of $35,525 was realized. For Avery's subsequent sales, see F. Lugt, *Répertoire des catalogues des ventes publiques,* 4 (The Hague, 1964), nos. 27823, 28929, 29426, and 29498.

30. Frank Frick (1828–1910), *Diaries,* September 2, 1864, Archives of the Peabody Institute, Johns Hopkins University; Walters to Newcomer, March 15, 1864, and Walters to Cameron, December 20, 1864, transcripts in the WAG Archives.

31. Glenn, *A Maryland Journalist,* 187–188.

Chapter Three: The Postwar Recovery, 1866–1884

1. For the founding of the Peabody Institute, see Franklin Parker, "George Peabody: Founder of Modern Philanthropy" (Ph.D. diss., George Peabody College for Teachers, 1956), 2:680, and idem, *George Peabody: A Biography* (Nashville, 1971), 153–154.

2. *Baltimore Daily Gazette,* October 26, 1866.

3. John W. McCoy (1821–89), whose biography appears in *The Biographical Cyclopedia of Representative Men of Maryland and District of Columbia* (Baltimore, 1897), 468–470, bequeathed his library and residence, together with a residual estate of a half-million dollars, to the Johns Hopkins University. His art collection eventually was given to the Peabody Institute. In addition to being an early member of and volunteer for the Baltimore Association for the Improvement of the Condition of the Poor, he was also a trustee of the Spring Grove Asylum. His obituary appeared in the *Baltimore Sun,* August 2, 1889, suppl., p. 1. It was McCoy who wounded Gardiner in the state capital during the "railway war" protests (*Baltimore Sun,* March 12, 1860).

4. Waldo Newcomer, *A Biographical Sketch of Benjamin Newcomer* [1827–1901] (Baltimore, 1902).

5. W. T. Walters to Nannie Newcomer, December 21, 1892, collection of Mrs. William Cattell Trimble Sr.

6. Newcomer, *Biographical Sketch,* 33; see also J. T. Scharf, *History of Baltimore City and County from the Earliest Period to the Present* (Philadelphia, 1881), 78–79, and George Pausch, "The Old Safe Deposit" (unpublished essay, 1958, WAG Archives).

7. H. D. Dozier, *A History of the Atlantic Coast Line Railroad* (Boston, 1920); *The Story of the Atlantic Coast Line, 1830–1930* (Wilmington, N.C.,

1930); C. McDowell Davis, *Atlantic Coast Line Fragments* (New York, 1950); R. E. Prince, *Atlantic Coast Line Railroad: Steam Locomotives, Ships, and History* (Green River, Wyo., 1966); G. J. Hoffman, "History of the Atlantic Coast Line Railroad" (Library, Law Department, CSX Transportation, Jacksonville, Fla., undated typescript).

8. *Atlantic Coast Line*, 8.

9. *Organization and Charter of the Southern Railway Security Company*, pamphlet reprinted by C. K. Brown in "The Southern Railway Security Company," *North Carolina Historical Review* 6, no. 1 (1929): 160.

10. For the role of the Southern Railway Security Co. in the formation of the Atlantic Coast Line, see Brown, "The Southern Railway Security Company," 158–170, and J. F. Stover, *The Railroads of the South, 1865–1950* (Chapel Hill, 1955), 99–121.

11. An unidentified newspaper clipping in the family Bible (Jane Ridder collection) reported that Walters bought the 32½-acre farm from Augustus Kohler. The obituary for William Walters in the *Baltimore Sun*, November 23, 1894, reported that Walters resided at St. Mary's spring through autumn and that the size of the estate was eventually 130 acres. The same source noted the bronze mastiff that Walters is said to have purchased from Charles S. Gilmor. The author is indebted to Mrs. John S. Hyman (née Marie Judge) and to Mrs. T. Russell Hicks for their family recollections of St. Mary's.

12. The contents of St. Mary's are listed in W. T. Walters's will filed in Baltimore County.

13. *Baltimore American*, January 23, 1874.

14. Major sources for the history of the Percheron in America include *The Percheron Horse, Translated from the French of Charles Du Haÿs* [*sic*] (New York: Orange Judd, 1868), and *A History of the Percheron Horse*, ed. A. Sanders, in collaboration with W. Dinsmore (Chicago, 1917).

15. *The Percheron Horse* (transl.). The growth of William Walters's stock can be traced in L. M. C. Randall, *The Diary of George A. Lucas: An American Art Agent in Paris, 1857–1909* (Princeton, 1979), and in the notes included in a deluxe edition of Du Haÿs's treatise, *The Percheron Horse — Translated from the French of Charles Du Haÿs*, privately printed by W. T. Walters (New York: Gilliss Brothers and Turnure, 1886).

16. The most recent history of Georgetown University is J. T. Durkin, S.J., *Georgetown University: The Middle Years* (Washington, D.C., 1963). Harry Walters's curriculum at the college may be traced in the *Catalogue of the Officers and Students of Georgetown College* for the years 1865 through 1869.

17. For Harry Walters's attendance at Loyola, see J. J. Ryan, *Historical Sketch of Loyola College, Baltimore, 1852–1902* (Baltimore, n.d.), 71. Walters referred to his health problems in 1867 in a letter to Rev. W. H. Summer, S.J., of January 17, 1903, in which he recalled with pleasure his six months at Loyola College and pledged $1,000 to the institution (Loyola College Archives). Summer had been Walters's professor of French at Georgetown.

18. For the Class Day and graduation ceremonies, see J. Gilmany Shea, *Memorial of the First Centenary of Georgetown College, D.C.* (Washington, 1891), 223–225.

19. Information regarding Jennie's activities at Georgetown Academy of the Visitation was provided by Sister Mada-anna Gell, VHM, author of "Georgetown Visitation: The Myth of the Finishing School," *Salesian Living Heritage*, spring 1986, 29–41.

20. For the Lawrence Scientific School, see F. O. Vaille, *The Harvard Book: A Series of Historical, Biographical and Descriptive Sketches* (Cambridge, 1875), 1:279. Charles W. Eliot called for a reform in "The New Education: Its Organization," *Atlantic Monthly* 23, no. 136 (1869): 203–220, 358–367.

21. For the unhappy courtship of Warren III (1852–1920) and Jennie, see Daniel W. Delano, *Franklin Roosevelt and the Delano Influence* (Pittsburgh, 1946), 182–183, and G. C. Ward, *Before the Trumpet: Young Franklin Roosevelt, 1882–1905* (New York, 1985), 101. Daniel W. Delano, confused by family references to Mr. Walters, erroneously referred to the senior and junior Walterses as Henry and Harry rather than William and Henry. He also repeated the romantic legend about the lamp. In actuality, William Walters ordered that his porch light remain lit continuously after witnessing a telegraph boy kicking the door because he could not see the house number in the dark. The letter from Jennie to the Delanos was written from Fair Haven, N.J., July 23, 1876 (Ridder family archives).

22. The Honorable and Mrs. William Cattell Trimble Sr. gave the author access to a small body of surviving correspondence between William and Henry Walters and the Newcomer daughters. Nannie Newcomer (1855–1901) married Frederick Home Hack, a Baltimore lawyer, in 1881.

23. Sarah Green (1859–1942) attended Notre Dame College of Maryland, receiving the degree "Major Mistress in English Literature," and in 1896–97 she served as the college's Alumnae Association president (Archives, College of Notre Dame of Maryland). She married Henry Walters on April 12, 1922.

24. For the Baltimore and Ohio Railroad's southern and western extensions after the Civil War, see E. Hungerford, *The Story of the Baltimore and Ohio Railroad, 1827–1927* (New York, 1928), and W. B. Catton, "John Work Garrett of the Baltimore and Ohio Railroad: A Study in Seaport and Railroad Competition, 1820–1874" (Ph.D. diss., Northwestern University, 1959).

25. For American collections in the postwar era, see Edward Strahan [Earl Shinn], *The Art Treasures of America,* 3 vols. (Philadelphia, [c. 1879–80]). For insight to specific dealers and collectors, see L. M. Fink, "French Art in the United States, 1850–1870: Three Dealers and Collectors," *Gazette des Beaux-Arts* 92 (September 1978): 87–100; K. Baetjer, "Extracts from the Paris Journal of John Taylor Johnston, First President of the Metropolitan Museum," *Apollo* (December 1981): 410–417; and M. Fidell-Beaufort and J. K. Welcher, "Some Views of Art Buying in New York in the 1870s and 1880s," *Oxford Journal* 5, no. 1 (1982): 8–55.

26. Local organizations, including the Maryland Academy of Art, the Decorative Arts Society, the Sketch Club, and the Charcoal Club, are mentioned in *The Taste of Maryland: Art Collecting in Maryland, 1800–1934,* Walters Art Gallery (Baltimore, 1984), viii–ix.

27. J. Stricker Jenkins (1831–78) published *Catalogue of Paintings Belonging to J. Stricker Jenkins, No. 187 N. Charles Street* (Baltimore, 1870). The Jenkins collection was sold at Clinton Hall, N.Y., on May 2–3, 1876. A reporter had speculated that, when the contents of the Walters and Jenkins galleries were combined, Baltimore would have the nucleus of a public museum ("The Liverpool of America," *Scribner's Monthly,* April 1875, 694). Bouguereau's *Art and Literature* is owned by the Arnot Art Museum, Elmira, N.Y.

28. In his diary, Lucas recorded purchases of Louis XVI furnishings on April 24–25, 1866 (p. 217), and May 16, 1866 (p. 219); the completion of the Gleyre (WAG 37.184) on January 18, 1867 (p. 233); and the acquisition of the Barye bronzes and Gavarni watercolors on January 31, 1866 (p. 212), and October 30, 1866 (p. 228), respectively.

29. Lucas mentioned visits to Whistler and Boughton on March 13, 1867. Walters never manifested the slightest interest in Whistler's work but, in following years, acquired two oils and a number of watercolors by Boughton.

30. Walters wrote a lengthy, rather humorous account of Derby Day to his children on May 24, 1867, WAG Archives. For the quotation, see W. T. Walters to his children, May 2, 1867, WAG Archives.

31. Lucas recorded the purchase of Paul Delaroche's *Hemicycle* (WAG 37.83) from George Petit for eighty thousand francs (October 3, 1871, Agenda, WAG Manuscript Department).

32. Charles Dickens to W. Harrison Ainsworth, March 1847, in *The Pilgrim Edition: The Letters of Charles Dickens,* ed. Graham Storey and K. J. Fielding (Oxford, 1981), 5:37; Alexandre Dumas, *Paris Guide* (Paris, 1867), 869.

33. For the history of the bronze and the duc d'Orléans's *surtout de table,* see R. Ballu, *L'oeuvre de Barye* (Paris, 1890), 56–58, 72–78; G. H. Hamilton, "The Origins of Barye's 'Tiger Hunt,'" *Art Bulletin* 18, no. 2 (1936): 249–257; and *Un age d'or des arts décoratifs, 1814–1848,* Galeries nationales du Grand Palais (Paris, 1991), 318–324, cat. nos. 167–171.

34. Six thousand francs were paid to the banker Hottinger on behalf of Philippe Burty for *The Tiger Hunt* on February 20, 1872.

35. For the comments on the Chinese entries, see "Artisan's Report upon the Vienna Exhibitions of 1873," *Practical Magazine* 3 (1873): 31, 203. The early porcelains owned by Prince Ehtezadesaltanet are mentioned by Walters in his catalogue, *Oriental Collection of W. T. Walters, 65 Mount Vernon Place* (Baltimore, 1884), ix.

36. For the beginnings of the Corcoran Gallery of Art, see W. MacLeod, *Catalogue of the Paintings, Statuary, Casts, and Bronzes, etc., of the Corcoran Gallery of Art* (Washington, D.C., 1874), 5–7. The Committee on Works of Art originally comprised W. T. Walters, J. C. McGuire, and G. W. Riggs. For

William Walters's acceptance of the trusteeship, dated May 13, 1869, see *A Grandfather's Legacy* (Washington, D.C., 1879), 295.

37. For the convention regarding the international exchange of reproductions, see the South Kensington Museum's *Catalogue of Reproductions of Objects of Art* (London, 1870), iii–iv. Walters wrote to William MacLeod, curator of the Corcoran Gallery, reporting that he had ordered casts of two-thirds of the Elgin marbles and of the Ghiberti Gates on July 13, 1873 (letter 91, Corcoran Gallery Archives), and Lucas recorded that he and Walters had selected the Louvre casts (*Lucas Diaries,* June 26, 1873, 2:378).

38. For the commission of the Hildesheim reproductions, see *Lucas Diaries,* September 18, 1873, 2:382. For the Lionnet "galvanoplasties" of armor, see Lucas to Walters, September 2, 1874 ("Register of Letters Received at the Corcoran Gallery of Art," Corcoran Gallery Archives). Galvanoplasties, or electrotypes, were metal, usually copper, facsimilies produced in the nineteenth century using molds that had been rendered electroconducive by a coating of graphite. The outer skin of copper was deposited on the mold through galvanic action (electricity produced through a chemical action). During the nineteenth century museum officials were pessimistic that major original works would ever be available and therefore relied on plaster casts and other replicas; see James Fenton, "Object Lessons," *New York Review of Books,* January 15, 1998, 40.

39. MacLeod contrasted the Sèvres porcelains, perhaps those recorded in *Lucas Diaries* (October 25, 1873), 2:384, to the Deck vase mentioned in the diaries. MacLeod, "Catalogue," 30–31.

40. The European additions to the Corcoran Gallery are listed in MacLeod, "Catalogue," 33–44. Many of the works are illustrated in Shinn, *Art Treasures of America,* 3–22. The now lost Gérôme, *César mort,* is illustrated in G. M. Ackerman, *The Life and Work of Jean-Léon Gérôme* (London, 1986), 204–205, no. 109.

41. In a letter to Walters of May 23, 1874 ("Register of Letters Received," Corcoran Gallery Archives), Lucas mentioned Louis Priou's *Family of Satyrs* (Salon 1874), G. C. Saint-Pierre's *Nedjma-Odalisque* (Salon 1874), J. A. Bail's *Sunday Morning in Auvergne* (Salon 1874), and A. Collette's *Young Savoyard Musician* (Salon 1873). Also acquired from the Salon were Hugo Salmson's *The Fete of St. John in Dalecarlia* (Salon 1874), L. A. G. Loustenau's *Monk Fishing* (Salon 1874), and H. Motte's *The Trojan Horse.* S. P. Avery's painting by P. C. Compte, *Scene at Fontainebleau — Costume of Louis XI,* was mentioned by Walters in a letter to MacLeod of March 6, 1875 (letter 581, "Register of Letters Received," Corcoran Gallery Archives). Walters also noted buying C. L. Muller's *Charlotte Corday in Prison* from Avery for two thousand dollars (letter 657, "Register of Letters Received," Corcoran Gallery Archives).

42. Walters first recommended the purchase of a collection of Barye sculptures in a letter to MacLeod of June 1, 1873 (letter 91, "Register of Letters Received," Corcoran Gallery Archives). Quotation from William Thompson

Walters, comp., *Antoine-Louis Barye: From the French of Various Critics* (Baltimore, 1885), 6.

43. Charles De Kay, *Barye* (New York, 1889), 115.

44. The Corcoran Gallery of Art's collection of Barye bronzes was published in MacLeod, *Catalogue of the Paintings, Statuary, Casts, Bronzes, Etc.* (Washington, D.C., 1874), 31–32, 35–36, 39–41, and subsequent Corcoran catalogues and most recently by L. F. Robinson and E. J. Nygren, *Antoine-Louis Barye: The Corcoran Collection* (Washington, D.C., 1988).

45. For the Rinehart additions to the Corcoran, see William Sener Rusk, *William Henry Rinehart, Sculptor* (Baltimore, 1939), 50–54. Walters and Newcomer invested the Rinehart fund, which grew from $39,000 in 1873 to $95,000 in 1891, the year it was transferred to the Peabody Institute. A Rinehart Fund Committee was established, and in 1895 the committee began to fund annual scholarships for students to study in Paris and Rome. Later, the fund was used to finance a sculpture school at the Maryland Institute. Today, the Rinehart School of the Maryland Institute offers graduate degrees, and the Henry Walters Traveling Scholarship is awarded annually by the Municipal Art Society of Baltimore.

46. For the purchases from the Johnston collection, see *New York Times*, December 21, 1876. Shinn makes very short shrift of Church's *Niagara Falls* in *Art Treasures of America* (Philadelphia, n.d.), 14.

47. The Detaille was purchased directly from the artist after the Brussels Exhibition for $5,000; see letter from Lucas, October 19, 1875 ("Register of Letters Received," Corcoran Gallery Archives). Boughton's *The Heir Presumptive* was bought from Goupil, New York, for $3,500 ("Register of Letters Received," letter 513). His *Edict of William the Testy* was acquired from the artist in 1877.

48. At the Robert Morrison Olyphant sale held at Chickering Hall, New York, December 18 and 19, 1877, Walters and Riggs bought for the Corcoran the following works: J. F. Kensett, *Autumn on Lake George*, $6,350; H. P. Gray, *Judgment of Paris*, $3,000; T. Cole, *Hurricane*, $850; J. F. Kensett, *Genesee River*, $1,300; A. F. Tait, *Chickens*, $120; W. J. Hays, *A Dog's Head*, $140. No pictures in the Walters collection can currently be identified as from the sale. In the Curator's Journal for December 31, 1877 (Corcoran Gallery Archives for the years of his chairmanship), MacLeod noted William Corcoran's enthusiasm for the painting by Gray and his dissatisfaction with Walters's and Riggs's other selections.

49. William Walters's recommendations to curator MacLeod appear throughout the Curator's Journal. His suggestions regarding colors are in the Minutes of the Trustees Meeting, November 25, 1874. See the Curator's Journal for his comments on labels (October 19, 1876), his intercession on behalf of C. L. Elliott's widow (September 13, 1876), and his funding of a class visit of forty schoolchildren from Baltimore (March 31, 1876).

50. William Walters's letter of resignation is recorded in the "Register of

Letters Received," vol. 1, April 11, 1877 (Corcoran Gallery Archives). For the early holdings of the Metropolitan Museum of Art and the Museum of Fine Arts, see C. Tomkins, *Merchants and Masterpieces: The Story of the Metropolitan Museum of Art* (New York, 1970), 35–59, and W. M. Whitehall, *Museum of Fine Arts, Boston: A Centennial History* (Cambridge, Mass., 1970), 20–39.

51. William Walters held the following offices at the Peabody Institute: Executive Committee, 1879–83; Gallery of Arts Committee, 1875–94 (chairman, 1876–94); Finance Committee, 1875–94; Vice-President, 1893–94. The Gallery of Arts Committee's acquisitions can be traced in the Invoice Book, Gallery of Art, Peabody Archives.

52. Lucas recorded the visit to the Maison Pompéienne on July 3, 1862 (*Lucas Diaries*, 2:137). This structure, designed by Alfred-Nicolas Normand in 1856, with its rich red-and-black color scheme, is described by David Van Zanten in *The Second Empire: Art in France under Napoleon III,* Philadelphia Museum of Art (Philadelphia, 1978), 63–64. It may have sparked the fashion for Pompeian-style interior decoration in the United States in the late 1870s and 1880s.

53. Lucas recorded commissions for both the mosque lamp from Joseph Brocard and the chimney pieces from Barbedienne & cie on April 15, 1874 (*Lucas Diaries*, 2:393). For references to the production of fine ebony and ormolu furniture and to artistic chimney pieces, see *Bronzes d'art, F. Barbedienne . . .* (Paris, 1882), 95.

54. For the Jenkins firm's activities as cabinetmakers, see John H. Hill, "Furniture Designs of Henry W. Jenkins & Sons Co.," in *Winterthur Portfolio* (Charlottesville, Va., 1969), 5:155–188. In addition to Jenkins's own work, a pair of small tables decorated in marquetry made by Wright and Mansfield of London were purchased through the firm. Edward S. King recalled that much of the woodwork he saw in the house when he joined the Walters staff in 1934 had been produced by the firm started by John C. Knipp in 1868 (letter to the author, May 29, 1989). For this Baltimore cabinetmaker, see Gregory R. Weidman, *Furniture in the Maryland Historical Society* (Baltimore, 1984), 233, cat. no. 213.

55. Thomas Kirby figures prominently in W. Towner's *The Elegant Auctioneers* (New York, 1959).

56. August Belmont (1816–90) had served initially as chargé and then as a minister resident to the court of William III from 1853 to 1857. After the loss of his position as chairman of the National Committee at the Democratic Convention in Baltimore in 1872, he left disheartened on a European tour. D. Black, *The King of Fifth Avenue: The Fortunes of August Belmont* (New York, 1981), 99–159. For the 1872 auction, see the *New York Times,* November 5, 1872.

57. At the sale of the estate of William T. Blodgett (c. 1823–75), the principal work in the collection, Church's *Heart of the Andes,* was withdrawn and sold privately. W. M. Story's statue *Semiramis* failed to meet a reserve of six

thousand dollars and was also withdrawn. *The Bear Hunt* had formerly been in the Blodgett collection (De Kay, *Barye,* 51).

58. Walters to Kensett, undated letter of 1860, Kellogg Collection, Archives of American Art.

59. For John Taylor Johnston's collection, see K. Baetjer, "Extracts from the Paris Journal of John Taylor Johnston," *Apollo,* December 1981, 410–417. Church's *Twilight in the Wilderness* had been sold by W. T. Walters on February 12–13, 1864, and was bought by Johnston at an auction at Leeds and Miner, New York, on March 9, 1866 (no. 174). The prices for Walters's purchases are listed in the *New York Times,* December 21, 1876: Horace Vernet's *Brigands Surprised by Papal Troops* (WAG 37.54), $6,100; John Loring Brown's *The Noonday Halt* (now unlocated), $600; Charles Daubigny's *Twilight* (WAG 37.128), $1,450; Gilbert Stuart's *Portrait of Consul Barry* (now Princeton University Art Museum), $560; and Johann Wilhelm Preyer's *Fruit* (WAG 37.139), $1,400. Another work that Johnston had acquired only several months earlier at the Blodgett sale, Alexandre-Gabriel Decamps's *The Suicide* (WAG 37.42), was bought by Avery and sold to Walters.

60. By act of Congress the official name of the 1876 Philadelphia exhibition is the International Exhibition of Arts, Manufactures, and Products of the Soil and Mine, but it is popularly known as the Philadelphia Centennial Exhibition.

61. Principal references for the Japanese participation in the Philadelphia Centennial Exhibition include the *Official Catalogue of the Japanese Section and Descriptive Notes on the Industry and Agriculture of Japan* (Philadelphia, 1876); J. D. McCabe, *The Illustrated History of the Centennial Exhibition* (Philadelphia, 1876), 441–446; and G. T. Ferris, *Gems of the Centennial Exhibition* (New York, 1877), 78–81. For the Japanese bazaar and dwelling, see C. Lancaster, *The Japanese Influence in America* (New York, 1963), 46–50.

62. The Chinese entries were catalogued in *China: Catalogue of the Chinese Imperial Maritime Customs Collection at the United States International Exhibition, Philadelphia* (Shanghai, 1876). The quotations are from McCabe, *Illustated History of the Centennial Exhibition,* 447–449.

63. G. T. Ferris, in *Gems from the Centennial Exhibition,* praised the vigor of the Japanese products (p. 87) and the conscientiousness of the Chinese artisans (p. 83).

64. E. Strahan [E. Shinn], *Mr. Vanderbilt's House and Collection* (New York, 1883–84), 1:59–74; D. O. Kisluk-Grosheide, "The Marquand House," *Metropolitan Museum Journal* 29 (1994): 63, figs. 27–29.

65. For H. O. Havemeyer's purchases, see F. Weitzenhoffer, *The Havemeyers: Impressionism Comes to America* (New York, 1986), 32–33.

66. William Walters wrote to MacLeod on August 4, 1876, expressing his enthusiasm for the centennial exhibition (Curator's Journal, Corcoran Gallery Archives). The manuscript "Centennial Exhibition 1876: Objects purchased, H. Walters, 68 Exchange Place, Baltimore, MD" survives in the WAG Archives.

67. For the sequence of the Walters purchases, see M. Boyer, *Japanese Lacquers in the Walters Art Gallery* (Baltimore, 1970), 9–21. The *kōgō* (WAG 67.285) and the *kōbako* (WAG 67.536) purchased from Minoda Chōjiro in 1876 were listed as nos. 252 and 264 (pp. 63–64).

68. The goblet by Gen-ō, described by Harry Walters as "Enamel Cup, Gold Filigree $250," has been identified by L. Bruschke-Johnson as the one appearing in an 1876 photograph; see "Japanese Cloisonné in the Walters Art Gallery," *Journal of the Walters Art Gallery* 47 (1989): 8–12.

69. Listed in the Chinese section of the manuscript "Centennial Exhibition 1876" were four names. Hu Kwang Yung and Ho Kan Chen have been identified as dealers, Hwang-li Chen probably was an assistant to Ho Kan Chen, and Esmondhouse has not been identified.

70. *Le Japon à l'Exposition universelle de 1878* was published under the direction of the Imperial Japanese Commission (Paris, 1878). P. Gasnault reviewed the Oriental ceramics in "La céramique de l'extrême Orient à l'Exposition universelle," and T. Duranty presented an overview of the Oriental exhibits in "L'extrême Orient," *Gazette des Beaux-Arts*, December 1878, 890–911, 1011–1048.

71. William Walters's tour with Lucas and Avery can be traced in the latters' respective diaries. The collection of Oriental porcelain of the Brussels notary Paul Morren was sold at Christie's in London on June 25, 1879. It consisted of particularly rich eggshell porcelains, many of which were bought by P. Sichel and S. Bing of Paris.

72. The invoice for the Grande Compagnie Kôchô-Kouaïcha, dated July 26, 1878, is preserved in the WAG Archives. The directors of the company are listed as Messrs. Wakai and Matsuo. Wakai Kanesaburō and his assistant Hayashi Tadamasa are discussed in S. Shinichi, "Tadamasa Hayashi: Bridge between the Fine Arts of East and West," *Japonisme in Art: An International Symposium* (Tokyo, 1980), 167–172.

73. Walters traveled to London with the two Averys on July 27 and left from there for Dublin on August 4. He embarked for America five days later, sailing on the same ship as the Averys.

74. For Walters's conversation with MacLeod regarding the *Exposition retrospective,* see Curator's Journal, September 11, 1878 (Corcoran Gallery Archives). The exhibition is described in *L'art ancien à l'Exposition de 1878,* ed. L. Gonse (Paris, 1879).

75. An invitation addressed to Alfred Jacob Miller and dated November 26, 1872, is preserved in the L. Vernon Miller family papers and is reproduced in William R. Johnston, *The Nineteenth Century Paintings in the Walters Art Gallery* (Baltimore, 1982), 20. Quotation from Dorothy Weir Young, *The Life and Letters of J. Alden Weir* (New Haven, Conn., 1960), 63–64.

76. William MacLeod, Curator's Journal, March 6, 1879, 38 (Corcoran Gallery Archives); unidentified newspaper clipping (Corcoran Gallery Archives).

77. The visit of the copyists on April 2, 1879, was entered in the Corcoran Gallery's Curator's Journal with an unidentified newspaper clipping.

78. Accounts of the Grand Charity Art Exhibition held in the Fifth Regiment Armory are to be found in the *Baltimore American and Commercial Advertiser,* January 19, 20, 21, and 23, 1874.

The 1874 opening of the Walters gallery was mentioned in the *Baltimore American and Commercial Advertiser,* March 29, 1874. The gallery was said to contain 118 oil paintings. In addition, a small room was devoted to works on paper. The same newspaper, on July 21, 1874, noted that the 1874 opening of the Walters gallery yielded $395. The Baltimore Association for the Improvement of the Condition of the Poor had been founded in 1849 with the purpose of distributing relief to the worthy poor. The association subsequently merged with related organizations to become the Family and Children's Society. Concern for the plight of the poor, an abiding interest of W. T. Walters, was manifested in his descriptions of the Genoese eleemosynary institutions during his Civil War travels. As early as 1858, he was listed as a contributor to the Poor Association.

79. The opening in 1876 raised $734 (Ernest H. Smith to W. R. Johnston, March 8, 1974). In 1931, the last year of the practice, 6,410 tickets were sold for $3,205 (Anna D. Ward to Henry Walters, July 17, 1931). The archives of the Family and Children's Society indicate that, between 1884 and 1931, $125,521.95 was raised through the Walters openings. M. Janvier recalled visits to the Walters gallery in the 1880s as social occasions. Washington's Birthday openings were particularly crowded, and viewers tended to throng in front of popular pictures. *Baltimore Yesterdays* (Baltimore, 1937), 47 59.

80. The catalogue (undated, but to which a date can be assigned on the basis of the works listed) was from the press of Daugherty and Wright, Baltimore. The author may have been John Robinson Tait, a painter and writer who resided in Baltimore after 1876 and was a frequent visitor to the collection. See D. Miner, "The Publishing Ventures of a Victorian Connoisseur: A Sidelight on W. T. Walters," *Papers of the Bibliographical Society of America* 57 (1963), 282, 306.

81. For William Walters's offer of financial support, see *Art Amateur* 20, no. 5 (1889): 98. For the issue of Sunday openings at the Metropolitan Museum, see Tomkins, *Merchants and Masterpieces,* 75–79.

82. Harry Walters's 1879 European tour can be followed in the *Lucas Diaries,* April 10–July 31, 1879 (2:471–475), and M. Fidell Beaufort, H. L. Kleinfield, and J. K. Welcher, *The Diaries 1871–1872 of Samuel P. Avery, Art Dealer* (New York, 1979), June 12–August 31, 1879, 504–539.

83. The Société d'aquarellistes français held its first exhibition at 16, rue Lafette in 1879. Among the seventeen founding titulary members were J. Jacquemart, C. E. de Beaumont, E. Detaille, G. Doré, F. Heilbuth, Eugène Isabey, and G. Vibert, all of whom were eventually represented in the Walters collection.

Lucas had bought Camille Pissarro's *Path by the River* (1864) and *Village*

Street in Winter (Louveciennes) (1870) in January 1870, but otherwise never patronized the impressionists, and Harry Walters did not begin to acquire impressionist paintings until the early twentieth century.

84. Harry's 1881 travels are mentioned in the *Lucas Diaries*, January 28– February 24, 1881, 2:514–515.

85. The estate of Jules Jacquemart (1837–80) was auctioned at the Hôtel Drouot on April 4–8, 1881. Notations in a catalogue (Walters Art Gallery Library) indicate that Jacquemart's pen drawings *La route de Menton à Monte- Carlo* (cat. no. 34) and *Une rue à San-Remo* (cat. no. 41) and his pastel *Inté- rieur de cour à Rouen* (cat. no. 82) were acquired along with a Shang bronze (cat. no. 91, WAG 54.1233), a Japanese bronze incense burner (cat. no. 111), and a Malayan kriss (cat. no. 202).

86. For the purchase of Rousseau's *Effet de givre* and Millais's *News from Home,* see Johnston, *The Nineteenth Century Paintings,* 70, 203. In addition to handling the firm's avant-garde impressionist works, Deschamps (1848– 1904) also dealt in the paintings of Alma-Tadema, an artist represented by his uncle Ernest Gambart.

87. For Alma-Tadema's archaeological reconstructions, see J. G. Lovett and W. R. Johnston, *Empires Restored, Elysium Revisited: The Art of Sir Lawrence Alma-Tadema,* Sterling and Francine Clark Art Institute (Williamstown, Mass., 1991).

88. V. G. Swanson, in *The Biography and Catalogue Raisonnée of the Paintings of Sir Lawrence Alma-Tadema* (London, 1990), includes *Catullus at Lesbia's* (p. 135, no. 66, illus. 297) and *A Roman Mother (Cuckoo)* (p. 142, no. 84). These two works and a landscape by Pauline Alma-Tadema were listed in *The Collection of W. T. Walters* (Baltimore, 1884), nos. 12, 146, and 149.86.

89. The other paintings by Alma-Tadema are listed in *W. T. Walters Col- lection: A Descriptive Catalogue Prepared for the Poor Association* (Baltimore, [1878]), 8. Among the Alma-Tademas retained in the Walters collection are *A Roman Emperor* (WAG 37.165), *The Triumph of Titus* (WAG 37.31), *My Sister Is Not at Home* (WAG 37.86), and *Sappho* (WAG 37.159). "The Works of Laurence Alma-Tadema, R.A., " *Art Journal (London),* n.s. (February–March 1883), 68.

90. The lot of land facing Washington Place and extending back parallel to Spring Alley (later Peabody Alley) had originally belonged to James McHenry and had been acquired by W. T. Walters from the Latrobe family on June 10, 1882 (Baltimore City Archives, FAP 935 402). Woodrow Wilson was a graduate student at the Johns Hopkins University from 1883 to 1885 and received his doctorate in 1886.

91. The schedule for the 1883 trip is taken from the *Lucas Diaries,* March 17–September 15, 2:562–572.

92. Lucas alluded to Philippe Sichel allowing Walters to select works from his collection on March 26, 1883 (ibid., 2:560). Although it is not possible

to identify the individual works bought in Paris in 1883, the quantity may be gauged from the fact that Lucas recorded crates 153 through 169 being shipped to W. T. Walters & Co. by the broker Lherbette.

93. The Charles Camino miniature of W. T. Walters (WAG 38.626) is signed and dated: *C. Camino. Paris. 1883.* The Bonnat portrait (WAG 37.758) was begun on March 30 and completed on June 5, 1883.

94. Louis Gonse wrote both the *Catalogue rétrospective de l'art japonais* (Paris, 1883) and *L'art japonais* (Paris, 1883).

95. For the 1883 purchases, including Jean-Léon Gérôme's *The Christian Martyrs' Last Prayers* (WAG 37.131), which measures 34⅝ × 59¹⁄₁₆ in. (p. 104); Camille Corot's *Saint Sebastian Succorded by Holy Women* (WAG 37.192), 101⅝ × 59¹⁄₁₆ in. (pp. 59–60), and Baron Hendrik Leys's *The Edict of Charles V,* 4 ft. 6 in. × 8 ft. ½ in. (p. 152), see Johnston, *The Nineteenth Century Paintings.* Gérôme's *Ave Caesar, Morituri Te Salutant* (1859) is now at the Yale University Art Gallery, and his *Pollice Verso* (1872) is at the Phoenix Art Museum.

96. Walters bought no. 15 of the 100 copies on Japan paper of Albert Wolff, *Cent Chefs-d'Oeuvre: The Choice of the French Private Galleries* (New York and Paris, [1884]).

Chapter Four: The Years of Fruition, 1884–1894

1. Benjamin Newcomer nominated Harry Walters general manager at the board meeting of the Wilmington & Weldon Railroad in Baltimore on June 13, 1884. G. J. Hoffman, "History of the Atlantic Coast Line Railroad" (Library, Law Department, CSX Transportation, Jacksonville, Fla., manuscript), 5:1. For the Atlantic Coast Line Association, see ibid., 5:5–8.

2. Ibid., 5:9, 11, 12.

3. Ibid., 5:16–26.

4. The American Improvement and Construction Co. had originally been incorporated for a foreign investment venture. Reorganized in April 1891, its officers included William T. Walters as president, Harry Walters as vice-president, W. G. Elliott as secretary and assistant treasurer, Benjamin Newcomer as treasurer, and A. Brandegee (a lawyer from New London, Conn.) and George B. Jenkins as assistant secretaries (ibid., 6:11). The change in name to the Atlantic Coast Line Co. was ratified by the General Assembly of Connecticut on May 29, 1893.

5. *New York Mail and Express,* February 27, 1884, reprinted in *The Art Collections of Mr. Wm. T. Walters, 65 Mount Vernon Place, Baltimore: Catalogue and Descriptive and Critical Articles* (Baltimore, [1884]), 61.

6. The opening is described in the *Baltimore Sun,* February 28, 1884, and *The Art Collections of Mr. Wm. T. Walters.* The Tile Club and its members are discussed in R. G. Pisano, *A Leading Spirit in American Art: William Merritt Chase, 1849–1916,* Henry Art Gallery, University of Washington (Seattle, 1983), 49–53.

7. The Barbedienne casts are of Goujon reliefs from the Fontaine des Nymphes, Paris, Cemetery of the Innocents, c. 1520–66.

8. *New York Tribune,* February 27, 1884 (reprinted in *The Art Collections of Mr. Wm. T. Walters,* 32).

9. *Oriental Collection of W. T. Walters, 65 Mount Vernon Place* (Baltimore, 1884). This and other Walters publications are discussed by D. Miner, "The Publishing Ventures of a Victorian Connoisseur: A Sidelight on William T. Walters," *Papers of the Bibliographic Society of America* 57 (3d quarter, 1963): 271–311.

10. *The Collection of W. T. Walters,* 1884. Revised editions appeared in 1887, 1888, 1893, 1895, 1897, 1899, 1901, and 1903. *Collection of W. H. Vanderbilt, 640 Fifth Avenue, New York* (New York, 1882), was printed by G. P. Putnam.

11. *The Art Collections of Mr. Wm. T. Walters,* published by permission of Mr. Walters, from the Press of the American Job Printing Office, no. 122 West Baltimore Street [1884].

12. For William Laffan's role as a critic, see F. M. O'Brien, *The Story of the Sun* (New York, 1928), 196–198. The quotation is from the *New York Sun* (editorial), February 27, 1884 (reprinted in *The Art Collections of Mr. Wm. T. Walters,* 27). William H. Vanderbilt began to form his collection in 1876 and assembled more than two hundred paintings by 1882, sparing no expense and drawing on the advice of George A. Lucas and Samuel P. Avery.

13. *New York Mail and Express,* February 27, 1884, reprinted in *The Art Collections of Mr. Wm. T. Walters,* 65.

14. In his annotations of R. C. Hawkins's "Report on the Fine Arts," in *Paris Exposition Universelle, 1889: First Groups, Works of Art* (Washington, D.C., 1890), Walters bracketed the author's comments on Couture's "immortal work" and inscribed "right" (WAG Archives).

15. The silver *Walking Lion* is nine inches longer than the bronze. Its base is inscribed PARIS 30 AVRIL 1865 FILLE DE L'AIR. Montaignac acquired the piece at the Comte Frédéric de Lagrange sale, Hôtel Drouot, Paris, February 25–27, 1884, for 6,906 francs (P. Endel, *L'Hôtel Drouot et la curiosité, 1883–84* [Paris, 1885], 204–206) and was paid 10,500 francs by Lucas on January 30, 1885. Charles De Kay related the story of the added silver bars in *Barye* (New York, 1889), 99.

16. In addition to purchasing the *Tiger Hunt* (WAG 27.176) from Philippe Burty for six thousand francs in 1872 and the *Wild Bull Hunt* (WAG 27.178) from Montaignac in 1885 for eleven thousand francs (*Lucas Diaries,* May 4, 1865, 2:607), William Walters acquired the *Bear Hunt* (WAG 27.183) from the William T. Blodgett collection before the actual sale in New York on April 27, 1876. Henry Walters added to the collection the two remaining hunt groups from the duc d'Orléans *surtout,* the *Lion Hunt* (WAG 27.174), acquired from Georges Sortais in 1898, and the *Elk Hunt* (WAG 27.175), bought about 1899. In addition, he acquired the *Python Strangling a Gnu* (WAG 27.152), one of the four smaller animal combat groups, from Maurice Mallet in 1906.

17. The invoice for the Sèvres porcelains (WAG 48.754–756) is preserved in the Walters Art Gallery Archives.

18. For the *Collision of Arab Horsemen* (WAG 37.6) and *Christ on the Cross* (WAG 37.62), see L. Johnson, *The Paintings of Eugène Delacroix: A Critical Catalogue* (Oxford, England, 1986), 3:178, no. 367; 220, no. 433. Delacroix's comment from his journal and the quotation from T. Thoré, *Le Constitutionnel*, Paris, March 17 and April 14, 1847, are reprinted in Johnson, *The Paintings of Eugène Delacroix*, 3:220–221.

19. For the purchase of Delacroix's *Christ on the Sea of Galilee* (WAG 37.186), see *Lucas Diaries*, November 25, 1886, 2:640; Johnson, *The Paintings of Eugène Delacroix*, 3:237–238, no. 456. Troyon's *Cattle Drinking* (WAG 37.59) was bought on the same occasion, and Millet's *The Sheepfold, Moonlight* (WAG 37.50) was acquired from another unidentified source before 1887.

20. Lucas recorded payment of eight thousand francs to Philippe Sichel for three Isabeys (WAG 37.61, 62, and 63) (*Lucas Diaries*, November 18, 1893, 2:778). The third represents an unidentified woman. Maréchal Bertrand had left the miniatures to his grandson, the Marquis Biron.

21. Wesley Towner provided a witty account of the Mary Jane Morgan collection in *The Elegant Auctioneers* (New York, 1959), 69–114. For contemporary accounts of the collection, see *Art Amateur*, October 1885, 88–90; March 1886, 76–77; April 1886, 98–99; May 1886, 121.

22. The only located version of Gérôme's *The Tulip Folly* (WAG 37.2612) was presented to the Walters Art Gallery by Mrs. Cyril W. Keene in 1983. Gerald M. Ackerman (*The Life of Jean-Léon Gérôme* [Paris, 1986], 250, nos. 310 and 310B) questions whether the Walters version is the same as that which appeared in the Mary J. Morgan sale because of a discrepancy in the measurements.

23. *Catalogue of the Art Collection Formed by the Late Mrs. Mary Jane Morgan, to Be Sold at Chickering Hall, March 3 and Following Days, at the American Art Galleries* (New York, 1886), 101.

24. Peach-bloom porcelains are described by R. M. Chait in "The Eight Prescribed Peachbloom Shapes Bearing Kang H'si Marks," *Oriental Art* 3 (1957): 130–137. See also *Art Amateur*, October 1885, 89.

25. The most extensive newspaper accounts appeared in the *New York Sun*, March 9–12 and March 14, 1886. The *New York Times* reported on the peachbloom vase on March 1, 11, 12, 16, 19, 20, 24, 26, 27, and 28. See "Booming Peach-Blooms," *New York Times*, March 1, 1886.

26. In the *New York Sun*, March 11, 1886, James F. Sutton confirmed that on behalf of William T. Walters he had paid $18,000 for the vase. Walters had originally intended to keep the transaction confidential, he noted, but when it became apparent that the secrecy jeopardized Sutton's reputation, Walters's son authorized full disclosure. William Walters also acquired at the Morgan sale lot 342, a similar vase of a slightly darker color, for $6,000.

27. The *Art Courier* reported that W. T. Walters had transferred the teakwood stand to a celadon porcelain (suppl. to the *Art Amateur*, March 1891, 2).

28. Charles A. Dana (1819–97) became the owner of the *New York Sun* after the Civil War and served as its editor from 1868 to 1897. Under his leadership the *Sun* became renowned for its serious and progressive reviews of the arts (J. Loughery, "The New York *Sun* and Modern Art in America: Frederick James Gregg, James Gibbons Huneker, Henry McBride," *Arts Magazine* 59 [1984]: 77–82). A collector of ceramics, Dana shared Walters's preference for monochrome porcelains. See James Wilson, *The Life of Charles A. Dana* (New York, 1907), 505–507.

29. Albert Christian Revi discussed the replicas in "Mrs. Morgan's Peach Bloom Vase and Its Facsimiles in Glass and Pottery," *Spinning Wheel*, Hanover, January–February 1965, 6–8.

30. Lucas bought at least three Chinese porcelains on Walters's behalf (WAG 49.606, 607, and 608) at the Marquis sale, Hôtel Drouot, February 10–18, 1890.

31. For the reference to Walters in connection with the World's Columbian Exposition, see Carolyn Kinder Carr, "Prejudice and Pride: Presenting American Art at the 1893 World's Columbian Exposition," in *Revisiting the White City: American Art at the 1893 World's Fair* (Washington, D.C., 1993), 48, 115n. 24, 122n. 201. Carr, citing an article in the *Chicago Tribune*, January 7, 1891, that described Walters as somewhat younger than Marquand, concluded that the references were to Harry. Actually, both Henry G. Marquand and William T. Walters were born in 1819.

32. Lucas recorded that Burty agreed to write the article on Léon Bonvin (*Lucas Diaries*, April 24, 1884, 2:586) and received five hundred francs for it (September 27, 1884, 2:594). Theodore Child, a friend of Henry James and a critic for the *Pall Mall Gazette* and *Harper's New Monthly Magazine,* undertook the translation of the article (*Lucas Diaries*, October 8, 1884, 2:595), which appeared in *Harpers New Monthly Magazine,* December 1885, 37–51.

33. Glenn F. Benge, *Antoine-Louis Barye: Sculpture of Romantic Realism* (University Park, Pa., 1984), 44–46, 52–56. Lucas reported the payment of 25,000 francs for the Barye bronzes (*Lucas Diaries*, September 13, 1884, 2:593). For the unveiling of the statues in Mount Vernon Place on January 27, 1885, see *Baltimore Sun*, January 28, 1885, and *Harper's Weekly,* January 24, 1885, 89, and February 7, 1885, 91.

34. Walters's neighbor, Robert Garrett, gave the city the circular fountain with bulrushes. The present installation of the groups dates from the Carrère and Hastings design of 1918. Quotation from the *Baltimore Sun,* January 28, 1885. For Wilson's observation, see R. S. Baker, *Woodrow Wilson: Life and Letters* (New York, 1927), 175n. 1.

35. Lucas ordered the replica from Barbedienne (*Lucas Diaries,* December 19, 1884, 2:599). The *Military Courage* by Paul Dubois (1827–1905)

recalls Michaelangelo's effigy of Lorenzo de Medici in the Church of San Lorenzo in Florence. Dubois's figure served as a corner element in the tomb of General Juchault de Lamoricière, the conqueror of Abd-el-Kadir in 1847, erected in Nantes cathedral in 1879.

36. The Taney statue was commissioned from Rinehart in 1870 and unveiled in Annapolis on December 12, 1872. William Walters commissioned the cast for Mount Vernon Place from Ferdinand von Muller of Munich in 1887 (M. C. Ross and A. W. Rutledge, *A Catalogue of the Work of William Henry Rinehart, Maryland Sculptor, 1825–1874* [Baltimore, 1948], 38). For Walters's gift of the bronze, see W. T. Walters to Mayor Benjamin Latrobe, November 14, 1887 (Baltimore City Archives, RG 9, S.3, box 60).

37. *Antoine-Louis Barye: From the French of Various Critics* (Press of Isaac Friedenwald, Baltimore, 1885).

38. The Bonnat portraits of Lucas and Barye (WAG 37.759 and 37.757) were not yet actually installed. They had been commissioned on November 18, 1884, but were not completed until the following spring (*Lucas Diaries*, July 17, 1885, 2:612). W. T. Walters, "Preface," in *Antoine-Louis Barye*, 7.

39. J. D. Kysela, "Sara Hallowell Brings 'Modern Art' to the Midwest," *Art Quarterly* 27, no. 2 (1964): 150–168.

40. *Lucas Diaries*, November 18 and 19, 1887, 2:658.

41. Cyrus J. Lawrence (1833–1908) served as a director of the Wabash and of the Toledo, Ann Arbor, and Michigan Railroads and was also a member of the New York Stock Exchange and vice-president of the Bush Terminal Co. In 1883–84, Lawrence was the major lender to a Barye exhibition held at the Lotus Club in New York (*Art Amateur*, December 1889, 5). His collection was dispersed at his death by auction at the American Art Galleries, New York, on January 21–22, 1910. The Barye holdings, through a previous agreement, went to the Brooklyn Museum.

42. Lawrence's negotiation for the plaster cast of the *Lion Crushing a Serpent* is reported in *Art Amateur*, January 1890, 30. The Géricault painting, *Lion couchant*, lent by Cottier & Co., is now in the Walters Art Gallery (WAG 37.882).

43. *Catalogue of the Works of Antoine-Louis Barye Exhibited at the American Art Galleries, 6 East Twenty-third Street, New York,* under the auspices of the Barye Monument Association Press of J. J. Little & Co. (New York, 1889). Charles De Kay wrote "Antoine-Louis Barye," *Century Magazine* 31, no. 4 (1886): 483–500, and *Barye: Life and Works of Antoine-Louis Barye, Sculptor, with Eighty-six Wood-cuts, Artotypes, and Prints in Memory of an Exhibition of His Bronzes, Paintings, and Watercolors Held at New York in Aid of the Fund for His Monument at Paris* (New York, 1889) (souvenir edition of 525 copies).

44. Norma Levarie, *The Art and History of Books* (New York, 1982), 280.

45. Charles Du Haÿs, *The Percheron Horse — Translated from the French of Charles Du Haÿs* (New York, 1886).

46. Dorothy Miner, "The Publishing Ventures of a Victorian Connoisseur:

A Sidelight on William T. Walters," *Papers of the Bibliographical Society of America* 57 (3d quarter, 1963): 278.

47. For Richard B. Gruelle (1851–1914) as a landscape painter, see J. V. Newton, *The Hoosier Group: Five American Artists* (Indianapolis, 1985), 139–150. For Gruelle's relationship with W. T. Walters, see pp. 140–141. *Modern Art* was first published in Indianapolis in January 1893. In the winter of 1895, Louis Prang of Boston undertook its publication, and its last issue appeared in the winter of 1897.

48. A unique copy of R. B. Gruelle, *Notes Critical and Biographical: Collection of W. T. Walters* (Indianapolis, 1895), was illuminated for the Walters family by Bowles's wife, Janet Payne (W. Scott Braznell, "The Metalcraft and Jewelry of Janet Payne Bowles," in B. Shifman, *The Arts and Crafts Metalwork of Janet Payne Bowles* [Indianapolis, 1993], 48).

49. Stephen Wootten Bushell (1844–1908) had prepared a translation of the *T'ao Shuo* and the *Ching-te chen T'ao Lu*. After the Walters publication, Bushell catalogued the J. P. Morgan collection of Chinese porcelains (1907) and published a history of Chinese art for the Victoria and Albert Museum (1919).

50. Charles Webster's extreme jealousy of Clemens had discouraged him from supporting the latter's proposal (C. Neider, *The Autobiography of Mark Twain* [New York, 1960], 285).

51. Louis Prang, "Color Lithography," in *Transactions of the Grolier Club of the City of New York,* pt. 3 (New York, 1899), 193–194.

52. Ruth Irwin Weidner proposed that the Callowhills working in Baltimore included James (1838–1917) and his sons James Clarence (1865–1927), Sidney (1867–1939), and Percy (1873–c. 1955). See "The Callowhills, Anglo-American Artists: An Introduction," *American Ceramic Circle* 10 (1997): 4–30.

53. *Oriental Ceramic Art: Illustrated by Examples from the Collection of W. T. Walters, with 116 Plates in Colors and Over 400 Reproductions in Black and White — Text and Notes by S. W. Bushell, M.D., Physician to H.B.M. Legation, Peking* (New York, 1897); *Oriental Ceramic Art: Collection of W. T. Walters,* text edition to accompany the complete work (New York, 1899).

54. It had been a family policy not to lend pictures from the gallery (Harry Walters to Florence N. Levy, June 1, 1895, Archives of American Art, 208W00, Washington, D.C.). William Walters, along with Brayton Ives and William Rockefeller, did, however, participate in an exhibition of Japanese art held at the Union League Club in 1889. Walters's contribution was an articulated bronze lobster made by the eighteenth-century artist Moriyoshi (*Art Amateur* 20, no. 6 [1889]: 123). During the same year, Walters participated in an exhibition of Chinese blue-and-white porcelains, also held at this club. William Walters's gift of Japanese swords to the Metropolitan Museum is referenced in an unidentified newspaper clipping dated March 14, 1891 (WAG Archives).

55. For Helen Warren Sears's recollection of visiting the collection with her

class from the Pennsylvania Academy of Fine Arts on February 5, 1886, see *Baltimore Sun,* January 1, 1950. Preceding the spring opening of the collection in 1893, Walters held a reception for artists, critics, and connoisseurs (*Philadelphia Ledger,* January 31, 1893, clipping in WAG Archives). Among the published accounts of visits to the collection are E. Durand-Greville, "La peinture aux États-Unis," *Gazette des Beaux-Arts,* series 2, 36 (July 1887), 65–75; (September 1887), 250–255; Alfred Matthews, "The Walters Collection at Baltimore," *Magazine of Western History* 10, no. 1 (May 1889): 1–16; and M. J. R. N. Lamb, "The Walters Collection of Art Treasures: Its History and Educational Importance," *Magazine of American History* 27, no. 4 (1892): 241–264. Joseph Jefferson IV visited the collection accompanied by his son Willie and the Boston architect Charles H. Waller (Francis Wilson, *Joseph Jefferson* [New York, 1900], 223–231). He praised the Millet and contrasted the Barbizon artist with Breton (225).

56. *Harper's Weekly,* December 1, 1894, 1138.

57. By 1891 the Rinehart estate had grown from $38,000 to $95,000. The fund was managed by W. T. Walters (chairman), Daniel C. Gilman, and Thomas W. Hall. The Rinehart scholarships began to be awarded in 1896.

58. For Walters's contributions to Goucher College and the Johns Hopkins University, see *Baltimore Sun,* November 23, 1894.

59. Quotation on Walters's expression is from the *New York Recorder,* undated clipping, WAG Archives. Blanchard Randall recalled visiting his neighbor William Walters, who was laid up with gout (*Baltimore Sunday Sun,* November 15, 1942). The reconciliation between Jennie and her father took place during a visit to Baltimore on April 4, 1894 (Warren Delano's diary, manuscript, family collection). The account of William's last days is based on Laura Delano's reminiscences as conveyed to Dorothy Miner and repeated to the author.

60. Nannie Newcomer (1855–1901) was the second of four daughters of Benjamin and Amelia Newcomer. In 1881, she married a lawyer, Frederick Home Hack. Correspondence of both William and Harry Walters with Nannie Newcomer has been preserved by Mrs. William Cattell Trimble, Mrs. Hack's granddaughter.

61. *Baltimore Sun,* November 23, 1894; *Baltimore American,* November 23, 1894.

62. Honorary pallbearers included Senator J. Donald Cameron of Pennsylvania; railroad executives General Grenville M. Dodge, C. M. McGhee of Tennessee, F. R. Scott, and H. B. Plant; Samuel P. Avery, William M. Laffan, and Henry G. Marquand (president of the Metropolitan Museum of Art), all three of New York; and local residents Dr. Daniel C. Gilman, Dr. S. C. Chew, J. P. McCay, Francis White, Thomas W. Hall, Enoch Pratt, Henry James, and Michael Jenkins (*Baltimore Sun,* November 25, 1894). In the register of Grace Church (now Grace and St. Peter's Episcopal Church), 707 Park Avenue, William T. Walters is listed as baptized but not confirmed (pp. 452–453). The

officiating priest was Authur Chilton Powell. Burial at Greenmount Cemetery was in lot nos. 36–37, area J. Also buried in the vault are the remains of Ellen Walters, William T. Walters Jr., Betsey Anthony, Harriette M. Clark, and Henry Walters.

63. For the Atlantic Coast Line's plans to drape its depots and locomotives in black, see *Baltimore Sun*, November 24, 1894. Nicholson's poem of five stanzas appeared in *Modern Art* 3, no. 1 (1895): n.p.

64. Walters said that "money was so tight — even the railway hands might lose their little earnings, and I could not desert my working people even for a day" (*Baltimore American*, November 23, 1894).

65. William Walters's obituary appeared in the *New York Times*, November 26, 1894. The comments on his taciturnity are those of Meredith Janvier ("The Walters," unidentified clipping dated June 1936, Enoch Pratt Free Library vertical files). George Davis was former attorney general of the Confederacy; for his comments on Walters, see H. G. Connor, *George Davis* (Wilmington, 1911), 37, Davis-Walker Papers, Southern Historical Collection, University of North Carolina, Chapel Hill.

66. The appraised value of the estate, $4,537,480.56, was published in the *New York Times*, February 21, 1895. The art collection was listed as follows: art gallery, $150,000; bridge room, $4,000; watercolor gallery, $4,000, and porcelain gallery, $30,000.

67. The reference to the proposed museum in the Thomas mansion appeared under "A Project Which Failed" in William Walters's obituary, *Baltimore Sun*, November 24, 1894.

68. The will dated May 13, 1874, was filed for probate in Orphan's Court, Towson, Baltimore County, on December 2, 1894, and the codicil repudiating it, dated March 2, 1883, was entered January 2, 1895. By the codicil Jennie was left $100,000 outright and a trust of $100,000 at the Safe Deposit and Trust Co.

Chapter Five: The Son Succeeds His Father, 1894–1909

1. The author is indebted to Henry Walters's relatives, Sara D. Redmond (niece) and Frederick B. Adams (great-nephew), for their recollections of Henry Walters. William Rand Kenan Jr. described Walters as "a wonderful executive with natural business ability" and as possessing "a remarkable legal mind although he never took any course in law" (*Incidents by the Way*, privately printed, St. Augustine, Fla., 1946, 42).

2. As early as 1866–67, William T. Walters & Co. had placed an advertisement for Baker's Rye Whiskey in *Smaw's Wilmington Directory* (Wilmington, N.C., 1867), 4. Henry Walters owned two lots with a cottage in Ocean View, adjoining the Carolina Yacht Club (Wrightsville Beach Property of the Wilmington Sea Coast Railroad Co., 1892, map). The cottage was "swept off the face of the earth" during a storm in 1899 (*Wilmington Messenger*, November 3, 1899).

3. Robert R. Bridgers's comments regarding North Carolina cooking were recorded by Meredith Janvier ("The Walters," unidentified clipping, Enoch Pratt Free Library vertical files). L. P. Hall mentioned several Venetian views in the restaurant. These could have been the work of Félix Ziem (Hall, *Land of the Golden River: Historical Events and Stories of Southeastern North Carolina and the Lower Cape Fear* [Wilmington, N.C., 1975], 2, 179–180).

4. Sarah Wharton Green (1859–1942) matriculated at Notre Dame College of Baltimore in 1877 and married Pembroke Jones on October 27, 1884. Her father was the proprietor of Tokay Vineyard, one of the South's largest wine-growing estates. Green ran for office on an antiprohibitionist ticket (W. E. Campbell, *Across Fortune's Tracks: A Biography of William Rand Kenan Jr.* [Chapel Hill, N.C., 1996], 29, 41). "Keeping Up with the Joneses" was the title of a comic strip drawn by Arthur R. Momand for the *New York Globe* from 1913 to 1931.

5. Pembroke Jones Jr. (1858–1919) was the son of an officer who had served on the *Raleigh,* a Confederate ironclad that broke the federal blockade of Cape Fear. He served as president of the Carolina Yacht Club from 1884 to 1886. He became a junior partner in the Carolina Rice Mills and later was involved with Alexander Sprunt & Co. In 1889, he was listed with Norwood Giles & Co., a naval stores and cotton broker. From 1890 to 1906, Jones headed the Standard Rice Co. W. E. Campbell characterized Jones as a "bisexual dandy" (*Across Fortune's Tracks,* 41).

6. Henry Walters and the Pembroke Joneses were regarded by their contemporaries as being a *menage à trois.* Although Henry seems to have been a constant guest of the Joneses, the author knows of no documentation pertaining to the relationships among the three individuals.

7. William Rand Kenan Jr. (1872–1965) recalled Henry Walters's close ties to his family and mentioned the Australian experience (*Incidents* 41–44, 122–123).

8. For a witty, somewhat misleading account of Flagler's courtship of Mary Lily Kenan, see Elizabeth Drexel Lehr, *King Lehr and the Gilded Age, with Extracts from the Locked Diary of Henry Lehr* (London, 1935), 158–160. Flagler wrote to Henry Walters on July 18, 1890, informing him of Mary Lily's visit to St. Augustine (archives of the Henry Morrison Flagler Museum, Palm Beach). For Flagler's divorce from Ida Alice Shrouds and his marriage to Mary Lily, see David Leon Chandler with Mary Voelz Chandler, *The Binghams of Louisville* (New York, 1987), 87–98. Flagler's invitation to Walters was extended on December 3, 1901 (archives of the Henry Morrison Flagler Museum, Palm Beach).

9. For Flagler's death and Mary Lily's subsequent marriage to her early admirer, see Chandler and Chandler, *The Binghams,* 99–157. Also outlined in this source are Mary Lily's death from heart failure and possible morphine poisoning and the settlement of her estate.

10. By 1903, Henry Walters's address in the *Social Register* was the same as

the Pembroke Joneses', 13 West Fifty-first Street. Walters wrote to Sara Delano from the Cloisters in Newport, Rhode Island, on July 15, 1899 (WAG Archives). In a conversation with the author (December 1997), Sheila Perkins recalled the shoe episode during her visit to Mrs. Jones.

11. Henry Walters joined the Ardsley Piping Rock Club, Atlantic Yacht Club, Automobile Club of America, Baltimore Club, Brook Club, Cape Fear Club (Wilmington, N.C.), Charcoal Club (Baltimore), City Midday Club, Colony Club, Eastern Yacht Club (Boston), Elk-Ridge Fox Hunting Club (Baltimore), Grolier Club, Jekyl Island Club, Larchmont Club, Maryland Club, Metropolitan Club, New York Yacht Club, Racquet and Tennis Club, Royal Mersey Club (Liverpool), Seawanhaka Corinthian Yacht Club, Sleepy Hollow Club, Tuxedo Club, Union Club, University Club (Baltimore), Westminster Kennel Club, Yeoman's Hall (Charleston), and Zodiac Club. Walters, however, was not a member of J. Pierpont Morgan's Corsair Dining Club, an organization composed solely of yachting companions.

12. See *Records of the Zodiac Club as They Appear in the Minute Books,* privately printed (New York, 1916).

13. John Lysaght ordered the *Narada* in 1889 from the firm of Ramage and Ferguson, Leith, Scotland, the leading producer of such vessels (Erik Hoffman, *The Steam Yachts: An Era of Elegence* [New York, 1970], 64–65). It initially was named the *Semiramis*. In 1893, Mme. Le Baudy of Paris acquired it as a scientific cruiser for her son Max, who is said to have taken one look at it and decided that he preferred to remain in Paris. Anthony J. Drexel of Philadelphia bought the yacht in 1894 and renamed it the *Marguerita*. Contrary to published accounts, Walters purchased the vessel in 1896, not 1899 (see "Mr. Walters Buys the *Margarita,*" *New York Times,* March 25, 1896). The name *Narada* may refer to the Indic mystical seer in the *Atharvaveda* (Arthur Anthony MacDonell and Arthur Barriedale Keith, *Vedic Index of Names and Subjects* [London, 1912], 1:445).

14. Dudley Aldrich Brand (1852–1920) served as skipper for the yacht when it was owned by A. J. Drexel and remained with her until forced by ill health to retire in 1914 (Dorothy B. Carvey, Brand's granddaughter, to W. R. Johnston, February 27, 1995). The only document pertaining to the visit to Egypt is a *laissez-passer* dated April 5, 1898, and signed by Emile Brugsch, Service de Conservation des Antiquités de l'Egypt (WAG Archives).

15. Warren Delano provided an account of the cruise to St. Petersburg in his diary, May 3 to September 14, 1900 (manuscript owned by family descendants). Princess Cantacuzene alluded to beginning her honeymoon on the *Narada* in *My Life Here and There* (New York, 1921), 205. Henry Walters's purchases of the parasol handles and carved enamels are discussed in M. C. Ross, *Peter Carl Fabergé, 1846–1920* (Baltimore, 1952), 1–3.

16. See Cornelius Vanderbilt Jr., *Queen of the Golden Age: The Fabulous Story of Grace Wilson Vanderbilt* (New York, 1956), 194–195.

17. A deluxe catalogue entitled *Description of Mr. Henry Walters Collection of*

Oriental Royal Arms, etc., etc., 1903 (manuscript) was compiled and presented to the purchaser by R. S. Pardo. The writer praised the "remarkable intuition and knowledge" displayed by Sadie Jones in guiding Henry Walters's selection. The water pipe consists of a Chinese, K'ang-hsi blue-and-white bottle mounted in Indian nineteenth-century brass openwork and set with semiprecious stones (WAG 49.2199).

18. Pembroke Jones to Jennie Delano, June 5, 1905, Franklin D. Roosevelt Library, Hyde Park, N.Y.

19. A syndicate comprising August Belmont, James Stillman, Oliver H. Page, Henry Walters, and W. Baker Duncan Jr. was building a defender, the *Constitution,* for the 1901 races (*Baltimore Sun,* November 22, 1900). For the race see Melissa H. Harrington, *The New York Yacht Club, 1844–1994* (Lyme, Conn., 1994), 54–55.

20. Cornelius Vanderbilt headed the syndicate that built the *Reliance,* which included Oliver Iselin, William Rockefeller, P. A. B. Widener, Elbert H. Gary, Clement A. Griscom, James J. Hill, W. B. Leeds, Norman B. Ream, and Henry Walters.

21. The 1906 tour is documented in an album of photographs taken by Laura Delano (WAG Archives). Writing to George Lucas on July 10, 1906 (photocopy, WAG Archives), Walters mentioned the Hotchkiss and the proposed purchase of a Mercedes.

22. See Lehr, *King Lehr.*

23. For the transformation of Friedheim into Sherwood, see *Town and Country,* September 19, 1908, frontispiece, 13–15. It was undertaken in two phases, 1904–5 and 1914–16.

24. Consuelo Vanderbilt Balsan discussed the reluctance of her husband, the ninth Duke of Marlborough, to sail with Pembroke (*The Glitter and the Gold* [Scranton, 1952], 49.

25. Lehr, *King Lehr,* 138. The extent of Sadie's entertaining can be surmised from an announcement in the *Baltimore Sun* of July 16, 1902, that she would be giving dinner parties on July 18, on July 29, and on every Friday in August except August 8.

26. The account of Henry Walters's party on the *Narada* appeared in the *Baltimore Sun,* August 3, 1903.

27. Hall, *Land of the Golden River,* 1:3–14; Anne Russell, *Wilmington: A Pictorial History* (Wilmington, N.C., 1981), 20.

28. Emma Woodward MacMillan recalled the Christmas parties at Airlie in *Wilmington: Vanished Homes and Buildings* (Raleigh, 1966), 84–85. Quotations are from Emma Woodward MacMillan, *A Goodly Heritage* (Wilmington, N.C., 1961), 84.

29. Samuel Howe, ed., *American Country Houses of Today* (New York, 1915), 157–164.

30. Hall, *Land of the Golden River* (Wilmington, N.C., 1975), 1:25–31.

31. Henry Walters maintained W. T. Walters & Co. as an office to manage

his affairs. It was located at 16 Chamber of Commerce until the fire of 1904 and then moved to 29 Abell Building. A caretaker with his family continued to live in the Mount Vernon Place residence. After many years of service, Jacob Sanders retired from this position in 1934.

32. Thomas Jenkins, father of Michael Jenkins (1848–1915), had been associated with William Walters in the development of both the Safe Deposit and Trust Co. and the Atlantic Coast Line. Michael Jenkins succeeded Benjamin Newcomer as president of the Safe Deposit and Trust Co. in 1901. He was a major Catholic philanthropist who helped found Catholic University of America and built Corpus Christi Church in Baltimore. As a result of this generosity, Pope Pius X appointed Jenkins and his wife Duke and Duchess of Llewellyn of the Holy Roman Empire.

33. *Baltimore Sun,* January 30, 1895 (clipping, WAG Archives). Henry also issued revised editions of the catalogue *The Walters Collection* in 1897, 1899, 1901, and 1903.

34. The author is indebted to Brian Harrington, archivist of the Johns Hopkins University, for the information regarding Henry Walters's contribution to the university. The professorship was established in 1904, and its first recipient was William Keith Brooks, who gained recognition for research in the field of marine biology, particularly regarding oysters (John C. French, *A History of the University Founded by Johns Hopkins* [Baltimore, 1946], 42).

In 1895, at the instigation of Arthur Bibbins, director of the museum of the Women's College, Henry Walters commissioned a series of sixty-three watercolors, of which only thirty-one were completed by Mayer's death in 1899. The commission presents a striking parallel to one given by W. T. Walters to Mayer's teacher, Alfred Jacob Miller, for watercolors of the annual fur-traders' rendezvous (see chap. 1). For the Mayer commission see *Baltimore Sun,* May 11, 1903.

35. The history of the Maryland Institute is outlined in Alon Bement, "The Maryland Institute," *Art and Archaeology* 19, nos. 5 and 6 (1925): 269–273. For Walters's intention to fireproof the building, see Henry Walters to George Lucas, March 19, 1905 (photocopy in WAG Archives).

36. The two Pissarros are *Path by the River (Village of la Varenne-Saint Hilaire),* 1864, and *The Versailles Road at Louveciennes (Snow),* 1870 (WAG 37.1989). Jongkind's *Moonlight on the Canal* is dated 1856. For Henry's assurance of the significance the collection to the institute, see Walters to Lucas, March 19, 1905 (WAG Archives). For his emphasis on fireproofing and safety, see Walters to Lucas, October 8, 1907 (photocopy, WAG Archives).

37. Michael Jenkins's letter written on behalf of Henry Walters, transferring the Lucas collection to the Maryland Institute and specifying Lucas's desires, and John M. Carter's letter of acceptance of the collection, both dated May 9, 1910, were published in the *Baltimore American,* May 10, 1910. The Lucas collection was installed in the galleries of the Maryland Institute in 1910, where it remained until 1933, when concern for its safety led to its transfer to

the Baltimore Museum of Art. Five key works were relocated to the Walters Art Gallery in 1944. In September 1996, the trustees of the Walters Art Gallery, with the support of the state of Maryland, approved the purchase of the five works from the Lucas collection, and the remainder of the collection was bought by the Baltimore Museum of Art. The Walters additions were H. Daumier, *Ratapoil* (WAG 27.497), H. Daumier, *The Loge* (WAG 37.1988), Georges Michel, *Gathering Storm* (WAG 37.1991), Adolphe Monticelli, *Allegory* (WAG 37.1990), and Camille Pissarro, *The Versailles Road at Louveciennes (Snow)* (WAG 37.1989).

38. For Henry Walters's service on committees of the Charcoal Club and the Peabody Institute, see album of clippings of art notes by W. W. Brown, reporter for the *Baltimore News,* December 16, 1908, and March 20, 1909 (WAG Archives).

39. A. P. Proctor received a scholarship for study in Paris in 1895. Walters bought his *Buffalo* (WAG 28.15). The following year, the Rinehart School of Sculpture was founded as a department of the Maryland Institute. Among its first students was Hans Schuler (*Ariadne Deserted on the Island of Naxos,* WAG 28.6), who received a scholarship to enroll at the Académie Julian in Paris (W. S. Rusk, *William Henry Rinehart, Sculptor* [Baltimore, 1939], 83–94).

40. Quotations from H. L. Mencken, *Happy Days* (New York, 1940), 54–55. For Baltimore's sanitary conditions, see J. B. Crooks, *Politics and Progress: The Rise of Urban Progressivism in Baltimore, 1895–1911* (Baton Rouge, 1968), and *Annual Report of the Free Public Bath Commission of Baltimore for the Year Ending December 31, 1899* (Baltimore, 1900), 7.

41. For the Walters public baths, see Crooks, *Politics and Progress,* 183; *Annual Report of the Free Public Bath Commission for the Year 1900,* Baltimore, 1901; Anne Beadenkopf, "The Baltimore Public Baths and Their Founder, the Rev. Thomas M. Beadenkopf," *Maryland Historical Magazine* 45 (September 1950): 201–214; and W. R. Johnston, "The Walters Public Baths," *Bulletin of the Walters Art Gallery* 26, no. 8 (1974). The Public Bath System was abolished in 1960.

42. Lucia N. Valentine and Alan Valentine, *The American Academy in Rome, 1894–1969* (Charlottesville, Va., 1973), 28–41. The academy was an outgrowth of the American School of Architecture, opened in Rome in 1894 largely through the efforts of Charles Follen McKim. Although the $750,000 was not raised, Henry Walters nevertheless subscribed outright $50,000 the following year.

43. Quoted in ibid., 34–35.

44. Quotation from ibid., 36. In 1906 the American Academy in Rome was transferred from rented quarters in the Villa Aurora to the Villa Mirafiori, which it owned until 1914. In 1911 the academy was consolidated with the American School of Classical Studies in Rome. After visiting the Villa Aurelia on the Janiculum, which had recently been bequeathed to the academy by the

American heiress Mrs. Clara Jessup Heyland, J. P. Morgan backed the purchase of the surrounding land for the academy, and a building was designed by William M. Kendall of the firm of McKim, Mead and White. Russell Lynes, "A Perspective," in *Artisti di quattro accademie stranieri in Roma* (Rome, 1982), 95–100.

45. Morgan's son-in-law, Herbert L. Satterlee, recorded Morgan's early collecting (*J. Pierpont Morgan: An Intimate Portrait* [New York, 1940], 145). The glass fragments were eventually incorporated into the windows of the West Room of his library (146). Morgan regarded his purchase of a Thackeray manuscript in 1888 as the beginning of his serious collecting (247).

46. William M. Laffan wrote to Walters on May 2, 1903, conveying Morgan's hope that Walters would join him on the *Oceanic* (WAG Archives).

47. The only gifts to the Metropolitan Museum of Art listed in Walters's name during these years were of minor monetary value. They include a silver medallion of his father by Oscar Roty (1898) and a bronze medal of Charles William Eliot, president of Harvard University, by Léon Deschamps (1908).

48. Henry Walters to George A. Lucas, November 23, 1909 (photocopy, WAG Archives).

49. For his disdain for Theodore Roosevelt, see Henry Walters to George Lucas, October 16, 1908 (photocopy, WAG Archives). For the Hepburn Act see Mark Sullivan, *Our Times: The United States, 1900–1925* (New York, 1931), 3:190–276.

50. See K. A. Herr, *The Louisville and Nashville Railroad, 1850–1942* (Louisville, Ky., 1943), 96–100.

51. John W. Gates spent a rainy afternoon with a companion on a train betting which rain drops coursing down the window would reach the bottom first. Altogether, he wagered $1 million (F. L. Allen, *The Great Pierpont Morgan* [New York, 1949], 132–133).

52. James Jackson Jarves, "A Lesson for Merchant Princes," in *Italian Rambles: Studies of Life and Manners in New and Old Italy* (New York, 1883), 361–380; quotations on 379–380. D. A. Brown noted Jarves's exhortations to his fellow Americans in *Raphael in America* (Washington, D.C., 1983), 32.

53. On Henry Gurdon Marquand (1819–1902), see D. O. Kisluk-Grosheide, "The Marquand House," *Metropolitan Museum Journal* 29 (1994): 151–181. For Lambert, see F. Alaya, *Silk and Sandstone: The Story of Catholina Lambert and His Castle* (Paterson, N.J., 1984), n.p. For Isabella Stewart Gardner and John Pierpont Morgan, see D. A. Brown, *Raphael and America* (Washington, D.C., 1983), 32–35, and W. G. Constable, *Art Collecting in the United States of America* (London, 1964), 47–52, 108–112.

54. In 1884 the Archaeological Institute of America incorporated the Johns Hopkins Archaeological Society into its local chapter, the first founded anywhere (French, *A History of the University,* 47–48). None of the Near Eastern cylinder seals purchased from Dikran Kelekian in Chicago in 1893 have yet

been identified. The encounter between Walters and Kelekian in that year is mentioned in a letter from Charles D. Kelekian (the dealer's son) to Dorothy Kent Hill, February 12, 1975 (WAG Archives).

55. For Walters's attempts to buy the *Maiden of Antium,* Museo Nazionale Romano, Rome, inv. 50170, see Dorothy Kent Hill, "William T. Walters and Henry Walters," *Art in America* 32, no. 4 (1944): 186.

56. Walters to Lucas, November 23, 1909 (WAG Archives).

57. On May 24, 1903, William M. Laffan wrote to Walters from Aix-les-Bains: "Have you no stenographers? Must I be plagued with telegrams?" (WAG Archives).

58. Germain Seligman, *Merchants of Art, 1880–1960: Eighty Years of Professional Collecting* (New York, 1961), 134.

59. George Lucas maintained a ledger from 1895 to 1909 to record his transactions on behalf of Henry Walters. On June 28, 1898, he recorded a payment of 12,500 francs for the Barye *Lion Hunt* (WAG 27.174).

60. Francis Henry Taylor, "The Walters Gallery Revisited," *Parnassus* 6 and 7 (December 1934): 3–6, 31.

61. Delacroix's *Sketch for the Battle of Poitiers* (WAG 37.110) was acquired from Durand Ruel in New York for $8,000 in June 1899. Among the purchases at the Mrs. S. D. Warren sale on January 8, 1903, were Ingres's *The Betrothal of Raphael and the Niece of Cardinal Bibbiena* (WAG 37.13) and Perugino's *Madonna and Child* (WAG 37.475).

62. Luther Hamilton, "The Work of the Paris Impressionists in New York," *Cosmopolitan,* June 1886, 240. For early collecting of impressionism in the United States, see Han Huth, "Impressionists Come to America," *Gazette des Beaux-Arts,* 6th series, 29 (April 1946): 225–252.

63. Alfred Sisley, *The Terrace at Saint-Germain: Spring,* 1875 (WAG 37.992); Fritz Thaulow, *Village on the Bank of a Stream* (WAG 37.175) and *The Adige Bridge at Verona* (WAG 37.97).

64. Lucas recorded payment to Mary Cassatt of 25,000 francs for Claude Monet's *Springtime* (WAG 37.11), about 1872, and Edgar Degas's *Portrait of a Woman* (WAG 37.179), 1863–65 (L. M. C. Randall, *The Diary of George A. Lucas: An American Art Agent in Paris, 1857–1909* [Princeton, 1979] [hereafter *Lucas Diaries*], April 20, 1903, 2:913).

65. For Van Dyck's *Virgin and Child* (WAG 37.234), see Eric M. Zafran, *Fifty Old Master Paintings from the Walters Art Gallery* (Baltimore, 1988), 112–113. For the *Portrait of Prince Rupert* (WAG 37.233), see Edward S. King, "Whatever He Wills He Wills Vehemently," *Bulletin of the Walters Art Gallery,* March 1968, n.p. More recently, see Erik Larsen, *The Paintings of Anthony Van Dyck* (Freren, Netherlands, 1988), no. A146/2.

66. D. A. Brown examined the provenances of Raphael's paintings in this country in *Raphael in America* (Washington, D.C., 1983). In his diary (formerly in the collection of Sara D. Redmond), Warren Delano recorded Ichen-

hauser's arrival at Southampton on June 20, 1900. Sidney Edward Bouverie-Pusey, in a receipt of June 19, 1900, acknowledged payment of £4,000 pounds by J. D. Ichenhauser (WAG Archives).

67. For Murillo's *The Immaculate Conception* (WAG 37.286), see Zafran, *Fifty Old Master Paintings,* 82. Romney's *Portrait of Miss Matilda Lockwood* (WAG 37.226) was acquired for $7,900. The price of Nattier's *Portrait of the Marquise d'Argenson* (WAG 37.895) is not recorded.

68. For the Christofle & cie *Amphitrite* (WAG 71.444), see Richard H. Randall Jr., with Diana Buitron, Jeanny Vorys Canby, William R. Johnston, Andrew Oliver Jr., and Christian Theuerkauff, *Masterpieces of Ivory from the Walters Art Gallery* (Baltimore, 1985), no. 444, p. 302, pl. 91.

69. A clipping in the WAG curatorial files refers to the French Book of Hours (WAG W.236) as "671 One curious antique Manuscript on vellum, French, 14th century, 'Heures Gotique,' with five miniatures and seven frontispiece illuminated pages."

70. Valerius Maximus, *Libri factorum dictorumque memorabilium* (WAG 91.1214) was purchased on April 4, 1897, from George H. Richmond & Co., New York, for $350. The three Shakespeare folios were reported in "First Folio of Shakespeare Found in Walters Gallery," *Baltimore Sun,* May 1, 1934.

71. On March 5, 1907, Walters paid Francis Scott Key's granddaughter Mrs. Edward Shippen $2,500 for the manuscript, which he stored in his Baltimore business office until his death. According to Walters's widow, he intended his stepdaughter's husband John Russell Pope to design an appropriate building in which to display the manuscript. When Mrs. Walters sold the manuscript at auction in 1934, the Commission for the Walters Art Gallery purchased it for $24,000. Although he had been retained by the Walters Art Gallery to undertake the bidding at the sale, Dr. A. S. W. Rosenbach, seeking personal publicity, represented himself to the press as the buyer. In 1942, the manuscript was deaccessioned by the gallery and sold to the Maryland Historical Society for $24,000. Rosenbach's role is discussed by Edwin Wolf 2nd and John F. Fleming in *Rosenbach: A Biography* (Cleveland, 1960), 391–392.

72. Paul Culot examined Hoe's collection of bindings in "La Bibliothèque Robert Hoe: Source d'enrichissement de la collection de reliures de Mariemont," *Seventh International Congress of Bibliophiles* (Boston, 1971), 13–67.

73. Tiffany & Co., Iris Corsage Ornament (WAG 57.939), in *Jewelry Ancient to Modern* (Baltimore, 1979), no. 698, p. 243; J. Zapata, "The Rediscovery of Paulding Farnham, Tiffany's Designer Extraordinare. Part 1: Jewelry," *Magazine Antiques,* March 1991, 563–565, pls. 5 and 6. Tiffany and Co.'s ledger book records the sale of the iris brooch on March 17, 1900, for $6,906.84. The frog (WAG 42.288) is mentioned in a unidentified newspaper clipping (WAG Archives).

74. See René Lalique, *Pansy Brooch* (WAG 57.943), in *Jewelry Ancient to Modern,* no. 714, 247–255. An undated invoice, Office of the French Govern-

ment Commissioner of Fine Arts, lists eight items by Lalique for a total of $8,100. The *Pansy Brooch,* no. 32, cost $2,000. A ninth piece, the *Tiger Necklace* (WAG 57.938), was sold separately.

75. Rodin to Marcel Adam in *Gil Blas,* Paris, July 7, 1904, reprinted by Albert E. Elsen, *Rodin* (New York, 1963), 53.

76. Rodin's *Thinker* was sold to Henry Walters for 25,000 francs. In 1949, the trustees of the Walters Art Gallery withdrew the *Thinker* from the collection after Jacob Epstein's donation of a sand casting of the same subject to the Baltimore Museum of Art. The Walters cast was sold to the executors of the estate of Arthur E. Hopkins of Louisville, Ky., for $22,500. It now stands in front of the University of Louisville Administration Building (*Louisville Courier-Journal,* March 23, 1986).

77. The 1893 purchases of eggshell porcelains (WAG 49.2477 and 49.1627) are mentioned by E. R. Seidmore in "The Porcelain Artists of Japan," *Harper's Weekly,* January 22, 1893, 83–87, and *World's Columbian Exposition,* rev. catalogue, Department of Fine Arts (Chicago, 1893), sec. 3, p. 387. For Walters's purchases of ivory in Paris, see *Baltimore Sun,* September 15, 1900. The ivory figure of the woman by Meidō Asahi (WAG 71.707) and the bronze of the fisherman rescuing a young woman (WAG 54.1581) ascribed to Unno Bisei were published in *Bijutsu Gaho, Extra Issue No. 2 of Fine Arts Magazine* (Tokyo, Meiji 33, 1900), pl. 15, fig. 5; pl. 18, fig. 20. Unno Bisei (1864–1919) visited France in 1900, whereas Numata Ichiga (1873–1954), a sculptor in ceramics, taught at the Tokyo School of Fine Arts and at the Sèvres Porcelain Manufactory.

78. For the tapestry of Kawashima Jimbei II (WAG 82.25), see K. Emerson-Dell, "Beyond the Exotic: Reflections on Later Japanese Decorative Arts in the Walters Art Gallery," *Orientations* 22, no. 4 (1991): 46–47. For the flower vase by Miyagawa Kōzan (WAG 49.1912), see Kathleen Emerson-Dell, *Bridging East and West: Japanese Ceramics from the Kōzan Studio, Selections from the Perry Foundation* (Seattle, 1995), p. 13, fig. 9. Okazaki Sessei's urn is now the property of Towson State University, Towson, Md. Other items purchased at the Japanese section in 1904 include Yabu Meizan (1853–1934), Satsuma-style bowl (WAG 49.2280), and Akatsuka Jitoku (1871–1921), Lacquer box (Ryōshi-bako) (WAG 67.121).

79. Bunkio Matsuki (1867–1940) emigrated to the United States in 1882. He arrived in Boston with a letter of introduction from Edward Sylvester Morse and opened a store at 380 Boyleston Street (Lee Bruschke-Johnson, "Studies in Provenance: Japanese Wood Carvings and Sculpture from the Matsuki Sale of 1906," *Orientations* 22, no. 4 [1991]: 43–50).

80. See Bruschke-Johnson, "Studies in Provenance," figs. 3–6, for the carved Guardian Lion (WAG 61.182), the seventeenth-century temple doors (WAG 64.176/7), the statue of the Sacred Monk (WAG 61.267), and the *ramma* (WAG 64.172/3).

81. The Auguste F. Chamot Collection was sold at the American Art Galler-

ies on March 16, 1907. No. 76, the headdress (WAG 86.3), was said to have been worn by the Manchu Dowager Empress, Tsz'e Hsi.

82. Dikran Garabed Kelekian (1868–1951) is discussed by Fernand Beaucour in "Une rencontre à Baltimore [États-Unis] avec quatre statues de l'ancien Hôtel Dieu d'Abbeville," *Bulletin Trimestriel de la Société des Antiquaires de Picardie* (Amiens, 1985), 26–28. The letterhead for his invoices lists "faïences, velvets, embroideries, rugs, statuettes, oriental manuscripts, Greek and Roman coins and ancient jewels" (example dated November 28, 1898, WAG Archives). Because of his wealth and imposing appearance, he was known in Paris as the "Persian satrap" (Frank Crowninshield, preface for the exhibition, *Kelekian as the Artist Sees Him,* Durand-Ruel Galleries, New York, 1944, n.p.). The Kelekian invoices for 1897 listed 134 items (WAG Archives). The Koran (WAG W.563), which was originally thought to be Persian of the Timurid period and is now regarded as Indian, was listed on April 2, 1897, for $2,750.

83. For the Robert Garrett collection, now at Princeton University, and the Morris K. Jesup donation to Yale University, see Stephen Roman, *The Development of Islamic Library Collections in Western Europe and North America* (London, 1990), 219–225.

84. Dikran Kelekian published *The Potteries of Persia: Being a Brief History of the Art of Ceramics in the Near East* (Paris, 1909). The examples from the Havemeyer collection were given to the Metropolitan Museum of Art; Charles L. Freer's early-thirteenth-century bowl, bought in 1909, is now in the Freer Gallery of Art (09.130), and a fourteenth-century bottle belonging to the pioneer patron of the impressionists, Theodore M. Davis, is unlocated. The Walters examples included a plate, listed as "Koubatcha" (WAG 48.1031), which actually demonstrates the continued activity of the potters in Nishapur into the late fifteenth century; the mosque lamp listed as Rhodian (WAG 48.1301); and the two Hispano-Moresque plates (WAG 48.1300 and 1100). Kelekian's personal collection was published as *The Kelekian Collection of Persian and Analogous Potteries, 1885–1910* (Paris, 1910) before being offered to the Victoria and Albert Museum, London.

85. The Turkish tile (WAG 48.1307) was purchased on April 7, 1897, for $125. In an addendum to the invoice, Kelekian assured Walters that it had been taken from the Hirka-i Saadet Dairesi.

86. *The Forman Collection: Catalogue of Egyptian, Greek, and Roman Antiquities,* Sotheby's Wilkinson & Hodge, London, June 19, 1899.

87. The Marlborough gems were purchased *en bloc* in the 1880s by David Bromilow, whose heir, Mrs. Jary, placed them for auction at Christie's, Manson and Woods, on June 26, 1894; £34,827 were realized. For Henry Walters's purchases see Dorothy Kent Hill, "From Venuti and Winckelmann to Walters," *Apollo,* August 1975, 100–103, and Diane Scarisbrick, "Henry Walters and the Marlborough Gems," *Journal of the Walters Art Gallery* 39 (1941): 49–58. Subsequently, Walters regretted not having taken full advantage of the sale

and, in a letter to Maskelyne dated August 16, 1901, he expressed his disappointment in his purchases and referred to Kelekian as "a quasi-expert in gems" (Scarisbrick, "Henry Walters and the Marlborough Gems," 49).

88. In an interview with Richard H. Randall Jr. and Jenny Vorys Canby in 1970, Charles D. Kelekian, Dikran's son, recalled his father overlooking the dealers' shoulders. Etienne Bertrand of the firm of Brimo de Laroussilhe mentioned the close relationships of the dealers who had left Constantinople for Paris in a letter to W. R. Johnston on January 20, 1996.

89. For the history of the Seligmann firm, see Seligman, *Merchants of Art.* The earliest invoice made out to Walters for the firm, dated April 19, 1902, lists six enamels and six watches. Among them is the pair of Reymond salts (Philippe Verdier, *Catalogue of the Painted Enamels of the Renaissance* [Baltimore, 1976], 223–226, cat. nos. 134–135). From his quarters at 42 West Forty-third Street, New York, Emile Rey wrote to Henry Walters on November 3, 1902, sending several auction catalogues (WAG Archives). As of 1904, Seligmann & Co. was at 303 Fifth Avenue.

90. Léon Gruel's role in the formation of the Walters collection is described by Lilian M. C. Randall, *Medieval and Renaissance Manuscripts in the Walters Art Gallery* (Baltimore, 1989), 1:xii, and by Elizabeth Burin, "Henry Walters," *Dictionary of Literary Biography* (Detroit, 1994), 140 ("American Book-Collectors and Bibliographers," 1st series, ed. Joseph Rosenblum, 297–303). E. Terquem served as Gruel's representative in Chicago in 1893 (see *Catalogue des relivres des style et objets artistiques . . . Exposés par Léon Gruel* [Paris, 1893]). Lucas paid Gruel's bill for binding two Grolier volumes for Henry Walters in 1896 (*Lucas Diaries,* September 26, 1896, 2:834).

91. Of the 123,840.60 francs paid out in 1900, 87,780 francs went to Gruel. In 1902, 163,083 francs were paid to the bookseller (Lucas's ledger listing transactions on behalf of Henry Walters).

92. For the tenth-century Gospel Book (WAG W.3) and the Missal (WAG W.302) listed on Gruel's invoice of June 9, 1903 (WAG Archives), see Randall, *Medieval and Renaissance Manuscripts,* vol. 1: cat. no. 3, and vol. 2: pt. 1, cat. no. 110.

93. For Olschki see Bernard M. Rosenthal, "Cartel, Clan or Dynasty? The Olschkis and the Rosenthals, 1859–1976," *Harvard University Bulletin* 25, no. 4 (1977): 386–397.

94. Olschki introduced himself to Walters in a letter of January 4, 1904 (WAG Archives). The chronicle (Jean Mansel, *La Fleur des Histoires* [WAG W.305]) was bought on March 5, 1904, for 10,000 lire (receipt, WAG Archives).

95. For the purchase of incunabula, see Rosenthal, "Cartel, Clan or Dynasty?" 395. At the Franz Trau sale, Gilhofer and Ranschburg, Vienna, October 27 and 28, no. 164, *Blockbook of the Apocalyptic Visions of St. John,* Augsburg, c. 1445–60, and no. 165, *Biblia Pauperum,* Nordlingen, 1470, were acquired.

96. *Incunabula Typographica: A Descriptive Catalogue of the Books Printed in*

the Fifteenth Century (1460–1500) in the Library of Henry Walters (Baltimore, 1906), binding by Legatoria C. Tartagli & Fo. via Cavour, Rome.

97. For the Conradin Bible (WAG W.152), see Dorothy Miner, "Since De Ricci: Western Illuminated Manuscripts Acquired since 1934," *Journal of the Walters Art Gallery* 31–32 (1968–69): 87–92, and Rebecca W. Corrie, "The Conradin Bible since De Ricci," *Journal of the Walters Art Gallery* 40 (1982): 13–24.

98. Russell Sturgis to General Charles G. Loring, New York, April 7, 1899 (curatorial files, Museum of Fine Arts, Boston, Mass.). Among the ivories tentatively identified as coming from Ongania in 1899 were a book pendant (WAG 71.351), two Venetian wedding mirrors attributed to the Embriachi workshop (one is WAG 71.92), and a late-nineteenth-century Renaissance-style mortar and pestle (WAG 71.380a–b). For the dedication, see Ferdinand Ongania, *A Glance at the Grimani Breviary Preserved in St. Mark's Library, Venice* (Venice, 1906).

99. For Fabergé's visit to Harding's, see H. C. Bainbridge, *Twice Seven* (New York, n.d.), 183. The George R. Harding invoice of June 30, 1899 (WAG Archives), listed the iron tabernacle door (WAG 52.103); a Limoges enamel casket, probably by Jehann Limousin (unlocated); a steel lock and key, French, about 1630 (WAG 57.172a–b); and an antique bronze figure of a gladiator (unlocated).

100. For Jean de Court and the history of the enameled platter (WAG 44.207), see Philippe Verdier, *Catalogue of the Painted Enamels of the Renaissance* (Baltimore 1967), xxv–xxvi, 306–308.

101. The *Vierge ouvrante de Boubon* (WAG 71.152) is one of several ivories that open to reveal scenes from the Passion and Resurrection of Christ. (Others are in museums in Paris [the Louvre], Rouen, and Lyons.) The post-revolutionary history of the piece was published by Magdeleine and René Blancher, *Recherches sur la Vierge de Boubon* (Paris, 1972). Scholars remain divided regarding the authenticity of all the Vierges ouvrantes. William M. Laffan wrote to Walters on July 5, 1902 (WAG Archives), regarding Morgan's interest in the ivory that was sold in the Sir Thomas Gibson-Carmichael sale, Christie's, London, May 12, 1902, lot 20. Most recently, Richard H. Randall Jr. discussed the ivory within the context of eighteenth-century ivory carving (*Images in Ivory: Precious Objects of the Gothic Age*, Detroit Institute of Arts in association with Princeton University Press [Princeton, N.J., 1997], no. 83, 285–289).

102. K. Bædeker noted that the torture instruments could be viewed for a payment of twelve kroner (*Southern Germany and Austria, Including the Eastern Alps* [Coblenz, 1873], 53). The *Illustrated Catalogue of the Historical and World-Renowned Collection of Instruments of Torture Removed from the Royal Castle of Nuremberg Lent by the Rt. Hon., the Earl of Shrewsbury and Talbot* (London, n.d.), announcing the exhibition of the instruments at Ichenhauser's Maddox Street Galleries, appeared in several editions.

103. The Iron Maiden is questioned by G. Baethcke in "Die eiserne Jung-frau von Georgenthal," *Mitteilungen der Vereinigung für Gothaische Geschichte und Altertumsforschung* (Gotha, Germany, 1907), 1–13.

104. *Opinions of the Press on the Exhibition of the Famous and Historical Collec-tion of Instruments of Torture from the Royal Castle of Nuremberg, Lent by the Earl of Shrewsbury and Talbot* (London, 1892), was compiled by Julius Ichenhauser (WAG curatorial files).

105. The British edition of the catalogue of the collection, as it appeared at Ichenhauser's Maddox Street Galleries in London, was reprinted for the New York showing in 1893. For the torture instruments see Julian Hawthorne, "Salvation via the Rack," *Cosmopolitan* 18, no. 4 (1895): 482–490. A letter from Ichenhauser to Walters confirms the purchase of the collection (Febru-ary 8, 1905, WAG Archives).

106. C. Morgan Marshall reported to the Walters Art Gallery Commission that Henry Walters had once confided to him that he did not think highly of the Nuremberg collection (minutes of the meeting, November 5, 1932). In 1964, the Nuremberg collection, apart from a few items including execu-tioners' swords and branks, was deaccessioned by the trustees of the Walters Art Gallery.

107. Although Walters occasionally purchased collections *en bloc,* this prac-tice was most frequently associated with J. Pierpont Morgan. In 1906, for example, Morgan purchased the first collection of decorative arts and medi-eval art formed by Georges Hoentschel, a Parisian *architecte décorateur,* and launched the Decorative Arts Department at the Metropolitan Museum of Art.

108. Quotation from James H. Duveen, *The Rise of the House of Duveen* (New York, 1957), 187. Obituaries for Don Marcello Massarenti (Budrio, 1817–Rome, 1905) appeared in *Il Giornale d'Italia,* October 25, 1905, and in *L'Italie,* Rome, October 26, 1905. Wilhelm von Bode published his recollec-tions of Massarenti in *Mein Leben* (Berlin, 1930), 1:36.

109. The earliest publication of the Massarenti collection is *Catalogue d'une collection des tableaux de diverses écoles spécialement des écoles italiennes* (Rome, 1881). It begins with a brief preface by Prof. Alt and a testimonial letter by Otto Donner, director of the Archaeological Society of Frankfurt.

110. Bartolommeo Nogara quoted Massarenti's servant, Enrico Santi, list-ing Massarenti's dealers (Nogara to Dr. Regina Soria, October 20, 1936).

111. *Catalogue du musée de peinture, sculpture et archéologie au palais Accoram-boni* . . . (Rome, 1897), xv. The introduction to the first part is by Edouard van Esbroeck, and that to the second is by authors known only as *U.e M.P.* A *Supplément au catalogue du Musée* . . . listing ninety-eight works was published in Rome in 1900. E. S. King discussed a now unlocated letter from Henry Walters to J. C. Anderson of January 18, 1922, and stated that all of the works listed in the *Supplément* were from the collection of the Marquis Marignoli (King to Ann T. Lurie, January 7, 1970, WAG Archives).

112. J. H. Duveen, *The Rise of the House of Duveen* (New York, 1957), 187.

113. No. 43, Margaritone d'Arezzo, *Le Christ en Croix* (WAG 37.710); no. 1, *La Vierge* (WAG 37.1155); and no. 121, Pinturicchio, *Architecture avec figures* (WAG 37.677) were published by Federico Zeri in *Italian Paintings in the Walters Art Gallery* (Baltimore, 1976), vol. 1: no. 2, pp. 4 and 5; no. 1, pp. 3 and 4, and no. 96, pp. 143–151. John Denison Champlin Jr. and Charles C. Perkins characterized Margaritone as a follower of the Byzantine school (*Cyclopedia of Painters and Paintings* [New York, 1887], 3:196–197). A. Crowe and G. B. Cavalcaselle discussed Margaritone in *A History of Painting in Italy*, ed. Langton Douglas and S. Arthur Strong [London, 1903], 1:165–168.

114. The paintings formerly attributed to Paul Bril (WAG 37.656) and Gerard van Honthorst (WAG 37.653) were published in Zafran, *Fifty Old Master Paintings*, no. 37, pp. 96–99, and no. 45, pp. 116. More recently, the Heemskerk appeared in *Fiamminghi à Roma, 1508–1608*, Palais des Beaux-Arts (Brussels, 1995), no. 111.

115. For the Roman sarcophagi (WAG 23.29, 23.31–33, 23.35–37), see Karl Lehman-Hartleben and Erling C. Olsen, *Dionysiac Sarcophagi in Baltimore* (Baltimore, 1942); Vagn Häger Poulsen, "A Note on the Licinian Tomb," *Journal of the Walters Art Gallery* 11 (1948): 9–13; and Katherine M. Bentz, "Rediscovering the Licinian Tomb," *Journal of the Walters Art Gallery* 55/56 (1997–98): 63–88.

116. For Clemente Maraini and Massarenti, see Margherita Guarducci, "La cosidetta fibula prenestina, antiquari, eruditi e falsari nella Roma dell' ottocento," *Atti della Accademia nazionale dei Lincei-Memorie classe di Scienze Morali Storiche e filologiche*, suppl. 8, vol. 28 (1984): fasc. 2, 168.

117. For the bronze imperial portraits (WAG 23.105, 23.190), see Dorothy Kent Hill, "A Cache of Bronze Portraits of the Julio-Claudians," *American Journal of Archaeology* 43 (1939): 401–409.

118. For the horse head and sword and sheath (WAG 54.759, 54.761), see Dorothy Kent Hill, *Catalogue of Classical Bronze Sculpture* (Baltimore, 1949), 6–7, nos. 10 and 10a.

119. For the cistae from Praeneste (WAG 54.132, 134, 136), see Dorothy Kent Hill, "Two Bronze Cistae from Praeneste," *Journal of the Walters Art Gallery* 35 (1977): 1–14. The Etruscan bucchero are archived as WAG 48.436–438.

120. The bronze box (WAG 54.2235) is listed in *Catalogue du musée de peintre, sculpture et archéologie*, pt. 2, p. 28, no. 148. The two plaques from San Clemente a Casauria (WAG 54.1057–58) were listed separately in the catalogue as no. 63 in the antiquities section and as no. 296 in the Renaissance section. See Konrad Hoffman, *The Year 1200: A Centennial Exhibition at the Metropolitan Museum of Art* (New York, 1970), 1:126–127, no. 130.

121. Dr. Joseph Henry Senner (1848–1908) received a degree in law and then emigrated from Austria to the United States in 1880. He served as the foreign editor of the *New Yorker Staats Zeitung* from 1885 to 1893 and as U.S. commissioner for immigration in New York from 1893 to 1897.

122. William Mackay Laffan (1848–1909), a journalist and art connoisseur, was educated in his native Dublin and emigrated to America, settling in Baltimore in 1870, where he became a reporter for and editor of the *Evening Bulletin*. In 1877, he moved to New York to work for the *New York Sun*, becoming its publisher in 1884 and its proprietor in 1902. Although his field of connoisseurship was Chinese porcelains, his interests in art varied. He served as an advisor to both Henry Walters and J. Pierpont Morgan. After Morgan's donation of the James A. Garland collection of Chinese porcelains to the Metropolitan Museum of Art in 1902, Laffan shared responsibility with Stephen Bushell for the publication of a catalogue. For Laffan's obituary and funeral, see *New York Times*, November 20 and 23, 1909. M. Sullivan intimated that Laffan had acquired control of the *New York Sun* with J. P. Morgan's financial backing (*Our Times*, 236).

123. Henry Walters reached Paris on April 2, 1902, and examined the gate from the choir screen of Troyes cathedral (*Lucas Diaries*, April 3, 1902, 2:897). He remained in town until at least April 4 (*Lucas Diaries*, 2:897) and subsequently signed the contract in Rome on April 16.

124. A transcription of the contract is preserved in the Walters Archives. According to the press Venturi's eliminations included a Raphael *Self-Portrait*, a Giorgione, and the Philippe de Champaigne. In actuality, no. 132, Raphael Sanzio, *Portrait de Raphael*, was sold with the collection, and only no. 385, Le Pordenone's *St. George et le Dragon*, and no. 567, Philippe de Champaigne's *Portrait de Chavelier Bernini*, were withdrawn and replaced by other works.

125. Walters's purchase of the Massarenti collection was reported in the *New York Times*, May 11, 1902. A correspondent, "B," reviewed the sale in the *Königlich privilegirte Berlinische Zeitung*, June 11, 1902. The Crivelli (WAG 37.593) was published as a late work by the artist in Zeri, *Italian Paintings*, 1:242–243, no. 163.

126. For the remarks of Prof. Barnabei, see the *New York Times*, April 19, 1903.

127. The collection was removed to the tenth floor of the Parker Building, at the southeast corner of Fourth Avenue and Nineteenth Street, and to a warehouse at 542 West Fifteenth Street. Walters announced his intent to dispose of 25 percent of the collection in the *Baltimore Sun*, August 21, 1902.

128. William Adams Delano (1874–1960) received an A.B. degree from Yale in 1895 and a diploma from the École des Beaux-Arts in Paris (atelier Victor Laloux) in 1902. From 1903 until his retirement in 1949, he was a partner with Chester Holmes Aldrich (1871–1940) in the New York firm of Delano and Aldrich. The firm is noted for its designs for clubhouses and residences on Long Island. Among its major works are the Knickerbocker Club, the Brook Club, the Union Club, La Guardia Airport (1943), and the Truman balcony on the White House (1948). *The Reminiscences of William Adams Delano* were transcribed but not published by Allan Nevins and Dean

Albertson under the auspices of the Oral History Project, the Bancroft Fund of Columbia University, and the Lucius N. Littauer Foundation.

129. *Reminiscences of William Adams Delano,* February 1950, 9; Brendan Gill, *A New York Life: Of Friends and Others* (New York, 1990), 92.

130. Delano wrote to Dorothy Miner on October 9, 1939, noting that he had chosen a Genoese model for the Walters Gallery because of the sloping site (WAG Archives). For the Collegio dei Gesuiti, see *Il Palazzo dell'Università di Genova, Il Collegio dei Gesuiti nella Strada dei Balbi* (Genoa, 1984). Giuseppe Piccoli's receipt for payment for the ceiling is dated May 27, 1903 (WAG Archives).

131. Gill, *A New York Life,* 92.

132. The Hôtel Pourtalès was designed by Félix Louis Jacques Duban (1797–1870) in 1836. It now serves as offices for the Mutuelle Générale Française. In the late 1930s, William Delano proposed a remarkably similar facade for a wing of the National Gallery to contain the Calouste Gulbenkian collection (*Manchester Guardian Weekly,* April 28, 1985, 19–20).

133. The bronze bust of William Walters is an enlarged cast of William H. Rinehart's sculpture (1866–67). It was commissioned from Barbedienne & cie (*Lucas Diaries,* May 16, 1907, 2:951).

134. Accounts of the building appear in the *New York Times,* April 9, 1905, sect. 3, p. 4, and in the *Baltimore Sun,* December 30, 1906. The contractor was the J. C. Vreeland Co. of New York. The fire in the Parker Building on January 10, 1908, was reported in the *Baltimore Sun,* January 13, 1908.

Chapter Six: The Walters Gallery, 1909–1919

1. For the Atlantic Coast Line from 1909 to 1919, see Glenn J. Hoffman, "History of the Atlantic Coast Line Railroad" (library, Law Department, CSX Corporation, Jacksonville, Fla., typescript), 10:31–11:32.

2. Henry Walters to Lyman Delano, about 1910, photocopy in WAG Archives (the original letter was destroyed after the recipient's death).

3. Bernard M. Baruch, *Baruch, My Own Story* (New York, 1957), 165.

4. For Warren Delano's role in the Kentenia Corp., see K. Herr, *The Louisville and Nashville Railroad, 1850–1942* (Louisville, 1943), 125.

5. For Walters's visit to the White House and his early friendship with Woodrow Wilson, see "Makes Plea for the South," *Baltimore Sun,* October 16, 1914. The president's father, Joseph R. Wilson, had served as a Presbyterian minister in Wilmington, N.C.

6. "News Bulletin," *Wall Street Journal,* March 5, 1910.

7. *Town Topics,* November 2, 1911, unidentified clipping in the WAG Archives. Young Sadie Jones married Pope at Airlie on October 31, 1913.

8. The author is indebted to H. J. MacMillan of Wilmington for his recollections of Sadie Jones and of her gardens.

9. John J. Walsh, manager of W. T. Walters & Co., resided in the gatehouse at St. Mary's. The estate was sold in 1924 (*Baltimore Sun,* October 1, 1924).

10. The account of the Jones-Walters former residence, 13 West Fifty-first Street, being lent to the White Cross Committee appeared in the *Baltimore Sun,* December 27, 1914. Henry Walters's certificates for *chevalier* of the *Légion d'honneur* and *Medaille de la Reconnaissance française* are preserved in the Walters Archives. In 1925, he was elevated to the rank of *officier* of the *Légion d'honneur.*

11. Correspondence regarding the monument to George Davis (1820–96) is preserved in the James Sprunt papers, William R. Perkins Library, Duke University. See also L. N. Boney, ed., *The Cape Fear Club, 1967–1983* (Wilmington, 1988). The painting of Juno was identified as "Allegorical Figure" by the seventeenth-century Paduan artist Pietro Liberi.

12. Thomas S. Cullen outlined the history of the Department of Art as Applied to Medicine in "Max Brödel, 1870–1941: Director of the First Department of Art as Applied to Medicine in the World," *Bulletin of the Medical Library Association* 33, no. 1 (1945): 5–29. Ranice Crosby and John Cody provided an account of Walters's endowment to the Department of Art as Applied to Medicine in *Max Brödel: The Man Who Put Art into Medicine* (New York, 1991), 144–150.

13. The Georgetown Preparatory School, designed by the firm of Marsh and Peter, opened on September 16, 1919 (W. Abell, *Fifty Years at Garrett Park* [Washington, D.C., 1970], 13–18). For the quotation, see Walters to Donlon, January 6, 1916, reprinted in Stephen J. Ochs, *Academy on the Patowmack: Georgetown Preparatory School, 1789–1927* (Rockville, Md., 1989), 56.

14. Draft of the "Report of the Subcommittee on Art Museum of the City Wide Congress," October 1911 (Baltimore Museum of Art Archives).

15. For an account of the early history of the Baltimore Museum of Art, see K. R. Greenfield, "The Museum: Its First Half Century," *Annual 1* (Baltimore, 1966), 1:5–14. The Baltimore Museum of Art opened in the Garrett House on February 22, 1923, and moved to its permanent location in 1928. The official opening on April 18, 1929, was regarded as a landmark in the city's history. Walters wrote to Blanchard Randall on July 23, 1928, declining to subscribe additional funds to the new museum (letter in the collection of Richard Slack, Baltimore).

16. Walters succeeded Andrew Carnegie on the Board of Trustees of the New York Public Library in 1920 and served on the Art Committee (1924–27) and the Finance Committee (1922–31). He was a lifetime member of the American Museum of Natural History. For Henry Walters's service to the Metropolitan Museum of Art, see the institution's annual reports for the appropriate years.

17. John La Farge's *Muse of Painting* (1870) was purchased from Otto Weir Heinigke Sr. (New York, October 1909) for $10,000 by Daniel Chester French acting as agent for Henry Walters and J. P. Morgan (correspondence in the

National Academy of Design, New York). William Macbeth of New York sold Henry Walters three works on paper by La Farge in December 1907: *The Resurrection, Study for Nevins Window, Methuen, Massachusetts* (WAG 37.1981); *Blind Man and His Daughter, Vaiala, Samoa* (WAG 37.918); and *Avenue of the Temple of Iyeyasu, Nikko, Mid-day Study* (WAG 37.917).

18. See "Memory by French," *Bulletin of the Metropolitan Museum of Art* 14, no. 3 (1919): 46. For the purchase of the Cézanne from the Armory Exhibition, see J. Rewald, *Cézanne and America: Dealers, Collectors, Artists, and Critics* (Princeton, N.J., 1979), 205.

19. For the treasures from the tomb of Sit-Hat-Hor-Yunet, see Albert M. Lythgoe, "The Treasure of Lahun," *Bulletin of the Metropolitan Museum of Art*, pt. 2/4, no. 12 (1919): 7–26.

20. For the purchase of the statues of Sekhmet, see Albert M. Lythgoe, "Statues of the Goddess Sekhmet," *Bulletin of the Metropolitan Museum of Art*, pt. 2, 14, no. 10 (1919): 3–23. For the Valentiner quotation, see Valentiner to von Bode, April 10, 1910, Staatliche Museen zu Berlin Preussische Kulturbesitz Zentralarchiv, Nachlass Bode. The carpets were auctioned at the Charles T. Yerkes sale, Mendelssohn Hall, New York, April 5–8, 1910.

21. The opening of the new Walters gallery was reviewed in the *Baltimore Sun*, January 30, 1909. James G. Huneker's account of his visit was reprinted in the *Baltimore Sun*, February 9, 1909. Mrs. Roosevelt's visit was reported in the *Baltimore American*, February 4, 1909.

22. Faris Chapell Pitt (1842–1922) operated a coffee-importing business until 1900 and then, with Henry Walters's financial backing, opened an art gallery at 518 North Charles Street. A collector in his own right, Pitt had previously been associated with both William and Henry Walters in various local activities, including the gallery committee of the Peabody Institute.

23. In his correspondence with Pitt (photocopies, WAG Archives), Walters mentioned his planning with blueprints, June 4, 1907; his drawings for bases and vitrines, July 10, 1907; and his arrangements of the Massarenti pictures, July 27, 1907; quotation, Walters to Pitt, July 31, 1907 (photocopy, WAG Archives).

24. The handbook listing the paintings is *The Walters Collection, Baltimore* (Baltimore: Lord Baltimore Press, n.d.), which was initially printed in 1909 and revised in 1922 and 1929. The last two editions included Berenson's revisions. The quotations are from Walters to Lucas, October 16, 1908 (Baltimore Museum of Art).

25. Francavilla's *Apollo* from the Salviati Palace, Florence, was "exported with great difficulty" from Italy by Raoul Heilbrunner of Paris, who then sold it to Henry Walters before 1909 (WAG Curatorial Files). The four garden statues, catalogued as French eighteenth century, were reputedly exhibited at the Exposition Universelle of 1900 (probably by Heilbronner) and were bought in New York from Eugène Glaenzer & Co.

26. For the history of the Paris–New York firm known as Maison Ringuet-

Leprince (1840–49), Ringuet-Leprince & L. Marcotte (1849–60), and L. Marcotte & Co. (1860–1918), see N. Gray, *Léon Marcotte: American Furniture* (Hanover, Pa., 1994), 49–72. After Léon Marcotte's death in 1887, Adrian Herzog and Edmund Leprince Ringuet headed the company.

27. Several scrapbooks containing the press clippings of W. W. Brown, critic for the *Baltimore News,* are preserved in the WAG Archives. On January 22, 1911, Brown noted the plantings in the court. The poll of the city's favorite art was begun on December 29, 1909. Other popular works included sculptures in the Fifth Regiment Armory, paintings in the Crescent Club and in the Peabody Institute, and pieces belonging to local collectors and dealers. On January 30, 1910, Brown noted that attendance for the first month that year had been 2,614, whereas 7,733 had visited the gallery during the opening month the previous year. Among the artists who volunteered as guides were Grace Hill Turnbull (in a conversation with the author, c. 1968) and Mrs. Henry Stockbridge (Thomas C. Corner, "The Season Starts at Walters Gallery," undated newspaper clipping, Enoch Pratt Free Library, vertical file).

28. Walters to Lucas, October 16, 1908 (Baltimore Museum of Art).

29. Berenson disparaged Raphael's *Madonna of the Candelabra* to Isabella Stewart Gardner on August 11, 1897 (reprinted, *The Letters of Bernard Berenson and Isabella Stewart Gardner, with Correspondence by Mary Berenson,* ed. Rollin Van N. Hadley (Boston, 1987), 92 [hereafter cited as *The Letters*]. Colin Simpson, drawing on Duveen firm archives deeded to the Metropolitan Musucm of Art but now impounded until the year 2002, presented a disquieting account of Berenson's role in the Massarenti purchase in *Artful Partners: Bernard Berenson and Joseph Duveen* (New York, 1986), 93–101. Simpson noted that Berenson was initially implicated, along with Charles Wakefield Mori and Gottfried von Kopp, in foisting the Mazarenti [*sic*] collection on Henry Walters. Later (according to Simpson), Berenson, not realizing that Walters had already completed the purchase of the collection, sought to caution him against it.

30. Quotation from Ernest Samuels, *Bernard Berenson: The Making of a Connoisseur* (Cambridge, Mass., 1979), 427. Berenson included works from the Walters collection in *The North Italian Paintings of the Renaissance* (New York, 1907); the other surveys dealt with Venetian painting (1894), Florentine painting (1896), and Central Italian painting (1897).

31. Mary Berenson to her mother, Hannah Whitall Smith, May 20, 1910, reprinted in Ernest Samuels, in collaboration with Jayne Newcomer Samuels, *Bernard Berenson: The Making of a Legend* (Cambridge, England, 1987), 106 [hereafter cited as *The Legend*].

32. Walters's contract with Berenson, dated May 24, 1910, is preserved at Villa I Tatti, Harvard University Center for Italian Studies, Florence. Walters actually agreed to pay 115 percent of the total price of each work, which included the commission and incidental expenses. The agreement is also discussed in *The Legend,* 106.

33. Mary Berenson to her mother, May 4, 1911 (*The Legend*, 124).

34. Berenson received £1,100 for Daddi's *Madonna and Child* (WAG 37.553), now attributed to the workshop of Bernardo Daddi (Federico Zeri, *Italian Paintings in the Walters Art Gallery* [Baltimore, 1976], 1:8, no. 4). See Berenson to Walters, October 8, 1911 (WAG Archives).

35. Berenson to Walters, October 8, 1911 (WAG Archives).

36. Berenson offered the Rosselli (WAG 37.518) (Zeri, *Italian Paintings*, 1:92, no. 57) and the "Guaroleagrele" (WAG 37.513) (Zeri, *Italian Paintings*, 1:197, no. 130) in a letter to Walters, October 8, 1911 (WAG Archives). Berenson discussed the Lo Spagna (WAG 37.526) (Zeri, *Italian Paintings*, 2:344–345, no. 228, as Umbro-Tuscan School) in a letter to Walters, December 16, 1911 (WAG Archives).

37. The panels by Giovanni di Paolo (WAG 37.489a–d) (Zeri, *Italian Paintings*, 1:116–212, nos. 78a–d) were executed in 1426 for the Pecci-Paganucci family chapel in the church of San Domenico in Siena. The only references to the works in the WAG Archives are photographs, which bear on the reverse the artist's name in Berenson's handwriting.

38. Berenson proposed the Bicci di Lorenzo (WAG 37.448) (Zeri, *Italian Paintings*, 1:32–35, no. 19, as Bicci di Lorenzo and Stefano di Antonio) in a letter to Walters, November 9, 1912 (WAG Archives).

39. Berenson mentioned the wedding invitation in a letter to Walters, October 21, 1912 (WAG Archives), and he observed Walters's gloom regarding conditions in America in a letter to Mary Berenson, July 25, 1913 (quoted in *The Legend*, 161).

40. Mary Berenson to Isabella Stewart Gardner, March 6, 1914 (*The Letters*, 514).

41. For Berenson's categorization of the Walters paintings and his proposals for eliminations, see Mary Berenson to her sister Alys Smith Russell, March 3, 1914 (*The Legend*, 174). Mary Berenson mentioned the gold pendant in a letter to Isabella Stewart Gardner, March 17, 1914 (*The Letters*, 515).

42. For the Sassetta at "a poor man's price," see *The Legend*, 130. Joseph Duveen requested information about Walters from Berenson on May 21, 1912 (*The Legend*, 136). For Carstairs's role as an adviser of Frick, see "Firm of Knoedler & Company Has Changed Hands," *Art News* 26, no. 19 (1928): 1, 15.

43. The "Pietro Carpaccio" (WAG 37.446) was first listed in the Walters handbook in 1922. See Berenson, *Venetian Painting in America: The Fifteenth Century* (New York, 1916), 164–165, fig. 67.

44. Acquired at the William M. Laffan sale, American Art Association, January 20, 1911, were no. 23, Lucas Cranach (now Rhenish School), *The Three Graces* (WAG 37.1002); no. 27, Jan Brueghel (now Lucas van Valckenborch), *Landscape with River* (WAG 37.1730); no. 28, Dutch (manner of Frans Pourbus the Younger), *Portrait of a Lady* (WAG. 37.377); no. 29, Dutch Primitive (Barthel Bruyn), *Portrait of a Lady* (WAG 37.1847); no. 30, Dutch

School, sixteenth century, *The Illness of King Antiochus* (unlocated); and no. 35, Anthony Claessen (manner of Roger van der Weyden), *Madonna and Child* (WAG 37.293).

45. Gerard Terborch, *The Glass of Lemonade* (WAG 37.342), was sold at the Charles T. Yerkes sale, American Art Association, April 7, 1910, no. 134. An invoice for the Velázquez (WAG 37.1191) and a manuscript were mailed to Walters by Trotti & cie of Paris on January 25, 1911. The price was clipped out by the purchaser. Walters was aware of the Apsley House original, since Trotti enclosed a photograph of it with the invoice.

46. *The Madonna Nursing the Child* (WAG 37.297), attributed to the Master of Flémalle, is now listed as being by a follower.

47. Sisley's *View of Saint-Mammès* (WAG 37.355) (originally mislabeled *Les bords de la Marne*) was painted in 1881, the year after Sisley's arrival in Moret. Manet's *At the Café* (WAG 37.893) appeared in *Works in Oil and Pastel by the Impressionists of Paris* (no. 223), which opened at the American Art Galleries on April 10, 1886, and was later transferred to the National Academy of Design.

48. At the sale of the collection of Cyrus J. Lawrence (1832–1908), held at the American Art Galleries on January 21–22, 1910, Walters bought the following Boudins: no. 49, *Low Tide* ($500); no. 47, *Port of Trouville* ($350); no. 53, *On the Beach at Trouville* (WAG 37.840) ($575); and no. 58, *View of Bordeaux* (WAG 37.841) ($450). Also, he was the successful bidder for no. 63, Degas, *Avant la course* (WAG 37.850) ($2,300); no. 61, Lépine, *Bassin de la villette* (WAG 37.892) ($700); no. 78, Raffaëlli, *Dewey Arch, September 1889* ($375); no. 60, T. Ribot, *Mignone* ($1,000); no. 5, Ribot, *Gossips* (WAG 37.2429); no. 33, H. Daumier, *Les avocats* (WAG 37.1229); and no. 34, H. Daumier, *L'atelier de l'artiste* (WAG 37.1228) ($1,225). Walters retained items nos. 47, 49, and 78 for the New York residence.

49. At the sale of James B. Haggin et al., New York, April 15, 1917, Walters bought the following Gérômes: lot 10, *Death of Caesar* (WAG 37.884); lot 33, *Le concert;* lot 40, *Bashi-Bazouk Singing* (WAG 37.883); and lot 119, *Sale of Circassian Slave*. Walters confided his longing for the *Death of Caesar* to *Baltimore Sun* journalist Mark S. Watson ("Adventures in Art Collecting: An Anecdotal Account of a Masterpiece of Museums," undated clipping, Enoch Pratt Free Library vertical file).

50. *Catalogue of the Ancient and Modern Paintings and Other Objects of Art Collected by the Late William M. Laffan,* American Art Association, New York, January 20, 1911; *The Very Valuable Art Property Collected by the Late Robert Hoe,* American Art Galleries, New York, February 9–25, 1911.

51. The Anderson ledger (records of the building superintendent) records on November 15, 1911, a box from Yamanaka, New York, containing "1 box Ivories all Chinese 10 pieces" (WAG Archives).

52. At the Yamanaka sale, American Art Association, New York, January 27, 1912, Walters bought lots 142, 147, and 151 (mortuary figures) and lot 185 (a

Ming sculpture). For the gilt-bronze Kuan-yin (WAG 54.1345), which was purchased for $500, see H. W. Woodward Jr., *Asian Art in the Walters Art Gallery: A Selection* (Baltimore, 1991), 21.

53. Hakurankwai Kyokwai, in *Japan and Her Exhibits at the Panama-Pacific Exhibition, 1915*, listed Yamada Chōzaburō under "Metallic Work" (p. 158) (WAG 52.158) and Sobei Kinkozan under "Porcelain, Earthenware and Cloisonné" (p. 159). Tomioka Hōdō's no. 16, *Resting,* appeared under "Sculpture" (p. 158) (WAG 71.669–670), and the Itaya Hazan (WAG 49.2281) was also listed in the same category as the Sobei Kinkozan (p. 159). H. W. Woodward, *Asian Art* (Baltimore, 1991), 56–58, published two scrolls as dating from the Ch'ing dynasty.

54. Germaine de Poligny, "L'ancien art Mexicain au Trocadéro," in Louis Gonse (ed.), *L'art ancien à l'exposition de 1878* (Paris, 1879), 452–458.

55. The Walters set (no. 78) of *The North American Indian,* published 1907–30, was deaccessioned by the trustees and is now preserved in the Gilcrease Museum, Tulsa, Okla.

56. For the Soissons cathedral windows (WAG 46.40–41), see Madeleine H. Caviness, "Modular Assemblages: Reconstructing the Choir Clerestory of Soissons Cathedral," *Journal of the Walters Art Gallery* 48 (1990): 57–68.

57. Bernard de Montfaucon erroneously identified the subjects as French kings rather than Old Testament rulers in *Les monumens de la monarchie française* (Paris, 1789) (see Marvin C. Ross, "Monumental Sculpture from St.-Denis," *Journal of the Walters Art Gallery* 3 [1940]: 91–107).

58. For the Ara Coeli medallion (WAG 44.462), see Philippe Verdier, "A Medallion of the 'Ara Coeli' and the Netherlandish Enamels of the Fifteenth Century," *Journal of the Walters Art Gallery* 24 (1961): 8–37.

59. For the Urbino plate (WAG 48.1368), see Joan Prentice von Erdberg and Marvin C. Ross, *Catalogue of the Italian Majolica in the Walters Art Gallery* (Baltimore, 1952), 22–23.

60. For the Flemish retable (WAG 61.57), see Lynn F. Jacobs, "The Marketing and Standardization of South Netherlandish Carved Altarpieces: Limits of the Role of the Patron," *Art Bulletin* 71, no. 2 (June 1989): 208–229, fig. 15.

61. For the sculptor's model of a left foot (either WAG 22.48 or 22.56), see George Steindorff, *Catalogue of the Egyptian Collection of the Walters Art Gallery* (Baltimore, 1946), 92, nos. 309–310. For the head of Serapis (WAG 23.120), said to have been found at Baliana, Upper Egypt, see Dorothy Kent Hill, "Material in the Cult of Serapis," *Hesperia* 15, no. 1 (1946): 60–72, figs. 1 and 2.

62. *Collections de feu M. Jean P. Lambros d'Athènes et de M. Giovanni Dattari du Cairo: Antiquités Egyptiennes grecques et romaines,* Paris Hôtel Drouot, June 17–19, 1912.

63. Kelekian to Walters, May 1915 (WAG Archives). Dikran Kelekian published *The Potteries of Persia: Being a Brief History of the Art of Ceramics in the*

Near East (Paris, 1909). Some of Henry Walters's purchases of *mina'i* wares, in particular, have proven to be mismatches of fragments.

64. The ewer (WAG 54.456) was signed by Yunus ibn Yusuf al-Mawsili in 1246. Kelekian recalled the reluctance of the ex–Grand Vizier Ghaz Mahmoud Moukhtar (1832–99) to sell the work (Kelekian to Walters, May 20, 1915, WAG Archives).

65. The bronze statue of Dispater (WAG 54.998) was acquired at the John Edward Taylor sale, Messrs. Christie, Manson, and Woods, London, July 1–4, 9–12, 1912, lot 364. Caesar mentioned Dispater in *De Bello Gallico,* 6:17–18.

66. The bronze Silenus (WAG 54.2291) was subsequently acquired by the gallery at the sale of the art collection of Mrs. Henry Walters in New York, Parke-Bernet Galleries, December 1–4, 1943, no. 503.

67. For the relief showing the procession of deities (WAG 23.40), see Ellen D. Reeder, *Hellenistic Art in the Walters Art Gallery* (Princeton, 1988), 117–119, no. 38. It was logged into the gallery on September 26, 1913, and unpacked on December 5, 1915.

68. The statue of the enthroned goddess was sold by Jacob Hirsch of Ars Classica, Geneva, to the Kaiser Friedrich Museum, Berlin, in 1915. For this statue, now dated 460 B.C., see *Die Antikensammlung im Pergamonmuseum und in Charlottenburg* (Berlin, 1992), 98–99, no. 20. Writing to Isabella Stewart Gardner on September 25, 1922, Berenson recalled Walters's reluctance to buy the sculpture (*The Letters,* 650).

Chapter Seven: The Final Years, 1919–1931

1. For the Atlantic Coast Line from 1919 to 1931, see G. J. Hoffman, "History of the Atlantic Coast Line Railroad" (Library, Law Department, CSX Transportation, Jacksonville, Fla., typescript), 12:1–52.

2. The obituary of Pembroke Jones appeared the day after his death in the *Wilmington Morning Star,* January 25, 1919. Jones was survived by his wife, his daughter Sadie (Mrs. John Russell Pope), and his son Pembroke Jr. (1892–1970). Henry Walters's marriage to Sadie Jones was conducted by Howard C. Robbins, dean of the cathedral of St. John the Divine, at 4 East Eighty-first Street, on April 11, 1922 (*New York Times,* April 12, 1922). William Rand Kenan Jr. was the only known guest.

3. Edith Wharton was an acquaintance of the Delano family and could have learned of Walters's character through their mutual friend, Bernhard Berenson. Edith Wharton, *The Mother's Recompense* (New York, 1925), 240.

4. The charges of forged Gothic statues in the Metropolitan Museum of Art were raised by John Vigoroux, the New York representative of the Paris dealer Georges Demotte ("Promises Inquiry," *New York Times,* June 23, 1923).

5. Baltimore's Mayor Preston overruled the opposition to the site of the Lafayette monument commemorating the recent wartime Franco-American alliance (T. Kidd, "Lafayette Bronze Brewed a Storm," *Baltimore Evening Sun,*

undated clipping, vertical file, Maryland Room, Enoch Pratt Free library). Walters had acquired O'Connor's lost-wax castings of *Justice* (WAG 54.693) and *Inspiration* (WAG 54.692) in 1906.

6. Captain Dudley Brand retired from his command of the *Narada* in 1914. After the war, L. B. Goss, who had originally joined the yacht as a forecastle mess boy, became captain (*New London Day,* June 11, 1932, sec. 2, p. 1).

7. Warren Delano (1909–89), the son of Lyman and Leila Delano, recalled the arrival of the *Narada* at Buzzards Bay in a talk with the author in September 1988. Laura Eastman related her conversation with her aunt, Leila Delano (December 1995).

8. H. L. Stone, *The America's Cup Races* (New York, 1930), 325–383.

9. The preparations for the 1930 race are outlined in "Yachts for the Race," *Fortune* 2, no. 1 (1930): 67–70. For Will Rogers's characterization of Lipton, see Melissa H. Harrington, *The New York Yacht Club, 1844–1994* (Lyme, Conn., 1994), 64–76.

10. For Elsie de Wolfe and Henry Clay Frick, see Elsie de Wolfe, *After All* (New York, 1935), 70–75, and *The Frick Collection: An Illustrated Catalogue,* 6, pt. 2 (Princeton, 1992), 10.

Richard Seymour Conway, Fourth Marquess of Hertford, resided in Paris at 2, rue Lafitte and outside the city in the château de Bagatelle. He bequeathed the collection to his natural son, Sir Richard Wallace, who left it to his widow. At the death of Lady Wallace in 1897, the portion of the collection in Hertford House, London, was bequeathed to the British nation, and the portion still in France was left to Sir John Murray Scott. He, in turn, bequeathed it to Josephine Victoria, Baroness Sackville, who sold it to Jacques Seligmann in 1913.

11. Immediately after Henry Walters's death, Mrs. Walters sold at auction some of the earlier, mostly seventeenth- and eighteenth-century works of art (*Period Furniture, Paintings, Objects of Art from the Estates of the Late Henry Walters by Order of the Safe Deposit and Trust Co., and Others,* American Art Association, Anderson Galleries, Inc., New York, January 11–13, 1934). The remaining contents of the Sixty-first Street residence were dispersed by auction at the Mrs. Henry Walters Art Collection Sale, Parke-Bernet Galleries, Inc., New York, April 23–26 and May 2–3, 1941, and at the Mrs. Henry Walters Sale, Parke-Bernet Galleries, Inc., New York, November 30–December 1, 1943. The eighteenth-century furniture is discussed by R. H. Randall Jr., "A French Quartet," *Bulletin of the Walters Art Gallery* 23, no. 3 (1970). The B.V.R.P. writing table is now in the Charles Wrightsman collection, Metropolitan Museum of Art, New York.

12. A receipt from Arnold Seligmann, Rey & Co. of New York, dated April 16, 1919, listed the sale of a diptych (WAG 37.1683a–c) for $18,206 (WAG Archives). For the rupture of the Seligmann firm, see Germain Seligman, *Merchants of Art, 1880–1960: Eighty Years of Professional Collecting* (New York, 1961), 43–46.

13. The Walters library was auctioned at *Four Centuries of French Literature, Mainly Bindings, by Old and Modern Masters, Illuminated Manuscripts, Incunabula, Drawings, Miniatures, Americana, and Other Choice Items, Collection of Mrs. Henry Walters*, Park-Bernet, New York, April 23–25, 1941. The Sannazaro appears as no. 590, Grolier binding. For the Armenian Gospel Book (WAG W.539), see Sirarpie Der Nersessian, *Armenian Manuscripts in the Walters Art Gallery* (Baltimore, 1973), 56–62, figs. 265–308, and *Treasures in Heaven: Armenian Illuminated Manuscripts*, ed. Thomas F. Mathews and Roger S. Wieck, Pierpont Morgan Library (New York, 1994), no. 8. Dikran G. Kelekian reported locating the manuscript and delivering it to Belle da Costa Greene for transmission to Baltimore (Kelekian to Morgan Marshall, March 26, 1935, photocopy, WAG Archives).

14. For the history of the Rubens vase (WAG 42.562), see Marvin C. Ross, "The Rubens Vase: Its History and Date," *Journal of the Walters Art Gallery* 6 (1943): 8–39; Michael Jaffe, "Rubens as a Collector," *Journal of the Royal Society for the Encouragement of Arts* 117, no. 5157 (August 1969): 641–660; and Daniel Alcoufe, "Gemmes anciennes dans les collections de Charles V et de ses frères," *Bulletin Monumental* 131, no. 1 (1973): 41–46. William Beckford purchased the vase from a G. Franchi in Holland in 1818 (Beckford manuscript, note 83, Hamilton Family Papers, courtesy of the trustees of the Hamilton Kinnel Estate, Scotland). The Rubens vase was one of eleven works of art that the board of trustees of the Walters Art Gallery decided to purchase at the Mrs. Henry Walters sale in April 1941. When the bidding surpassed the $4,000 level set by the board, curator Marvin C. Ross buried his head in his hands in disappointment, only to learn hours later on the train ride back to Baltimore that the trustee accompanying him, Philip B. Perlman, had raised the bid another $500 to obtain the treasure (M. C. Ross to the author, 1976).

15. In the registrar's copy of the 1897 catalogue of the Massarenti collection, the red stamp mark "Disposed of" appears next to sixty-seven entries. Two of the stamp marks are dated February 9, 1922. Otherwise, the fate of these works is unrecorded.

16. For the Hugo van der Goes (WAG 37.296), see Eric M. Zafran in *Fifty Old Master Paintings from the Walters Art Gallery* (Baltimore, 1988), 92–93, and Joaneath Spicer, "The Psychyological Subtlety of Hugo Van Der Goes's Portrait of a Donor," *Walters Monthly Bulletin*, summer 1993. J. P. Filedt Kok, in a conversation with the author in 1997, noted that the 40,000 florins raised at the sale of the painting at the Frederik Muller auction house on April 13, 1920 (lot 66), far exceeded the Rijksmuseum's accessions funds at that time. The *Loan Exhibition of Flemish Primitives in Aid of the Free Milk Fund for Babies, Inc.*, was shown in the F. Kleinberger Galleries, Inc., in the autumn of 1929.

17. The "Rembrandt" *Head of an Old Man* (WAG 37.298) came from Arnold Seligmann, Rey & Co., New York, in 1919. Walters purportedly paid Kleinberger $50,000 for the "Rembrandt" portrait (WAG 37.681) in 1925. As late as 1947, W. R. Valentiner maintained that the work was by the master

(W. R. Valentiner to Edward S. King, October 13, 1947, WAG Curatorial Files).

18. The Paolo Veronese portrait (WAG 37.541) came from Paolo Paolini, Rome, in 1921. The Schiavone (WAG 37.1026), formerly in the Philip Lehman collection, was acquired from A. S. Drey in 1925, and the Sfonisba Anguissola (WAG 37.1016) was sold as a Giovanni Battista Moroni at the C. C. Stillman sale, American Art Galleries, New York, February 3, 1927, no. 29.

19. Wilhelm von Bode published the bronze of St. John the Baptist (WAG 54.463), sold by Arnold Seligmann, Rey & Co. in 1926 for $15,000, in *Die Kunstsammlungen Ihrer Majestät der Kaiserin und Königin Friedrich in Schloss Friedrichshof* (Berlin, 1896), 18.

20. For the early-sixteenth-century *Venus Prudentia* (WAG 54.1027), see von Bode, *Die italienischen Bronzestatuetten der Renaissance* (Berlin, 1907), pl. 239. It has also been attributed to Tullio Lombardo of Venice.

21. After the *Exhibition of Paintings and Drawings by Bryson Burroughs* at Montross Gallery, New York, March 19–April 9, 1921, Walters bought Burroughs's *Saint Martin and the Beggar* (WAG 37.301) and two drawings, *Demeter* (WAG 37.1003) and *Hippocrene* (WAG 37.1085). Burroughs (1869–1934) had been hired as an assistant by Roger Fry in 1906, and three years later he had succeeded Fry as curator of paintings at the Metropolitan Museum of Art. For Fry's disdain for American culture and his admiration for Bryson Burroughs, see Calvin Tompkins, *Merchants and Masterpieces: The History of the Metropolitan Museum of Art* (New York, 1970), 231.

22. Louise Burroughs, Bryson Burroughs's second wife, narrated to the author the account of the purchase of Ingres's *Odalisque with Slave* (WAG 37.887) in April 1977.

23. Eastman Johnson's *The Nantucket School of Philosophy* (WAG 37.311) had been lent to the World's Columbian Exposition in Chicago (no. 620) in 1893 by Edward D. Adams of New York. Walters acquired the picture from Knoedler and Co. on April 5, 1924.

24. Eliot Clark lived to see *Theodore Robinson: His Life and Art* published by R. H. Love Galleries, Inc. (Chicago, 1979).

25. The cassolette (WAG 54.2261) and the pair of Sèvres vases (WAG 48.1796–1797) were purchased from Arnold Seligmann, Rey & Co. in 1930 and 1926, respectively. They were subsequently acquired by the gallery at the Mrs. Henry Walters sale in April 1941.

26. The ivory casket with scenes of romance and chivalry (WAG 71.264) was purchased from Arnold Seligmann, Rey & Co., which also, in 1926, supplied for 400,000 francs the Byzantine casket lent by the countess D'Authenaise to the *Exposition rétrospective* in the Trocadéro in 1878.

27. *Catalogue of an Important Collection of Old Sèvres Porcelain, Louis XV and Louis XVI Period Belonging to E. M. Hodgkins* (Paris, n.d.), with a preface signed "S.J.," had been privately printed before Henry Walters's purchase of the collection. Previously, Seymour De Ricci had published *Catalogue of a Collection of*

Mounted Porcelain Belonging to E. M. Hodgkins (Paris, 1911). On May 16, 1927, Hodgkins auctioned at the Hôtel Drouot, in Paris, some eighteenth-century furnishings (*Catalogue des objets d'art et d'ameublement . . .*). See Count Xavier de Chavagnac, "Porcelaines de Sèvres, Collection E. M. Hodgkins," *Les Arts,* no. 89 (May 1909): 1–32. The *Vases à jet d'eau* (WAG 48.637–638) and the *Vases ovales Mercure* (WAG 48.635–636), once in the possession of Lord Gwydir, were sold by his widow, Lady Willoughby d'Eresby (Lord Gwydir sale, Christie's, London, May 20–21, 1829).

28. For the reliquaries of Saints Amandus (WAG 53.9) and Symphorien, see Marvin Chauncey Ross, "The Reliquary of Saint Amandus," *Art Bulletin* 17, no. 2 (1936): 187–198.

29. For the history of the firm of Brimo de Laroussilhe, see Etienne Bertrand, *Emaux Limousins du Moyen Age* (Paris, 1995). Bertrand listed among the dealers in this network Fabius, Bacri, Antoine Brimo (Nicolas's brother), Altounian, Kelekian, Gurekhian, and Minassian (Bertrand to Johnston, January 20, 1996, WAG Archives).

30. The two early Chinese sculptures (WAG 25.4 and 25.9) sold by Yamanaka and Co. in 1920 were published in Hiram W. Woodward Jr., *Asian Art in the Walters Art Gallery: A Selection* (Baltimore, 1991), nos. 8 and 9. The two horse-shaped buckles (WAG 54.2041, 54.2046) acquired from Yamanaka and Co. in November 1930 were said to have been excavated at Shinrindo, Tokaimen, Keisho Hakudo province.

31. Warren R. Dawson and Eric P. Uphill, *Who Was Who in Egyptology,* 3d ed. (London, 1995), 267–268.

32. For the collection of William MacGregor (1848–1937), see Henry Wallis, *Egyptian Ceramic Art* (London, 1898), and the sales catalogue of the MacGregor Collection of Egyptian Antiquities, Sotheby, Wilkinson and Hodge, London, June 26–30, July 3–6, 1922. Ellen D. Reeder published the rhyton dating from the third to second century B.C. (WAG 48.368) and the third-century bowl (WAG 48.366) in *Hellenistic Art in the Walters Art Gallery* (Baltimore, 1988), nos. 105 and 108. Lot 469, the Meroitic double-faced relief (WAG 22.258a–b) was sold for £31. The game board, lot 263 (WAG 48.408), said to have been found in Abydos, realized £176. Kelekian paid £134 for the five ivory dwarfs (WAG 71.531–535) from Saoniyeh (Semaineh).

33. Kelekian's inscription on the reverse of a photograph identifies Cassatt as the original owner of the relief fragment from the Tomb of Maya (WAG 22.86). For Mary Cassatt's visit to Egypt, see Nancy Mowll Mathews, *Mary Cassatt: A Life* (New York, 1994), 287–292.

34. See George Steindorff, *Catalogue of Egyptian Sculpture in the Walters Art Gallery* (Baltimore, 1946), 23 (WAG 22.405, 22.115) and 76 (WAG 22.120).

35. The Anderson ledger (records of the building superintendent, WAG Archives), 55, refers to the June 1930 purchases from the "Sheik of the Pyramids." The same month, Anderson recorded the pieces bought from Maurice Nahman (1868–1948), former chief cashier of the Credit Foncier Égyptien.

Khawam Brothers of Cairo, on May 26, 1930, sold Walters such objects as the statuette of Anubis (WAG 54.552) and the gold amulet (WAG 57.1560).

36. Reeder published the Neo-Attic Peplophoros statue (WAG 23.87) in *Hellenistic Art,* 114–116, nos. 36 and 37. A portion of the collection initiated by Thomas Hope (1770?–1831), including the statue (lot 234), was auctioned by Christie's, London, on July 23, 1917.

37. For accounts of Joseph Brummer (1883–1947) and his brothers Ernest (1891–1964) and Imre (d. 1928), see Leslie A. Hyam, "Foreword," *The Notable Collection Belonging to the Estate of the Late Joseph Brummer,* pt. 1, Parke-Bernet Galleries, Inc., New York, April 20–23, 1949; William H. Forsyth, "Acquisitions from the Brummer Gallery," in *The Grand Gallery in the Metropolitan Museum of Art* (New York, 1974–75): 1–5; Caroline Bruzelius and Jill Meredith, *The Brummer Collection of Medieval Art* (Durham, N.C., 1991), 1–11. James Roundell published Rousseau's portrait of Brummer in "Portrait de Joseph Brummer by le douanier Rousseau," *Christie's International Magazine,* November–December 1993, 20–21.

38. For the Egyptian relief (WAG 22.121), see Steindorff, *Catalogue of Egyptian Sculpture,* 72, no. 236. The Greek funerary relief is WAG 23.38.

39. The two reliefs from the palace of King Assurnasirpal II are the example with the embroidered hunt scenes (WAG 21.9) and another showing a winged genius (WAG 21.8). William Frederic Williams (1818–71) was an American missionary in Mosul in 1851. Dwight Whitney Marsh (1823–96) served on the American Board of Commissioners for Foreign Missions at Mosul in 1850–60. A possible source for the second relief might have been Dikran Kelekian, who, at the time, was involved in complicated negotiations with several American museums and also with John D. Rockefeller Jr. regarding the sale of the Assyrian reliefs from Canford Manor. These had been placed on the market in 1920 by Ivor Churchill Guest, the first Viscount Wimborne. The reliefs were sold in 1927 to Rockefeller, who subsequently presented them to the Metropolitan Museum of Art (see John Malcolm Russell, *From Nineveh to New York* [New Haven, Conn., 1997]).

40. See Marlia Mundell Mango, *Silver from Early Christian Byzantium* (Baltimore, 1986).

41. Edgar J. Banks (1866–1945) noted that Palmyrene busts were once either hoarded by wealthy Arabs or sold to travelers (*Bismya, or the Lost City of Adab* [New York, 1912], 46). The Silene mask (WAG 21.2) is thought to date from 248 B.C.–A.D. 226, and the Palmyrene head (WAG 23.231) from the first or early second century A.D.

42. For the Carolingian lectionary (WAG W.8), see *Two Thousand Years of Calligraphy* (Baltimore, 1965), no. 16, 32–33.

43. Dorothy Miner published the two Greek manuscripts (WAG 10.526 and 10.533) in "The Book of Eastern Christendom: American Collections of Near-Eastern Manuscripts," *Gazette of the Grolier Club,* n.s., 3 (February 1967): 19.

44. *Illustrated Catalogue of the . . . Collection of Ancient Arms and Weapons, Egyptian Antiquities, and Oriental and European Curios Collected by S. H. Austin,* American Art Galleries, April 24–28, 1917.

45. *European Arms and Armor, Eleventh to Eighteenth Century: The Collection of Henry Griffith Keasbey,* American Art Association, New York, Part I, December 5–6, 1924; Part II, November 27–28, 1925. Lot 145, the Saxon, late-sixteenth-century combination battle-ax and wheel-lock pistol (WAG 51.430), was sold for $575.

46. The Italian arm defense (WAG 51.539) was published in *The Art of the Armorer,* Flint Institute of Arts in the DeWaters Art Center, Flint, Mich., December 7–April 1, 1968, no. 14. Walter J. Karcheski Jr. drew the comparison between the Walters pauldron and vambrace and the foot combat pauldron for the Duke of Savoy's armor in the Royal Armory of Turin.

47. *European Arms and Armor, Mainly Fifteenth to Seventeenth Century, Including Artistic and Rare Specimens from Princely Provience,* American Art Association, Inc., New York, November 19–20, 1926. Lot 232, the German sallet (WAG 51.470), was among the items from the Schloss Vaduz.

48. An early photograph of the suit of ceremonial armor (WAG 51.585), dated 1925, identified it as Spanish parade armor.

49. For his curatorship at the Stieglitz Museum, see Alexandre Polovtsoff, *Les trésors d'art en Russie sous le régime Bolcheviste* (Paris, 1919). Mary Churchill Humphrey, a friend of the Polovtsov family, referred to Polovtsov's "historical romance" with the *comtesse du Nord* in a letter to Edward S. King, June 26, 1957 (WAG Curatorial Files). Suzanne Massie, in *Pavlovsk: The Life of a Russian Palace* (Boston, 1990), 132n, related the rumor that Polovtsov's grandfather, Baron Stieglitz, had an adopted daughter who was actually the natural daughter of Grand Duke Michael, Maria Feodorovna's youngest son.

50. During the Russian Revolution, Polovtsov, P. P. Weiner (publisher of the art journal, *Starie Godi*), and V. P. Zubov, founder and director of the Institute of the History of Art, St. Petersburg, endeavored to catalogue and preserve the contents of the two palaces.

51. The snuff box with the six daughters of Paul I and Maria Feodorovna (WAG 57.45) has not been published. The Kolb snuff box (WAG 57.261) was published by Philippe Verdier in *Russian Art: Icons and Decorative Arts from the Origin to the Twentieth Century* (Baltimore, 1959), no. 44.

52. How the Gatchina Palace egg (WAG 44.500) and the rose-trellis egg (WAG 44.501) had passed from the imperial family's collection to Alexandre Polovtsoff remains unknown.

Chapter 8: Postscript

1. The death certificate (no. 105076), Bureau of Records, City of New York, listed the causes of death as uremia and myocarditis complicated by pan-

sinusitis, chronic bronchitis, and cystitis. Walters had been treated for these ailments for over nine years.

2. Henry Walters's will was dated in New York on April 11, 1922, and was probated in Baltimore on December 7, 1931. The inventory of the estate initially valued at $11,962,140 was the largest that had been filed in Maryland to that date.

3. Francis Henry Taylor, "What Baltimore Will Do with the Walters Bequest," *American Magazine of Art* 27, no. 5 (1934): 261–266. Upon his death in 1917, John G. Johnson bequeathed his comprehensive collection of European paintings to the city of Philadelphia. The William Rockhill Nelson Gallery opened in Kansas City in 1933. In Toledo, Edward Drummond Libbey was a founder of the Toledo Museum of Art in 1901 and a major donor of funds for the construction of a new building in 1912; in 1924, he bequeathed his Old Masters collection to the museum. Henry Clay Frick provided an endowment of $15 million for his collection when he died in 1919. Two years after his widow's death in 1933, the Frick Collection opened in New York. J. Pierpont Morgan died in 1913. For tax reasons, Morgan's son was obliged to sell much of his father's collection, but in 1916 and 1917 he gave over 40 percent of it to the Metropolitan Museum of Art. Meanwhile, J. Pierpont Morgan Jr. established the Pierpont Morgan Library as a public institution in memory of his father's love of rare books and his belief in the educational value of the collection.

4. Mayor Howard W. Jackson appointed the commission on November 18, 1932. Its members included Sadie Walters; B. Howell Griswold, a member of the board of the Municipal Museum and a founding board member of the Baltimore Museum of Art (BMA); C. Morgan Marshall, president of the board of trustees of the Maryland Institute and a member of the board of the BMA; Robert Garrett, a member of the board of the BMA; Philip B. Perlman, a member of the boards of the BMA, the Maryland Institute, and the Municipal Museum; Dr. A. R. L. Dohme, vice-president of the BMA; and James J. Nelligan, a former member of the finance committee of the BMA.

5. Minutes of the Meeting, Walters Art Gallery Commission, November 5, 1932.

6. The establishment of the Walters Art Gallery and its early history can be traced in the minutes of the meetings of the Walters Art Gallery Commission, followed by the minutes of the meetings of the trustees of the Walters Art Gallery. Philip B. Perlman (1890–1960), in addition to his contributions as a member of Mayor Jackson's commission drafting various ordinances and by-laws leading to the gallery's establishment, later served as its president. Under his leadership, in 1958 and again in 1960, unsuccessful efforts were made to win public financial support for an expansion of the gallery utilizing the Jacobs and Jencks (Hackerman) mansions on the southwest side of Mount Vernon Place.

7. On March 8, 1933, the mayor approved ordinance 400 authorizing the acceptance of the property and funds given to the city according to Henry Walters's will and establishing the trustees of the Walters Art Gallery. Chapter 217 of the Laws of Maryland effective June 1, 1933, incorporated the Board of Trustees of the Walters Art Gallery, and city ordinance 468, approved fifteen days later, vested the management and control of the gallery in the trustees of the Walters Art Gallery, a body corporate.

8. Henry Walters's letter to General Riggs of January 27, 1928, was read to the trustees at their meeting on February 26, 1934 (Minutes of the Meeting, Trustees of Walters Art Gallery). Lawrason Riggs (1861–1940), a fellow collector of Chinese ceramics, was a director of the Safe Deposit and Trust Co. and a member of the board of trustees of the Baltimore Museum of Art.

9. Walter H. Siple (1890–1978), a pupil of Paul Sachs's museology course at the Fogg Art Museum, became director of the Cincinnati Art Museum in 1929. His role in supervising the 1932 opening of the house and the art collection bequeathed to Cincinnati by Charles Phelps and Anna Sinton Taft would have qualified him to be director in Baltimore.

10. Charles Morgan Marshall (1881–1945) was the grandson of John E. Marshall, who had started the family building business. After the Walters Art Gallery was built, the firm of John E. Marshall & Son maintained it. C. Morgan Marshall attended the Maryland Institute School of Mechanical Draftsmanship and participated on the boards of various cultural institutions. He was largely responsible for the establishment of the Walters's Conservation Department.

11. Francis Henry Taylor, "The Walters Art Gallery Revisited," *Parnassus* 6, no 6 (December 1934): 6.

12. Seymour De Ricci, with the assistance of W. J. Wilson, *Census of Medieval and Renaissance Manuscripts in the United States and Canada* (New York, 1935), 1:758; Lilian M. C. Randall, *Medieval and Renaissance Manuscripts in the Walters Art Gallery* (Baltimore), vol. 1 (1989), vol. 2 (1992), vol. 3 (1997).

13. The professional staff of the gallery in 1934 included the following (the asterisk indicates those who remained at the Walters Art Gallery for their entire careers): C. Morgan Marshall,* temporarily known as the acting director; his assistant, John Carroll Kirby;* Winifred Kennedy,* registrar; her assistants Ann Elizabeth Anderson and Elizabeth C. G. Packard;* Research Associates Dorothy Kent Hill,* Marvin Chauncey Ross, Dorothy E. Miner,* Edward S. King,* and George Heard Hamilton; David Rosen, technical advisor, and his assistant, Harold D. Ellsworth. In addition, May Copinger was secretary of public relations; Mary R. Poe,* information and sales; James C. Anderson,* building superintendent; William H. Smith,* captain of the watch, and a staff of eight for security and maintenance.

14. Walters wrote to Robinson regarding the "cankers" on December 8, 1910, and received a reply four days later (photocopies, WAG Archives). For

the history of the Walters Conservation Department, see Terry Drayman-Weisser, "A Perspective on the History of the Conservation of Archaeological Copper Alloys in the United States," *Journal of the American Institute for Conservation* 33, no. 2 (1994): 141–152.

15. *The Star Spangled Banner* was purchased for $24,000 at the American-Anderson Art Galleries on January 5, 1934. From the same source during that month came a relief sculpture of *The Agony in the Garden* (WAG 27.223), then attributed to "Della Robbia" but now identifed as from the atelier of Benedetto and Santi Buglioni. Key's manuscript was deaccessioned in 1953 with the stipulation that the proceeds be applied to the purchase of a medieval manuscript. It was sold to the Maryland Historical Society on October 7, 1953.

16. The large duct system originally installed in the gallery proved adequate to receive the modern air-cooling system introduced in 1934. Walters had previously used strips of canvas mounted on large rollers to cover the skylights during the summers when the building was closed. He had also introduced a dehumidifier that could be activated when a mechanism sounded a large horn loud enough to be heard throughout the building.

17. Francis Henry Taylor, "The Walters Art Gallery Revisited," *Parnassus,* nos. 6 and 7 (December 1934): 3–6, 31.

18. "Able Son," *Baltimore Evening Sun,* July 29, 1946.

19. In 1971, Dorothy E. Miner related to the author the exchange between Belle Da Costa Greene and B. Howell Griswold.

20. Myeric C. Rogers narrated his recollections of the Walters opening reception to the author, c. 1967.

21. H. L. Mencken, *A Mencken Chresthomathy* (New York, 1949), 561–562n. 1.

INDEX

Italic page numbers indicate illustrations.

Library of Congress Cataloging-in-Publication Data

Johnston, William R.
 William and Henry Walters : the reticent collectors / William R.
Johnston.
 p. cm.
 Includes bibliographical references and index.
 ISBN 0-8018-6040-7 (alk. paper)
 1. Walters, W. T. (William Thompson), 1820–1894. 2. Walters,
Henry, 1848–1931. 3. Art—Collectors and collecting—United States—
Biography. I. Walters Art Gallery (Baltimore, Md.) II. Title.
N5220.W43J65 1999
709'.2'273–dc21
[B] 99-10315